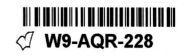

RUTH VOLLMER 1961–1978
THINKING THE LINE

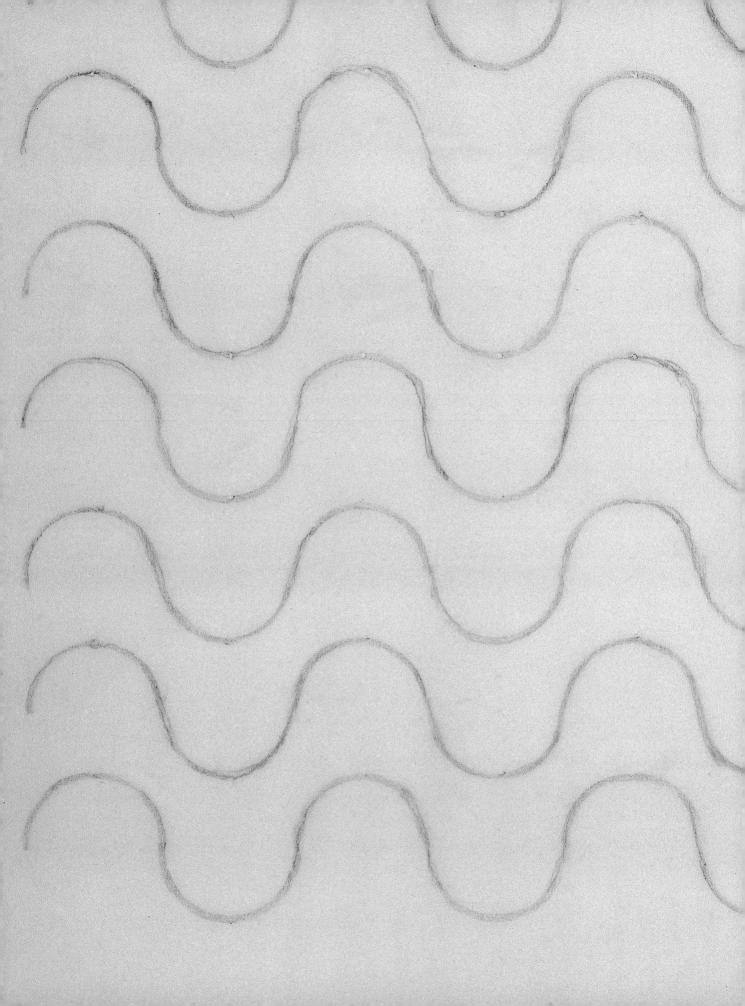

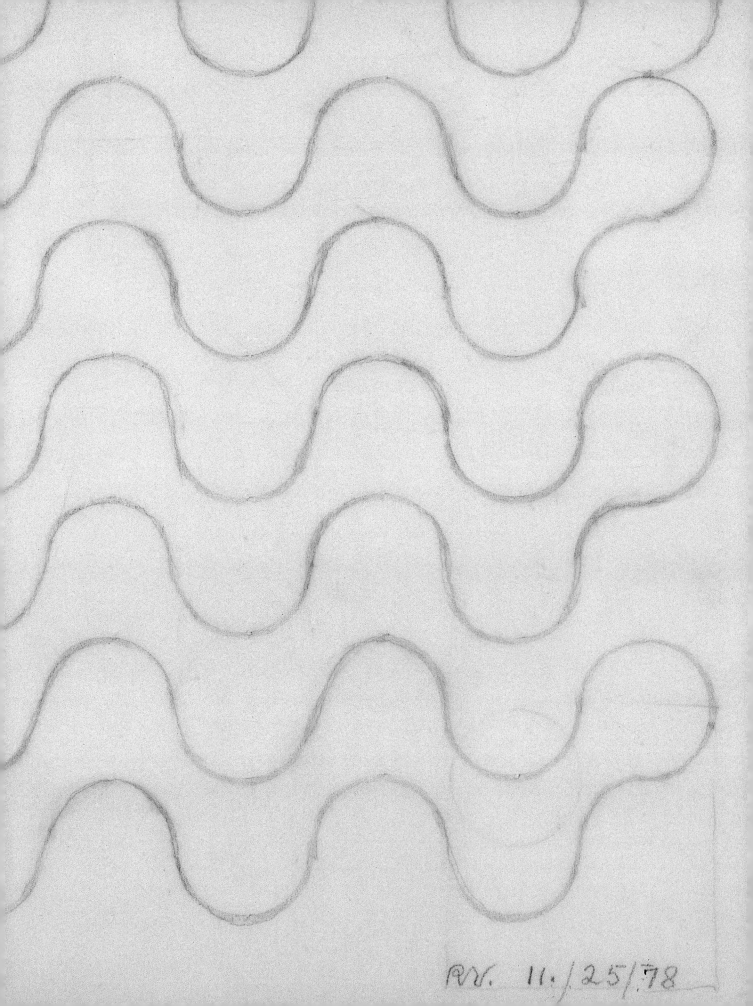

RR. 11./25/78

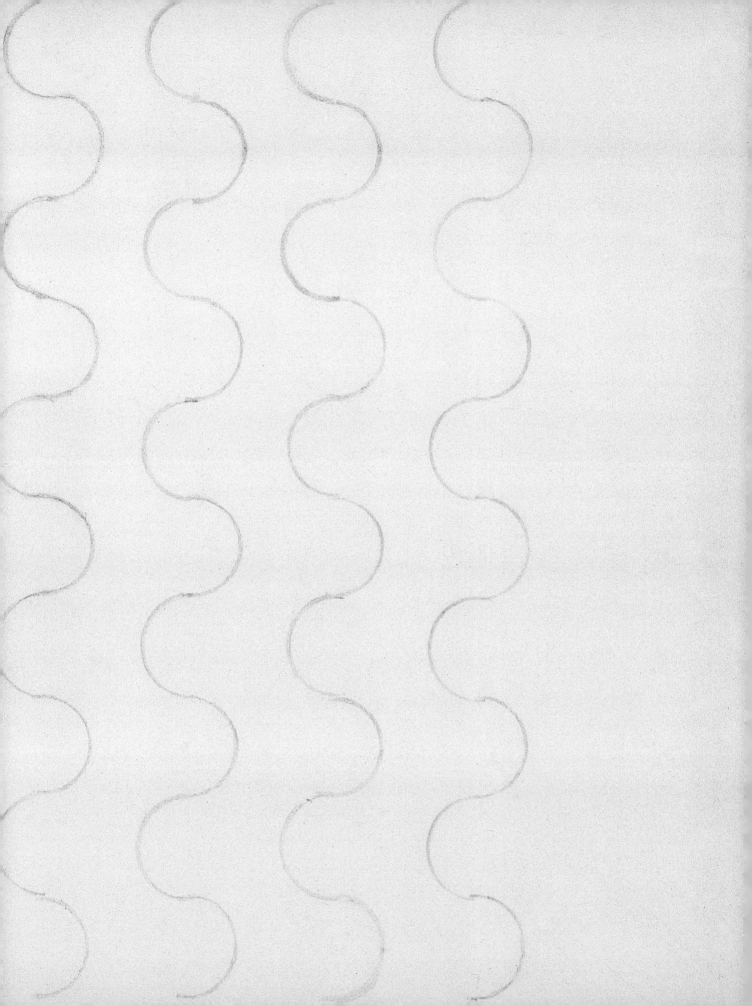

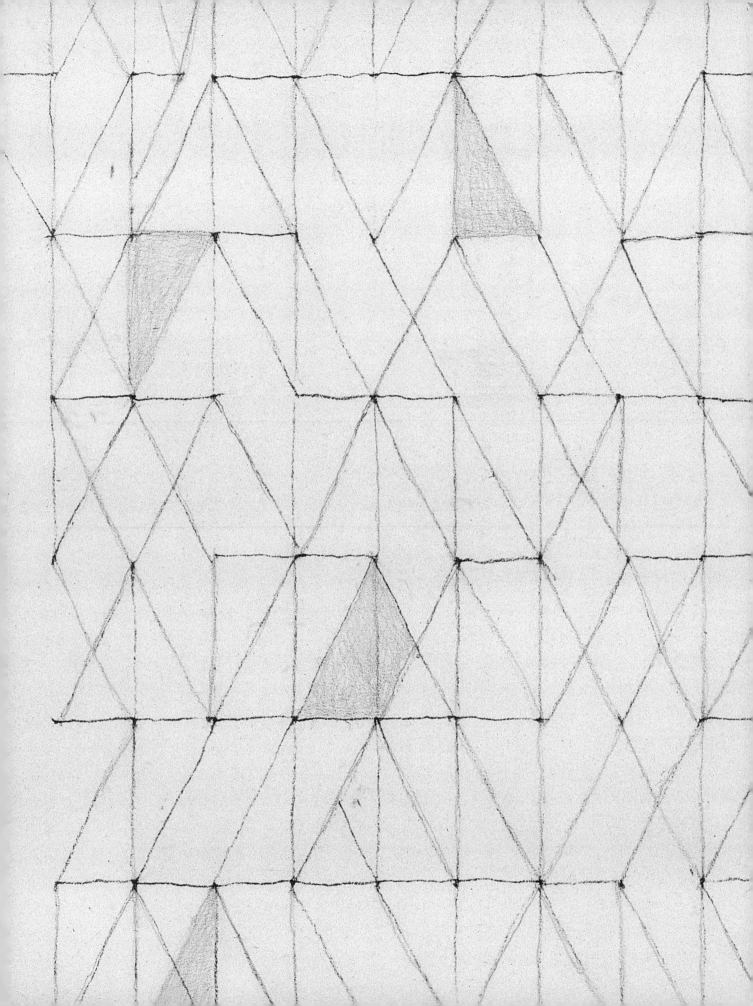

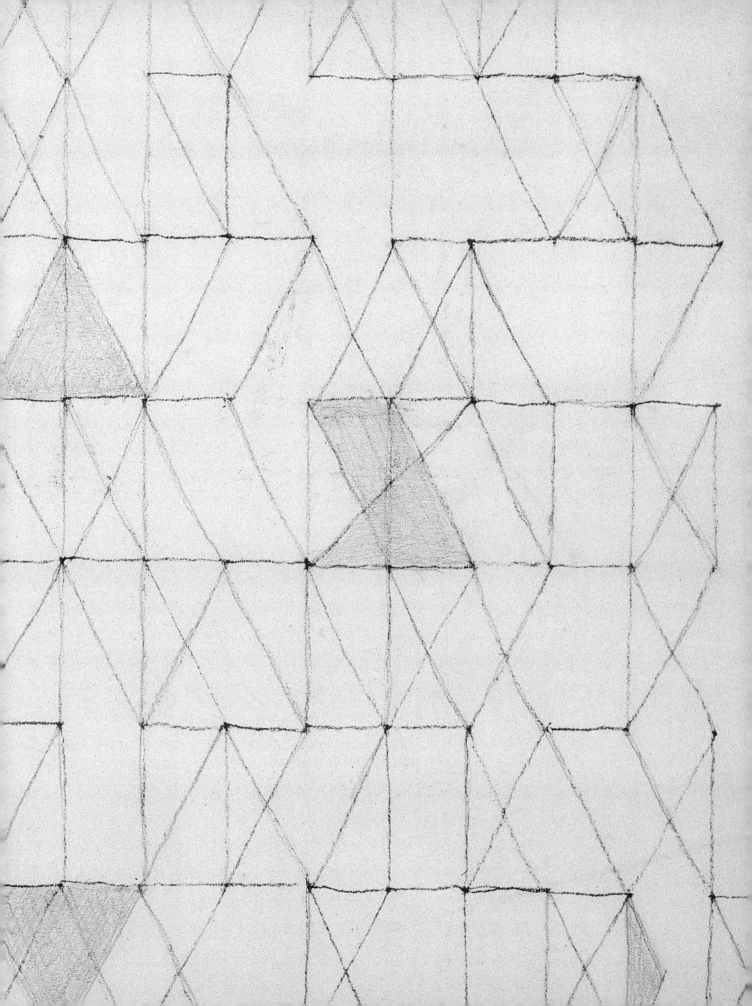

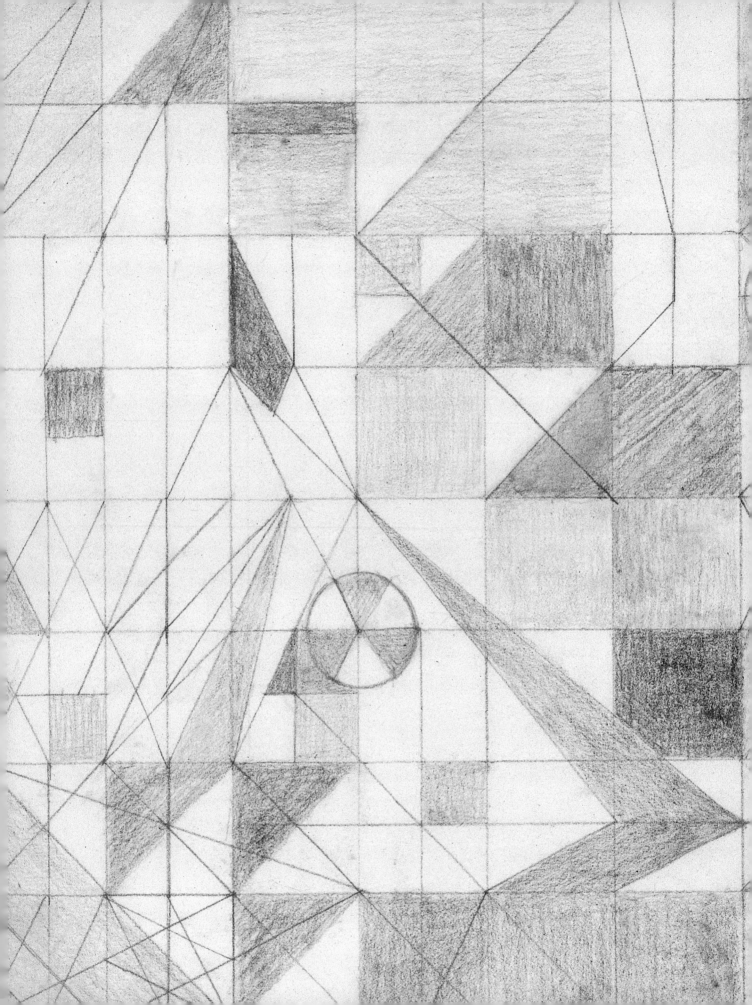

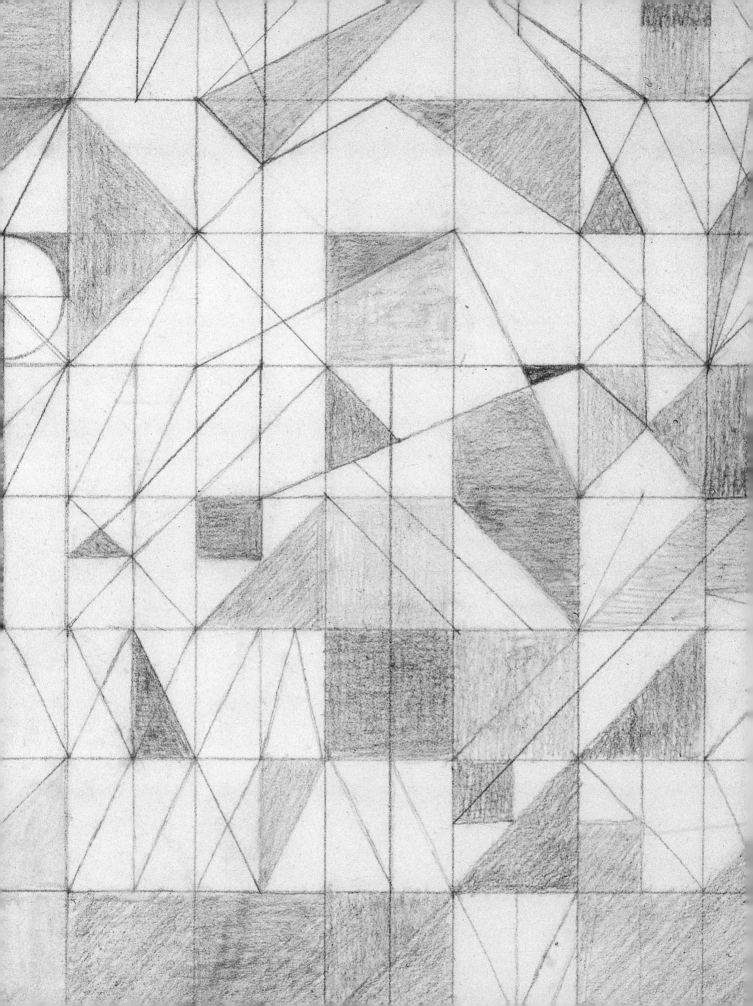

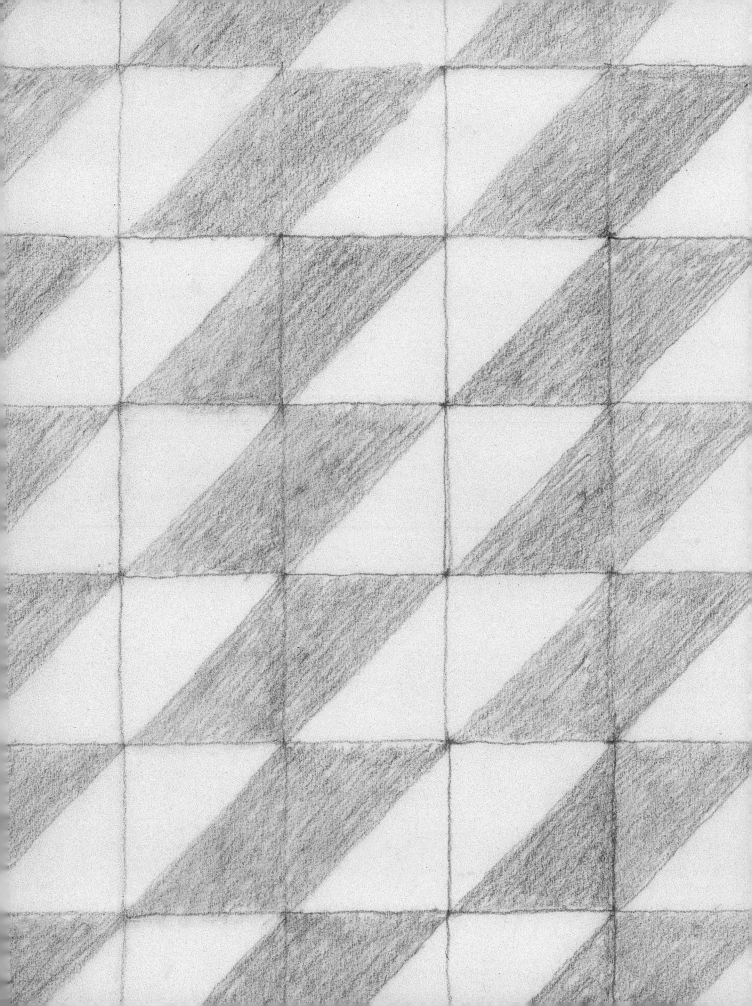

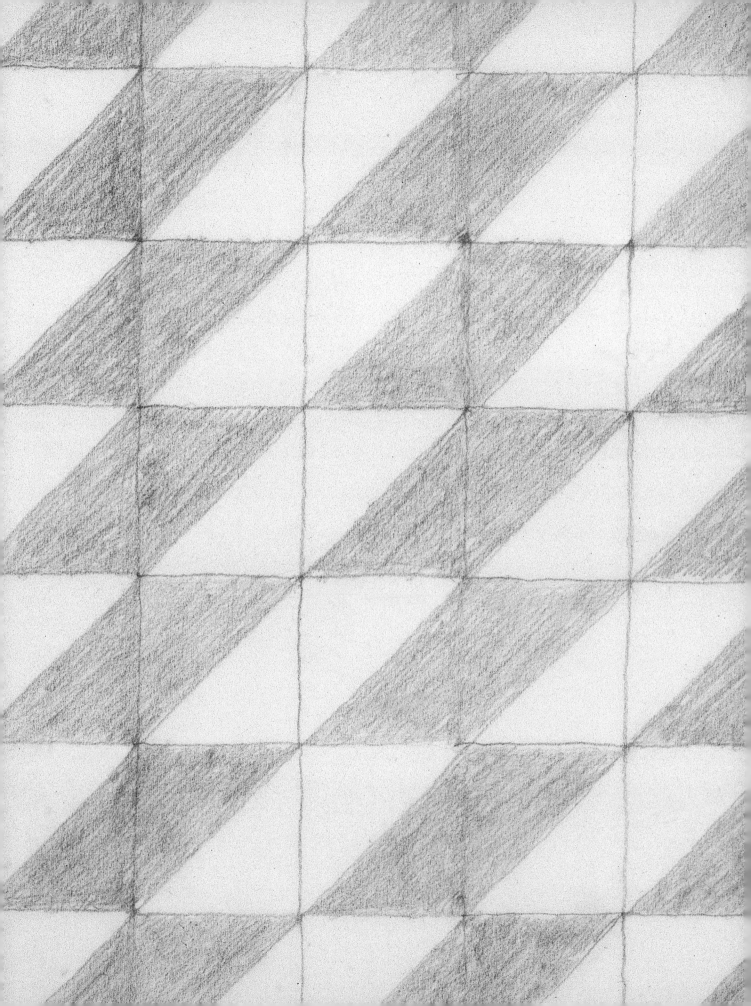

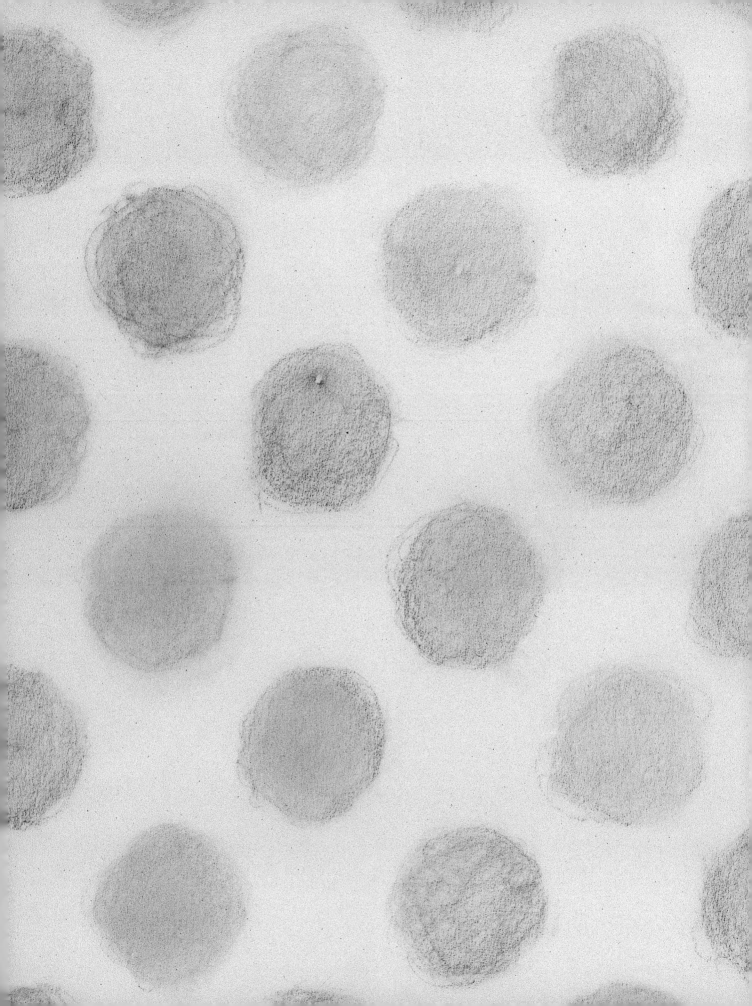

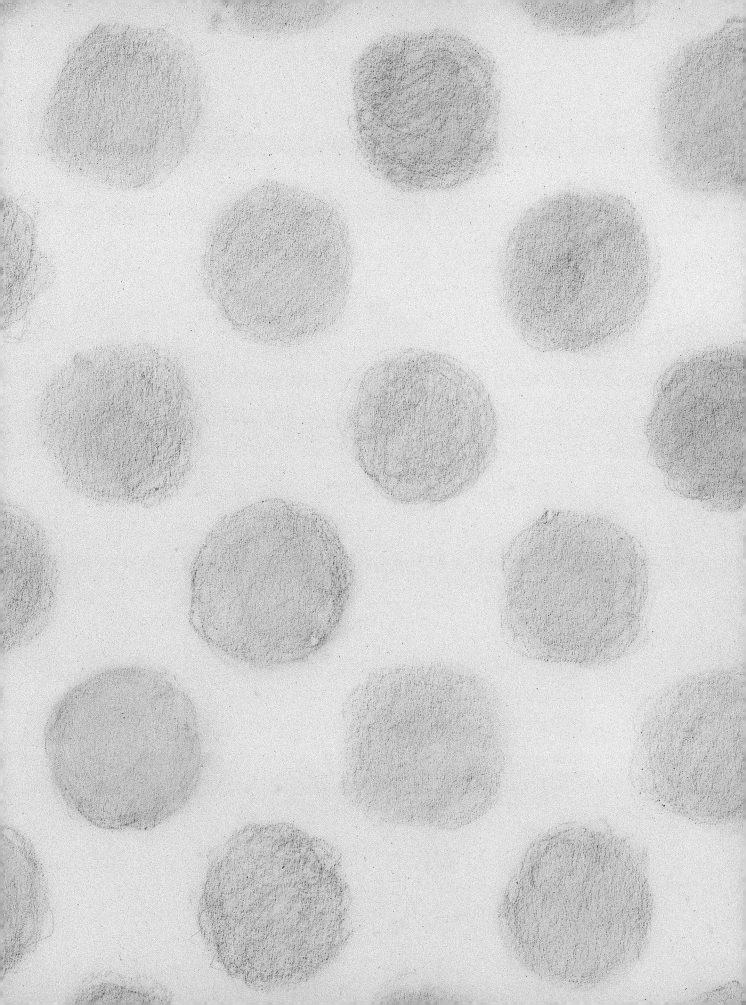

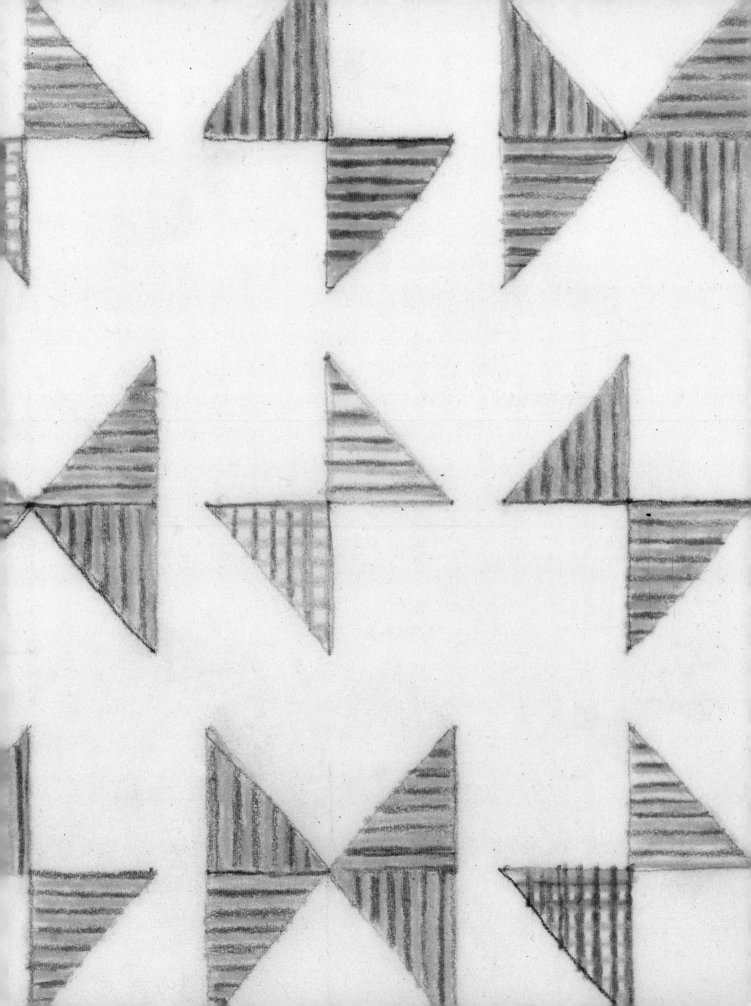

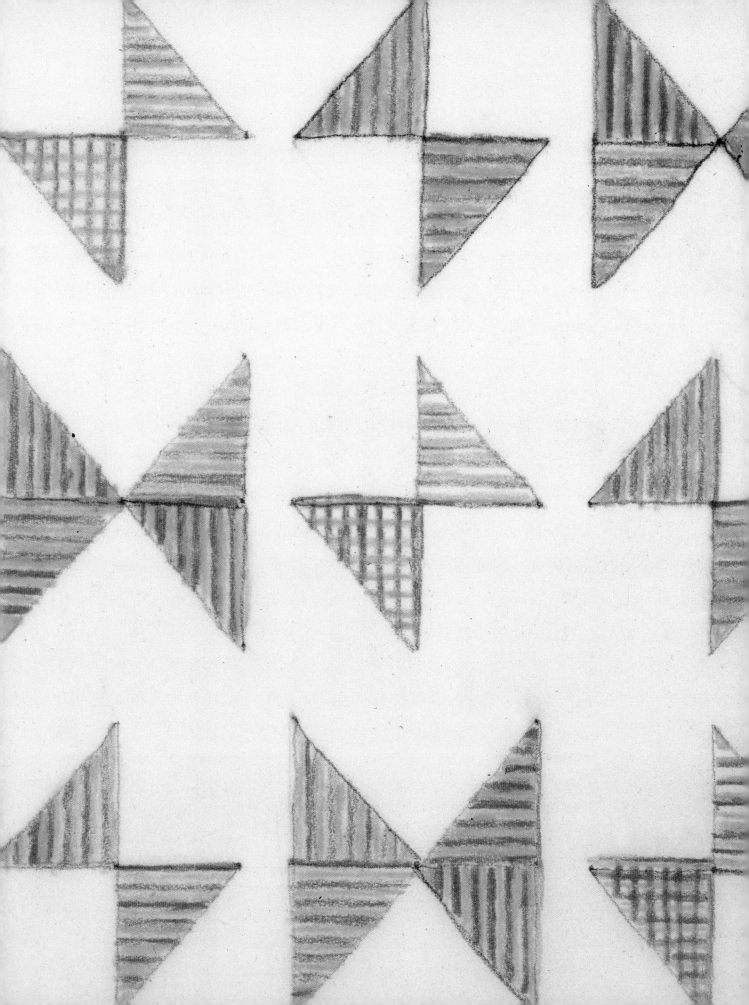

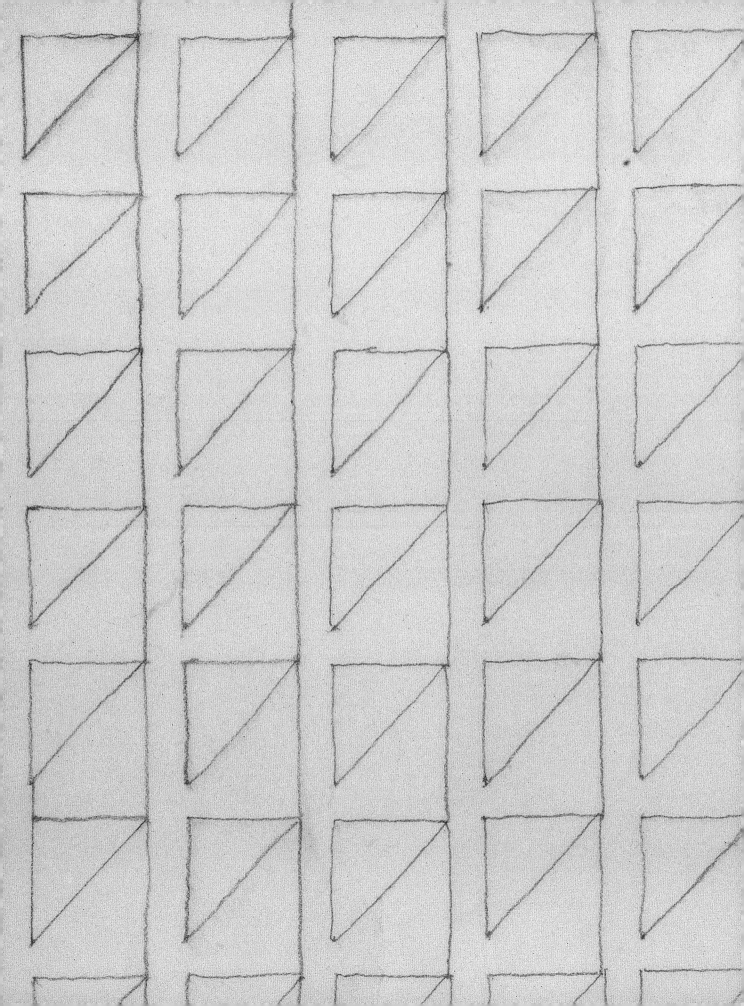

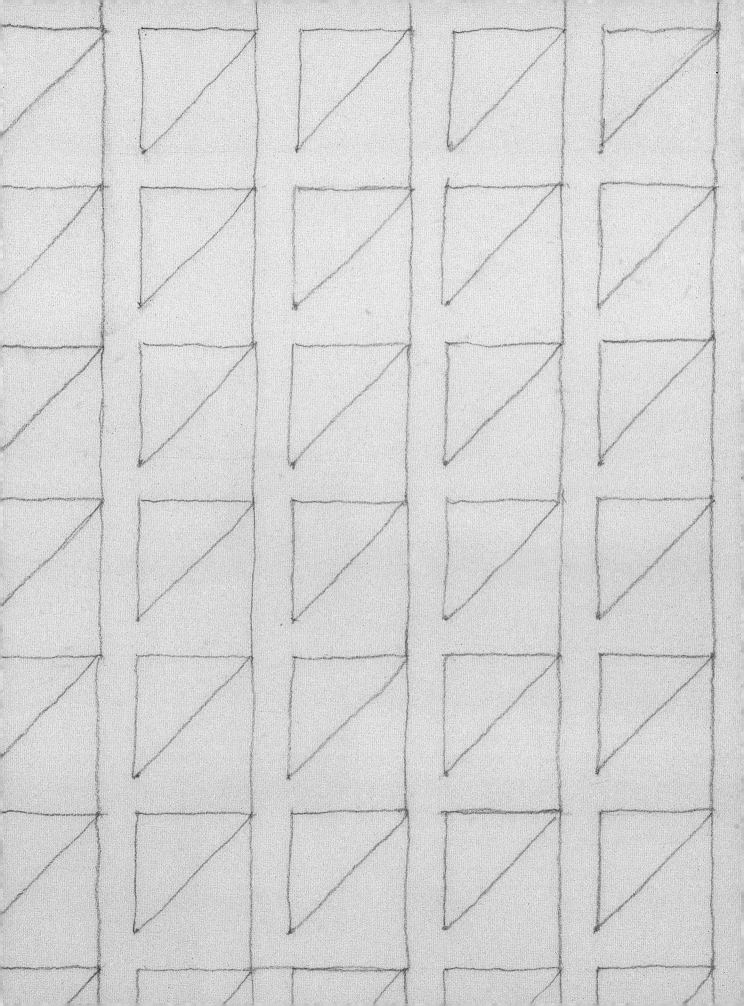

ZKM I Zentrum für Kunst und Medientechnologie Karlsruhe
Lorenzstraße 19 / D-76135 Karlsruhe
Tel. +49 721-81001200 / Fax +49 721-81001139
info@zkm.de / www.zkm.de
Director Peter Weibel

Neue Galerie am Landesmuseum Joanneum
Sackstraße 16 / A-8010 Graz
Tel. +43 0316-829155 / Fax +43 0316-815401
neuegalerie@stmk.gv.at / www.neuegalerie.at
Director Christa Steinle

Miami Art Central
5960 SW 57th Avenue Miami, Florida 33143
Tel. +1 305-455-3333 / Fax +1 305-455-3334
www.miamiartcentral.org
Director Rina Carvajal

RUTH VOLLMER 1961–1978
THINKING THE LINE

NADJA ROTTNER+PETER WEIBEL, EDITORS

HATJE
CANTZ

PAGES 2-3

UNTITLED (WAVES), N.D.
PENCIL ON TRANSPARENT PAPER
9 X 12 IN. (22.9 X 30.5 CM)
JACK TILTON GALLERY, NEW YORK
PHOTO KOINEGG/NEUE GALERIE GRAZ

PAGES 4-5

UNTITLED (WAVES), 1978
PENCIL ON TRANSPARENT PAPER
14.2 X 16.7 IN. (36 X 42.5 CM)
JACK TILTON GALLERY, NEW YORK
PHOTO KOINEGG/NEUE GALERIE GRAZ

PAGES 6-7

UNTITLED, 1977
PENCIL ON TRANSPARENT PAPER
8.5 X 10.8 IN. (21.5 X 27.5 CM)
COLLECTION PHILIP MCCARTER TIFFT, NEW YORK
PHOTO KOINEGG/NEUE GALERIE GRAZ

PAGES 8-9

UNTITLED (SQUARES, SHADED), 1977
PENCIL ON TRANSPARENT PAPER
10.6 X 13.8 IN. (27 X 35 CM)
JACK TILTON GALLERY, NEW YORK
PHOTO KOINEGG/NEUE GALERIE GRAZ

PAGES 10-11

UNTITLED (ROWS OF SHADED RHOMBUS), 1978
PENCIL ON TRANSPARENT PAPER
8.5 X 10.8 IN. (21.5 X 27.5 CM)
JACK TILTON GALLERY, NEW YORK
PHOTO KOINEGG/NEUE GALERIE GRAZ

PAGES 12-13

UNTITLED (SHADED CIRCLES), 1978
PENCIL ON TRANSPARENT PAPER
8.5 X 12 IN. (21.5 X 30.5 CM)
JACK TILTON GALLERY, NEW YORK
PHOTO KOINEGG/NEUE GALERIE GRAZ

PAGES 14-15

UNTITLED, JANUARY 1977
PENCIL AND COLORED CRAYON ON TRANSPARENT PAPER
8.5 X 11 IN. (21.6 X 28 CM)
KUNSTMUSEUM WINTERTHUR

PAGES 16-17

UNTITLED (ROWS OF TRIANGLES), 1978
PENCIL ON TRANSPARENT PAPER
8.3 X 10.8 IN. (21 X 27.5 CM)
JACK TILTON GALLERY, NEW YORK
PHOTO KOINEGG/NEUE GALERIE GRAZ

ACKNOWLEDGMENTS

We gratefully acknowledge the writers and artists represented in this book for their willingness to explore new territories. We owe particular thanks to those who shared their memories and knowledge during the initial stages of research, including Dorothea and Leo Rabkin, Thomas Nozkowski, Linda Norden, B.H. Friedman, Jack Tilton, Nancy Holt, Sol LeWitt, Mel Bochner, Richard Tuttle, Dan Graham, Brian O'Doherty, Lucy R. Lippard, Dorothy Levitt Beskind, Steven Antonakis and Naomi Spector, Hedda Sterne, Susan and Michael Hort, and Philip McCarter Tifft.

For their various contributions to the realization of this project, we thank Benjamin H.D. Buchloh, David DiGiacomo, Graham Domke, Dana Gramp, Nicole Russo, Wendy Hurlock, Annie Bayly, Sabine Sarwa, Barry Rosen, Andreas Landshoff, Gisela Fischer, Robert G. Geiger, Herbert Lust, Gwyn Metz, Carol Dreyfus, Nancy Cricco, Tom McNulty, Paul McCarter, Marianne Hauser, Jock Truman, H. & D. Vogel, Dieter Schwarz, Ellen Safir, Helen Hesse Charash, Lee B. Ewing, Irving Solero, Janet Passehl, Paul Nesbitt, Jane Timken, and Dorit Yaron.

Lastly, we thank the collectors and institutions who so generously lent their works, and without whom the exhibition "Thinking the Line: Ruth Vollmer and Gego" would not have been possible.

CONTENTS

PREFACE

"Thinking the Line," the exhibition, offered an unprecedented pairing of the works of two artists, Ruth Vollmer and Gego. In different ways, Vollmer and Gego rejected the deductive logic of modernist abstraction and developed an experimental, open-ended practice of "thinking the line" that is activated by the beholder and the space in which the work is seen. "Thinking the Line" sought to advance the critical questioning of the category of "geometric abstraction," calling for an inquiry into different modes of abstraction. Both artists produced their best-known works during the sixties and seventies, a period in which the boundaries of the art world and the objectives of art making were radically revised, allowing for a new, and creative, synthesis of different cultural intellectual traditions. The exhibition, which toured Germany, Austria, and the United States in 2003–04, brought together two singular and distinctive practices that nevertheless had certain things in common. Both, by having received their education in Germany, were shaped by a European avant-garde heritage of Bauhaus and Russian constructivism. And both were transformed by, and contributed to, the art in their adoptive countries—the U.S. and Venezuela, respectively—thus offering the possibility of correcting an art history written in large part from a post-fascist, Cold War perspective.

For the publication, it seemed imperative to transcend the conventional format of the exhibition catalogue. What made for an interesting exhibition—morphologically examining works so different, yet connected on a conceptual level—would not translate into a single book format. Two separate volumes would offer readers the opportunity to choose according to personal preference and interest, and, equally important, provide a more effective means of reintroducing each artist's work to her adoptive country.

The challenge was to design publications for a project that neither conformed to established exhibition catalogue or monograph formats, nor fit into existing categories of coffee-table book or academic anthologies. Here, John Isaacs has created books that are fundamentally based on symmetry, but whose typography and other design details reflect the work and sensibility of the individual artist.

We consider ourselves fortunate to offer in the present volumes a large number of unpublished images, never-before-translated historical texts and interviews, together with new scholarly essays. "Ruth Vollmer, 1961–1978: Thinking the Line" is the first comprehensive account of its kind. "Gego, 1957–1988: Thinking the Line" provides the first fully English-language-based scholarly publication. Although the present volumes are somewhat interested in comprehensiveness, they are not complete, chronologically structured, monographic studies. Foregoing the acclaim of timeless and artistic genius, these volumes take the difficulties of writing art historical accounts—of writing history in general—as major concerns.

"Thinking the Line" has been, right from the start, a research-driven project. As co-editors of the present volume, we learned of Ruth Vollmer while attending a lecture by Brian O'Doherty at the ZKM | Center for Art and Media Karlsruhe in 2002. In the process of contextualizing his own formation as an artist, O'Doherty mentioned Vollmer as an artist-colleague of Eva Hesse, Peter Hutchinson, Robert Smithson, Mel Bochner, Sol LeWitt, and Dan Graham who had "sort of vanished from history but who should be rediscovered." We were intrigued by this historical oversight. Shortly after the talk, research began in New York. Nadja Rottner located the Ruth Vollmer Papers at the Archives of

American Art (AAA), in the Smithsonian Institution, Washington, D.C. Jack Tilton, who has represented Vollmer's estate since Betty Parsons's death in 1982, generously provided access to the other cache of archival materials. The discovery of many unpublished manuscripts provided evidence of an appreciation of Vollmer's works by her peers. At the same time, it was puzzling to see her neglect by scholars. A very large number of high-quality vintage photographic prints of Vollmer's works by Hermann Landshoff, the artist's brother, further substantiated the viability of an in-depth historical and critical account. Why had she received only minor critical attention? What are the methodological issues at stake when looking at a "marginal" artist? In general, how productive is it to assign an artist the status of minor or major? What role did emigration play in the formation of Vollmer's and Gego's alternate models of abstraction? Especially relevant for Peter Weibel was tracking the development of the work of two women artists, both of whom were forced to emigrate because of their Jewish heritage, and neither of whom returned to Europe: "The impact of the Nazi regime on the their work can still be seen today; even in cultural circles, because nearly all of the media and art institutions have shown little interest in the work of these two artists." (Weibel)

Weibel had for some time been talking with Jiří Ševčík, an art historian and professor in Prague, about preparing an exhibition of works by Gego and the Czech sculptor Karel Malich. After discussing the initial results of the Vollmer research, it was quickly decided to attempt a pairing of Vollmer and Gego. It was only in a later phase of the research that pieces of anecdotal evidence linked Vollmer directly with Gego. Vollmer had scrawled in pencil on an index card, found in one of the two cardboard storage boxes at the AAA,

Gego's name and address in Venezuela. Likewise, within the substantial collection of works, ranging from Paul Klee to Matt Mullican, that Vollmer bequeathed to The Museum of Modern Art, New York (MoMA), is a painting by Gerd Leufert, Gego's partner of many decades. These pieces of circumstantial evidence link Vollmer and Gego to a flourishing New York art scene in the early sixties, most likely through their connections with the Betty Parsons Gallery.

The beginning of research in 2002 also marked the beginning of an international wave of larger public and academic recognition of Gego's work that continues today. MoMA, in an effort to bring together sufficient works for a proposed retrospective, had been (unsuccessfully) negotiating for the purchase of Gego's only remaining room-size work, *Reticulárea*, which is installed permanently at the Museo de Bellas Artes in Caracas. In addition to providing invaluable access to its archive, the Fundación Gego in Caracas, founded after the artist's death in 1995 by her two children, Bárbara and Tomás Gunz Goldschmidt, also loaned a substantial number of sculptures and drawings, some of which, mostly drawings, had never been exhibited or published.

In the case of "Ruth Vollmer, 1961–1978: Thinking the Line," the search for authors as well as exhibition loans was complicated by the apparent lack of scholarly material. The guiding principle in the hunt for authors was a familiarity, no matter how fragmentary, with the works of Vollmer. The authors selected had already encountered Vollmer through their work on other artists—for example, Rhea Anastas on Dan Graham, Ann Reynolds on Robert Smithson, and Kirsten Swenson on Eva Hesse. In the process, many generously shared their personal recollections of Vollmer's works and thought processes. For Gego, the existing scholarly literature

spans two generations of Venezuelan art historians, critics, and curators who knew the artist personally and have been involved with her work for decades. For this reason, we placed emphasis on finding a third generation of authors, with varying academic backgrounds, who could take a fresh approach.

The planning and research for this project would not have been possible without the involvement of various institutions. This project was financed, for the most part, by German and Austrian museum funds, as well as by a research grant awarded to Rottner by the Austrian Bundesministerium für Unterricht, Kunst und Wissenschaft (Federal Ministry for Education, Art, and Science) in 2003. Along with the commitment of the ZKM | Center for Art and Media Karlsruhe, Ursula Blickle from the Ursula Blickle Stiftung, in Kraichtal, provided the principal financial backing for this project in its initial stages. Dr. Christa Steinle from the Neue Galerie am Landesmuseum Joanneum in Graz also courageously agreed to join in this endeavor—a difficult venture and one not without risk, given that the two artists are entirely unknown in Europe and little known to larger audiences in the United States. We were therefore very pleased that we could build a bridge to North America, not only through these publications, but also through the show's installation at Miami Art Central (MAC). As a bridgehead between North and South America, Miami was especially suitable as the endpoint for the exhibition's tour. We would like to express our special thanks to Rina Carvajal, executive director and chief curator of MAC, Ursula Blickle, and Christa Steinle for their ongoing support of this extensive research-based project throughout its three-year course from conception to completion.

Nadja Rottner and Peter Weibel

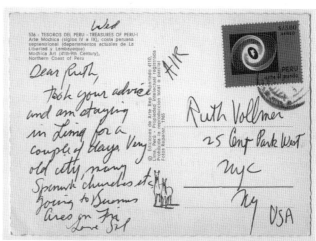

POSTCARD FROM SOL LEWITT TO RUTH VOLLMER, DATE UNKNOWN
RUTH VOLLMER PAPERS, 1939–1980, ARCHIVES OF AMERICAN ART,
SMITHSONIAN INSTITUTION, WASHINGTON, D.C. .

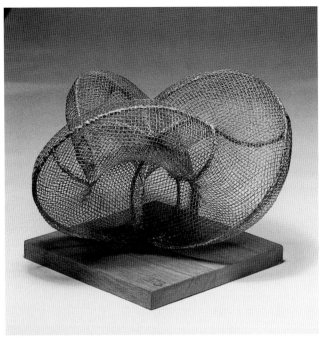

BOY'S SURFACE, WIRE MODEL IN PETER WEIBEL ESSAY
MATHEMATICAL INSTITUTE, UNIVERSITY OF GÖTTINGEN

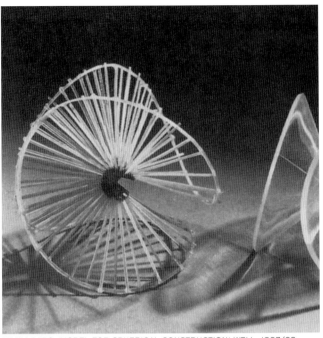

NAUM GABO, MODEL FOR SPHERICAL CONSTRUCTION: WELL, 1937/38,
AND MODEL FOR SPHERICAL THEME, 1936/37
FROM MICHAEL SCHWARZ, ED., LICHT UND RAUM (1998)

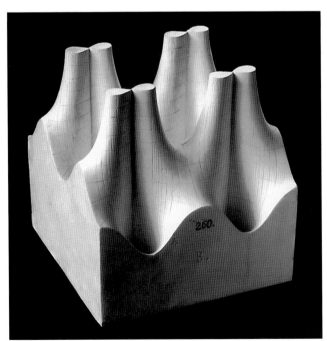

PLASTER MODEL OF THE P-FUNCTION, ONE OF KARL WEIERSTRASS'S
HIGHLY "UNINTUITABLE" MATHEMATICAL CREATIONS
FROM GERD FISCHER, "MATHEMATISCHE MODELLE" (1986)

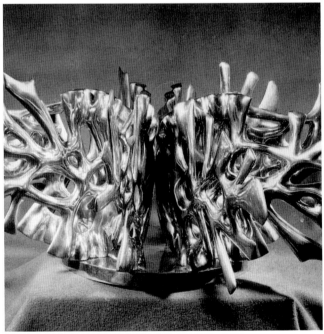

ETIENNE BÉOTHY, NUCLEAR FORM, N.D.
FROM PETER WEIBEL, ED., JENSEITS VON KUNST (1997)

RUTH VOLLMER'S "MATHEMATICAL MODELS": SCULPTURES BETWEEN ABSTRACTION AND ANSCHAUUNG
BY PETER WEIBEL

Mathematics possesses not only truth but supreme beauty, a beauty cold and austere, like that of sculpture, sublimely pure and capable of a stern perfection, such as only the greatest art can show. —Bertrand Russell

Around the time Ruth Vollmer (born Landshoff) and her husband, Hermann, had to leave Germany in 1935 because of her Jewish faith, two important books concerning the crisis of *Anschauung,* or sense-perception, were published. The one was by David Hilbert, in 1932, and the other by Edmund Husserl, in 1936. In his *Die Krise der europäischen Wissenschaften und die transzendentale Phänomenologie* (The Crisis of the European Sciences and the Transcendental Phenomenology), Husserl identified this crisis with the rationalization of the sciences, especially with the "Galilean mathematization of nature," in which "the latter itself became reduced to mathematical diversity." During the industrial and political revolutions that took place in Europe after 1800, rationalization and the tenets of the Enlightenment dominated scientific thought, which bid farewell to political and ideological absolutism in the name of progress. But Husserl claimed that science, in abandoning experience and history for the purely abstract, had instituted its own crisis. Against this formulation of the modern world as "more geometrico" and against the "non-visual symbolism" of mathematics, he proposed *Anschauung,* or contemplation, intuition, and visualization: "In the current act of measuring of visual objects of experience all we gain are empirical-inexact variables and figures." Husserl evidently disliked vari-

ables and numbers, formulae and figures—in short, mathematics—because of their abstract, rational character and their lack of visual symbolism. For him, only *Anschauung,* with its visual character and as a visual experience of the world, encompassed the historical experience. This reduction to a mathematical diversity of nonvisual character and to a mere science of fact constituted the crisis in the European sciences, as it led to science losing its "significance for life." Precisely at this point, the crisis of science became a crisis of life, and only a return to history and the "lifeworld" (*Lebenswelt*) could free us. Like the Romantics, Husserl evoked history as the highest authority for our actions. With history, he proposed a determinism that excluded free will—the ability to choose.

F.W.J. Schelling, the philosophical champion of Romanticism, had already claimed, in his *System des transzendentalen Idealismus* (System of Transcendental Idealism) of 1800, that only through "intellectual contemplation" and "congenial intuition"—that is, *Anschauung*—could one grasp the absolute, the highest form of knowledge. This romantic program was in sharp contrast to the philosophy of the Enlightenment, which rested on the power of rational thought. Therefore, G.W.F. Hegel, in his *Die Phänomenologie des Geistes* (Phenomenology of Spirit), which he penned in Jena in 1806, saw himself in opposition to the Romantics, whom he accused of "not construing, but feeling and contemplating the Absolute, and it is not the concept thereof, but the emotion and contemplation of it that are meant to lead the way to be expressed." Hegel stated that the

Absolute could not be gained through *Anschauung* (contemplation and intuition) but only through the labor of the "concept" (*Begriff*). For him, Romanticism marked the end of art, because philosophy, in the guise of self-awareness, had taken the place of religion and art in the search for absolute truth. In the battle between *Anschauung* and abstraction, Hegel (and Immanuel Kant as well) voted clearly for abstraction. Abstraction, the Enlightenment, and rationalization formed the block against *Anschauung* and experiential evidence in the search of truth. The legitimacy of modern science was founded on abstract concepts and mathematical formulae. That a formula like $e=mc^2$ could become so famous shows the culmination of this tendency, which started in sync with the beginning of the industrial, technical, and political revolutions around 1800.

The great eighteenth-century mathematician Joseph Louis Lagrange wrote in the preface to his influential book *Mécanique analytique* (Analytical Mechanics; 1788): "One will not find figures in this work. The methods that I expound require neither constructions, nor geometrical or mechanical arguments, but only algebraic operations, subject to a regular and uniform course." Lagrange expressed most radically the conviction of his time, that only mathematical rationalization could explain the world correctly. Only a mathematical analysis of the mechanics of the world could give us the absolute truth. Any trace of *Anschauung* had to be expelled as a possible contamination of the pure "construction of the Absolute," as Hegel defined it around the same time. Lagrange's rejection of any image or graphical construction, even of a geometrical proof, in order to achieve the ideal mathematical form was the climax of the "mathematization of nature" that Husserl bemoaned and that the scientific community acclaimed.

Lagrange had the reputation of being Europe's best mathematician. In 1766, he followed Leonhard Euler as president of the Berlin Academy, where he worked until 1786. In his books *Théorie des fonctions analytiques* (1799) and *Leçon sur le calcul des fonctions* (1801), Lagrange gave mathematics its strength by assiduously avoiding the use of visual materials, *Anschauung*, or "intuition," using only algebraic tools and operations. Classical mechanics was given mathematical form by Euler and Lagrange. Lagrange not only influenced later mathematicians such as Carl Friedrich Gauss and Bernhard Riemann, but also the nineteenth-century physicist Hermann von Helmholtz and even philosophers like Kant and Hegel in their fight for analyticity and rationality instead of *Anschauung* and intuition.

Coincidentally, in 1790 Lagrange also formulated a mathematical problem commonly known as "Plateau's problem," after Joseph Plateau. Plateau solved it experimentally using soap films on wire frames—those same soap films that would later fascinate Ruth Vollmer. Lagrange's problem was to fit a minimal surface to the boundary of any given closed curve in space. A surface may be "minimal" in respect to the area occupied or to the volume enclosed, the area being the surface that the film creates when it fills up a ring, whether a plane or not. The geometers are apt to restrict the term "minimal surface" to forms such as these, or, more generally, to all cases where the mean curvature is nil; the others, being only minimal with respect to the volume contained, are called "surfaces of constant mean curvature." If we limit ourselves to surfaces of revolution—that is to say, to surfaces symmetrical about an axis—we find that there are six in all: the plane, the sphere, the cylinder, the catenoid, the unduloid, and a curious surface Plateau called the nodoid. The sphere is, of all possible figures, that which encloses the greatest volume with the least area of surface (see Jacob Steiner's *Einfache Beweise der Isopermetrischen Hauptsätze* [Simple Proofs of the Isopermetric Axioms; 1836]). As such, the sphere is not only an ideal body mathematically, but also biologically. Oil globules and soap bubbles are wonderful examples of the sphere in nature, a model for the organic cell as being in a "steady state" simulating equilibrium. In 1930, Jesse Douglas and Tibor Rado would prove Plateau's problem mathematically with the help of the Dirichlet principle, for which Douglas was awarded the Fields Medal, the "Nobel Prize" of mathematicians, in 1936.

It is evident that Ruth Vollmer knew this history of *minimae areae*, as the titles of some of her works, like *Steiner Surface* (1970), suggest. Her interest in soap bubbles, demonstrated by the film *Soap Film Forms* in 1974, is also well known. It is interesting and evident that the concept of minimal surfaces in connection with volume and space played a central role in the paintings of modernism and in the minimal and conceptual art of the sixties—more than 150 years later. Vollmer's interest in these mathematical objects, more than the artistic atmosphere of New York in the sixties, provided the context for the evolution of her sculptures. She realized, in a very original way, that the problems and descriptions of surfaces of revolution, viewed through the lens of modern art, could be reinterpreted and constructed as

aesthetic problems of contemporary sculpture. Her focus on these surfaces of revolution, on minimal surfaces, reveals her exceptional understanding of sculptural issues of the twentieth century. Questioning and defining the boundaries of closed curves in space is the last moment of modern sculpture, still treated as a volume, before it dissolved into acts of enactment (the "happenings" of the Fluxus group) or acts of naming (conceptualism's embrace of the idea as the real substance of art). At the same time, this interest in spheres, cylinders, undoloids, and catenoids shows Vollmer's awareness of the kinetic aspects of sculpture, expressed through the search for thermodynamic equilibrium. Therefore, Vollmer was interested not only in Platonic (idealized) mathematical objects, but also in how the constraints of nature shape biological forms after these mathematical and thermodynamic laws. Her sculptures are sites of both abstraction as ideal mathematical models (like Pascal's spiral) and *Anschauung* as concrete biological organisms (like a shell).

One of the founders of statistical mechanics and thermodynamics, Josiah Willard Gibbs, was equally interested in this equilibrium of abstraction and *Anschauung*, in the sense of visualization, in dynamics and geometry. In two papers of 1873, "Graphical Methods in the Thermodynamics of Fluids" and "A Method of Geometrical Representation of the Thermodynamic Properties of Substances by Means of Surfaces," Gibbs illustrates the problem of surfaces, of thermodynamically stability, using graphical means. A sculptural model of this graphical presentation of fluids in motion exists, and is a wonderful demonstration of the possible mix of abstraction and *Anschauung* that would also be realized by Vollmer.

Underlying the dichotomy of abstraction and *Anschauung*, we find a much deeper opposition that is between theory and experience, as hinted at by Husserl. Before the successful mathematization of nature by modern physics, experience came before theory. In modern science, theory comes before experience. This triumph of theory over experience further aggravated the conflict between abstraction and *Anschauung*. Abstraction has advanced to such a high complexity that modern mathematics and physics now go far beyond *Anschauung*, becoming not only the languages of the *Unanschauliche*—the unintuitable—but also the languages of the incomprehensible. But this is precisely the reason why we construct these mathematical models, because they help us to understand the laws of nature better than our sense-perception could ever do. The "labor of concept" (Hegel) turned the world of experience

into a world of mathematical formulae on paper, and these formulae in turn have transformed the real world.

Theoretical physicist James Clerk Maxwell, in his seminal paper "A Dynamical Theory of the Electromagnetic Field" (1865), used the dynamics of Lagrange and his analytical methods to postulate the existence of electromagnetic waves, giving mathematical expression to Michael Faraday's 1821 discovery of electromagnetism. In 1887, Heinrich Hertz succeeded in proving that the postulated electromagnetic waves did indeed exist. Hertz turned theory into experience, providing an experimental proof—by showing that electrical signals can travel through open air—for Faraday's and Maxwell's theory. The physics of the nineteenth and twentieth centuries declared clearly the primacy of theory over experience. As a result, Hans-Jörg Rheinberger and Michael Hagner could even speak of *Experimentalsysteme in den biologischen Wissenschaften 1850/1950* (Experimental Systems in the Biological Sciences 1850/1950; 1993).

Around 1800, pictures were strictly forbidden in mathematical books if their authors wanted to be taken seriously. These books of science were what Husserl had in mind when he blamed the crisis of European science on the loss of experience and history. But one hundred years later, around 1900, pictures triumphantly returned, in two ways: first, as *Veranschaulichung des Unanschaulichen* (visualization of the abstract); and second, as the revaluation of intuition— *Anschauung*.

So we see on the one side the triumph of theory and abstraction, the explanation of mechanics and motion in mathematical terms. The description of the world in mathematical expressions has as its result the technical revolution of the nineteenth and twentieth centuries. This school of thinkers was opposed to *Anschauung* and pictures, because pictures deceive and are only valid for specific cases. Formulae describe laws and ideas beyond particularities. This approach could be described as Platonic.

On the other side we have mathematicians and physicists like Henri Poincaré, who did not dismantle visually oriented work in mathematics and even supported intuition. In his 1899 paper "La logique et l'intuition dans la science mathématique et dans l'enseignement" (Logic and Intuition in Mathematical Science and Teaching), he wrote: "And even though pure mathematicians could do without intuition, it is always necessary to come back to intuition to bridge the abyss which separates symbol from reality." Even pure mathematicians need intuition to create new theorems. Poincaré even

drew pictures and figures to illustrate his ideas. And Dutch mathematician Luitzen Egbertus Jan Brouwer, around 1911, established a doctrine of intuitionism that viewed the nature of mathematics as mental constructions governed by *self-evident* laws.

In the early nineteenth century, pictures, diagrams, and figures took a three-dimensional turn as mathematical models, used by Gaspard Monge, in France, and in the latter part of the century by Alexander Brill, Karl Weierstrass, and Felix Klein, in Germany. Klein wrote the influential book *Lectures on the Icosahedron* (1913), and he promoted the use of mathematical models in teaching. Built from wood and plaster, wire and paper, glass and brass, they looked like objects made by artists, and therefore like modern sculptures; they were widely used, particularly at the mathematics institute of the University of Göttingen, where they served not only to teach "spatial intuition" to students, but also to support progress in abstraction. Their aim, finally, was to picture the *Unanschauliche*—the unvisualizable. It is evident that these models, especially those from the Göttingen institute, served as one of the starting points for the abstract sculpture of the early avant-garde in the twentieth century, and especially for Ruth Vollmer. In art movements such as constructivism and abstraction-création, and in the work of Naum Gabo, Antoine Pevsner, Etienne Béothy, and Georges Vantongerloo, among others, you can see these influences of the "mathematical sensibility" the futurists spoke of in their 1914 manifesto, "Geometric and Mechanical Splendour and the Numerical Sensibility," written by Filippo Tommaso Marinetti. This interest in mathematics by the early avant-garde was also continued in the neo-avant-garde, from Max Bill to Mario Merz, and influenced the development of both minimal and conceptual art.

Central to the visualization approach—to make the unintuitable intuitable—was the chair of the mathematics department at the University of Göttingen, the eminent mathematician David Hilbert, who was known as a formalist. In his book (with Stephan Cohn-Vossen) *Anschauliche Geometrie* (1932; published in English as *Geometry and the Imagination* in 1952), Hilbert embraced the *Anschauliche* (the intuitable, the visual), as the title already suggests. In the preface to the book, he writes:

> In mathematics, as in any scientific research, we find two tendencies present. On the one hand, the tendency toward abstraction seeks to crystallize the logical relations inherent in the maze of material that is being studied, and to correlate the material in a systematic and orderly manner. On the other hand, the tendency toward intuitive understanding fosters a more immediate grasp of the objects one studies, a live rapport with them, so to speak, which stresses the concrete meaning of their relations.

As to geometry, in particular, the abstract tendency has here led to the magnificent systematic theories of Algebraic Geometry, of Riemannian Geometry, and of Topology; these theories make extensive use of abstract reasoning and symbolic calculation in the sense of algebra. Notwithstanding this, it is still as true today as it ever was that intuitive understanding plays a major role in geometry. And such concrete intuition is of great value not only for the research worker, but also for anyone who wishes to study and appreciate the results of research in geometry.

In this book, it is our purpose to give a presentation of geometry, as it stands today, in its visual, intuitive aspects. With the aid of visual imagination we can illuminate the manifold facts and problems of geometry, and beyond this, it is possible in many cases to depict the geometric outline of the methods of investigation and proof, without necessarily entering into the details connected with the strict definitions of concepts and with the actual calculations.

Hilbert would even go so far as to say that the propositions of geometry would be just as true if one took the terms "line," "point," "place," and replaced them with "table," "chair," "mug." For him, there was no gap between symbol and reality, between abstraction and concretion, between Platonism and realism. Also, his friend Hermann Minkowski, who, like Klein and Hilbert, taught in Göttingen, reconceptualized pure number theory in visual terms in *Geometrie der Zahlen* (The Geometry of Numbers; 1896).

So we could say that the Göttingen School was the site for the *Anschauliche* in mathematics, and that Ruth Vollmer was its artistic heir. What does this mean? Precisely that her position, too, resided between abstraction and *Anschauung*, between the mathematical modeling of space and the *Anschauung* of space, between spheres of numbers and spheres of life, between topology and biology. Therefore, Vollmer could exercise influence on Eva Hesse, who had close contact with her, and on Sol LeWitt.

Like the Bauhaus School, Vollmer transported the European tradition of the mathematical mentality in the arts and in design (for example, the early "abstract ornaments" of the Wiener Werkstätten) to North America. Her work did not derive from that of R. Buckminster Fuller or from architecture generally. Rather, it is closer to instruction manuals like *Mathematical Models* (1961) by H. Martyn Cundy and A.P. Rollett, or *Polyhedron Models* (1971) and *Spherical Models* (1979) by Magnus J. Wenninger, who cites the mathematician and logician Bertrand Russell: "Mathematics possesses not only truth but supreme beauty, a beauty cold and austere, like that of sculpture, sublimely pure and capable of a stern perfection, such as only the greatest act can show." Russell connected mathematics to sculpture because of its purity and cold perfection—its sublimity. This, too, could have been a source of Vollmer's fascination with "mathematical forms," as LeWitt called her sculptures, denying their sculptural status in favor of describing them as "ideas made into solid forms. The ideas are illustrations of geometric formulae; they are found ideas." Minimalist sculptures, too, are sublimely pure and capable of a stern perfection, and certainly owe a lot to the problems of surface, *minimae areae*, and space anticipated by the mathematics of the nineteenth century. But the case of Vollmer is more complex. The art world has the tendency to accept natural forms like human bodies, flowers, animals, et cetera, and even models of natural forms, which are, essentially, what figurative sculptures are. Models of natural forms are accepted as self-sustaining works of art due to the romantic tradition of *Anschauung*, which still dominates the art world. A marble sculpture of a person's body, being in fact a model of that person in three dimensions, is not questioned as a work of art. But a marble sculpture of a mathematical object or a Platonic body like a regular polyhedron, being equally in fact a model (of a Platonic idea), is, strangely enough, not readily accepted as a work of art. Just as shells, as models of natural forms, are accepted as artworks, so should spirals as models of mathematical forms, especially those created in the age of minimalist sculpture. This might have been what was in LeWitt's mind when he spoke of "mathematical forms" in relation to Vollmer's sculptures instead of the dominant anthropomorphic and biological forms of traditional sculpture. Therefore, it is interesting to see Vollmer situated between LeWitt, Walter De Maria, Carl Andre, and Robert Mallary in the chapter "Systems Elementary and Complex" of Nicolas and Elena Calas's *Icons + Images of the Sixties* from 1971.

Because of the status of Vollmer's sculptures—as lying somewhere between abstraction and *Anschauung*, between topology and biology—her work is closer to more contemporary sculptural practices, like that of Olafur Eliasson, for example, than to the works of the minimalists with whom she is often aligned. On the one hand, one can reference her work in the images of the nine regular solids, from Platonic (five) to Kepler-Poinset (four), and the various polyhedra in physicist Alan Holder's *Shapes, Space, and Symmetry* (1971), which, indeed, look very similar to some works by Robert Smithson and Donald Judd. The same is even more valid for John Borrego's *Space Grid Structures: Skeletal Frameworks and Stressed Skin Systems* (1968), an overview of international architecture and design, since systems, structures, and grids played a central role in the conceptual and minimal art of the sixties. But, on the other hand, one can refer Vollmer's work to the biological interpretation of mathematical models and ideas that started for artists with the magnificent work *On Growth and Form* (1917), by D'Arcy Wentworth Thompson, which was followed in 1933 by George D. Birkhoff's *Aesthetic Measure* and in 1952 by Hermann Weyl's *Symmetry*. These interpretations culminated in papers like "Patterns of Growth of Figures: Mathematical Aspects" (1962) by the Polish mathematician Stanislaw Ulam, in *Module, Proportion, Symmetry, Rhythm* (1966), edited by Gyorgy Kepes (the successor of László Moholy-Nagy as director of the Chicago Bauhaus or School of Design); and in genetic algorithms developed, for example, in *The Algorithmic Beauty of Plants* (1990) by Przemyslaw Prusinkiewicz and Aristide Lindenmayer, and *Digital Design of Nature* (2005) by Oliver Deussen and Bernd Lintermann. (Vollmer was familiar with an earlier volume, *Patterns in Nature* by Peter S. Stevens, which was published in 1974.) Today, after the triumphant return of the visual with the invention of fractals by Benoit Mandelbrot (see his *The Fractal Geometry of Nature* of 1982), the sciences, from medicine to astronomy, are using visualization methods in perfect legitimization, and three-dimensional visualizations are popular like never before.

Between 1998 and 2004, the German philosopher Peter Sloterdijk published three volumes with the title *Sphären* (Spheres): *Blasen* (Bubbles), *Globen* (Globes), and *Schäume* (Foams). Here, again, we encounter the terminology of Plateau's problem and the conflict between abstraction and *Anschauung*. In these books, which center around the sphere as ideal mathematical and biological form, Sloterdijk

develops a history of mankind as the evolution and construction of spheres, from mother's womb to Fuller's geodesic dome. The history of human housing as the artificial control of natural atmospheres builds the horizon in which being is not defined in relation to time, as Martin Heidegger did in *Sein und Zeit* (Being and Time; 1935), but in relation to space; we could, therefore, paraphrase Heidegger's title as *Sein und Raum* (Being and Space) or *Sein und Sphäre* (Being and Sphere). This biological and anthropological interpretation of mathematical models resides precisely in the German tradition of the opposition between abstraction and *Anschauung*, but it has the virtue of dedefining established positions and giving them a much deeper foundation. Sloterdijk gives an old philosophical problem a new reading by turning the sphere into the focus of being. Vollmer's achievement as an artist, her concentration on spheres and polyhedra, can be seen as a step toward Sloterdijk's philosophy of spheres: sculpture as a biological and mathematical form, as a model of both mankind and mathematics, *Anschauung* and abstraction. Art, for many, resides in the domain of intuition (*Anschauung*), and mathematics, in the domain of abstraction. But as the title of a wonderful book of 1973 by the great Hungarian mathematician Rényi Alfréd shows, a combination and convergence of the two is possible: *Ars Mathematics*. This could also serve as the inscription on the gate to the territory of Vollmer's art.

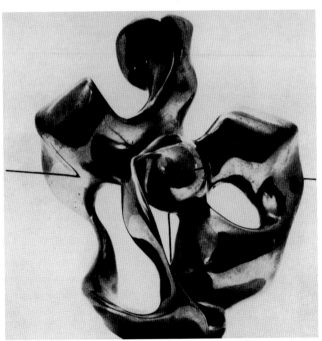

GEORGES VANTONGERLOO, CONSTRUCTION DANS LA SPHÈRE, 1918
FROM ANGELA THOMAS, DENKBILDER (1987)

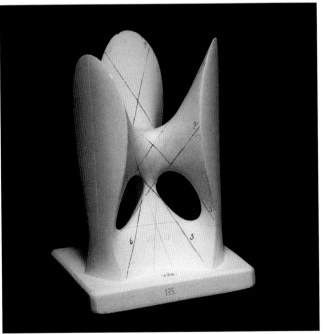

MODEL OF CLEBSCH DIAGONAL SURFACE, CA. 1870
MATHEMATICAL INSTITUTE, UNIVERSITY OF GÖTTINGEN

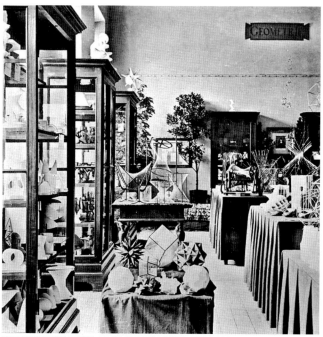

THE GEOMETRY ROOM, PART OF THE MODEL EXHIBITION AT THE
TECHNISCHE HOCHSCHULE, MUNICH, HELD IN CELEBRATION OF THE
THIRD ANNUAL MEETING OF THE GERMAN MATHEMATICAL UNION, 1893
PHOTO © ARCHIVE DEUTSCHES MUSEUM, MUNICH

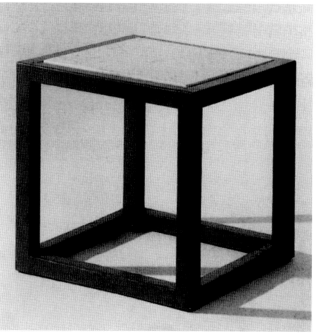

JOSEF HOFFMAN, CUBICAL TABLE, CA. 1904
FROM PETER WEIBEL, ED., JENSEITS VON KUNST (1997)

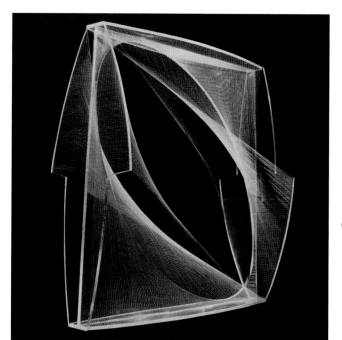

NAUM GABO, LINEAR CONSTRUCTION IN SPACE NO. I, 1943
THE PHILLIPS COLLECTION, WASHINGTON, D.C.
PHOTO HERBERT MATTER

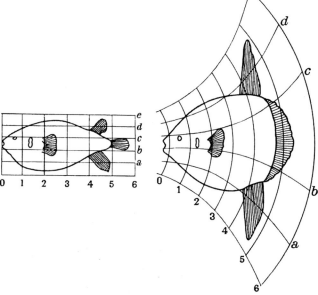

LEFT: DIODON, OR COMMON PORCUPINE FISH
RIGHT: ORTHAGORISCUS MOLA, OR SUNFISH. THE VERTICAL
CO-ORDINATES WERE DEFORMED INTO CONCENTRIC CIRCLES AND THE
HORIZONTAL COORDINATES INTO A SYSTEM OF CURVES. THE NEW
OUTLINE SHOWS THE SUNFISH, WHICH IS CLOSELY ALLIED TO THE
PORCUPINE FISH. FROM D'ARCY WENTWORTH THOMPSON, ON GROWTH
AND FORM (1917)

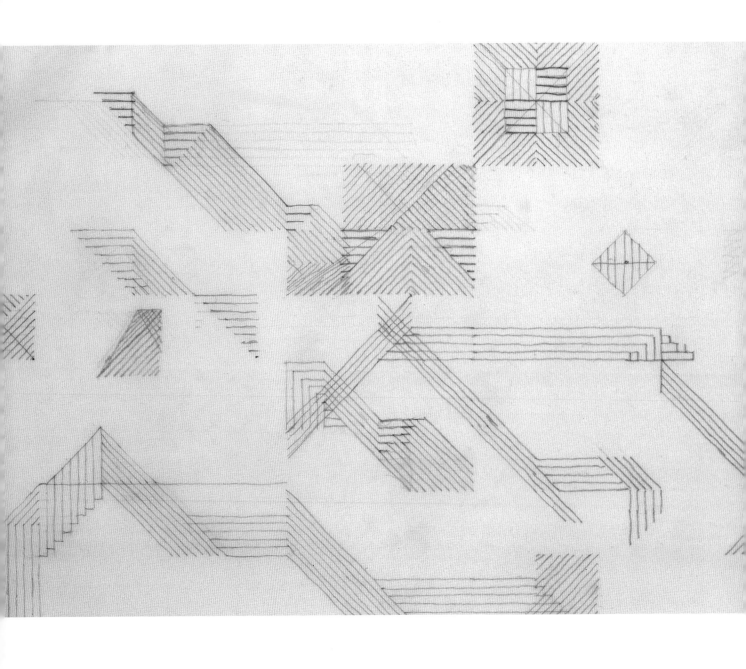

RUTH VOLLMER. UNTITLED (3/78), 1978
PENCIL ON TRANSPARENT PAPER
12 X 18 IN. (30.5 X 45.7 CM)
KUNSTMUSEUM WINTERTHUR

INTERSECTIONS BY LUCY R. LIPPARD

What, I wondered as I began to write this essay, did Olle Granath mean by calling the exhibition "Vanishing Points"? It could be a reference to some of the artists' involvement with time, space, and distance, or even to specific works by Dan Graham, Doug Huebler, Donald Burgy. Or it could be a reference to the speed with which the past disappears—is severed from the present—in modern life. (How many artists are even vaguely aware of the history of this period, 1965–70, aside from having seen the artifacts it produced, which is not at all the same thing?) Or the title could imply that even the most unlike parallels meet in infinity, because I've spent some time wondering what exactly these seven artists have in common.

Eva Hesse might be the focal point. All these artists were friends of hers—one (Doyle) was her husband, one (LeWitt) was her best friend and strongest supporter, two more (Bochner and Vollmer) were very close to her, as was I. And the years covered by this show—1965–70—were the years in which Hesse matured as an artist, made a brilliant series of works, and died; while the others' careers extended variously before and afterwards. All of these artists influenced Hesse's development esthetically and/or intellectually, as did others not included here, notably Carl Andre.

Given the age and stylistic range, perhaps the most interesting aspect of this particular grouping is the intricacy of its interactions between 1965 and 1970. These years were exhilarating for those of us just moving into our mature work at the time. The "ideas in the air" seemed especially heady, despite the dryness of some of the products. There was a

sense of possibility, of rebellion against the looming authorities and institutions of the recent past, a desire for a kind of tabula rasa that would allow not just a new art style or movement, but new ways of conceiving of, experiencing, and distributing art.

All of this may have had something to do with our ages. Several of us turned thirty during those years. In 1965, Hesse, Bochner, Graham, LeWitt, Smithson (and myself) were all at career turning points. LeWitt had his first show that year (at a gallery run by Dan Graham, who was then, and probably is now, not sure he was "an artist"). I began writing criticism regularly in the winter of '64–65; Smithson was making his plastic and mirror geometric sculptures which led directly into the work for which he became famous. Hesse began to make sculpture after limited success as a painter; Bochner was working as a guard at the Jewish Museum and reading philosophy, thinking about Jasper Johns—who had also been a prime influence on most of these artists (especially Hesse and LeWitt). In 1965, Smithson and Nancy Holt met Bochner, Hesse, Vollmer (and me). Bochner met Hesse and LeWitt. I had known LeWitt since 1960, which is when he met Hesse, then Doyle in 1961; I met Hesse and Doyle in 1963. Hesse met Graham, Vollmer, and Bochner in 1966...and so forth.

In the same period, Tom Doyle brought his dealer, Virginia Dwan, to LeWitt's studio; LeWitt introduced her to Smithson; both ended up with Doyle in the stable of the Dwan Gallery, and Smithson helped Ad Reinhardt with the "Ten" show there in fall 1966, which made Dwan the

hotbed of "cool art." Opening the same day, same building, downstairs at the Fischbach Gallery, was the first show I organized—"Eccentric Abstraction," which included Hesse (along with Louise Bourgeois, Bruce Nauman, Keith Sonnier, and others). These two shows, according to Robert Pincus-Witten, represented the apogee of Minimalism and the beginning of "post" or "counter" Minimalism.

The most interesting part of all this name-dropping is the fact that the interactions also took place in written, published form. In 1966, Bochner reviewed "Eccentric Abstraction" for *Arts Magazine,* and later he wrote about LeWitt and Hesse. Smithson began to publish his writing in 1965, with an essay on Don Judd. His "science fiction" style began in 1966 with "The Crystal Land" in *Harper's Bazaar,* and "Domain of the Great Bear" in *Arts.* The latter was a collaboration with Bochner—a photo-and-quote essay purporting to "review" the Museum of Natural History's planetarium. I wrote the first articles on LeWitt in 1965 and 1966 and Smithson wrote about LeWitt, Hesse, Bochner, Graham, and Vollmer. Graham wrote about LeWitt. LeWitt later wrote about Vollmer. Doyle and LeWitt were in the pivotal "Primary Structures" show at the Jewish Museum in 1966, curated by Kynaston McShine and reviewed by Bochner; and everyone but Doyle was in Bochner's "Art in Series" show at the Finch College Museum in 1967.

Each time these artists wrote about each other (and a useful appendix to this catalogue would be such a cross-referential bibliography), they brought the subject's work into their own domain, commenting on it from the viewpoint of their own obsessions, as of course critics do too. For instance, LeWitt was influential for all of them, but what Bochner liked and disliked about LeWitt's work was not necessarily what Smithson or Graham or Hesse liked and disliked about LeWitt's work. Smithson, for instance, saw LeWitt's 1965 show as helping "to neutralize the myth of progress. It has also corroborated Wylie Sypher's insight that 'entropy is evolution in reverse.'" Bochner saw LeWitt's 1966 *Serial Project* as "a mass of data-lines, joints, angles.... What is most remarkable is that they are seen, moment to moment, spatially (due to a mental tabulation of the entirety of other views) yet do not cease at every moment to be flat." Doyle, who once said he "didn't like flat things," and who does like LeWitt's work, probably didn't see it as "flat."

Graham, predicting his own video work, wrote: "In viewing a LeWitt construction there is a conceptual scale of parallel

distances defined also by this relationship: the distance in the room contained/containing the art object and between the viewing subject and the viewed object perceived translates to the conceived concept art 'distance' between *object and concept and viewer's place* and the *a priori in the artist's mind,* for the perception (here and now) to take place— i.e., how did it get there?" And when I wrote about *Serial Project,* I concluded that "the establishment of the physical autonomy of each form is more important in the end than perfect conceptual consistency. By admitting the visual priority, LeWitt, in spite of himself, proves his own paradox and proves himself more of an artist than a theoretician."

In the mid '60s the lines between "artist" and "writer" and "theoretician" were blurred more than they have been since, though today a similar reaction against the "division of labor" is resurfacing with a younger generation. To varying degrees, Bochner, Graham, and Smithson incorporated writing into their artmaking. LeWitt, who wrote rarely but significantly, has made the book form a major element of his artmaking. Hesse had a great respect for words and for writers and wrote voluminously in her private diaries, some of which have been posthumously published.

All of these artists are extremely literate. In the early '60s, many of us were reading with great interest the novels of the French *nouvelle vague*—Robbe-Grillet, Pinget, Sarraute. (I was introduced to them by LeWitt, who read voraciously as the night desk watchman at The Museum of Modern Art.) Beckett and Borges held special places in hearts and discussions. Ad Reinhardt gave artist friends copies of George Kubler's *The Shape of Time* and recommended John Berger. The more philosophically oriented spouted Merleau-Ponty, Barthes, Wittgenstein, Ayer, and Foucault. In fact the cult of the quotation (extended in the '80s to quoting images as well as words) was rampant in the mid '60s. Smithson was a leading practitioner. He used quotations from a vast repertory of obscure books about nature, science, or linguistics idiosyncratically, almost as art, where others tended to use them as pseudo-academic boisters to their intellectual pretensions. Articles were composed of quotations alone; quotations were made up and intentionally misattributed; quotations led off articles and surrounded pictures. (I was as guilty as the next, at one point in the '70s writing a text on Duchamp's Readymades that totally consisted of quotations from found library sources.)

There was a lot of cleverness floating around, but it was very serious cleverness, less related to Dada's harsh and zany

iconoclasms (or to Punk/New Wave's humors) as to Duchamp's post-Dada ironies (and those of Post-modernism). We all liked puns, to greater and lesser degrees, which was inevitable, given late Minimalism's covert hermeticism—the way this obdurately "meaningless" art hid so many multi-leveled meanings; and given conceptual art's basis in language and the idea. The results could be just plain cute, but they could also be quite profound. LeWitt's commonsensical "Paragraphs on Conceptual Art" and "Sentences on Conceptual Art" remain models of clarity "despite" their suggestive power; e.g., "perception of ideas leads to new ideas."

The only artist in this exhibition who might be considered a Conceptual Artist is Dan Graham, but he has never fit comfortably into any category. In a 1970 radio show he said, "I don't define myself, but whatever I do, I think, is defined by the medium.... The artist is defined by the product he makes, but not necessarily by himself.... I was never interested in words or syntax in poetry, but more in information. I wanted the things I did to occupy a particular place and be read in a particular present time. The context is very important. I wanted my pieces to be about place as in-formation which is present." In the late '60s, he was a pioneer in "body video," analyzing perception, experience, the seeing and the seen as interchange between performers and audience and place. He has always been ahead (or off to one side) of his time and is probably the original post-modernist—one of the first artists not only to pick up on software but to understand the extent of its power. His rock journalism is always buried in a sort of structuralist pop culture theory. Smithson wrote: "Graham responds to language as though he lived in it. He has a way of isolating segments of unreliable information into compact masses of fugitive meaning" (which might be a description of Smithson's own writing).

Graham shared Smithson's attraction to New Jersey–like wastelands, though his tastes (in the '60s photographs) ran to monotonous kitsch—critical hymns to homogeneity in housing projects and architectural detail, rather than to Smithson's wallowing in the sludge of post-industrial prehistory. Much of Graham's '60s work was structured in blocks and steps, both visually and conceptually; his most "beautiful" photograph is of a stepped corner that incidentally recalls some of Smithson's mirror and glass sculptures and LeWitt's magazine piece on ziggurats. The "conceptual step" is best exemplified by a piece called *March 31, 1966*, reproduced here in full:

Dan Graham. *March 31, 1966*
1,000,000,000,000,000,000,000,000.00000000 miles to edge of known universe
100,000,000,000,000,000,000.00000000 miles to edge of galaxy (Milky Way)
3,573,000,000.00000000 miles to edge of solar system (Pluto)
205.00034600 miles to Washington, D.C.
2.85100000 miles to Times Square, New York, N.Y.
.38600000 miles to Union Square subway stop
.11820000 miles to corner 14th St. and First Ave.
.00367000 miles to front door, Apt. 1D, 153 First Ave.
.00021600 miles to typewriter paper page
.00000700 miles to lens of glasses
.00000098 miles to cornea from retinal wall

Graham was "deconstructing" before it was fashionable. His 1966 *Schema for a Set of Pages* suggested that a text be broken down into its parts (adjectives, lines, typeface, paper stock, words capitalized, etc.) and each part published in a different publication, the idea being that "the work defines itself in place only as information with simply the external support of the facts of its external appearance as information (or art); as the sign for its own appearance or presence in print in place of the object." Also in the mid '60s, he organized a show of "Monuments, Tombstones, and Trophies" and wrote about Dean Martin, Godard, rock groups, housing developments, horoscopes, drug side effects, grammar, Mallarmé's *Book*, McLuhan, Borges; and he began thinking about the circles of perception that sparked his video work. In the '70s Graham merged the interest of the photos and the videos into analyses of architectural spaces as puns on societal structures.

Late Minimalism/early conceptualism was a synthesis of two contradictory impulses—Ad Reinhardt's witty insistence on "Art As Art"—his ironically doctrinaire "purism"; and Jasper Johns' option for "the impure situation," for an art focused on "a constantly changing and shifting relationship to things." The '60s climate of doubt and anger called attention to these elements in both Reinhardt's and Johns' work, the former expressed as a belligerent and anxious belief that

art was free from anger and doubt; the latter expressed as an apparent retreat to the phenomenological characteristics of the materials of art. Paradoxically, it was Reinhardt whose work was (almost unintentionally) open-ended, with political and spiritual implications; while Johns, whose work was supposedly "impure," remained closer to "art for art's sake," even while changing its terms.

Reinhardt was a model in his persistent integrity and rebelliousness, his art world position as a loner and thorn in the flesh of the reigning Greenbergian formalist establishment. But Johns' questions raised more issues for this group than Reinhardt's "answers." As Bochner put it, Johns' *0−9* series "defines the lateral boundaries of its surface by measure of the stencil typeface used for the successive laying on of numerals... [Johns] interrogated the phenomenological condition of painting but went further by injecting *doubt* into the deadening self-belief of art thinking to that time. Most essentially he raised the question of the relation of language to art."

Reinhardt and Johns each in his own way was the *éminence grise* (or *noire*) behind the late Minimalists' rejection of color in favor of black, white, and gray. LeWitt, for instance, stated categorically by 1966 that black and white were the "only possible choices" for his sculpture; even the natural colors of materials fell into disrepute for a while. Concurrently, rejective artists were constrained to neutralize all compositional elements so that "things" or "specific objects" (as Don Judd called them) became "non-relational" and non-referential. No "peaks" were allowed. Energy was a tabu unless it entropically canceled itself out. Single forms, serial progressions and permutations, lines of identical modules, obsessively repeated shapes, numbers, diagrams evolved from the models of Reinhardt, Frank Stella, and Don Judd. There was much talk about serial relationships—one to one to one. Dan Flavin celebrated William of Occam's "nominal three"; Robert Morris recommended Anton Ehrenzweig's "or/or" structure (as opposed to "either/or"); Hanne Darboven compulsively counted off her thought patterns in numbers on graph paper.

LeWitt said: "Most ideas that are successful are ludicrously simple. Successful ideas generally have the appearance of simplicity because they seem inevitable." Morris warned about confusions between simple and simplistic, while Smithson and Graham both delighted in confounding the simple. In an article called "The Dematerialization of Art," written in fall 1967, John Chandler and I noted that "the idea has to be awfully good to compete with the object," at least in an art context. We distinguished between "non-visual"

ideas (e.g., LeWitt) and "invisible ideas" (e.g., Barry). The deemphasis on form and complex or subtle relationships, the emphasis on the gestalt, led to the kind of literalism that also made dictionary and thesaurus definitions popular (e.g., Kosuth). There was also a mania for systems of any kind, carried over from the early '60s, but now manifested more bureaucratically than formally. (Hesse wrote in her diary: "File. How to keep one. Ask Me," because Bochner was a major proponent of this approach.) And there was a mania for math books, which is where Ruth Vollmer comes in.

I first saw Vollmer's work around 1965 at the home of Leo and Dorothy Rabkin. They own *Musical Forest* [1961]..., a bronze, bowl-like piece that brustles with rods and can be played with a wooden mallet as a musical instrument. I made no connection with the Minimalism I was so involved in. But Vollmer, who was over a decade older than Reinhardt (with whom she exhibited for years at the Betty Parsons Gallery) and was raised in Germany, provided a bridge from the Bauhaus and European constructivists like Gabo and Pevsner to the younger artists. They were attracted to her overt "pragmatism," to her unpretentious use of mathematical forms— "purer than language," she explained, "because, like music, they were free of most associations." Although her techniques were rooted in a conventional modernism, she viewed her mathematical sculptures as "found objects," simple models of natural laws rather than as creative flights or made-up forms (though of course scale, material and execution made them unavoidably her *art*). LeWitt wrote of Vollmer's sculpture: "The pieces have a size small enough to mitigate any expressiveness. They are not gross and pompous. They are of the necessary size, neither large nor small; the form is in harmony with the idea." Underlying her work is a metaphysical classicism, maybe Pythagorean, in which abstraction becomes so pure that it bends over backwards toward nature/realism/life again.

There is something of this contradiction in Smithson's work too, and he was drawn to Vollmer in his "mathematical" stage, which preceded or merged with his "geological stage." Vollmer and Smithson had spirals in common, and a sense of metaphysical/microcosmic nature that I don't think interested, say, Bochner, Graham, or LeWitt, who identified more with her theoretical side. Hesse and Vollmer were close friends, their German (and tragic) backgrounds a bond as well as aesthetic common ground. Unlike any of the men shown here, who would have thought these forms "too sculptural, too associative," they both used spheres and compart-

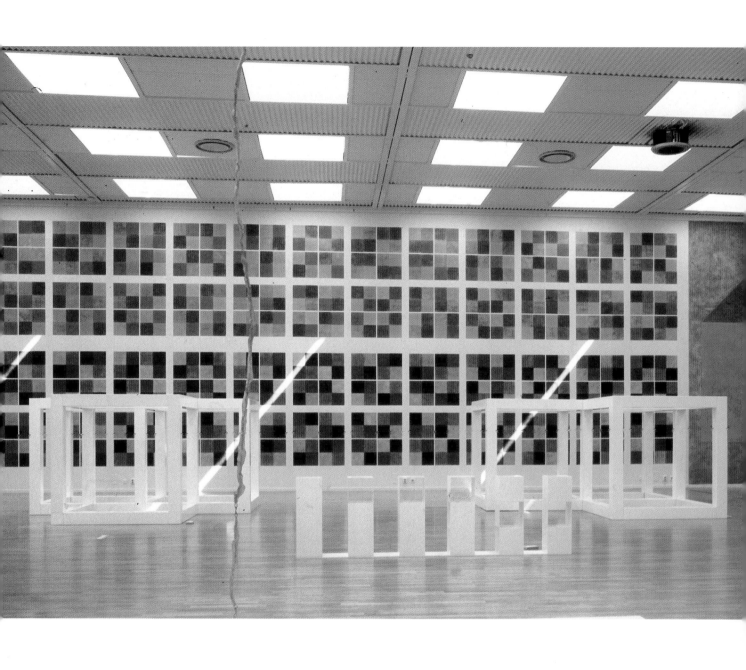

SOL LEWITT ROOM, "FLYKTPUNKTER/VANISHING POINTS," MODERNA MUSEET, STOCKHOLM, APRIL 14–MAY 27, 1984
PHOTO MODERNA MUSEET, STOCKHOLM

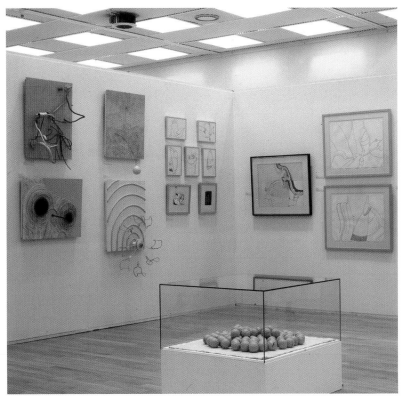

EVA HESSE ROOM, "FLYKTPUNKTER/VANISHING POINTS," MODERNA MUSEET, STOCKHOLM, APRIL 14–MAY 27, 1984
PHOTO MODERNA MUSEET, STOCKHOLM

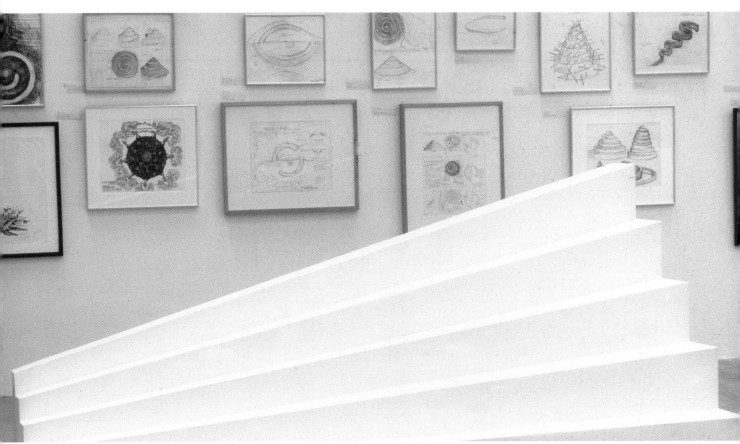

ROBERT SMITHSON ROOM, "FLYKTPUNKTER/VANISHING POINTS," MODERNA MUSEET, STOCKHOLM, APRIL 14–MAY 27, 1984
PHOTO MODERNA MUSEET, STOCKHOLM

mentation devices—boxes with things inside. Vollmer, like Hesse, had a sympathy for the biological which the others generally denied.

At the same time, in 1966–67 Smithson was going through what he called "a crisis of abstraction," when he "couldn't accept the Reinhardtian dogmas," and he cited the strong impact of Hesse's work then. He felt that Hesse understood his "turbulence." I'm sure she did, because she too was subject to doubtful periods, when she recognized how distant her art could be from that of her closest friends: "Sometimes I feel there is something wrong with me," she wrote in her diary. "I don't have that kind of precise mind or I just don't feel that way, I feel very very strongly in the way that I feel, but I don't stand on that kind of system." The serial arrangement of much of Hesse's work was certainly prompted by LeWitt's, and it provided a crucial armature for her emotive tendencies. Yet, like Darboven, she carried the repetitive element past system to possession. LeWitt supported this personal direction all along, writing to her when she was still in Germany: "Don't worry about cool, make your own uncool"—which she did.

One reason for this was, of course, Hesse's roots in Abstract Expressionism and her development of a sculptural oeuvre in close proximity with Tom Doyle's work. Doyle is covered by practically none of the generalizations I'm making here. In 1965 he was already a well-known "space sculptor," associated with the Park Place group—with Mark di Suvero, Chuck Ginnever, David Weinrib, George Sugarman, Peter Forakis, Ronnie Bladen, and others. Their work ran obdurately counter to all Minimalist precepts. It was freewheeling and polychromed; it lunged expressively into space as though buoyantly escaping from the confines of the Abstract Expressionist canvas. Hesse's first reliefs included winged, yearning shapes clearly related to Doyle's: vestiges remained in the 1966 *Hang Up*, one of her most important works, which reaches gawkily out into space.

Doyle's relationship to space was active where the Minimalists' was passive. Neither boxes nor flatness interested him. Where the others backed away from all but heavily schematized organic imagery, he welcomed it. He wrote me from Germany in winter 1964–65, "The studio is really alive with things growing up all over; sometimes when I come up out of the trap door I feel like running for the watering can." Doyle's real sources are in engineering—the soaring, cantilevered forms of bridges, docks, decks, ramps, roots—"primary" in their own way. His *Owl Creek* in the

"Primary Structures" show was solid and flowing, its tough grace clearly at odds with the modules surrounding it.

Doyle was and is a close friend of LeWitt's. But in some curious way his work of 1965–70 had more in common with Smithson's, although they were *not* close friends and would have disagreed about almost everything. Smithson disavowed romanticism. Doyle is an avowed romantic; his literary heroes are Joyce and Whitman rather than Beckett and Pinget. But Smithson's deep involvement with New Jersey, with William Carlos Williams (who was his pediatrician), with snakes and primal ooze and outer pace, though carried by very different aesthetic vehicles, overlaps somewhere with Doyle's enthusiasm for American history, the Civil War, and American places. I wrote about Doyle in 1965, and it still applies: "He dislikes the monolithic or object aesthetic, seeing his work as landscape—not self-contained, but expansive, free, stretching out and upwards. His swinging, subtly balanced forms do not confine space nor take up space nor are they drawn against space, but attempt to embrace and become part of space"—or, I would add now, in regard to his monumental outdoor pieces of the '70s and '80s—part of *place*.

Words and walls were the basic blocks for this group in 1965–70. Robert Barry, Hans Haacke, and Robert Hour all did "invisible" pieces that emphasized and/or incorporated the room itself; words informed the viewer what was "there." In 1967–68, Robert Ryman was drawing out of the canvas onto the wall; Hour made taped wall pieces to stress architectural space and detail, as did Bochner and Frederick Barthelme, and, later, Bill Vazan and Rosemarie Castoro. LeWitt's first wall piece came out of the studio into the Paula Cooper Gallery for an anti–Vietnam war show in November 1968. The concern with the room as fundamental "support" was related to the Minimalist obsession with "flattering" and led to detailed examinations of physical surroundings and our perception of them—earthworks and "site sculpture" being among the results. On the verbal side, these preoccupations led to much pseudophenomenological speculation, which in turn led to a plethora of work in the late '60s that focused on measurement, both indoors and out.

Among the favorite subjects of thought and discussion at the time were finity and infinity, Beckett and Borges, and boundaries—Smithson's site/non-site premise being the most fertile and innovative result. Differences in scale reflected conceptual differences. Smithson mapped where Bochner measured. The fascination with process—the Serra/Morris/Smithson/Hesse spilling/scattering/pouring syndrome—was

similarly distinguished from the fascination with procedure, though both were highly dependent on context. Bochner's work was primarily located in the second group. With others, he challenged the assumption that art necessarily dealt with objects, "that things have stable properties, i.e., boundaries.... Consider the possibility that the need to identify art with objects is probably the outgrowth of a need to assign our feelings to the things that prompt them."

Bochner's "procedural work" was "initiated without a set product in mind. The interest is only in knowing that the procedures, step by step, have been carefully and thoroughly carried through. The specific nature of any result is contingent on the time and place of implementation, and is interesting as such. It is the 'proceeding' that establishes it." Along these lines, he organized an influential show of "Working Drawings" at the School of Visual Arts in December 1966. The full title was "Working Drawings and Other Visible Things on Paper Not Necessarily Meant to Be Viewed As Art," and it offered procedural detail and diagrams from a range of non-art workplaces.

Replacing the "furniture" of art with place, and the factual perimeters of the place (interior place, not the broader landscape aspect of place that Carl Andre and others were exploring), like Smithson, Bochner focused on the dialectic of external/internal relations: "It is only through the function of its 'opening out' that we are presented with a passage to the density of things," he wrote. "This realm of ideas is the operative link preceding any of the forms of objectness; it is an expanse of directions, not dimensions; of settings, not points; of regions, not planes; of routes, not distances. Beneath materiality are not merely facts but a radiation spreading out beyond dimensionality, involvement, and signification." These ideas, which I find easier to relate to the work of Graham and Smithson than to Bochner's, were much in the air at the time, and we argued about them in the bars and in studios which were becoming *studies*.

Despite the aura of specialization exuded by this art, and despite the rapid academization of Minimalism, these artists were making brave attempts at independence. There was a liberating sense of being able to move out (or at least to entertain the illusion of moving out) of what Smithson called "cultural confinement." And there was a healthy attempt to demystify the role of the artist by getting down to basics. Marxism played a role in the dawning comprehension of reification and commodification, and the social role of art (or lack thereof) under capitalism.

In 1969–70, some of these artists occasionally attended meetings and protests mounted by the Art Workers' Coalition (AWC), though none were active in it. However, they profited from the AWC's consciousness-raising around artists' issues—from professional autonomy to social responsibility. And this consciousness affected their art in roundabout ways. The general political climate of the mid '60s—the Black Liberation Movement in particular—provoked much debate around framing and self-identity. Although mostly disconnected from the major social movements of the time, artists did share with them certain needs. By writing articles and incorporating the "defining" words of criticism into their own work, late Minimal and conceptual artists reflected the general movements toward self-determination and self-affirmation. Like the civil rights and the women's movements, conceptual art in the broad sense was a reclamation project, denying the conventional separations between the artists' intentions and the critics' of viewers' interpretations.

Artists reclaimed books, too—not only making them and writing them but incorporating their readings into their art. In spring of 1967 the storefront Museum of Normal Art had a show called "15 People Present Their Favorite Book"; in June, the Dwan Gallery held its first "Language to Be Looked At and/or Things to Be Read" show, and Dan Graham wrote an article on "The Book As Object" for *Arts Magazine*. This year also marked the beginning of communications with the Art/Language group in England, which was extremely important to the whole tendency when not enamored in language so obscure that it became art merely by virtue of its incomprehensibility. (A/L's more politicized branch continued the expansion of Marxist consciousness in New York in the mid '70s through *The Fox* and within Artists Meeting for Cultural Change.) Hans Haacke, applying visual analysis to vulnerable social structures—such as absentee landlord networks, art viewing and collecting habits, and the dissemination of information through the mass media—carried this political use of language in art through the '70s, accompanied by Martha Rosler, Dan Graham, Adrian Piper, and, by 1980, many others. These were the origins of the best of what is now called Postmodernism—a left-leaning critical analysis of the ideological function of word and image in mass culture.

Thus, buried in the deadpan objects and simple/complex verbiage of 1965–70 was no less than an urge to change the world through changing perception. To oversimplify: understanding how we see would lead to changing what we see that we don't like, which would amount to revolution. Daily life

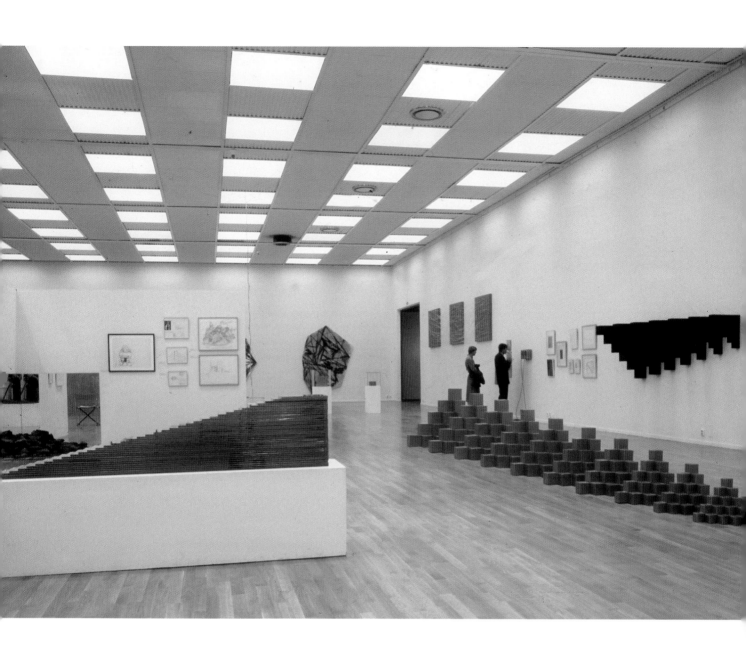

MEL BOCHNER ROOM, "FLYKTPUNKTER/VANISHING POINTS," MODERNA MUSEET, STOCKHOLM, APRIL 14–MAY 27, 1984
PHOTO MODERNA MUSEET, STOCKHOLM

and the facts of individual existence were thoughtfully scrutinized by artists like On Kawara (his date paintings, accompanied by daily news clippings, his "I Met," "I Got Up," and "I Am Still Alive" series); Ed Ruscha (his books on "dumb" subjects like all the buildings on Sunset Strip, parking lots, swimming pools); Lawrence Weiner (his word teases around physical fact and ownership); Ian Wilson (his "oral communication," i.e., talk as art); Hilla and Bernd Becher (their photographic researches into industrial structures and lives); Ian Baxter (his N.E. Thing Co., which went Duchamp one better by "claiming" anything at all, anywhere at all); or Doug Huebler (his photo-text documentation of "everyone in the world"). Robert Barry wrote in 1969, "Making art is not really important. Living is." He quoted Robbe-Grillet: "If art is going to be anything then it has got to be everything."

Barry's release of inert gases into the atmosphere remains a striking metaphor for the notion of breaking away, literally taking off into the stratosphere, as were Huebler's points in space, Graham's *March 31, 1966*, and Smithson's heroic attempts to expand the axes and vortices of art into the "real world" by relating it to geological time, the cosmos, corporate architecture, industrial ruins, grandiose notions of life and death, to vulgar "pop" notions of image and environment via the media, especially B-movies. A practical parallel, or result, was Seth Siegelaub's stroke of near genius when he began to publish catalogues as exhibitions, bypassing the long institutional familiarization/success process by sending the work directly to its audience. For instance, in "July, August, September, 1969" eleven artists made one work of art at eleven different locations throughout the world, so the catalogue/show took place simultaneously all over the world, in three languages.

Since the early '70s practitioners of this expansionism have often retrenched into conservative attitudes. LeWitt, on the other hand, has continued to expand his art into the world through the personal (or impersonal) framework he evolved in the '60s. His permutational system can be laid over any experience/place/idea he chooses. Thus the brick wall outside his studio window, graffiti on the Lower East Side's walls, every object in his house, baroque statuary, and whatever else are all grist to his mill, becoming visibly "permutational" while reaching into the real meaning of permutation, which is infinity or possibility.

This decidedly non-Minimalist spirit extends to LeWitt's relationship to the art world and to other artists. No single American artist has been so supportive of other (unknown, young, neglected, women, minority) artists. First, his ideas and his openness to other's ideas sparked what he calls "conceptual art with a small *c*" (which is not a movement, but a "third stream"—a new *medium* which continues to be used to the most diverse ends). As he became known, his emotional/intellectual support for other artists became still more valuable, and as his economic situation improved, be often extended that support to the financial domain, having small works across a broad stylistic span. The generosity that characterizes his friendship, honest criticism, and feedback also informs his art. There is a hopeful, optimist element in the permutational form he has chosen, which is one reason his work wears so well. It stays fresh because it remains in touch with the world.

In June 1970, we were "validated" by the establishment, in the form of a rather anti-establishment exhibition— "Information," curated by Kynaston McShine at The Museum of Modern Art. (The situation was ironic, because the AWC was picketing MoMA in force, protesting its lack of support for minority and women artists, its refusal to take a stand on the Vietnam war, and its elitist allies, principles, and entrance fees.) The "Information" catalogue, with its Ben-Day–dotted cover picturing computer, TV, typewriter, tape recorder, telephone, opened to inside covers depicting hundreds of thousands of people protesting the Vietnam war in Washington. That was the spring of Cambodian bombings, of Kent State and of Jackson State, so the "Information" show became more political than most similarly assembled catalogues of the period.

"Information" (and institutional validation) marked the beginning of the end of an era. After McShine's text in the catalogue there were blank pages for anyone to add their work to the show, followed by a series of "unrelated" photographs mingling art, life, and the mass media. Toward the end of his essay, McShine asked, "How is the Museum going to deal with the introduction of the new technology as an everyday part of its curatorial concerns?" That question has not been answered directly, but suffice it to say that MoMA today is a very different place than it was in 1970 and the change parallels the increasing homogenization and dehumanization of the U.S. in general.

Despite the politically charged atmosphere of the late '60s and the sense of hope paradoxically underlying the deathlike surfaces of late Minimalism and the aesthetic denials of much conceptual art, few avant-garde artists found direct ways to reflect their politics in their art. Political naivete, fear

of activism, careerism, lack of support, and a basic incomprehension of how the World really works finally led not to change but back to the art world, from which bastion artists can remain safely "critical" of society without having to worry about being heard. The suggested populism (too strong a word) I saw as inherent in the notions of a new simplicity and formal egalitarianism never made the potential audience connections. It is difficult to *épater le bourgeois* (by making one's work "unsaleable," impermanent, site specific) and not to scare off everyone else at the same time. The traditional alienation of high art won out, although at the grass roots level the '60s socio-aesthetic strategies bloom today. Most of the Minimalists/Conceptualists were highly idealistic, even while theoretically denying idealism with their "factual" art. For all their expansionism, their work remained art as art, though dialectically framed by its longing to be otherwise, which continues to push at the walls, which is why, for me, it was such an important time.

1984

Reprinted with permission of the author. Lucy R. Lippard, "Intersections," in Olle Granath and Margareta Helleberg, eds., *Flyktpunkter/Vanishing Points* (Stockholm: Moderna Museet, 1984), pp. 11–29.

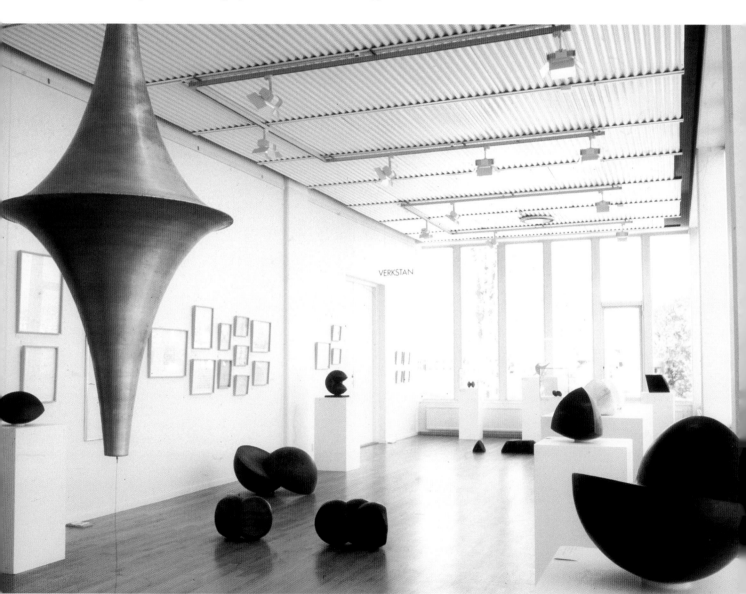

RUTH VOLLMER ROOM, "FLYKTPUNKTER/VANISHING POINTS," MODERNA MUSEET, STOCKHOLM, APRIL 14–MAY 27, 1984
PHOTO MODERNA MUSEET STOCKHOLM

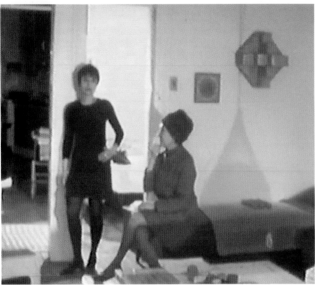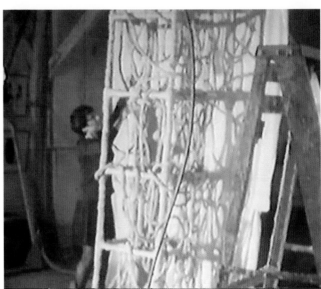

DOROTHY LEVITT BESKIND. UNTITLED (DOCUMENTARY OF EVA HESSE AND RUTH VOLLMER IN HESSE'S BOWERY STUDIO IN NEW YORK), CA. 1967-68
16 MM FILM. SILENT; COLOR. APPROX. 10 MINUTES
FILM STILLS © ZKM KARLSRUHE

A STRUCTURE OF CREATIVITY
BY ANN REYNOLDS

Ruth Vollmer was an "artist's artist." She and her work were—and continue to be—significant to artists, particularly the generation of artists who came of age in New York during the fifties and sixties. Until recently, however, both she and her work had rarely been mentioned by art historians and curators. Vollmer is also an artist without a substantial or consolidated public archive of photographs, personal papers, books, and interviews, even though she often appears in the archives and oral histories of others. Her own lack of a proper archive might be one reason why she remains unknown to or unacknowledged by scholars, and writing her history or writing her into history will necessarily require generating new archival materials such as oral histories. But recovering her history could also encourage a different mode of looking at extant archival materials, and of generating new ones as well.

I first became aware of Ruth Vollmer while conducting research on Robert Smithson.[1] Working with an archive as vast as Smithson's forced me, almost immediately, to decide whether or not I should consider the numerous references to, and letters from, artists and other individuals whose names did not appear in the literature on Smithson or on sixties art in general. Based on the volume and types of materials related to these artists and other individuals in the archive, however, many of them were obviously active participants in New York's cultural life during the sixties. How to account for this disparity? Also, the communities rendered visible by Smithson's archive overlapped at numerous points and were much more heterogeneous than I had previously assumed. They consisted of individuals from a variety of professions,

class backgrounds, age groups, genders, and sexual orientations. In fact, many of the artists who were unfamiliar to me yet significant members of the communities I was beginning to uncover were largely accountable, in large part, for this heterogeneity. In the world I could glimpse through Smithson's archive, all of these individuals were corresponding with one another, sometimes exhibiting their work side by side, and continually trading images and works of art. They and the relatively fluid communities they were a part of did not have much institutional visibility then and certainly do not have much more now; their presence, participation, and influence are, for the most part, missing from the historical narratives of the decade. Ruth Vollmer was one of these artists: absent from these narratives, but present in the archive.

Artists like Vollmer, if discovered in archives like Smithson's and then acknowledged in the art-historical literature, usually serve as fresh background or supporting material for the main event. They add useful factual details to a known artist's story, allowing it to become a more definitive historical narrative. But the presence of artists like Vollmer in the archives of others is also indicative of other possible narratives. I would like to suggest that Vollmer's presence in other artists' archives does just that, not only by shifting focus away from the known artists and onto her unrecognized significance as an artist with her own unique narrative, but also by providing a marker of other points of view—and of viewing—within a historical narrative that is larger, more complex, and, necessarily, more self-consciously speculative.

One of the viewing points that Vollmer's presence provides

was a physical space: her Upper West Side apartment. When interviewed, many of the individuals who knew Vollmer in New York repeatedly recall her apartment, which functioned as both a living and working space at different points in her life. Even if they do not focus on the precise location, physical details, or contents of this space, they speak about what took place there, with whom, and the nature and impact of these experiences on their sense of themselves as artists and as part of a larger creative community. Richard Tuttle, for example, recalls:

> You could walk into her apartment and see about six Giacomettis.... She and her husband had visited the studio and known him casually. Then there were four Etruscan black vases that she had the sensibility to collect and pass on her love [for] to visitors. So I felt very much a student in that sense. But in other ways, I felt she was the student in terms of her ideas, what was actually going on—how the world was breaking into a new chapter. And it was a wonderful liaison because each side was enriched.[2]

And Tom Nozkowski remembers Vollmer's invitations to

> come up to her house for dinner or drinks or to meet some people. And people always talk about artists' salons. I'll tell you, in thirty-five years in New York the only real one I ever experienced was basically at Ruth's. Kind of catch-as-catch-can, ongoing—the cast would change slightly every time. But I would say most of the time when you went there somebody else would turn up. Maybe half a dozen other people would turn up.[3]

Such a space and set of reciprocal, intergenerational experiences, salon-type experiences for some, might seem like old-fashioned or even anachronistic models for artistic communities of the mid- to late sixties, but this was obviously not the case for the artists involved. I want to consider what these types of experiences and memories might intimate, not only about Vollmer's significance for the artists she knew in New York, but also about how artistic communities might have functioned for these and other artists of the period. This is a question of real physical spaces, spaces in which art was conceived, made, or discussed, and of how these spaces and communities—and there were many—were imagined, experienced, represented, enacted, and internalized by those who were a part of them, as distinct from those who were not. Through her presence in the archives and memories of others,

Vollmer provides evidence of multiple models for "creative spaces" and communities and the limitations of art history's methods of recognizing and interpreting them.

By the mid-sixties, the nature and location of a New York artist's living and working space were considered crucial signifiers in relation to both her identification as an artist and the understanding of her work. This is demonstrated by the increasing number of photographic, cinematic, and textual descriptions of artists' studios—downtown loft spaces in particular—being generated by artists and by others both inside and outside their communities, and which appeared in a variety of different contexts for a broad range of audiences. Some of these descriptions were made by professional writers, photographers, and documentary filmmakers and destined for a wider, more general consumption via magazines, books, or documentary films; several obvious examples of this type would include Fred W. McDarrah's 1961 book, *The Artist's World in Pictures*; Alan Solomon's *New York: The New Art Scene*, published in 1967; and Emile de Antonio's 1972 documentary film, *Painters Painting*.[4] Others, perhaps the majority, were made by technical "amateurs," individuals with little or no film or photographic training who produced images for themselves or for a more limited group of other individuals.

The short 16mm films and videos Dorothy Beskind made of artists in their studios starting in 1963 are examples of this second type. Beskind, an untrained filmmaker, claims that she made these films as a means of better understanding an individual artist's work, often after she had first seen it in a public exhibition. She made one of Eva Hesse in the artist's studio at 134 Bowery Street in either late 1967 or early 1968.[5] In this film—as in a number of her other films and videos—Beskind's camera measures the spatial terms of her subject's studio by scanning up, down, and across it, momentarily resting on, and sometimes focusing in on, particular collections of objects or individual works of art by the artist or her contemporaries that were arranged in the space: Hesse's *Hang Up* (1966), *Vertiginous Detour* (1966), *Laocoön* (1966), and *Schema* (1967–68), among other works; a wall sculpture by Robert Smithson; and drawings and photographs by Sol LeWitt.[6] The film also contains sequences of Hesse working on specific pieces; for example, Beskind records Hesse washing the rope for one work in her bathtub, rearranging the cords in *Laocoön*, and threading plastic tubing through the cardboard tubes of a model for *Accretion* (ca. 1968).

In addition to Hesse, one other artist makes an appearance in Beskind's short film: Ruth Vollmer. The film was included in the *Eva Hesse* retrospective that originated at the San Francisco Museum of Modern Art in 2002. Both the wall label for the film and the exhibition checklist included a short description of the film's contents, but only the checklist identified Vollmer as a sculptor and friend of the artist.[7] Neither addressed how Vollmer is presented or her possible significance to Hesse. Vollmer appears near the beginning of the film; Beskind uses a doorway to frame her and Hesse as they discuss and then arrange some objects and papers on a low table that is not clearly visible from the camera's perspective. In the sequence that follows, the shots through the doorway, the two women sit facing each other. Beskind's camera frames Vollmer's head and then Hesse's in profile; in between these two close-ups, Beskind pulls the camera back and then tracks across the space between the two artists, a gesture that simultaneously indicates that Hesse and Vollmer are seated at some distance from each other in the space and cinematically draws them together. The sequence concludes with a shot of the two artists now together in a single frame, still conversing, while Vollmer remains seated and Hesse stands next to her.[8] Vollmer does not appear in the rest of the film, although her coat, which was draped on a chair near Hesse when the latter was seated in the previous sequence, hangs from a hook on the wall in later shots, indicating that Vollmer remained in the loft for the duration of the filming, even if her presence was no longer directly acknowledged by Beskind's camera.

Beskind's film is a type of informal documentary; it catalogues, however incompletely, the contents of Hesse's loft, how her works and her working processes were physically integrated within the space in which she lived. It also provides a visual record of a relationship she had with another artist—in this case, Ruth Vollmer. From the point of view of the filmmaker, the film provides a view inside the private space and life of the artist, one that, as already stated, might help her and, potentially, a wider audience of viewers to understand the works that they have seen or may see in more public spaces such as galleries or museums. And, even though Beskind was an amateur, she rendered these "private" spaces and lives in terms of already well-established public conventions that would be readily understood by a public—including herself—that has been informed by other, more professional photographic images or films of artists in their studios, for example, those published by

McDarrah, Solomon, and others. Some of these conventions include demonstrating that the types of spaces artists occupy conform to contemporary preconceptions about where and how artists, particularly young artists, live and work—in open, relatively raw spaces in which living and working are combined; acknowledging that a sense of how a work is made is crucial to understanding its significance; and confirming that artists are social individuals who often share their living and working space with family and/or other artists and consult them about their work.

Leo Rabkin, an artist and close friend of both Hesse and Vollmer, recalls that Hesse was "like Ruth's daughter."[9] Sol LeWitt also describes their relationship as a "surrogate mother-daughter" one.[10] Vollmer and Hesse's biological mother, Ruth Marcus Hesse, were close in age, and all three were German-Jewish refugees from the Holocaust. Vollmer supported Hesse emotionally, professionally, and financially in a number of ways. She encouraged her in her art; helped her to find materials or solve technical problems with her materials or processes; took her on trips—to Mexico, for example, in 1969, on the anniversary of Hesse's mother's death by suicide; bought Hesse designer clothing; and helped her to find a better doctor once she began to become seriously ill.[11] Beskind's film seems to capture some of these aspects of Vollmer and Hesse's personal relationship—the relationship itself through the shot, counter-shot sequence; the obvious age difference, which appears to approximate that between a mother and a daughter, evident conversations about works of art; and Hesse's stylish clothing—despite the fact that Beskind claims that she knew nothing about the relationship, or even who Vollmer was, when she arrived at Hesse's loft to make her film.[12]

But Beskind's inclusion of some of these elements, particularly the suggestion of a familial relationship, or at least a close, intergenerational friendship, can also be accounted for by established conventions for representing artists, circa 1967–68. For example, Solomon's *New York: The New Art Scene* contains numerous images of artists living, working, and socializing with their wives, children, and other artists in their studios. Because Beskind appears to be reiterating photographic and cinematic conventions rather than deliberately representing some of the qualities of a particular relationship between these two artists that their peers recall, the film hasn't really encouraged any investigation of the specific nature or significance of this relationship or its reciprocity— Hesse in Vollmer's studio discussing Vollmer's work, for

example. What we see if we read Beskind's film through the conventions of the then current genre of documentary films on artists is quite limited and, most obviously, only the half of it, at least for the artists. They did not experience their relationship or their studio practice in terms of a strict dichotomy between public and private spaces or roles, familial or otherwise; nor did their peers. They experienced both within a series of spaces and through a number of different, overlapping roles, all of them providing opportunities for ongoing dialogues about making, collecting, arranging, and combining objects, works of art among them, in space.

As no equivalent film or video footage of Vollmer in her studio environment exists, it would be helpful to balance, and complicate, a reading of Beskind's evidence with a reciprocal set of images of Vollmer's living and working space. I offer a description and analysis of the arrangement of works in Vollmer's collection in one room of her apartment drawn from the memories of Hesse and Vollmer's peers[13] (page 48). This room, off the main living area and next to the kitchen, contained three works: Sol LeWitt's *B8*, a "black painting" by Ad Reinhardt, and an untitled sculpture from 1966 by Eva Hesse. All three works were gifts from the artists. *B8* consists of a thin, 13-1/2-by-13-1/2-inch piece of steel painted gray, with a white grid of nine equal squares superimposed on it. A thin steel cube rests on this base and echoes the overall dimensions of the two-dimensional base as a three-dimensional framework. At the center of the base, a second, smaller three-dimensional steel framework articulates the dimensions of one square of the painted grid. Both frameworks are white. The result is a cube inside a cube inside a square. *B8* is part of a series of works by LeWitt titled *ABCD*, which comprises four groups of variations on open and closed cubic forms. In an essay written shortly after he completed the series, LeWitt claimed that "the serial artist does not attempt to produce a beautiful or mysterious object but functions merely as a clerk cataloguing the results of his premise."[14]

Vollmer displayed *B8* on a plywood base at table height and next to the Reinhardt painting. Hesse's sculpture hung on the other side of this painting, facing the LeWitt. Hesse's work consists of a papier-mâché–covered balloon that has been wrapped with cord and then painted with black enamel paint. The resulting long, thin, black form curves into a comma and is suspended on the wall by an elastic cord attached to it at both ends. One form simultaneously reiterates and encloses—hides—the other; in this case, no glimpses of the void inside the balloon and its covering, however partial, are permitted. At the same time, the papier-mâché and cord covering solidify the shape of the unseen void contained within the balloon's fragile skin.

Like LeWitt's *B8*, this work is part of a series; Hesse made several other papier-mâché and cord-encased balloon works in the mid-sixties. For one, also untitled, Hesse sliced open the papier-mâché–covered balloon several inches from one end. The severed end dangles precariously from the unraveled cord that connects it to the rest of the covered balloon, revealing a section of its dark inner shape. One peers into a circumscribed void that indistinctly emerges from an inky blackness, an experience akin to looking at a black painting by Ad Reinhardt.

Vollmer placed these three works—the Hesse, the LeWitt, and the Reinhardt—relatively close together, since the room they shared was somewhat small. Vollmer's arrangements of everything in her apartment were carefully considered and composed. According to artists Joyce Robins and Tom Nozkowski, Vollmer "would make a big deal of where to put your pieces and 'consult' with you about it."[15] She and the artists were partners in determining the spatial arrangement of their works and in considering the visual and conceptual dialogues these arrangements would engender. As an isolated work, or even as a part of the *ABCD* series, *B8* initially might seem like the predictable result of a clerk's cataloguing of his premise, with no mystery and nothing to hide, until one considers the fact that its cubic frameworks enclose a series of voids—absences—that can only signify stable planes of a cube once the mind and eye have willed them into existence. Vollmer's placement of *B8* next to a black Reinhardt painting and across from Hesse's untitled work provokes analogous if not even more pressing questions. The work opens up in ways it might not in other situations and in other spaces.

Tom Nozkowski has observed that when Vollmer's spheres first "appeared in the midst of minimalism, what attention they received was largely from other artists. The sphere, seemingly a perfect minimalist image (it is the least surface of any given volume), was not accepted as the cube or tetrahedron was."[16] Nozkowski proposes two reasons for this: the technical difficulties inherent to casting a sphere, and the rather romantic associations suggested by the patina of Vollmer's first bronze spheres and by her description of them as "mysterious forms."[17] Nozkowski acknowledges that "the real coolness of conceptual art" made it possible in retrospect "to look back and detect a real romantic impulse

at work in some minimal artists."[18] Nozkowski was writing in the late seventies, but his observations seem even more valid twenty years later. Works like LeWitt's *ABCD* series possess a deeply ambiguous if not mysterious side once one moves beyond the apparent simplicity of the individual formal units. Ruth Vollmer noticed this mystery and attempted to draw it out through her placement of *B8* in relation to other works in her collection. Hesse was also attracted to the mysterious and ambiguous aspects of rudimentary forms, and so indirectly was LeWitt. He acquired Hesse's untitled work, with its sliced-open yet evasive void, from her; it was also probably a gift.

With these spatialized relationships in mind, one can return to the Beskind film and reconsider its depiction of Hesse's arrangements of objects in space. In her studio, one sees a geometric wall unit by Smithson next to one of Hesse's ink-wash-and-pencil concentric circle drawings, each one consisting of stacked or nested geometric forms; a collage-drawing by Carl Andre above her desk and, on the wall nearby, an array of small framed drawings by her and other artists; a bulletin board covered with postcards and exhibition announcements to the right of her desk; tableaux or still lifes of her own work composed on chairs and the studio floor; and a low table, its white painted surface superimposed with a thin, black, LeWitt-like grid, on which there are numerous test pieces, little sculptures and objects of various types, and some pieces of paper. This is the table that Hesse and Vollmer are shown looking at and arranging things on. Beskind's camera scans this table several times, which suggests that the filmmaker recognized that it and the objects on its surface were significant.[19] But, cued by Vollmer's presence, one might also consider the assortment of objects on the table as a more fluid version of Vollmer's arrangements in the small room in her apartment. By considering these two spaces reciprocally, and Vollmer's and Hesse's actions within and to them, the fact that they contain conscious arrangements rather than haphazard collections of things becomes more obvious.[20] And these arrangements do not just provide evidence of the fact that artists knew each other and collected each other's work, or evidence of Hesse's "private" or "personal" attempt to imitate, on a smaller scale, an institutional model of curating the work of her generation. Through her groupings of objects, Hesse created something new, something that was useful to her in relation to the conventional, institutional, and domestic arrangements she had seen, yet not synonymous with them. Such comparisons between the

placements of objects and images in space also reveal that there are numerous ways to gain information from Beskind's film, and that audiences other than the one represented by the filmmaker are implied—even if these audiences were not intended or even imagined by the filmmaker herself. These audiences would have had a more informed frame of reference, and thus would have recognized the work by many more of the artists in Hesse's space, where they were located previously, both in the studio and before Hesse acquired them, and why they were ultimately hung side by side. Some of these audience members may even have been involved in the curatorial decision making. Ruth Vollmer was certainly one of these audience members. The film reaches beyond its original intent to tell us these things once we can recognize and then consider the significance of Vollmer's presence in terms of the creative spaces of the artist circa 1967–68.

In a chapter from his book on underground film titled "The Pad Can Be Commercialized," the film critic Parker Tyler makes a distinction between underground film and what he calls "Hollywoodized" versions of underground film and underground culture. According to Tyler, Roger Corman's *The Trip*, a 1967 film about drug-induced psychedelic experiences, is an example of the former because it "recognizes the borderline between illusion and reality while exploiting the former."[21] In other words, *The Trip* defines its characters' psychedelic illusions in opposition to reality—what happens when they are not under the influence of LSD or mescaline. Underground film, on the other hand,

> regards the reality/illusion dimension seriously enough to pretend—even as lunatic or drug addict—that what really matters is not the peripheral reality but the central illusion. A struggle, let us say, is always present (just as the struggle between desire and its fulfillment seems to be a permanent state), but programmatically the Undergrounders take the side of illusion and attempt to breed and interweave and transplant this illusion so that, like drug addiction, it may become, or seem to become, the daily round of life. *Illusion is what really happens.* This is why all varieties of Underground Film are curiously "documentary" instead of "artistic." If they fail of major illusion, they at least document the traditional social activity of making life itself into a work of art, with the result (doctrinally considered) that art as such becomes a superfluous occupation.[22]

Here, Tyler appears to describe a different kind of documentary practice from Beskind's and, it goes without saying, from the professional photographers and filmmakers from whom she derived her sense of documentary practice. Instead of conceiving of reality as a measure of a documentary image's or film's "truth"—or, conversely, as something against which to measure the degree or intensity of cinematic illusion, whether drug-induced or just standard Hollywood spectacle—reality has no place at all. It is subsumed by the illusion: Illusion is "what really happens." True underground film consists only of illusion as reality: art as a way of making a life, even if it is a superfluous one. Tyler offers Bob Fleischner, Jack Smith, and Ken Jacobs's 1963 *Blonde Cobra* as one of many examples of underground film's particular form of documentary.[23] According to Tyler, *Blonde Cobra* documents the "life" of Jack Smith, whom he calls an "acting personality":

> Wildly fantastic in one aspect, the film is simply a candid portrait of an offbeat personality, Jack Smith, the same Jack Smith who later made the banned film *Flaming Creatures.... Blonde Cobra*, whose sound track is an improvised monologue by Smith, has all the traits of Underground Film's most candid camera work: off-center shots, in-and-out-of-focus photography, a way of lurching about and a total look of odds and ends put together. In other words, it has the casual empiricism of technique that may come from inexperience but may be also, as here, deliberately affected by the Underground because it imparts to the most extravagant and grotesque material the air of being literally true. From this point of view the clumsiness of the film's technique is a tour de force.[24]

Beskind's film also contains some lurching camerawork, a number of off-center and out-of-focus shots, and some rough editing. All of these elements are indicators of inexperience, but they add equally to the sense of the film's *vérité*—just as Tyler claims they do in underground films. And the manner in which the two artists are dressed in Beskind's film—throughout, Hesse wears a fitted sweater, short skirt, tights, and heels, and Vollmer, a fitted gray tweed suit, mink hat, stockings, and heels—suggests that many of their actions, specifically the ones meant to suggest the artists at work, were just for show.[25] Although their clothes obviously were not recovered from the "trash pile of cast-off clothing" that, according to Tyler, was part of Smith's "kindergarten"

method of inventing his costumes, the wardrobes of the two women play a role in their "acting for the camera" and, in addition to the way they were framed and filmed, their enactment of their relationship through the camera. Their actions can be viewed as straightforward reenactments of everyday studio activities that Beskind translated into the recognizable codes of documentary, an illusion defined in terms of a peripheral "reality"; but their clothing suggests something more, a decision, at least on the part of Hesse, that was not strictly determined by either documentary codes or reenactments of the everyday. It is in excess of both. In part, Hesse's appearance reveals her vanity: She wanted to look good for the camera, and for anyone who might view the resulting film. But her choice of outfit—and perhaps Vollmer's as well—served no purpose in connecting her actions to a peripheral reality of "artists at work." Hesse's and Vollmer's actions and interactions in these costumes could be considered, in Tyler's words, self-sufficient creative acts of "making life itself into a work of art with the result that art as such becomes a superfluous occupation."

According to Robert Smithson, there was more to both types of acting—naturalistic and excessive —than met the eye. In an essay written around 1967 titled "From Ivan the Terrible to Roger Corman, or Paradoxes of Conduct in Mannerism As Reflected in the Cinema," Smithson describes two distinct types of contemporary avant-garde practice in terms of two different forms of acting. He claims that Constantin Stanislavsky's naturalistic "method" acting indirectly shaped the first type, and cites as evidence the photographs of artists "pos[ing] or fak[ing] being unaffected" and imitating "everyday, mundane, natural events—such as playing baseball, on-the-job painting or drinking beer" in McDarrah's *The Artist's World in Pictures* and Solomon's *New York: The New Art Scene.*[26] Smithson compares such images of a "phony naturalism of we're-just-ordinary-guys-doing-our-thing" to a second, more Brechtian form of acting, exemplified by the ways in which Andy Warhol directed "queens" to act like naturalistic "plain-janes" in films such as *Chelsea Girls* (1966). According to Smithson, Warhol's actors self-consciously call attention both to their artificiality and to their ability to function as cultural referents, whereas the artists "caught" by the camera in the midst of an everyday activity unconsciously assume an unmediated expression of a "natural self" even as they conform to a set of recognizable, predominately middle-class stereotypes of family and domesticity not previously associated with artists. The latter is a con-

structed "natural" moment, the former, a simulacrum of one, with "intellect added." Myth-making conventions give way to the acknowledgment of a deliberate fiction.

The two types of acting described by Smithson are roughly comparable to the two types of film contrasted by Tyler: one—traditionally, Hollywood film—passes off its images and scenarios as real or at least believable by creating the illusion of a reality, the other—underground film—provides an illusion that is clearly just that, an illusion that subsumes the real. Which type of acting or illusion does Beskind's film contain? One might initially assume the first, naturalistic type; yet the formality of Hesse's and Vollmer's physical appearance, the didactic nature of their gestures and their attitudes toward art making, and their positions relative to each other and in relation to the camera suggest something else, something more self-consciously staged, both by the filmmaker and by the artists themselves. And these two stagings should not necessarily be assumed to be equivalent. What did—and do—two well-dressed women playing at being artists signify, in either case? The two artists are and are not acting like "plain-janes" or "ordinary-guys-doing-their-thing." Through their appearance and their staged actions they acknowledge both the camera's presence, and what it—and ultimately Beskind—want to know. Both camera and filmmaker are outsiders, there to unlock the evidence of the so-called private life and space behind the work that appeared in the gallery, in public, as a form of explanation.

And Hesse and Vollmer, to some extent, comply, in tune with the documentary rhetoric of the time; they know how to act like artists for the camera. But their self-consciousness also indicates that what they enact for each other and for the camera might also be a manifestation of something less conventionalized, both psychologically and socially, something I would like to call a "structure of creativity." By using this term, I want to suggest Raymond Williams's concept of a "structure of feeling," an emotional—and creative—presence that is something practical, in action, and readable from inside a culture, but to which fixed forms, categories, or conventions—such as, in this case, the "postwar" or "contemporary" artist—do not speak at all.[27] Such an affective or creative structure may depend on the presence of the camera, but it produces a different type of documentary, perhaps one closer to that associated by Tyler with *Blonde Cobra* and with underground film in general. Beskind's film might then be considered part of a continuity that includes the films of Smith, Warhol, Kenneth Anger, and other New York under-

ground filmmakers, not because of Beskind's intentions from behind the camera—I am certainly not arguing that she made, intentionally or unintentionally, an underground film—but because of Hesse's and Vollmer's actions and emotional presence in front of the camera. The filmmaker and her camera provide a framework within which the artists can make sense of their relationship and their work and present it to themselves and to each other; what Beskind's camera captures is secondary for them. Hesse and Vollmer are actors of a different kind, each of them actively so in relation to each other, but also in the sense of what it is to enact their artistic relationship, both in terms of an audience—and a reality—on the other side of the camera, and in terms of an audience—and a reality or, to use Tyler's term, an illusion that "is what really happens"—that is in front of the camera. Vollmer's presence in Beskind's film, whether intended or the result of coincidence, signals a set of creative structures that conform to, yet also depart from, the usual narratives. She provides Hesse with an audience who is inside her space and inside her creative process. Once her presence is acknowledged by Beskind's camera, the viewer can never be certain whom Hesse is smiling at, speaking to, or gesturing toward when she turns toward the camera, Beskind or Vollmer. But, unlike Beskind, Vollmer is never just, can never be considered, an outside observer.

The enacting of Hesse and Vollmer's "structure of creativity" was and continues to be unintelligible in terms of the dominant institutional models used to define artists and artistic communities of the sixties, and thus Vollmer's presence is assumed to be secondary or irrelevant to these models. To paraphrase the feminist historian Carolyn Steedman, outside of these models, there seems to be nothing to tell. What I am looking for is a way to speak not only about an alternative set of categories for artists, and, by extension, artistic communities, but also about how a community is made and experienced, what is being lived with whom, the life as well as the lifestyle of the studio. And I want to view these studios as something more than the location of a private life, to be explored by outsiders in an effort to unlock the meaning of that life so as to better understand the work that surfaces in public exhibitions. Such false distinctions between the private and public experience and understanding of objects—how they are made, the experience of making them, and with whom—have severely limited our understanding of artistic practice. It is not a question of replacing an inaccurate image with an accurate one, but a matter of directing one's attention

to not only who is telling or filming the story, or who the story is ostensibly about, but also who might be watching from inside the frame, and how.

Notes

1 This research resulted in Robert Smithson: *Learning from New Jersey and Elsewhere* (Cambridge, Mass., and London: MIT Press, 2003). I am referring to the Robert Smithson and Nancy Holt Papers, 1905–1987, Archives of American Art, Smithsonian Institution, Washington, D.C.

2 Richard Tuttle, interview with the author, February 18, 2002.

3 Tom Nozkowski, interview with the author, March 4, 2002. The collectors Dorothy and Herbert Vogel describe evenings at Vollmer's apartment in similar terms: "Ruth sort of bridged a lot of our friends together.... It was like going to a Gertrude Stein salon. Every evening we went there, she welcomed you in a very warm manner, and she'd always have interesting people. Museum people, artists. There's no one I have met since who was able to put people together the way Ruth did." Dorothy and Herbert Vogel, "Dorothy and Herbert Vogel in Conversation," in *From Minimal to Conceptual Art: Works from the Dorothy and Herbert Vogel Collection* (Washington, D.C.: National Gallery of Art, 1994), p. 66.

4 For a broader historical background on the representation of the artist's studio during the post–World War II period in New York, as well as a detailed analysis of these descriptions and de Antonio's film *Painters Painting*, see Caroline A. Jones, *Machine in the Studio: Constructing the Postwar American Artist* (Chicago and London: The University of Chicago Press, 1996).

5 Or possibly as late as 1969. In a phone conversation with the author on August 7, 2003, Dorothy Beskind stated that she became aware of Hesse's work in the 1969 exhibition "Art in Process IV," which was curated by Elaine Varian at Finch College Museum of Art, New York. Hesse's *Contingent* (1969) was included in this exhibition. But the film is dated circa 1967–68 in Elisabeth Sussman, ed., *Eva Hesse* (San Francisco: San Francisco Museum of Art, 2002), p. 324, and 1968 in Helen Cooper et al., *Eva Hesse: A Retrospective* (New Haven, Conn.: Yale University Art Gallery and Yale University Press, 1992), pp. 43–44. So perhaps Beskind first became familiar with Hesse's work earlier on. The states of various works by Hesse depicted in the film suggest that the earlier date of 1967–68 is probably more accurate.

6 Beskind uses a similar strategy to cinematically measure the living and working spaces in Robert Smithson and Nancy Holt's loft in a short 1969 film.

7 Sussman, ed., *Eva Hesse*, p. 324.

8 Beskind uses similar shots and editing to link Smithson and Holt together across the space of their loft.

9 Leo Rabkin, interview with the author, December 11, 2001.

10 Sol LeWitt, interview with the author, December 2001. Joyce Robins and Tom Nozkowski made similar analogies in an interview with the author on March 4, 2002.

11 Leo Rabkin notes that Vollmer "took over Eva in an enormous way. She took her to Mexico—Eva had never been to Mexico." Dorothea Rabkin agrees: "Again, she was very generous. When they went to Mexico and Eva went out with younger people—after all, she couldn't be together with Ruth all the time. She didn't make any fuss to go. She went out and bought her marvelous clothes and Gucci handbags and Gucci boots." Dorothea and Leo Rabkin, interview with the author, December 11, 2001. LeWitt and Robins and Nozkowski provided some of the same information about Vollmer and Hesse's relationship during my interviews with them in 2001 and 2002, respectively.

12 Beskind, interview with the author, 2003.

13 This section of my essay depends on a portion of another, titled "Space Matters," written for *Ruth Vollmer*, forthcoming from Inverleith House, Edinburgh, in 2006. I have derived my information about Vollmer's collection and where specific works were placed in her apartment from several different interviews, but the majority of my information comes from a drawing made for me by Robins and Nozkowski during our interview in March 2002; for a reproduction of this drawing, see the forthcoming "Space Matters."

14 Sol LeWitt, "Serial Project No. 1," *Aspen Magazine*, nos. 5–6 (1966): n.p.

15 Joyce Robins and Tom Nozkowski, interview with the author, April 14, 2002.

16 Thomas Nozkowski, "Ruth Vollmer," p. 4. Ruth Vollmer Archive, Jack Tilton Gallery, New York.

17 Ruth Vollmer, "Fragments Towards the Sphere," 1965. Ruth Vollmer Archive, Jack Tilton Gallery, New York.

18 Nozkowski, "Ruth Vollmer," p. 4.

19 Others would later inventory these contents as recorded in photographs. See, for example, Anne M. Wagner, "Another Hesse," *October* 69 (summer 1994): 49–50.

20 Hesse owned a number of works by Vollmer; unfortunately, none of them appear in Beskind's film. Dorothea and Leo Rabkin, interview with the author; and Robins and Nozkowski, interview with the author, March 2002.

21 Parker Tyler, "The Pad Can Be Commercialized," in *Underground Film: A Critical History* (New York: 1969); reprint (New York: Da Capo Press, 1995), p. 69.

22 Ibid.

23 Ken Jacobs edited *Blonde Cobra* in 1963 using footage shot by Bob Fleischner and audiotapes recorded by Jack Smith in 1958. For a discussion of the film's chronology and an interpretation of its historical significance as a U.S. avant-garde film, see P. Adams Sitney, "Recovered Innocence," in *Visionary Film* (New York: Oxford University Press, 1974/2002), pp. 315–45, 447–48.

24 Tyler, *Underground Film*, pp. 80–81.

25 Hesse appears in two different outfits in the film, which suggests that Beskind either shot the footage on at least two separate occasions or that she and/or Hesse decided that Hesse should try different outfits to enhance the contrast in different shots, since one outfit consists of a black sweater and a rust or maroon skirt and the other of a maroon sweater and black skirt. Such formal considerations only serve to underscore a description of Hesse's self-presentation as a form of acting.

26 Robert Smithson, "From Ivan the Terrible to Roger Corman, or Paradoxes of Conduct in Mannerism As Reflected in the Cinema," in Nancy Holt, ed., *The Writings of Robert Smithson* (New York: New York University Press, 1979), p. 213. For a more extensive discussion of this essay, see my *Robert Smithson: Learning from New Jersey and Elsewhere*, pp. 219–21.

27 Raymond Williams's most concise discussion of this concept appears in "Structure of Feelings," in *Marxism and Literature* (Oxford: Oxford University Press, 1977), pp. 128–35; but the most comprehensive elaboration and application of it occurs in his *The Country and the City* (New York: Oxford University Press, 1973).

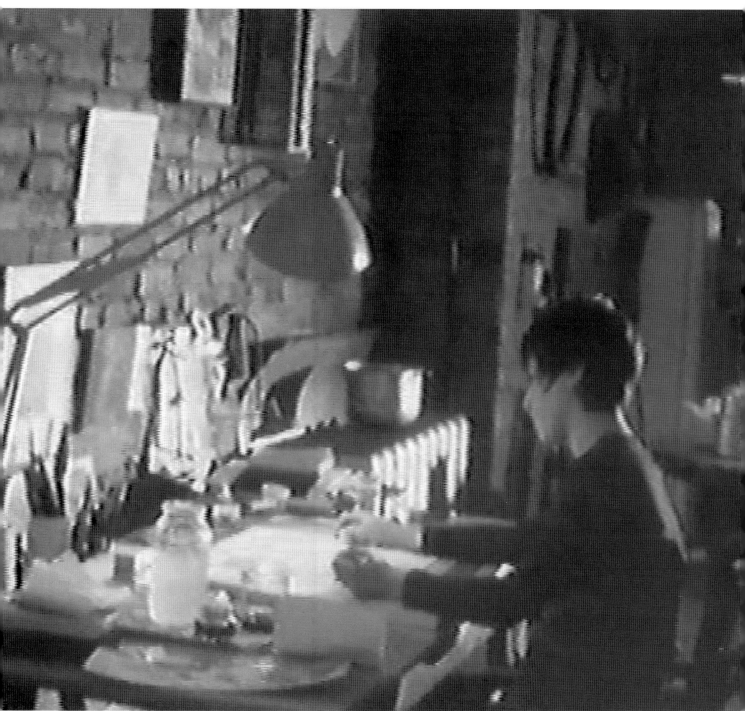

Hilbert*, Chapter 32, "Eleven Properties of the Sphere":

"A sphere can be rolled arbitrarily between two parallel tangent planes. It would seem plausible that the sphere is uniquely defined by this property. In actual fact however, there are numerous other convex surfaces, ... whose width is also constant and which therefore can also be rotated between two fixed parallel plates to which they remain tangent throughout........."

*All quotes are from Geometry and the Imagination by David Hilbert and S. Cohn-Vossen.

Hilbert says in the preface to his book Geometry and the Imagination that it "should contribute to a more just appreciation of mathematics by a wider range of people than just the specialists ... by offering, instead of formulas, figures that may be looked at ... supplemented by models ... to bring about a greater enjoyment of mathematics."

"CONSTRUCTION DRAWING OF PSEUDOSPHERE"

"PSEUDOSPHERE"

A concept of the mathematician Bernhard Riemann, the "Pseudosphere" is a 'false' sphere, a surface of negative curvature.

As seen in the drawing, this curve is constructed on many equal circles, centered on equidistant points on a longitudinal axis. Beginning at the intersection of the central circle with a perpendicular to the axis, lines are drawn from one circle to the next continuing to the successive point on the axis, ad infinitum. The rotation of the resultant curve, the tractrix, around the axis creates the "Pseudosphere".

Since the lines which are the tangents of the tractrix are all of equal length, they relate to the curve of the Pseudosphere as the radii relate to the circle or the sphere.

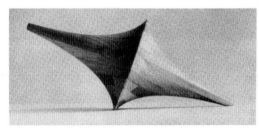

"HEPTAHEDRON"

The hepta-seven, hedron-side is initially constructed of eight triangular sides like the octahedron and an inside structure of three squares perpendicularly intersecting at the diagonals. These lines of intersection are also the three axes; height, width and depth. Of the eight triangles, alternating four have been cut away; thus four triangles and three squares create the "Heptahedron".

The strange characteristic of this form is that in its center point and along the axis it comes to nothing, but the thickness of a material. This characteristic of the "Heptahedron" is shared with the "Steiner Surface".

"STEINER SURFACE"

"Just as the simple polyhedra can be continuously deformed into the sphere, so there is a simple closed surface into which the 'Heptahedron' can be deformed. This is the 'Roman Surface' investigated by Steiner." In this country it is called the "Steiner Surface"

Transparent material was chosen to make the form easy to comprehend.

A separate wire circle can be leaned against the sides of any Steiner Surface - or its circular light reflection observed. See "Three Axes Holding Four Rings", the Steiner Surface having four equal sides like the "Tetrahedron".

My math. advisor, Dr. Erna Herrey, Professor of Physics, member of the Doctoral Faculty of the City University of New York, has devised a structure of ovals from the formula of the Steiner Surface:

$$y^2 z^2 + z^2 x^2 + x^2 y^2 + zyx = 0.$$

See "Intersecting Ovals", transparent multi-colored and white opaque and the structure of all shown Steiner Surfaces.

The Steiner Surface is one of approximately one hundred mathematical models at Columbia University. They were used in the mathematics department but now are kept in a cupboard in the Low Library, where nobody ever sees them.

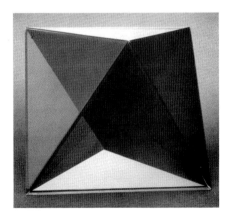

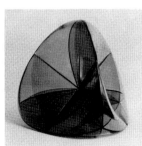
Steiner Surface

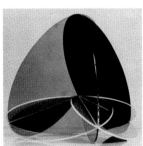
Intersecting Ovals

PAGES FROM THE HANDOUT ACCOMPANYING THE EXHIBITION "RUTH VOLLMER"
BETTY PARSONS GALLERY, NEW YORK, NOVEMBER 3-24, 1970
RUTH VOLLMER PAPERS, 1939-1989, ARCHIVES OF AMERICAN ART, SMITHSONIAN INSTITUTION, WASHINGTON, D.C.

THINKING THE LINE BY NADJA ROTTNER

The plumb line in our hand, eyes as precise as rulers, in a spirit as taut as a compass...we construct our work as the universe constructs its own, as the engineer constructs his bridges, as the mathematician his formula of the orbits.—Naum Gabo[1]

Ruth Vollmer's sculptural works investigate the shared potential of art and mathematics.[2] In 1969–70 the artist recast a series of found mathematical models into didactically motivated sculptures; they are clearly not "geometrically abstract," a predicate that, if attached to a work of art, refers to the work's inherently Platonic ideal of the perceptually simple, the intellectual, the structural, and the pure in its capacity to reduce and represent the universal essence of form. Thinking the line[3] refers to a process of artistic translation in which mathematical debates on the nature of abstract thought are introduced into the discourse of art by using a strategy of mapping: Vollmer based her sculptures of 1969–70 on found mathematical models and the "found" mathematical ideas they embodied. Thinking the line, in an axiomatic reading of forms as modular connections between points and lines in space, replaces modernist geometric abstraction and its interest in pure forms distilled from nature with an emphasis on the conceptual premise of an abstract work of art. Assuming a revisionist view of the sixties enables us to look beyond the restrictions of modernist models of criticism, in which the external and the referential were refused in favor of a history of art that built itself exclusively upon reflections on its own progressive development. From an alternative perspective, the works of Ruth Vollmer, in their engagement

with mathematics, are not seen as a "belated" reading of constructivism but as a challenge to prevailing critical notions of form/shape, concept, and idea.[4]

Vollmer's attempt was not to engage through the work in discussions on the status of the art object, but to link different fields of knowledge, such as literature, geometry, mathematics, and linguistics, through a deep-seated belief in the communicative potential of the work of art made public. Sculpture was tested and explored in its capacity as a mediator between the visual and the textual, between creative and scientific thought. In an unpublished interview with Colette Roberts in 1970, Vollmer quotes a passage from Herbert Read's introductory essay for the "Naum Gabo–Antoine Pevsner" exhibition at The Museum of Modern Art, New York, in 1948, a text that explicitly tackles the constructivist relationship between art and science. The quotation reveals not only her affinity for the works of Gabo, but also her interest in Read's main observation that art can be sensual *and* intellectual:[5] "Between the objectivity of science and the creativity of art there is the difference: the one aims to 'inform,' the other to 'please.' The pleasure afforded by the work of art need not take the channels of emotional indulgence, of sentimentality. Pleasure results from many degrees of perception, and the purest pleasure is, according to the view I am presenting here, intellectual as well as (at the same time as) sensuous."[6] It is difficult, if not impossible, to say to what degree Vollmer supported the fundamentally Platonic hypothesis articulated by Read in works such as *The Philosophy of Modern Art* (1952), where he states that "there is no phase in art, from the

Paleolithic cave paintings to the latest developments in constructivism, that does not seem to me to be an illustration of the biological and teleological significance of the aesthetic activity of man."[7] Read emphasized the sublimity and timeless beauty of an abstract aesthetic, for which geometry became the means to achieve transcendence and universalism. This essay is not concerned with Vollmer's conception of aesthetics per se, but, rather, looks at her works in the context of ongoing cross-fertilizations. Her practice is based in a unique type of idea visualization that not only foregrounds the conceptual nature of constructivist thinking but also revives questions pertaining to the role of a constructivist legacy for conceptual art.[8] An artistic project such as Vollmer's, motivated by a constructivist reevaluation of the role of the plastic object as a mediator between disciplines, provides an alternate model of art production in the sixties, a decade that is most commonly identified with the "dematerialization" and destruction of the art object.[9] Vollmer's idiosyncratic work shares the quixotic dream of constructivism, insofar as it encompasses two realms that seem incommensurable from a Platonic point of view: on the one hand, the Cartesian and scientific, on the other, the creative and imaginative. In her work, the political aspirations of the constructivist avant-garde are transformed into a notion of a creative utopia that renews modernist abstraction by looking for the mathematical truth of how abstract forms (and formula) are conceived—from intuition or from conception.

Vollmer touched upon a fundamental feature of mathematical thinking: the role and function of the model. A model is not a translation of the formula; it is the equivalent of the formula. She based her works of 1969–70 on materializing the found model by prefabricating it in transparent acrylic as opposed to the original, opaque plaster of the original model. In traditional sculpture, the idea was embodied in the work as a translation (and was thus weakened) in the process of realizing the work. For Vollmer, the conceptual content of the work was identical with the form, similar to the way a mathematical model and the formula it represents are identical.

Vollmer's choice of mathematical sources followed a progression corresponding to that of the history of mathematics, from Platonic solids to Archimedean geometry, in which the line was defined less as an essence than as a continuous process of "rounding"; to the predominantly German, non-Euclidean mathematics of the nineteenth and early twentieth centuries, which was involved with topology, calculus, and the problematic of tangents (how to determine the lines tangential to a given curve); to Bernhard Riemann's differential geometry, the precursor of Einstein's theory of relativity and the forms of hyperspace;[10] and, lastly, to the fields of physics and biology.

A variant of modular thinking, more complex than algorithms or similar logical operations, was used by Vollmer in the creation of a series of works in 1969–70. In line with topological thinking—in which "figures that are theorematically distinct in Euclidian geometry, such as a triangle, a square, and a circle, are seen as one and the same 'homeomorphic' figure, since they are capable of being continuously transformed into one another, like a rubber band being stretched"[11]—Vollmer conceived of space in a non-Euclidian manner, as being beyond the limits of empirical or sensible perception, while, in a seeming paradox, remaining within the parameters of plasticity and the traditional confines of sculptural volume and mass. She resuscitated the communicative potential of the art object in order to turn to an interdisciplinary investigation of the shared territories of mathematics and art, both of which perform operations of idea visualization. Contrary to Vollmer, the works of Mel Bochner, Robert Smithson, and Sol LeWitt (to name only those who directly engaged with Vollmer and the mathematical nature of her works) relegate science to a merely affirmative and amplificatory function that assists the artist in the development and consolidation of his or her ideas and practice. The belief in transparency is programmatically dismantled, and a critique of the art object and the avant-garde notion of communicability is undertaken. The need for transparency now lies in the potential of the object to expose its own limitations. A German-born émigré who arrived in New York in 1935 at the age of twenty-seven, Vollmer was of a generation and cultural background very different from those of Bochner, LeWitt, and Smithson. Contemporary critics seldom paid attention to her works, registering her individualism through the reductive lens of historical "belatedness." Her mathematical knowledge and her first-hand experience of Bauhaus and Russian constructivism were attractive to a younger generation of artists who sought a way out of the American narrative of modern art as purely abstract, as it was then so narrowly defined by Clement Greenberg. It was this same "belatedness" that attracted her artist colleagues to engage in a dialogue with her and her works throughout the sixties. Yet, the nature of this generational dialogue was infused by the clash of two radically different artistic conceptions of production. For the younger, upcoming group of artists, the making of a work of art needed to be recentered, away from the locus of the imagination and

conventional standards of creation and toward a prefabricated set of rules and regulations that not only determined the work's form but also, and more importantly, were inscribed on the object in a way that was transparent to the viewer. Interestingly, those critics who did choose to write about Vollmer—Rolf-Gunter Dienst, Peter Frank, and LeWitt among them—were vehement in their attempt to align her works with then-current minimalist and/or conceptualist practices by maneuvering away from discussing the idiosyncratic aspects of her works.[12] This essay dissociates Vollmer from any adherence to the movements of minimalism and conceptualism, emphasizing instead her highly individualistic mapping of art and mathematics that utilized constructivist, conceptualist, and minimalist strategies in an eclectic manner, in much the same way she sampled mathematical ideas from the history of mathematics.

Turning Geometric: 1964–68

Next, I explored the sphere geometrically. I looked inside. I was looking for proportions.—Ruth Vollmer [13]

In 1964, Vollmer turned toward the construction of three-dimensional sculptures as abstract and unitary objects that examine the form of the sphere and the mathematical properties of space. At first, she approached the sphere intuitively, drawing analogies to Euclidian geometry in a series of bronze sculptures shown in New York in 1966 as part of the exhibition "Ruth Vollmer: Sculpture, Spheres" at the Betty Parsons Gallery.

From a Euclidian point of view, a sphere is a quadric consisting only of a surface; as such, it is hollow. Herein lay Vollmer's interest: in the interior of the sphere. It was opened up, cut, and dissected along the lines of the radius, diameter, and tangents, in a manner that mined the geometric, axiomatic properties of the sphere alongside the formal parameters of inside/outside, hollow/full, convex/concave, rounded/squared. Vollmer's reliance on the roundness of the given shape focused on the existent center and its relationship to gravity rather than on ideal circularity. The unpolished bronze surfaces were partially subjected to abstract-expressionistic ornamentation and incrustation. Vollmer's preoccupation with the sphere, as opposed to the minimalist predilection for "empty" cubic shapes, was motivated by the form's inherent richness in associative and referential meaning, and its embeddedness in scientific history:[14] "I have found forms within the sphere. Being immersed in the mystery

of the sphere, I can vaguely perceive a variety of manifestations: cosmic and earthly, biological and crystalline."[15]

Conceived as, but not originally exhibited as, floor sculptures—a presentational format Betty Parsons found too unconventional in 1966—Vollmer's bronze sculptures share with the works of Carl Andre what Robert Smithson would later term a "metaphorical materialism,"[16] a concern with surface nuances and effects. Seriality, for Vollmer, was understood rather traditionally as the production of different, unique variations on a single theme, in editions of up to six pieces. The repetition of the preselected unit of the sphere did not predict the outcome of the individual work. And whereas Andre's sculptures press against the floor, deprived of illusionistic space or an anthropomorphic center, Vollmer's interior spaces are devoid of illusion only by mathematical definition. The blank, empty interior, which could be filled with yet another sphere, a spiral, or even a square, demarcates the surface of the volume as a membrane that can be easily cut, yet the weightiness of the bronze conflates the sphere's mathematical center with the perceived density of the form, the accretions to the bronze surface triggering the

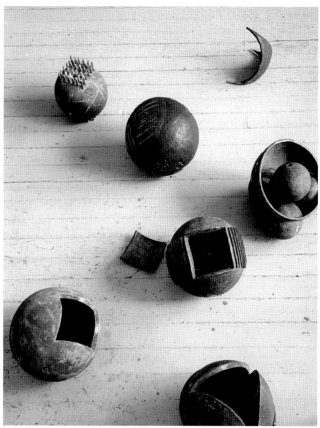

RUTH VOLLMER. ASSORTED SPHERICAL SCULPTURES IN BRONZE, 1963-66
PHOTO HERMANN LANDSHOFF

metaphorical potential of the sphere: These sculptures are at once abstract, materialist, and anthropocentric.[17] Smithson would concretize the latent metaphorical capacity of Vollmer's work in his 1968 essay "A Museum in the Vicinity of Art." In her *Bound Sphere Minus Lune* of 1966 (page 122), the thick bronze ring encircling the sphere's equator, together with the incised lune—a triangular cut made through the surface of the piece—evoked, for Smithson, ideas of mapping and the Earth.[18] The sphere (as opposed to the square) is not a man-made form; consequently, the dimension of time enclosed in the sphere is geological. In Vollmer's words,

> Of all forms, the sphere is the most purely three-dimensional. A cube, having six sides (six flat planes), can be constructed from a flat pattern. A sphere, on the other hand, touches any plane at only one point. And a sphere can never be constructed from planes. The inside surface of a sphere is smaller than the outside surface. The dimension of time is probably also enclosed in the sphere.[19]

By cutting the sphere in accordance with Euclid's axiomatic method for solid geometric forms, Vollmer was able to describe space abstractly through points and lines, yet left room for naturalistic associations. Similarly, LeWitt's modular employment of the square triggers responses in the viewer that register both the logical, geometric foundation of the form of the square *and* the subsequent chain of permutations. Rosalind E. Krauss has seen LeWitt's work through the lens of nonsensical systems of structures, such as creative babbling in adult language games.[20] The permutational character of set theory would allow for yet another reading of seriality in LeWitt as an infinite system that is driven by sets of numbers that are not geometrically but arithmetically organized. For LeWitt, geometry provides a matrix for the production of an antirelational, anticompositional work of art whose conceptual clarity is set against his visually complex constructions in order to complicate the legibility of the work. This play on empirical verifiability results in an increased cognitive engagement with the work on the part of the viewer that is based on the partial loss of conceptual transparency. The complexity of LeWitt's *Variations of Incomplete Open Cubes* (1974), for example, stands in opposition to prevailing fundamental orders of geometry, such as mathematical progressions based on the addition of a constant number (as in the work of Dan Flavin) or those derived from the multipli-

cation of a constant factor (Smithson, Donald Judd, LeWitt, Andre), or they can employ more complex Fibonacci and inverse natural numbers (Judd).[21] The ideational premise here consists of either an empirically verifiable, transparent set of rules, or an opaque set-theoretical system. These rules condition the shape "arrangement" of the work of art, as opposed to the traditional avant-garde notion of "composition"—a notion that Vollmer continued to embrace in 1964–68 but broke away from in 1969–70 by bringing to the fore another mode of production through which sculpture could literally incorporate mathematical thought.

From the position of the European avant-garde of the twenties and thirties, Max Bill, in 1949, unknowingly predicted, by means of a negative assessment, this shift in attitude toward scientific/mathematical thinking in the sixties: "By a mathematical approach to art it is hardly necessary to say I do not mean any fanciful ideas for turning out art by some ingenious system of ready reckoning with the aid of mathematical formulas."[22] Such formulas and systems of numbers were employed as a new matrix for artistic production. For Vollmer, the Euclidian conception of the geometry of the sphere was more than a constructive parameter for how to cut the sphere; it was utilized in its capacity of providing a theme that could determine content and meaning. Furthermore, Vollmer used mathematics itself as a history of ideas: The sphere can be understood in Euclidian terms, in the mathematical terms of Riemann or Jacob Steiner, to name only two nineteenth-century mathematicians whose concepts of the sphere Vollmer consistently employed in 1969–70. Bill, evidencing his knowledge of modern, non-Euclidian mathematics, furthermore states that "mathematics itself had arrived at a stage of evolution in which the proof of many apparently logical deductions ceased to be demonstrable and theorems were presented that the imagination proved incapable of grasping. Though mankind's power of reasoning had not reached the end of its tether, it was clearly beginning to require the assistance of some visualizing agency."[23] This new need in the discipline of modern mathematics for forms of idea visualization—for mathematical models—delivered the perfect argument for a constructivist artistic mind in proving the universal applicability of art. Thus, sculpture for Bill in 1949, as for Vollmer in 1969–70, had an infallible potential to communicate mathematical ideas, since it "could be made a unique vehicle for the direct transmission of ideas, because if these were expressed by pictures or plastically there would be no danger of their original meaning being

perverted."[24] In both views, the medium of art potentially supersedes the medium of language in its direct access to the (mathematical) idea. The more the artwork approximates in its own conception the "mental concepts" of mathematical thinking—"the more comprehensive the unity of its basic idea"—the more universal will the scope of art become.[25]

Vollmer, in 1969–70, translated found mathematical models and formulas into sculptures by changing the opaque plaster of the mathematical model into transparent acrylic. She adhered to a constructivist notion of the primacy of visuality—a deep-rooted belief in the artistic object and its aesthetic potential to communicate and inform—that stood in opposition to a conceptualist skepticism whose desire to visualize and to demonstrate was fostered by the disruption of this very idea of reasoning. Yet, at the beginning of the sixties, artists such as Andre, Bochner, LeWitt, and Smithson were interested in a constructivist project. Andre, in his writings, most vehemently distanced himself from a constructivist legacy. The extent to which this artistic debate was framed philosophically in terms of a Platonic versus an anti-Platonic conception of creation was demonstrated by Andre in 1974, when he offered the following observation: "I am not an idealist as an artist. Artists are trained to be idealists: they start with a vision, then they seek to implement it. I do not proceed like that at all. I try to discover my visions in the conditions of the world. It's the conditions which are important."[26] Andre's "flight from the mind"[27] was only one way of formulating a different philosophical conception of materiality, in an attempt to "escape" the Platonic ideal and the legacy of European avant-gardism implicit in it. Bochner and Smithson's collaborative essay of 1966, "The Domain of the Great Bear,"[28] was the climax of an ongoing debate with regard to whether science should be seen as a historically contingent "cultural style"[29] or treated as a universalist notion. For Bochner, Vollmer's enterprise was the antipode of his and Smithson's understanding of science: "Vollmer's idea of science is empirical, hers is a romantic science, a poetic one that leads her to discover the secret structure of the universe."[30] This certainly applied to Vollmer's new technological emphasis in 1966, presumably adopted under the influence of a then strongly prevailing minimalist aesthetic. In concert with engineers at Grumman Aircraft Engineering in Bethpage, New York, she developed a process of working in spun aluminum and copper that resulted in a highly polished, auratic surface and closed volumes. Her works from 1969–70 break away from this categorization of Platonic versus anti-Platonic,

where modes of conception and modes of execution are seen as separate entities.

Any historiographical account of Vollmer's work from 1964 to 1974 that relates the artist to her contemporaries through the lens of their relationship to constructivism (and science) is confronted with the notion of "belatedness." It is only from a vantage point that goes beyond this model of history writing that an alternate reading of Vollmer's unique model of abstraction can be established, by reading her works from 1969–70 as an amalgamation of constructivist and conceptual models of art that successfully conflates ideation and abstraction.

Vollmer Reviewed

Vollmer's works were assessed by the end of the decade as "simple," "basic," and "single"—attempts to inscribe her within different historical genealogies. The notion of simplicity and its properties of basic and single are featured prominently, if understood differently, in separate accounts. The writings of German critic Rolf-Gunter Dienst outline a constructivist-minimalist trajectory, whereas Sol LeWitt's 1970 account locates Vollmer's work within a contemporary conceptual practice. A review by Peter Frank in 1974 speaks of a constructivist-conceptualist lineage.

In the winter of 1969, Dienst wrote a review for *Das Kunstwerk* titled "Ruth Vollmer's Magic of Simplicity." As with many critics of his time, Dienst conceived of minimalism as reductionist due to its austerity—its lack of illusionistic space and relational composition. The idea of reduction as the driving force behind the development of modern abstraction often resulted in an essentialist position whose ultimate goal was purity of the medium.[31] Within this narrative, "minimalist abstractionist" works were seen as the logical culmination of modernist art. Artists protested most immediately and vehemently against a Greenbergian reading of their works as reductivist. Notions of the "simple" and of "simplification" stood against Clement Greenberg's one-dimensional conception of "reduction."[32] Consequently, artists, functioning as critics, positioned their practices as simple; yet the understanding of simple was anything but uniform. Carl Andre, for example, in a 1970 interview, describes his works as "essentially the simplest that I can arrive at, given a material and a place."[33] The idea of constructivism that Vollmer found in Naum Gabo's work aspired to a transcendence that was founded in opposition to Vladimir Tatlin's productivism and the latter's move into real space and real materials.

Andre's interest in the concrete—the site-specific—is mirrored in the split nature of constructivism itself.

Yet another model that tends toward a notion of a participatory aesthetic can be found in Robert Morris's claim that "Simplicity of shape does not necessarily equate with simplicity of experience."[34] It is rather peculiar that when Dienst, in his review, speaks of a "young American art" in the context of which Vollmer has to be viewed; he mentions Ronald Bladen and Morris as its representatives. Here, Dienst does not seem to pay attention to the ideological battle in which contemporary artists were then engaged in an effort to get away from Greenberg's reductive conception of medium-specificity, purity, and essentialism. Dienst bypasses these ongoing discussions by connecting a minimalist reductionism and its inherent simplicity directly to a constructivist notion of a "found" simplicity, through their shared interest in the aesthetic properties of geometric and stereometric shapes:

> The magic of the simple geometric form, in which esthetic propositions can be demonstrated individually, is recognized in numerous constructivist works of art over recent years.... Minimal art—in which the art is reduced to few plastic sensations—has given preference to calculated, reproducible, stereometric forms.... The sculptor Ruth Vollmer must be viewed in the context of this young American art. Her forms, also, are reduced, strictly geometric, built with calculation, and renounce the pretention of any superficial attraction. The basic element in all her recent work is the sphere.... Each piece develops the logic of a mathematical concept, yet never becomes merely an illustration of a scientific formula.[35]

It is Gabo who, in the early decades of this century, shifted from understanding the cube as a closed form, as volumetric, to an exhibition of its interior structure—its stereometric properties—by cutting the volume open and exposing it as an assemblage of intersecting planes. The ideational premise of Gabo's constructivist works has been described by Rosalind E. Krauss as "the conceptual penetration of form."[36] The formal clarity with which Gabo revealed the work's structure became the trademark of a brand of constructivism whose desire for simplicity was based on an increased interest in demonstrative clarity—a need for conceptual transparency that is reflected in the choice of transparent materials. Critics have attempted repeatedly, yet somewhat unsuccessfully, to establish a constructivist legacy for minimalism based on artists' reception of constructivist practices in the early sixties.[37] The newer and more interesting set of questions is the one that presupposes the relevance of a constructivist legacy for these practices. One way of approaching this is to consider the increasingly didactic nature of works of art. A latent didacticism also can be found in conceptualist practices, where, in opposition to a minimalist simplicity of shapes, clarity and transparency of thought were paramount. One has only to think of Dan Graham's glass architecture, or even LeWitt's series of white, cubic lattices of 1965–66. LeWitt claimed early on that white—as opposed to black—would enhance the reading of his delicate geometries. A white shape could "be seen easily," while in a black shape one could never "really see the turn in the form."[38] The need for transparency of construction would converge with a quest for transparency of thought. In the case of Vollmer, this quest led to the literal embodiment of complex mathematical ideas.

For LeWitt, Vollmer's work stands squarely in the pantheon of conceptualist—as opposed to minimalist—practices through this concept of the embodiment of "ideas made into solid forms."[39] One year after the publication of Dienst's review, LeWitt, quite out of character, wrote—at Vollmer's request—"Ruth Vollmer: Mathematical Forms," a short, manifesto-like text that was published in *Studio International* in late 1970. In it, LeWitt describes Vollmer's most recent works:

> These pieces are not sculpture; they are ideas made into solid forms. The ideas are illustrations of geometric formulae; they are found ideas, not invented, and not changed. The pieces are not about mathematics; they are about art.... The geometry is only a mental fact. There is a simple and single idea for each form; there is a single and basic material of which the piece is constructed....[40]

Although Dienst's article concerns an earlier period, 1964–66, and LeWitt's addresses her works from 1970, both demonstrate an awareness of the deeply referential yet abstract nature of Vollmer's sculpture. Acknowledging its profoundly aesthetic nature, Dienst writes: " Each piece develops the logic of a mathematical concept, yet never becomes merely an illustration of a scientific formula."[41] LeWitt disputes the status of the work as aesthetic object in his seemingly paradoxical claim that the pieces are not sculptures: They are found ideas—formulas—made solid. In

works such as *Steiner Surface* (1970; pages 58 and 163), Vollmer recast a found mathematical model (from a cache in Columbia University's Low Library) in Plexiglas—a transparent acrylic plastic. Dienst creates a constructivist-minimalist trajectory for this kind of work, while LeWitt opts for a conceptual legacy emphasizing a Duchampian moment of the "found." More precisely, each work originates from a single idea attached to a single mathematical model. "Simple" is now appropriated to describe the idea through which the work was conceived, not the work itself. Form follows conception, and the idea, the mathematical origin in a formula or concept, is made visible in Vollmer's choice of a transparent material in white, gray, and even bright colors. These works clearly break with modernist aesthetic autonomy: "These pieces are not sculpture," and yet they *are* art. Are they, then, to be placed in the vicinity of illustration, or not? Are we encountering here one of the paradoxes for which LeWitt's writings are so famous? When he states that these pieces "are ideas made into solid forms," he is emphasizing the process of visualization—the act of transference or the method by which these works were generated—over an act of interpretation determining what the status of the work "is." It is the *idea* that is the illustration of a formula, only now the idea refers to both, the work and the embodied formula, interchangeably. These works embody mathematical ideas and formulas already visualized by mathematicians and educators in the form of plaster models (presumably in the twenties), transferred by Vollmer into the realm of art and recast in a newly patented material—Plexiglas—designed solely for industrial use. For LeWitt, the conceptual ramifications of Vollmer's work lie somewhere buried in this act of transference. He holds on to this ambiguity through which the work and its constituting idea become one "form." As he states, "The geometry is only a mental fact. There is a simple and single idea for each form; there is a single and basic material of which the piece is constructed." "Simple" now implies the simplicity of geometric form *and* the simplicity of conceptual process. Their clarity is guaranteed and preserved by the artist's choice of a transparent material.

Frank, in a review of Vollmer's 1974 retrospective at the Everson Museum of Art in Syracuse, New York, attributes to her work the constructivist notion of art's subservience to pure knowledge.[42] Constructivist sculpture, seen as an investigatory tool in the service of knowledge, dominates the material by means of a projective, conceptual grasp: "Itself an analytic object, the sculpture is understood as modeling, by reflection, the analytic intelligence of both viewer and maker."[43] For Frank, a conceptualist subservience to pure knowledge is "didactic and self-indulgent." He rehearses the familiar critique of conceptualist practices, in which the artwork's mathematical formalism simply offers an elongated and tangential illustration of a more complex idea. I would like to offer an account of Vollmer's works from 1969–70 as complex mappings of mathematics and art whose subservience is not to "pure knowledge" (Dienst), but to a potentially cognitive enterprise of reading the shared properties of mathematics and art, both steeped in a debate on the nature of abstraction.

Turning Conceptual: 1970

In November 1970, Vollmer exhibited new "sphere-sculptures" at the Betty Parsons Gallery. Although her theoretical preoccupation was still very much with the sphere and its properties as an *n*-dimensional volume, these works, all from 1969–70, are beyond empirical verifiability; they are not readily identifiable as spheres. The forms' non-Euclidian nature and increasing mathematical complexity in hyperbolic space are a direct reflection of the new need for conceptual transparency; in these works, Vollmer, consciously or not, dispensed with Platonic notions of the purity of thought.[44] Euclidean geometry was conceived as an idealization of physical geometry; its forms are concepts suggested by, or abstracted from, physical reality, just as the idea of an object is abstracted from the object itself. Although these new, modern mathematical forms were logically derived from axioms (axioms are not chosen arbitrarily but in accordance with "intuitive notions of a line or a set"),[45] their conceptual premise is not empirically evident, since they no longer directly correspond to any "real" object. The ideal versus the real and the idea versus the object are categories that no longer apply in a domain that exists only in the virtual realm of abstract thought. The conceptual premise of Vollmer's 1969–70 works is as follows: The mathematical idea of the form is transferred into the realm of art in a readymade manner. Increased conceptual transparency is needed to communicate not only the *ideational* but also the *conceptual* premise of each work. Ideational hereby refers to the work's literal embodiment of the idea, its mathematical meaning. Its conceptual premise goes beyond the work's foundation on a literal idea by setting up, through the act of transference (from mathematics into art), a very different meaning for the work.

The plaster model Vollmer recast in Plexiglas in 1970

was based on the work of Jacob Steiner, a Swiss mathematician who worked on issues of projective geometry at the University of Berlin, where he taught from 1834 until shortly before his death in 1863. A Steiner form is one of the three possible surfaces obtained by adhering a Möbius strip to the edge of a disk. Also referred to as the Roman surface, a Steiner surface is essentially six cross-caps (a cross-cap is an image of a projective plane) "glued" together, and the resulting form contains a double infinity of conic sections. For this specific exhibition, Vollmer created a five-page handout (page 58) and explanatory wall texts to accompany the works shown, all of them from 1969–70: *Tangents, Pseudosphere, Heptahedron, Steiner Surface, Intersecting Ovals*, and *Spherical Tetrahedron*. The handout includes seven photographs of the works taken by Vollmer's brother, Hermann Landshoff, a professional fashion photographer; next to each photograph is a quote stating the works' underlying mathematical principles. The quotes were taken from David Hilbert and Stephan Cohn-Vossen's *Geometry and the Imagination*, which was originally published in German in 1934.[46] Vollmer's transposition of a mathematical text into the context of an exhibition was in the spirit of conceptualist practices where the text becomes part of the artwork.[47] For Vollmer, the mathematical formula was equivalent to the idea, much in the same way that the figure in a mathematical text *is* the text and not an illustration of it. Vollmer's handout, instead of carrying just secondary, contextualizing information, acted as both an instruction manual on how to interpret the works in the exhibition and as a script, providing insight into the artistic processes of conception and execution.

In other words, it is not factual knowledge of Jacob Steiner and the mathematical functioning of the Steiner surface that is of primary relevance. The work's informational nature is only a stepping-stone toward its conceptual dimension. We are looking at a mathematical formula that was translated into a mathematical model, which in turn was found by Vollmer and brought into the context of art. Through this act of transference, an emphasis was placed on the investigation of the shared territories of mathematics and visual art. We need to understand that "these pieces are not about mathematics; they are about art," as LeWitt wrote in 1970,[48] and, as such, the works—taken in toto—succeed in implicating the creative process, and the role of the imagination as a faculty of the senses, in both the arts and mathematics.

As a sort of leitmotif for her selection of these models, Vollmer writes matter-of-factly on the handout's first page:

"Hilbert says in the preface to his book *Geometry and the Imagination* that it 'should contribute to a more just appreciation of mathematics by a wider range of people than just the specialists...by offering, instead of formulas, figures that may be looked at...supplemented by models...to bring about a greater enjoyment of mathematics.'"[49] This impulse for a "greater enjoyment of mathematics" had its onset in the short-lived tradition of mathematical model making, when, at the end of the nineteenth century and into the early twentieth century, mathematicians felt the need to visualize their new, complex, non-Euclidian theories in order to both confirm and inform.

Vollmer addresses her latest works as being based on "mathematical models" in the draft of a letter to Naum Gabo, written around the time of her 1970 exhibition: "When I found the almost 100 mathematical models in Columbia Univ. I also found a catalogue of them from 1902 (of which I have a XEROX copy). When I saw the string models I had to think of your sculpture."[50] Vollmer goes on to inquire into the origin of Gabo's interest in model making by paraphrasing a quote from his own biography: "In physics you learned to make three-dimensional models illustrating mathematical formulas." She asks, "Were these the mathematical models that were used in teaching Math.[,] as were the ones that I had found in Columbia's Low Library?" There is no evidence that Gabo ever responded to this letter, but we do know that his models were fashioned in wire, string, wood, and plaster, and provided illustrations and analytical insights for theses and research papers that addressed the geometric, algebraic, and analytic fields of mathematical inquiry. But, whereas in Gabo's work there is little indication that particular scientific ideas entered into the creation of his sculptures,[51] and thus his work cannot be considered didactic, Vollmer drew directly on mathematical sources, which she also made public in the context of her exhibition, for her idea-visualizations. How a wider range of people can appreciate mathematics, as Hilbert envisioned it, and as Vollmer set it in place for her 1970 Betty Parsons exhibition, is through the faculty of intuition. In his preface to *Geometry and the Imagination*, Hilbert shifts the discussion from the conception of forms onto the experience of its conceptions when he explains his interest in intuition as that which always precedes shapes. Both the mathematician, when he conceives of a new form, and the viewer, when he is asked to observe and analyze the form, employ this: "In mathematics, as in any scientific research, we find two tendencies present. On the one hand, the ten-

dency toward *abstraction* seeks to crystallize the *logical* relations inherent in the maze of material that is being studied, and to correlate the material in a systematic and orderly manner. On the other hand, the tendency toward *intuitive understanding* fosters a more immediate grasp of the objects one studies, a live *rapport* with them, so to speak, which stresses the concrete meaning of their relations."[52]

This intuitive grasp of a potentially cognitive dimension (that is the result of mapping different disciplines) was not a stated premise of all conceptualist practices. Dan Graham, in *Homes for America* (1966–67), turned to a permutational system in which the order was defined by the structure of the object: the serialized architecture of suburban houses. This modular system of architecture was translated into the structure of the work of art. For Vollmer, modular thinking was not the operational logic in the construction of a single work; it was not a rudimentary formal endeavor of adding and subtracting, piling and stacking, or opening and closing. Rather, modular thinking bridged the gap between one work and the next. The Steiner form, for example, is a "closed" surface in which the heptahedron is deformed by curves.[53] Geometric figures, understood topologically, are collections of points in space, and the lines that connect these points to form edges are arbitrary and man-made. They can implode and explode, as regular organizations of points can move outward or inward through helical movements, arriving at new positions and thus creating new forms. These new forms are not the outcome of modernist artistic systems of abstract form finding based on reduction; they entail alternate geometries that, rather than using traditional Euclidian geometry to define volume or mass or position in space, conceptualize sculptural practice through a breakdown of empirically verifiable space into numbers and mathematical functions. The constructivist alliance of sculpture with science, philosophy, and mathematics was necessitated by an artistic drive for conceptual and linguistic transparency.[54] This impulse can be read into Vollmer's choice of quotations from Hilbert and Cohn-Vossen's *Geometry and the Imagination*.[55] The primacy of conceptual thinking is made evident not only by the handout and the allusion to the history of mathematical model making as such. It also is expressed quite directly by Vollmer's choice of material; she remade the found, opaque plaster model in transparent Plexiglas, thus reinterpreting a constructivist need for communicative transparency into a didactic tool, an art to educate the audience about the shared properties of mathematics and art.

The experience of Vollmer's works from a contemporary vantage point probes and reenacts existing tensions in modernist abstraction: the agitation between reference-rich and referenceless abstraction, and the nettlesome assumption that abstract art cannot be conceptual—that it *should not* be conceptual at the expense of its visually engaging nature. Looking at Vollmer's art brings this alternate form of abstraction into closer focus. Hers is a practice in which sculptural shapes are renewed in a series of mathematical conceptions derivative of the same simple form, potentially in perpetuity, the sphere giving rise to such morphologically distinct forms as the Steiner surface, the pseudosphere, the heptahedron, and the soap bubble. Vollmer's works are highly referential—their titles refer directly to the works' conceptual bases in mathematical history—but their referents are found in another domain of abstract creation, that of abstract mathematical thought.

Ruth Vollmer's "belatedness" has troubled the majority of those critics under the spell of a teleological view of modernist progress. Can one artist create a new paradigm? Is it possible that a single, marginal artist could offer a substantial correction to existing views of the neo-avant-garde? Clearly, the answer is no. There is not one Vollmer. There are as many as could be seen by her artist peers, encumbered as they might have been by their artistic and intellectual preoccupations. From today's perspective, it seems that the most productive way to write about Vollmer is alongside and within a history of ideas.

Notes
Thanks are due to Federico Windhausen for reading this essay in its first draft stages, and to John Rajchman and Anna Vallye for providing collegial feedback to the final manuscript.

1 Naum Gabo, "The Realist Manifesto" (1920), reprinted in J.E. Bowlt, ed., *Russian Art of the Avant-Garde* (London: Thames and Hudson, 1988), p. 213.

2 Peter Weibel's essay in the present volume, "Ruth Vollmer's 'Mathematical Models': Sculpture Between Abstraction and *Anschauung*" (pp. 29–35), was written in response to this essay, in particular to my main argument of idea visualization between conception and intuition and my primary research into Vollmer's interest in mathematical models. Weibel's claims about influence and genealogy, on the level of the specific artist (Eva Hesse, Sol LeWitt), and movements (minimalism) are largely, if not entirely, speculative. Both essays, his and mine, attempt to situate Vollmer within a history of ideas, but Weibel's purview is much broader. In contrast to his general account of mathematical models and their use in twentieth-century art, my essay seeks to restore historical specificity to our understanding of Vollmer's particular interest in models, which is tied to her reading of constructivism and conceptual art, and to art history's ongoing discussion of how artistic translation situates itself within a larger debate of cross-fertilizations between art and science in the sixties.

3 I first conceived of the phrase "thinking the line" as the title for an exhibition that brought together the works of two artists, Ruth Vollmer and Gego, both of whom were motivated by their engaged reading of

constructivism to create alternate models of sculptural abstraction in the sixties, albeit with very different outcomes.

4 The book that is seen as a benchmark for the first wave of the reception of constructivism in the United States—read by artists and critics alike—was published in 1962. See Camilla Gray, *The Russian Experiment in Art: 1863–1922* (New York: Harry N. Abrams, 1962).

5 Herbert Read has proposed that, what Auguste Rodin is for a tradition of an expressionistic sculpture of depth, Naum Gabo is for the tradition of a geometric ideal in abstract sculpture. Gabo is the first truly abstract sculptor, according to Read. For an elaboration of his position on abstraction, see David Thistelwood, "Herbert Read's Organic Aesthetic, 1918–1950," in David Goodway, ed., *Herbert Read Reassessed* (Liverpool: Liverpool University Press, 1998), pp. 215–47.

 Like "abstract," the term "geometric" is ideologically muddled, and both involve confusing definitions that have at stake what we consider modern. Geometry as the mathematics of measurement and the relationships of points, lines, angles, surfaces, and solids was used by artists of the avant-gardes of cubism, surrealism, and constructivism as a compositional means to a variety of pictorial ends and/or as the subject of an aesthetically independent work of art. From a modern point of view, *To be abstracted from* or *to be abstract* is a deductive stage in a process of distilling forms from nature by means of gradual generalization.

6 Ruth Vollmer in conversation with Colette Roberts, "Meet the Artist" adult education program, New York University, Fall 1970; audiocassette transcript, p. 8. Colette Roberts Interviews with Artists, 1961–1971, Archives of American Art, Smithsonian Institution, Washington, D.C.

 The second part of Vollmer's lengthy quotation reads as follows: "'The particular vision of reality common to the constructivism of Pevsner and Gabo and the neo-plasticism of Mondrian is derived, not from the superficial aspect of a mechanized civilization, nor from a reduction of visual data to their "cubic planes" or "plastic volumes" (all these activities being merely variations of a naturalistic art)'—and this is very interesting—'but from the structure of the physical universe as revealed by modern science. The best preparation for a true appreciation of constructive art is a study of Whitehead or Schrödinger. But it must again be emphasized that though the intellectual vision of the artist is derived from modern physics, the creative construction which the artist then presents to the world is not scientific, but poetic. It is the poetry of space, the poetry of time, of universal harmony, of physical unity. Art—it is its main function—accepts this universal manifold which science investigates and reveals, and reduces it to the concreteness of a plastic symbol.'" The citation is from Herbert Read, introduction to *Naum Gabo–Antoine Pevsner* (New York: The Museum of Modern Art, 1948), p. 11.

7 Herbert Read, *The Philosophy of Modern Art* (London: Faber and Faber, 1952), p. 13.

8 The term "conceptual" refers to a general property of modern art—such as "expressive" or "formalist"—as opposed to the mid-sixties art movement of conceptual art. It was Benjamin H.D. Buchloh who, in his landmark essay "Conceptual Art 1962–1969: From the Aesthetics of Administration to the Critique of Institutions" (*October* 55 [winter 1990]: 105–43), opened the idea of conceptual art to different histories of conceptualisms with specific trajectories and distinct points of emergence. A conclusive analysis exclusively devoted to the different notions of "conceptual" that pertain to conceptual art has yet to be conducted.

9 Lucy R. Lippard and John Chandler, "The Dematerialization of Art," *Art International* 12, no. 2 (February 1968): 46–50.

10 See, for example, Vollmer's interest in issues of infinity in her sculpture of Bernhard Riemann's pseudosphere (page 58). A pseudosphere is the result of a constant negative spherical curvature—a so-called tractrix— in infinite rotation around a y-axis in hyperbolic space. Riemann (1826–1866) was a German mathematician who made important contributions to analysis and differential geometry, some of them paving the way for the later development of the theory of general relativity.

11 Daniel W. Smith, "Badiou and Deleuze on the Ontology of Mathematics," in Peter Hallward, ed., *Think Again: Alain Badiou and the Future of Philosophy* (London, New York: Continuum, 2004), p. 80. For a full account on how a debate on the role of deduction in mathematics between theorems and problems was revived by late-nineteenth- and early-twentieth-century non-Euclidian mathematics, see pp. 77–93.

12 Being interested in the dematerializing works of Naum Gabo in the sixties links an artist with a "bourgeois proponent of pure art" as opposed to the more progressive, materialist production of Vladimir Tatlin and Alexandre Rodchenko. See Hal Foster's account of the conceptual appeal of constructivism to the neo-avant-garde of the sixties in his "Some Uses and Abuses of Russian Constructivism," in *Art into Life: Russian Constructivism, 1914–1932* (Seattle: The Henry Art Gallery, 1990), pp. 242–43. See Anna Vallye, "The Reenchantment of the World: Ruth Vollmer's Science," p. 113 of the present volume, n. 24. It is exactly a practice such as Vollmer's, in its conceptual mapping of disciplines, for which Foster's account of a belated neo-avant-garde separated into a materialist versus a dematerialized set of practices does not account.

13 Ruth Vollmer, 1965, untitled manuscript page, Ruth Vollmer Papers, 1939–1980, Archives of American Art, Smithsonian Institution, Washington, D.C. (hereafter, RVP).

14 From a mathematical point of view, the sphere, and not the square, is the simplest and most minimal of all surface forms: "The sphere has the smallest surface area among all surfaces enclosing a given volume and it encloses the largest volume among all closed surfaces with a given surface area"; see Michele Emmer, "Soap Bubbles in Art and Science: From the Past to the Future of Math Art," in Michele Emmer, ed., *The Visual Mind: Art and Mathematics* (Cambridge, Mass., and London: MIT Press, 1993), p. 137. Due to the minimal surface area, the sphere consumes the least amount of energy in maintaining its shape, and thus appears frequently in nature due to its energy efficiency. Vollmer conceived a soap-film form project in 1966 (see page 105 of this volume). Sol LeWitt considers this work one his "favorites" (telephone interview with the author, May 13, 2003).

15 Ruth Vollmer, untitled manuscript page, 1966 (RVP).

16 Robert Smithson, "A Museum in the Vicinity of Art" (1968), in Jack D. Flam, ed., *Robert Smithson: The Collected Writings* (Berkeley: University of California Press, 1996), p. 80. Smithson also discusses Andre's materialist conception of poetry, then links it to a materialist reading of his sculptures; see p. 84. Lucy R. Lippard's assertion of Andre's sculptures as romantic and prone to surface effect and nuances (in "Rebelliously Romantic?" *The New York Times*, June 4, 1967: D25) is seen not in opposition to but in alignment with his own notion of metaphorical materialism: "One person's 'materialism' becomes another person's 'romanticism'" (p. 84).

17 Andre defies anthropocentric notions of matter and materials by taking recourse to the condition of the object as man-made. For a discussion of Andre's materialism in stark opposition to Smithson's conception of a metaphorical materialism, see James Meyer, "Carl Andre, Writer," in Carl Andre, *Cuts: Texts 1959–2004* (Cambridge, Mass.: MIT Press, 2005), pp. 17–18. Meyer positions Andre in accordance with Yve-Alan Bois's notion of a materialist formalism that aspires only to lay open its own conditions of making, and thus negate meaning by being "abstract, materialist and anti-anthropocentric" (p. 17). For Bois's full account of the notion of a materialist formalism, see the introduction to his *Painting As Model* (Cambridge, Mass.: MIT Press, 1990), pp. xxv–xxix.

18 Smithson, "A Museum in the Vicinity of Art," p. 93f. Toward the end of his essay, Smithson compares Vollmer's *Bound Sphere Minus Lune* to Jasper Johns's *Map* of 1967 by linking both to a quote by R. Buckminster Fuller; see p. 94.

19 Ruth Vollmer, untitled manuscript page, 1966 (RVP).

20 See Rosalind E. Krauss's analysis of Sol LeWitt's *Variations of Incomplete Open Cubes*, 1974, in "LeWitt in Progress," *October* 6 (fall 1978): 46–60. Krauss successfully critiques Donald Kuspit's and Lucy R. Lippard's conception of LeWitt's work as fully rationalized, geometric

emblems and illustrations of the mind. For Krauss, LeWitt's ideas are ultimately subversive and "purposeless"—devoid of reason—since they incorporate errors that can be extrapolated to infinity.

21 See Mel Bochner, "The Serial Attitude," *Artforum* 6, no. 4 (December 1967): 31.

22 Max Bill, "The Mathematical Way of Thinking in the Visual Art of Our Time" (1949), reprinted in Emmer, ed., *The Visual Mind*, p. 5.

23 Ibid., p. 8.

24 Ibid., p. 9.

25 Ibid.

26 Carl Andre, quoted in Meyer, "Carl Andre, Writer," p. 18. The original source for this quote is *Un entretien entre Carl Andre et Elisabeth Lebovici et Thierry Cabanne*, the catalogue of the exhibition at the Yvone Lambert Gallery, Paris, July–November 1976, question no. 8; reprinted in its entirety as "It Is Being Which Makes Language Possible," in Andre, *Cuts*, pp. 125–27.

27 This is Andre's term. See Meyer, "Carl Andre, Writer," p. 18.

28 Mel Bochner and Robert Smithson, "The Domain of the Great Bear" (1966), reprinted in Flam, ed., *Robert Smithson*, pp. 26–33.

29 This is Mel Bochner 's term (interview with the author, May 13, 2003).

30 Ibid.

31 The argument surfaced as a dispute over terminology around 1962, when Clement Greenberg's popularity was at a zenith, but it rapidly declined into the open counterreactions that culminated in Donald Judd's "Specific Objects" essay of 1964 (published in *Arts Yearbook* 8 [1965]: 74–82]. Judd also firmly subscribed to the value of simplicity. For Greenberg's conception of reduction, see, for example, "Toward a Newer Laocoön"(1940), in John O'Brien, ed., *The Collected Essays and Criticism: Clement Greenberg*, vol. 1: *Perceptions and Judgement* (Chicago: University of Chicago Press, 1986), pp. 23–37.

32 For a discussion of the notion of simplicity versus reduction, see Frances Colpitt, *Minimal Art: The Critical Perspective* (Seattle: University of Washington Press, 1993), p. 114.

33 Quoted in ibid. The quote was originally published in Phyllis Tuchman, "An Interview with Carl Andre," *Artforum* 8, no. 10 (June 1970): 57.

34 Ibid. The quote was originally published in Robert Morris, "Notes on Sculpture, Part 1," *Artforum* 4, no. 6 (February 1966): 44

35 Rolf-Gunther Dienst, "Ruth Vollmer's Magic of Simplicity," *Das Kunstwerk* 22, nos. 5–6 (February/March, 1969): 36. For the full text of the article, see pp. 190–91 of this volume.

36 Krauss, "LeWitt in Progress," p. 58.

37 Rosalind E. Krauss strongly disputes this historical trajectory; see "Sculpture in the Expanded Field" (1978), in Rosalind E. Krauss, *The Originality of the Avant-Garde and Other Modernist Myths* (Cambridge, Mass.: MIT Press, 1997), pp. 277–90. For a detailed discussion of the minimalist/Russian dialogue and a short account of the literature, see James Meyer, *Minimalism: Art and Polemics in the Sixties* (New Haven, Conn.: Yale University Press, 2001), p. 290, n. 144. Andre, for example, recollects the importance of Rodchenko for his works, Frank Stella and Donald Judd refer to Malevitch, and Dan Flavin his interest in Tatlin. It should be noted here that Meyer argues throughout his book against a direct association of minimalism and constructivism.

38 Sol LeWitt, quoted in Meyer, *Minimalism*, p. 200.

39 LeWitt uses Vollmer's *Skewed Hemispheres* as the opening illustration in his "Paragraphs on Conceptual Art" (*Artforum* 5, no. 10 [June 1967]: 79–83), together with *Steps* by Dan Graham, a Frank Stella–type illustration; and an untitled work by Jo Baer (see page 70 of this volume).

40 Sol LeWitt, "Ruth Vollmer: Mathematical Forms," *Studio International* 180, no. 928 (December 1970): 256. For a facsimile of the article, see p. 73 of this volume; for the full text, see p. 193.

41 Dienst, "Ruth Vollmer's Magic of Simplicity," p. 36.

42 Peter Frank, "Syracuse: Ruth Vollmer at the Everson Museum of Art," *Art in America* 63, no. 2 (March/April 1975): 98, 105: "Rather, Vollmer makes sculpture to involve herself thoroughly and continually with the basic properties of geometrically ordinated solids. In that her passion is for the logic of mathematics in three dimensions, Vollmer is a Conceptual artist—at least to the extent that her interest is in principle, not product. But for Vollmer, principle is oriented as much towards the production of a specific object as towards the method underlying its production.... It is this subserving of her craft to pure knowledge, in both its didactic and self-indulgent manifestations, that links Vollmer's work with recent Conceptual concerns."

43 Krauss, *Passages in Modern Sculpture*, p. 67.

44 Vollmer confirms her awareness of the non-Euclidian nature of her 1969–70 works: "This [the form of the hepta and the tetrahedron] comes from a mathematics book by David Hilbert, who was the first one to work out the mathematics for non-Euclidean geometry, which had been developed by Riemann and Gauss. He has adapted the 'Eleven Properties of the Sphere'—which I have used very much when I did the sphere" (Vollmer/Roberts interview, p. 5).

45 See Smith, "Badiou and Deleuze on the Ontology of Mathematics," p. 85.

46 *Geometry and the Imagination* was first published in English by Chelsea Publishing Company in 1952, but it was originally conceived as *Anschauliche Geometrie*, a series of lectures David Hilbert presented in 1920–21 at the University of Göttingen in Germany.

47 Vollmer never took on the radicality of conceptualist practices such as Mel Bochner's *Working Drawings and Other Visible Things on Paper Not Necessarily Meant to Be Viewed As Art* (1966). For Bochner, the element of text is not only an integral part of the work, it *becomes* the work. Consequently, the sculpture can be seen to be *made* of language.

48 LeWitt, "Ruth Vollmer: Mathematical Forms," p. 256.

49 RVP.

50 Handwritten, undated draft letter (RVP). Many models still exist, but to a great extent their significance has been lost. The mathematical models of Jane Sabersky, a collection that Vollmer had access to at Columbia University, was destroyed in the early seventies in the wake of many "house cleanings" that occurred when special departmental collections were either destroyed, integrated into centralized holdings, or dispersed to university libraries across the country.

51 See Christina Lodder, "Art and Science, 1930–1960," in Martin Hammer and Christina Lodder, *Constructing Modernity: The Art and Career of Naum Gabo* (New Haven, Conn.: Yale University Press, 2000), pp. 379–401.

52 David Hilbert, preface (1932) to David Hilbert and Stephan Cohn-Vossen, *Geometry and the Imagination*, trans. P. Nemenyi (New York: Chelsea Publishing Company, 1952), p. iii.

53 For an illustration of how the Steiner surface morphs into a heptahedron, see Ashay Dharwadker, "Heptahedron and Roman Surface EG-Models Home,"http://www.eg-models.de/models/Surfaces/Algebraic_Surfaces/2003.05.001/.

54 See Daniel Herwitz's excellent study of constructivism in *Making Theory, Constructing Art: On the Authority of the Avant-Garde* (Chicago: University of Chicago Press, 1993). Herwitz has greatly enhanced my understanding of constructivism's conceptual mechanisms; see especially the chapters "Constructivism's Descartes" (pp. 33–60) and "Constructivism's Utopian Game with Theory" (pp. 61–92).

55 David Hilbert envisioned a universal, axiomatized system of thought for mathematics. One principle in this system is simplicity: Primitive or discrete elements are the result of geometric figures reduced to arithmetic ones, which in turn can be reduced to a logic of sets. The "simple" is not any longer a thinking with shapes and figures, but amounts to a thinking with notational symbols (Russell)—the source of all theory in physics and mathematics.

PARAGRAPHS ON CONCEPTUAL ART

Jo Baer, untitled paintings, 1966.

Steps (Photograph by Dan Graham.)

Ruth Vollmer, 2/2 Spheres, bronze, 16½" dia.,
1966-67. (Betty Parsons Gallery.)

SOL LeWITT

The editor has written me that he is in favor
of avoiding "the notion that the artist is a kind
of ape that has to be explained by the civilized
critic." This should be good news to both artists
and apes. With this assurance I hope to justify his
confidence. To continue a baseball metaphor (one
artist wanted to hit the ball out of the park, an-
other to stay loose at the plate and hit the ball
where it was pitched), I am grateful for the op-
portunity to strike out for myself.

FROM SOL LEWITT, "PARAGRAPHS ON CONCEPTUAL ART," ARTFORUM (JUNE 1967)
© ARTFORUM

"NOT IN EULOGY NOT IN PRAISE BUT IN FACT": RUTH VOLLMER AND OTHERS, 1966–70

BY RHEA ANASTAS

A history of the German-born artist Ruth Vollmer's position during the sixties begins with the regular exhibition of her work at the Betty Parsons Gallery on West 57th Street in New York starting in 1959.[1] Over the following decade, her work developed from a sustained formal engagement with the geometry and symbolism of the sphere, in sculptures in cast bronze. Through repetition and variation, Vollmer explored associations from the organic to the crystalline, in spheres that she alternately incised, paired, split, punctuated with openings or compartments, or interposed with the structures of the cube and cross—a sculptural project that would culminate in a mode of three-dimensional work the artist Sol LeWitt has described as "ideas made into solid forms."[2] By 1968, Vollmer's sculpture featured a larger scale and increasingly conceptual process based on geometric variations of the sphere, fabricated from working drawings in new industrial materials such as spun aluminum. By 1970, her forms included a series of well-known mathematical models —pseudospheres and trigonal volumes—fabricated in acrylic and reinforced fiberglass. Of these, LeWitt wrote, "There is a simple and single idea for each form; there is a single and basic material of which the piece is constructed."[3]

Over the course of the decade, Vollmer's sculpture was seen in the Whitney Annuals of 1964 and 1968; a two-person exhibition, with Leo Rabkin, at Drew University in Madison, New Jersey; and five solo exhibitions at the Parsons Gallery, among other venues. But it was within another type of venue—the art magazine—that her work of the sixties would be represented, if not ultimately recognized, within art criticism and art history. A single, striking black-and-white photograph, reproduced in *Artforum* in June 1967 as part of LeWitt's "Paragraphs on Conceptual Art," is perhaps the most important representation of Vollmer's place in the discourse of sixties art[4] (opposite). "Paragraphs on Conceptual Art," which appeared in a special issue of the magazine devoted to contemporary American sculpture, can be said to have located Vollmer's work within a collective context of artistic reception, interrelating it with that of other contemporary artists, among them, LeWitt, Robert Smithson, Eva Hesse, and Mel Bochner.[5] The majority of the artworks LeWitt included as reproductions were made in New York between 1966 and 1967. They share an engagement with geometric form akin to LeWitt's own formulation of Vollmer's work—that of a simple and single idea for each form, a single and basic material—while exhibiting various interrelated approaches.[6]

Vollmer's is represented by an installation view of her cast-bronze *Skewed Hemispheres* (also called *2/2 Spheres*) of 1966–67. The angle of the photograph emphasizes the sculpture's position, resting directly upon the wood floor of a gallery or studio space, and the displacement of its volume (see page 153). The polished outer surface of the upper hemisphere, which is centered in the lower half of the photograph, directs the eye to the faintly lit and subtly textured surface of the lower hemisphere, a plane that unfolds between the dark, luminous volume and the planks of the floor.[7] In the layout, the photograph appears within a grid of three reproductions that dominates the article's first page and

announces an aesthetic as well as spatial unity between *Skewed Hemispheres* and the two other reproductions present within the grid: *Steps*, by Dan Graham, a photograph of granite stairs framed to create a Frank Stella–like abstraction; and an untitled diptych by the painter Jo Baer, presenting two white fields with dark borders.[8] "Paragraphs on Conceptual Art" thus places Vollmer within the historical structure of the field of sixties art, a kind of positioning in method and values that is notably distinct from the norms of the art criticism of the period.

Despite LeWitt's inclusion of *Skewed Hemispheres*, Vollmer's work was not often associated with the discourse about advanced sculpture during the sixties. In fact, to represent her work in this company, "no declared aesthetic attributions, no dominant discourses, authorized readings, or defined institutional contexts" can be enlisted.[9] Outside the relationship of artistic association that ties Vollmer to the historical horizon of "Paragraphs on Conceptual Art"—a horizon that has faded significantly since 1970—is an absence of history, an archive of facts and events without representation as art history. Here we find a series of works made, regular exhibitions, photographic and textual documentation of these objects and events, and a very sparse record of criticism, the whole of which never achieves the period's marks of recognition—a major museum survey exhibition, collection by institutions, a monographic catalogue. Instead, Vollmer's narrative remained fragmentary, and was thus relegated to invisibility as a valid subject of art history.

In what follows I neither attempt to rescue Vollmer's reputation for the dominant narratives of art history, nor to present an alternate historical narrative for her work. I wish to explore instead the problem of art-historical representation itself as a discursive and evaluative structure by considering the kinds of information that writings such as LeWitt's "Paragraphs" provide in their own time. Firstly, the absence of Vollmer in art-historical texts stands in marked contrast to contemporary assessments of her work by the artists close to her, a circle later characterized in familiar terms by Philip Leider, *Artforum*'s founding editor, as "the whole group around Eva Hesse, who loved LeWitt."[10] Not only did LeWitt include Vollmer's *Skewed Hemispheres* among the work he was advocating in "Paragraphs on Conceptual Art," three years later he also wrote a feature article for another art magazine in which he assessed her works in unequivocal terms of "quality and excellence."[11] "Ruth Vollmer: Mathematical Forms" (opposite), one of the few feature-length examinations of Vollmer's art, is an elegantly constructed text composed of a dozen declarative sentences paired with an equal number of quotations from a book on geometry, and accompanied by an "exhibition" of seven reproductions of the artist's work.

LeWitt's articles take their place among a small group of artist-written articles and documents as well as artworks that reflect Vollmer's association with the common art problematic of the period. Among LeWitt's writings, "Ruth Vollmer: Mathematical Forms" is lesser known than "Paragraphs on Conceptual Art," and hardly known at all in comparison to Robert Smithson's "Quasi-Infinities and the Waning of Space" (1966)[12] and "A Museum of Language in the Vicinity of Art" (1968).[13] Few have noted that "Quasi-Infinities and the Waning of Space," Smithson's first article for *Arts Magazine* and manifestly an essay in which the artist engages art historian George Kubler's critique of biological and organicist models of art history, also narrates the social world of the Betty Parsons Gallery by highlighting Ad Reinhardt and Ruth Vollmer (page 74). In the article Smithson also strongly links Vollmer with the younger artist Eva Hesse. (Smithson's "Quasi-Infinities and the Waning of Space" was among the earliest critical articles on Hesse, apart from brief exhibition reviews, to appear in an art magazine.) And though art historians and critics have turned to "A Museum of Language in the Vicinity of Art" for Smithson's reflections on artists' writing in the sixties and its sites, here we find also the work of Vollmer written about and reproduced as an example of the conceptual mapping Smithson saw artists producing. Her *Bound Sphere Minus Lune* (1966) is placed in the privileged company (by this moment in 1968) of Jasper Johns's *Map* of 1967 (based on R. Buckminster Fuller's *Dymaxion Airocean World*), to which Smithson attaches the adjective "'paint'-clogged"[15] (page 75).

The interest in and advocacy for Vollmer's work by LeWitt and Smithson, as well as by Hesse and Bochner (the latter two largely through visual works rather than in critical writings), has been duly noted by critics and art historians during and since the sixties. However, after 1970, a perspective on the social space in which such associations and ideas were generated and exchanged has not been possible without the coloring of critical evaluation and aesthetic judgment—that is, without Vollmer's lack of art-historical representation remaining the determining factor in any critical narrative. Thus, these intergenerational relationships have tended to be

Ruth Vollmer: mathematical forms

Sol LeWitt

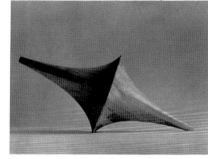

The 'Spherical Tetrahedron' is a regular tetrahedron, constructed from equilateral *spherical* cutouts instead of flat-plane triangles. I consider the small spun bronze piece to suggest a five feet or taller spun-aluminum one, to stand outdoors and be rocked by the wind.

A concept of the mathematician Bernhard Riemann, the 'Pseudosphere' is a 'false' sphere, a surface of negative curvature.

As seen in the drawing, this curve is constructed on many equal circles, centred on equidistant points on a longitudinal axis. Beginning at the intersection of the central circle with a perpendicular to the axis, lines are drawn from one circle to the next continuing to the successive point on the axis, ad infinitum. The rotation of the resultant curve, the tractrix, around the axis creates the 'Pseudosphere'.

Since the lines which are the tangents of the tractrix are all of equal length, they relate to the curve of the 'Pseudospheres' as the radii relate to the circle of the sphere.

The hepta-seven, hedron-side is initially constructed of eight triangular sides like the octahedron and an inside structure of three squares perpendicularly intersecting at the diagonals. These lines of intersection are also the three axes; height, width and depth. Of the eight triangles, alternating four have been cut away; thus four triangles and three squares create the 'Heptahedron'.

The strange characteristic of this form is that in its centre point and along the axis it comes to nothing, but the thickness of a material. This characteristic of the 'Heptahedron' is shared with the 'Steiner Surface'.

'Just as the simple polyhedra can be continuously deformed into the sphere, so there is a simple closed surface into which the "Heptahedron" can be deformed. This is the "Roman Surface" investigated by Steiner.' In this country it is called the 'Steiner Surface'. Transparent material was chosen to make the form easy to comprehend.

A separate wire circle can be leaned against the sides of any Steiner Surface – or its circular light reflection observed. See 'Three Axis Holding Four Rings'; the Steiner Surface having four equal sides like the 'Tetrahedron'. My math. adviser, Dr Erna Herrey, Professor of Physics, member of the Doctoral Faculty of the City University of New York, has devised a structure of ovals from the formula of the Steiner Surface:

$$y^2 z^2 + z^2 x^2 + x^2 y^2 + zyx = 0$$

See 'Intersecting Ovals', transparent multicoloured and white opaque and the structure of all shown Steiner Surfaces.

The Steiner Surface is one of approximately one hundred mathematical models at Columbia University. They were used in the mathematics department but now are kept in a cupboard in the Low Library, where nobody ever sees them.

* All quotes are from *Geometry and the Imagination* by David Hilbert and S. Cohn-Vossen.

[Ruth Vollmer recently exhibited at Betty Parsons Gallery, New York. Illustrations are courtesy Betty Parsons Gallery.]

These pieces are not sculpture; they are ideas made into solid forms.

The ideas are illustrations of geometric formulae; they are found ideas, not invented, and not changed.

The pieces are not about mathematics; they are about art. Geometry is used as a beginning just as a nineteenth-century artist might have used the landscape.

The geometry is only a mental fact.

There is a simple and single idea for each form; there is a single and basic material of which the piece is constructed.

The material used has physical properties that are evident, and useful to the form.

The pieces have a size small enough to mitigate any expressiveness. They are not gross and pompous. They are of the necessary size, neither large nor small; the form is in harmony with the idea.

The scale is perfect.

They are works of quality and excellence.

Hilbert*, Chapter 32, 'Eleven Properties of the Sphere'.

'A sphere can be rolled arbitrarily between two parallel tangent planes. It would seem plausible that the sphere is uniquely defined by this property. In actual fact however, there are numerous other convex surfaces.... whose width is also constant and which therefore can also be rotated between two parallel fixed plates to which they remain tangent throughout....'

Hilbert says in the preface to his book *Geometry and the Imagination* that it 'should contribute to a more just appreciation of mathematics by a wider range of people than just the specialists...by offering, instead of formulas, figures that may be looked at... supplemented by models...to bring about a greater enjoyment of mathematics.'

256

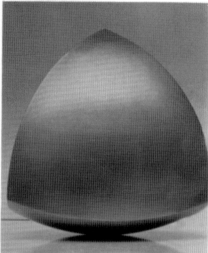

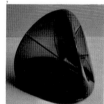

1 *Tangents* 1970
Clear acrylic. Height 18 in.

2 *Spherical Tetrahedron* 1970
Spun bronze. Height 12 in.

3 *Construction Drawing of Pseudosphere* 1970
10 × 32 in. Total length Pseudosphere 20 in.

4 *Pseudosphere* 1970
Laminated wood 10 × 24 in.

5 *Heptahedron* 1970
Brown opaque and transparent acrylic. Height 12 in.

6 *Steiner Form* 1970
Grey transparent Plexiglas. Height 12 in.

7 *Three Axis and Four Rings* 1970
Brass wire. Height 12 in.

FROM SOL LEWITT, "RUTH VOLLMER: MATHEMATICAL FORMS," STUDIO INTERNATIONAL (DECEMBER 1970)
© SOL LEWITT

cast less as exchanges between peers who shared a formative period in an artistic field (though not the same chronological age, since Vollmer was sixty-four years old at the time "Paragraphs on Conceptual Art" was written, LeWitt thirty-nine, and Smithson twenty-nine), than as a situation of influence, with Vollmer characterized as a receiver of the younger artists' aesthetic and intellectual precociousness. For her part, the elder artist, who famously presided over an artistic salon, is seen as giving the younger group encouragement and support, which included collecting their work, and the benefit of her intellect. Robert Storr, writing on the occasion of an important posthumous exhibition of Vollmer's work at the Jack Tilton Gallery in New York in 1983, characterized Vollmer's role in this way:

> New ideas passed freely back and forth through the generational membrane which separated Vollmer, born into the culture of Steinerism and the Bauhaus, from her much younger peers. Their discoveries were as important to her development as her intellectual and moral support was to theirs.

Nevertheless, near the end of his review, Storr registers an ambivalence about how to assess Vollmer's achievement, and how evaluative judgments are made:

> However crucial to the early stages of Minimalism, Vollmer's art may not be seminal, and like any artist's it is uneven; but these drawings and the best of her sculptures have an unmistakable clarity and serenity that are rare indeed, and one would welcome the chance to see more of her work.[17]

In the published criticism on Vollmer's work, the exercise of judgment produces several effects. Not only is the artist relegated to a marginal position according to the categorical norms of art discourse as a hierarchical structure, but the historical conditions of production and reception as a collective set of social conditions are negated, and along with them, a view of the moment of history as a field of relative positions sharing a common problematic. As a result, the state of this field is obscured. The judgments of art history work retrospectively to codify the distinctions between these positions as successes or failures.

18 The truncated ideas in *Nova Express* (Evergreen Black Cat Book BC-102) disclose in part the "heat-death" of the biological metaphor. "The Insect Brain of Minraud enclosed in a crystal ..." M. L. von Franz in *Time and Synchronicity in Analytic Psychology* states, "Physicists studying cybernetics have observed that what we call consciousness seems to consist of an intra-psychic flux or train of images, which flows 'parallel to' (or is even possibly explicable by) the 'arrow' of time. While M. S. Watanabe convincingly argues that this sense of time is a fact sui generis, others like Grunbaum tend to believe that entropy is the cause of time in man." See *The Voices of Time* (p. 218), edited by J. T. Fraser, New York: George Braziller, 1966.

"In principle, nothingness remains inaccessible to science." Martin Heidegger, *An Introduction to Metaphysics*

"The unity of Nature is an extremely artificial and fragile bridge, a garden net." T. E. Hulme, *Cinders*

"It came to him with a great shock that not one of the robots had ever seen a living thing. Not a bug, a worm, a leaf. They did not know what flesh was. Only the doctors knew that, and none of them could readily understand what was meant by the words 'organic matter'." Michael Shaara, *Orphans of the Void*

24 A. For further edification concerning obelisks see *A Short History of the Egyptian Obelisk* by W. R. Cooper, London: Samuel Bagster and Sons, 1877. "The first mention of the obelisk, or Tekhen, occurs in connection with the pyramid: and both are alike designated sacred monuments on the funeral stele of the early empire, and also were undeniably devoted to the worship of the sun; occasionally the obelisk was represented as surmounting a pyramid, a position which it has never actually been found to occupy."

tion." An intelligible dissatisfaction with this faith is very much in evidence in the work of certain artists.

THE VANISHING ORGANISM

The biological metaphor has its origin in the temporal order, yet certain artists have "detemporalized" certain organic properties, and transformed them into solid objects that contain "ideas of time." This attitude toward art is more "Egyptian" than "Greek," static rather than dynamic. Or it is what William S. Burroughs calls "The Thermodynamic Pain and Energy Bank"[18]—a condition of time that originates inside isolated objects rather than outside. Artists as different as Alberto Giacometti and Ruth Vollmer to Eva Hesse and Lucas Samaras disclose this tendency.

Giacometti's early work, *The Palace at Four A.M.*[19], enigmatically and explicitly is about time. But, one could hardly say that this "time-structure" reveals any suggestion of organic vitality. Its balance is fragile and precarious, and drained of all notions of energy, yet it has a primordial grandeur[20]. It takes one's mind to the very origins of time—to the fundamental memory. Giacometti's art and thought conveys an entropic view of the world. "It's hard for me to shut up," says Giacometti to James Lord. "It's the delirium that comes from the impossibility of really accomplishing anything[21]."

There are parallels in the art of Ruth Vollmer to that of Giacometti. For instance, she made small skeletal geometric structures before she started making her bronze "spheres," and like Giacometti she considers those early works "dead-ends." But there is no denying that these works are in the same class with Giacometti, for they evoke both the presence and absence of time. Her *Obelisk*[22] is similar in mood to *The Palace at Four A.M.* One thinks of Pascal's "fearful sphere" lost in an Egyptian past, or in the words of Plotinus the Stoa, "shadows in a shadow[23]." Matter in this *Obelisk*[24] opposes and forecloses all activity—its future is missing.

The art of Eva Hesse is vertiginous and wonderfully dismal[25]. Trellises are mummified, nets contain desiccated lumps, wires extend from tightly wrapped frameworks, a cosmic dereliction is the general effect. Coils go on and on; some are cracked open, only to reveal an empty center. Such "things" seem destined for a funerary chamber that excludes all mention of the living and the dead. Her art brings to mind the obsession of the pha-

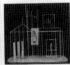

19 Alberto Giacometti, *The Palace at Four A.M.* (1932-33)

B. *The New York Obelisk—Cleopatra's Needle* by Charles E. Moldenke, New York: Amson D. F. Randolph and Co., 1891. "We know of the Obelisk of Karnak, erected by Queen Hatasu, that the apex of its pyramidion was covered with pure gold ..."

C. *Cleopatra's Needles and Other Egyptian Obelisks* by Sir E. A. Wallis Budge, London: The Religious Tract Society, 1926. Regarding obelisks in Rome: "The brass globe which had been fixed on the top of the obelisk when Caligula set it up was removed; it was empty, though many believed that it would be found to contain valuable objects."

D. *Salambo* by Gustave Flaubert, a Berkeley Medallion Book, 1966. Regarding obelisks in Byrsa: "... obelisks poised on their points like inverted torches."

20 The following is part of a manuscript that describes *The Palace at Four A.M.* It was dictated by Giacometti to André Breton for publication in the magazine *Minotaure* (No. 3-4, 1933, p. 42) and later translated by Ruth Vollmer into English (see the magazine *Transformation* published by Wittenborn). "This object has taken form little by little; by the end of summer 1932 it clarified slowly for me, the various parts taking their exact form and their particular place in the ensemble. Come autumn it had attained such reality that its execution in space did not take more than one day." He also goes on to say, "... the days and nights had the same color, as if everything happened just before daybreak."

21 *A Giacometti Portrait*, The Museum of Modern Art.

"The individual is the seat of a constant process of decantation, decantation from the vessel containing the fluid of future time, sluggish, pale and monochrome, to the vessel containing the fluid of past time, agitated and multicolored by the phenomena of its hours." Samuel Beckett, *Proust*

23 Quoted from *Enneads*, in *Concepts of Mass in Classical and Modern Physics* (Harper Torch Book TB571) by Max Jammer, page 31. On the same page Jammer goes on to say, "Proclus, the other great exponent of Neoplatonism in the East, accepts Plotinus' doctrine, but with one important modification: the passivity or inertia of matter follows from its extension." The decline of the category of "painting" and of "sculpture" seem to be the result of this problem of spatial extension from matter. Space becomes an illusion on matter.

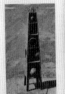

22 Ruth Vollmer, *Obelisk* (1962)

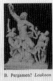

25 A. Eva Hesse, *Laokoon*, 1965

B. Pergamon? *Laokoon*

C. In her *Laokoon* based on the sculpture by Pergamon? second century B.C. we discover an absence of "pathos" and a deliberate avoidance of the anthropomorphic. Instead one is aware only of the vestigial and devitalized "snakes" looping through a lattice with cloth bound joints. Everything "classical" and "romantic" is mitigated and undermined. The baroque aesthetic of the original *Laokoon* with its flowing lines—soft and fluid—is transformed into a dry, skeletal tower that goes nowhere.

raohs, but in this case the anthropomorphic measure is absent. Nothing is incarnated into nothing. Human decay is nowhere in evidence.

The isolated systems Samaras[26] has devised irradiate a malignant splendor. Clusters of pins cover vile organs of an untraceable origin. His objects are infused with menace and melancholy. A lingering Narcissism[27] may be found in some of his "treasures." He has made "models" of tombs and monuments that combine the "times" of ancient Egypt with the most disposable futures of science fiction.[28]

TIME AND HISTORY AS OBJECTS

At the turn of the century a group of colorful French artists banded together in order to get the jump on the bourgeois notion of progress. This bohemian brand of progress gradually developed into what is sometimes called the avant-garde. Both these notions of duration are no longer absolute modes of "time" for artists. The avant-garde, like progress, is based on an ideological consciousness of time. Time as ideology has produced many uncertain "art histories" with the help of the mass-media. Art histories may be measured in time by books (years), by magazines (months), by newspapers (weeks and days), by radio and TV (days and hours). And at the gallery proper—*instants!* Time is brought to a condition that breaks down into "abstract-objects[29]." The isolated time of the avant-garde has produced its own unavailable history or entropy.

Consider the avant-garde as Achilles and progress as the Tortoise in a race that would follow Zeno's second paradox of "infinite regress[30]." This non-Aristotelian logic defies the formal deductive system and says that "movement is impossible." Let us paraphrase Jorge Luis Borges' description of that paradox. (See *Avatars of the Tortoise*): The avant-garde goes ten times faster than progress, and gives progress a headstart of ten meters. The avant-garde goes those ten meters, progress one; the avant-garde completes that meter, progress goes a decimeter; the avant-garde goes that decimeter, progress goes a centimeter; the avant-garde goes that centimeter, progress, a millimeter; the avant-garde, the millimeter, progress a tenth of a millimeter; and so on to infinity without progress ever being overtaken by the avant-garde. The problem may be reduced to this series:

$$10 + 1 + 1/10 + 1/100 + 1/1000 + 1/10{,}000 + :::$$

26 Lucas Samaras, *Untitled*, 1963

30 A. Don Judd has been interested in "progressions" and "regressions" as "solid objects." He has based certain works on "inverse natural numbers." Some of these may be found in *Summation of Series* by L. B. W. Jolley, a Dover paperback.

27 Self-love, self-observation, self-examination, and self-awareness result in an isolated mind. This kind of mind would tend to produce a fictitious "reality" detached from organic nature. *Monsieur Teste* by Paul Valéry is perhaps the greatest elucidation of Narcissism. "He watches himself, he maneuvers, he is unwilling to be maneuvered. He knows only two values, two categories, those of consciousness reduced to its acts: the possible and the impossible. In this strange head, where philosophy has little credit, where language is always on trial, there is scarcely a thought that is not accompanied by the feeling that it is tentative...."

28 In *13 French Science-Fiction Stories* edited by Damon Knight (Bantam paperback (F2817)) is a story by Charles Henneberg called *Moonfishers*. "The Interplanetarians were landing in these sands. They were of many kinds. Much later, the Pharaoh Psammetichus III noted: 'They fell from the sky like the fruits of a fig-tree that is shaken; they were the color of copper and sulphur, and some had eyes.'"

29 The following book elucidates this idea: *Abstraction and Empathy* by Wilhelm Worringer, London: Routledge and Kegan Paul Ltd., 1953; translated from the German *Abstraktion und Einfühlung*, 1908. "In so far, therefore, as a sensuous object is still dependent upon space, it is unable to appear to us in its closed material individuality." And "Space is therefore the major enemy of all striving after abstraction...."

B. Don Judd, *Untitled*, 1965

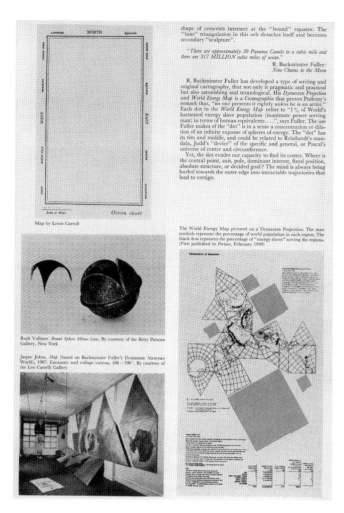

shape of crescents intersect at the "bound" equator. The "lune" triangulation in this orb detaches itself and becomes secondary "sculpture".

"*There are approximately 50 Panama Canals to a cubic mile and there are 317 MILLION cubic miles of ocean.*"

R. Buckminster Fuller:
Nine Chains to the Moon

R. Buckminster Fuller has developed a type of writing and original cartography, that not only is pragmatic and practical but also astonishing and teratological. His *Dymaxion Projection* and *World Energy Map* is a *Cosmographia* that proves Ptolemy's remark that, "no one presents it rightly unless he is an artist." Each dot in the *World Energy Map* refers to "1%, of World's harnessed energy slave population (inanimate power serving man) in terms of human equivalents . . .", says Fuller. The use Fuller makes of the "dot" is in a sense a concentration or dilation of an infinite expanse of spheres of energy. The "dot" has its rim and middle, and could be related to Reinhardt's mandala, Judd's "device" of the specific and general, or Pascal's universe of center and circumference.

Yet, the dot evades our capacity to find its center. Where is the central point, axis, pole, dominant interest, fixed position, absolute structure, or decided goal? The mind is always being hurled towards the outer edge into intractable trajectories that lead to vertigo.

Map by Lewis Carroll

Ruth Vollmer. *Bound Sphere Minus Lune.* By courtesy of the Betty Parsons Gallery, New York

Jasper Johns, *Map* (based on Buckminster Fuller's Dymaxion Airocean World), 1967. Encaustic and collage/canvas, 186 × 396". By courtesy of the Leo Castelli Gallery

The World Energy Map pictured on a Dymaxion Projection. The man symbols represent the percentage of world population in each region. The black dots represent the percentage of "energy slaves" serving the regions. (First published in *Fortune*, February 1940)

FROM ROBERT SMITHSON, "A MUSEUM OF LANGUAGE IN THE VICINTITY OF ART," ART INTERNATIONAL (MARCH 1968)
© VG BILD-KUNST, BONN 2006

The critic Lucy R. Lippard, an early and important advocate of minimal and conceptual art and women artists, published a monograph on Eva Hesse in 1976. Already by that time, the relative status of Hesse and Vollmer was so marked that Lippard hardly characterized Vollmer as an artist at all: "As an artist and as a sensitive and loving older woman bearing her mother's name, also German by birth, also with some tragedy in her life, Vollmer was important to Hesse in a unique way."[18] LeWitt, in contrast, was described as "a good friend" of Hesse and "extremely influential in her life"[19] in the years 1965–70, despite the fact that, during this period, his art was still developing alongside that of Hesse and Vollmer.

Lippard would not write a review or feature article about Vollmer's work during the sixties or seventies.[20] In 1984, when the critic revisited the work of these artists on the occasion of the group exhibition "Flyktpunkter/Vanishing Points," she speculated that Hesse might have been "the focal point" of a set of relationships she understood as friendships as well as more collegial associations of mutual influence within an "intricacy of...interactions between 1965 and 1970."[21] Recounting the first time she saw the work of Vollmer, Lippard writes: "I made no connection with the Minimalism I was so involved in."[22]

There is an obvious dichotomy between critics' views of Vollmer's work and those of her peers.[23] Gender certainly comes into play here. Lippard recognized Vollmer as a "bridge between the Bauhaus and European constructivists like Gabo and Pevsner to the younger artists," and noted the "pragmatism" of her method, her "unpretentious" use of mathematical forms as "found objects." Yet she also segregated the dialogue between Vollmer and Hesse from that of the larger, male-dominated field: "Unlike any of the men shown here [in "Flyktpunkter/Vanishing Points"], who would have thought these forms 'too sculptural, too associative,' they both used spheres and compartmentation devices—boxes with things inside. Vollmer, like Hesse, had a sympathy for the biological which the others generally denied."[24]

All of this suggests what remains undertheorized in the art history of the sixties: a description of the structure of the historical field through the interrelationships of the artists involved. This structure shares an approach—indeed, borrows its approach—from the same body of magazine writing to which LeWitt's "Paragraphs on Conceptual Art" belongs, from a field of critical activity dominated by the artists themselves. Lippard was acutely aware of this: "The most interesting part of all of this name-dropping is the fact that the interactions also took place in written, published form.... Each time these artists wrote about each other (and a useful appendix to this catalogue would be such a cross-referential bibliography), they brought the subject's work into their own domain, commenting on it from the viewpoint of their own obsessions, as of course critics do too." [25]

Spatial Unity, 1966–68

Excited! could not sleep. Last eve. with Mel, Smithson, Nancy [Holt], Brian O'Doherty and Barbara Novak and Will Insley and Ruth Vollmer. Beautiful communication, basically positive feelings, intuitive liking all around, warm things said also, heated undertones but with mutual respect... Ruth Vollmer asked to see me and work. O'Doherty also work. Smithson and Mel described and highly praised my work. Necessary because 1. am relatively unknown, 2. am woman. Am sure that exists for all, however. I must drop that thought as totally meaningless.—Eva Hesse [26]

There are parallels in the art of Ruth Vollmer to that of Giacometti. For instance, she made small skeletal geometric structures before she started making her bronze "spheres," and like Giacometti she considers those early works "dead-ends." But there is no denying these works are in the same class as Giacometti, for they evoke both the presence and absence of time. Her *Obelisk* is similar in mood to *The Palace at Four A.M.* —Robert Smithson [27]

I must confess that I like minimal art very much. —Ruth Vollmer [28]

What kinds of information about Vollmer do these observations actually contain, and what is the potential historical value of this information? Why did many of the critical interactions among artists in the sixties take place in writing—in print? What does it mean for an artist to place another artist's

work, as Lippard put it, "into their own domain," into a critical context of which they are a part? Artists writing on the work of their contemporaries in the field may not have perceived their critical observations as self-reflective and marking a difference in morals or values relative to prevailing art critical methods—although some critics did. As early as January 1967, Annette Michelson, in her review of the seminal 1966 exhibition "10" at the Dwan Gallery, noted the role of artists' writing within a methodological "crisis in criticism" she attributed to the practices of the minimalists. [29]

In *The Rules of Art: Genesis and Structure of the Literary Field*, the French sociologist Pierre Bourdieu describes the problem of chronological contemporaneity in terms that are relevant to the conditions of the advanced art and social worlds in New York during the mid-sixties. [30] His theory of fields, whereby the artistic and literary fields are related to economic and political fields by structural homologies, proposes that artworks are read, not as reflective or symptomatic, but as positional. An artwork's actual expression and its potential expressions are assessed within the sociocultural field within which they are recognized. For Bourdieu, the task of social analysis is to develop a detailed description that maps the complexity of the work's moment in history as a space of interrelations. The empirical data—a description of the "space of possibles"—include not only the chronological fact of when a work was made, but also those of the shared cultural spaces—the art galleries, museums, and magazines—in which the work is "placed." This evidence reveals what Bourdieu calls a "common problematic," neither the shifts in art history nor in the location of an artistic community or cultural capital alone, but, more specifically, a network of persons, positions, practices, theories, and sites in relation to which each artwork—as well as each statement, article, exhibition, and publication—must take its place.

Smithson's "Quasi-Infinities and the Waning of Space" can be assessed as one such model of chronological contemporaneity. In it, Smithson quotes and illustrates various models of space and time in theories and structures both ancient and modern, but he discerns these in a highly associative way. Smithson unites ideas and artists through "reproduced reproductions"—Ad Reinhardt, for instance, via an installation view of his March 1965 exhibition at the Betty Parsons Gallery. Smithson's drawings for the article emphasize the distinction made in the layout between materials that are photographic reproductions and visual diagrams, which become the visual "text," and the notes in textual form, all of

which appear as footnotes, elevating the image to the status of discourse, or, conversely the footnote to that of illustration. This use of conventions by Smithson in "Quasi-Infinities," with its "four ultramundane margins" and "reproduced reproductions," can be likened to the citation of a bibliographic reference, except the artists' "quoting" of other artists' work functions as an advocacy across positions, some of these intergenerational and not yet legitimated, as in the case of the relationship between Eva Hesse and Ruth Vollmer.

"Quasi-Infinities" presents a body of empirical evidence whose facts ring true. It appears to have been through Vollmer that Smithson met Reinhardt. Nineteen sixty-six was the year Smithson's article was published, the year Vollmer and Smithson met, and the year Vollmer met Bochner and Hesse.[31] It was also the year Smithson met Bochner.[32] By the end of 1966, Smithson, LeWitt, Bochner, and Graham would each publish in *Arts Magazine*, often reviews of one another's exhibitions.[33] (Of the late fifties and early sixties in New York, a period during which she met Betty Parsons, Vollmer would later say, "I think the first time that I consciously saw an art scene, was here."[34]) Smithson locates Vollmer first in relationship to Alberto Giacometti, an artist she much admired and whom she had visited in Paris. Yet Smithson doesn't separate the older European artists from his own moment. In a second interpretive maneuver, he offers an aesthetic-organic category, "The Vanishing Organism" (after Giacometti's attenuated figures), as a way to link Vollmer's recent work with contemporary works by Hesse and Lucas Samaras that had recently been shown in New York: "The biological metaphor has its origin in the temporal order, yet certain artists have 'detemporalized' certain organic properties, and transformed them into solid objects that contain 'ideas of time.'... Artists as different as Alberto Giacometti and Ruth Vollmer to Eva Hesse and Lucas Samaras disclose this tendency."[35] Smithson used as illustrations Vollmer's *Obelisk* of 1961–62 and Hesse's first freestanding three-dimensional work, the *Laocoön* of 1965, both reproduced in an art magazine for the first time.

"He believed in magazines and their potential; he believed in Clement Greenberg's real theoretical and political power, and other people in terms of their power; and he realized the potential power of the artist-critic."[36] This is how Graham characterized Smithson's magazine writing, reflecting Smithson's (and his own) desire for participation within the dominant discursive structures of their time. Such power was also felt in nonverbal modes. Here, Bourdieu's idea of spatial unity—a spatialization more total than the biographical facts of living and working in the same cultural capital at the same moment—is significant. Here experience circulates from the institutional and discursive spaces of art galleries, museums, magazines, and publications to more private modalities. Hesse's diary entry of June 9, 1966, as quoted above, recounts a typical evening shared among the group (Vollmer was a frequent host at her Upper West Side apartment), and reflects her acute perception of her place within a social and artistic world, a positionality Bourdieu would call "habitus." It describes how the space of art is internalized in its practitioners, how structures of value and recognition and of mutual influence and interest mark participants according to the rules of the field or discipline. What Hesse's writing so movingly captures is the felt qualities of being an artist, from "positive feelings" to "heated undertones," from "warm things said" to the dramatic swings between insecurity and confidence she would so often recount in her diary.

Among a series of visual documents and traded artworks[37] that trace the development of the bond between Vollmer and Hesse is a film by Dorothy Beskind of Hesse at work in her Bowery studio during the winter of 1967–68, a segment of which depicts Vollmer, who was visiting the studio, in a rapt exchange with Hesse.[38] Beskind's is the only extant footage of Vollmer that dates to the late sixties. Vollmer's presence in the silent 16mm film was unplanned, or at least not intended by Beskind, who had made an appointment to film Hesse. Perhaps Hesse asked her friend to be present to put her more at ease. The film opens with views of Hesse's downstairs studio, as Beskind's camera pans across materials such as a gathered rope and a ladder, then on to works such as *Untitled or Not Yet*, of 1966, a hanging piece made of weighted polyethylene net bags, and the large-scale wrapped-frame construction *Hang Up* (1966), oddly placed near the center of the large room.

Hesse soon appears in the frame, and the scene shifts from Hesse alone, shown readily touching and manipulating the objects in the downstairs space, to a visit upstairs with Vollmer. Vollmer has just arrived, and still wears her fur hat and her coat; both women are dressed in street, not studio clothes, in stockings and heels. They appear together in several different sequences, which together loosely "narrate" their conversation. At one moment they talk while sitting and kneeling, their heads in close proximity, in a private and hushed manner (the filmmaker's position as an outside

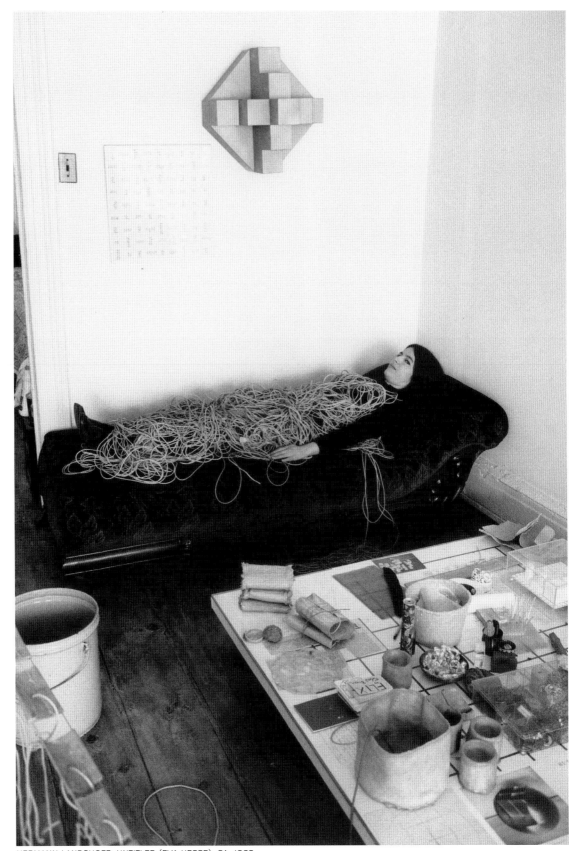

HERMANN LANDSHOFF. UNTITLED (EVA HESSE), CA. 1968
© MUSEUM AT FIT, NEW YORK

observer is apparent). At another, the two kneel around Hesse's worktable while viewing and touching some objects or materials found there, then Vollmer sits on the daybed while Hesse stands, gesturing with her hands as she speaks. She smiles easily around her friend. Even after Vollmer exits the frame, she appears to serve as a foil to Hesse's being filmed, as the artist moves through her living and working spaces, alternately showing and working with a series of sculptures, some completed, others in progress. For much of the film Hesse appears to continue her earlier conversation with Vollmer, with Beskind remaining a distant observer, framing images and making compositions, catching details of the artist at work and of the studio space.

Vollmer would later say of Hesse, "She made pieces where the process of making and the piece were one.... She really made the materials. That's also something that nobody had done before."[39] The two artists supported each other in their first experiments with fiberglass, in 1968, with Doug Johns at Aegis Reinforced Plastics. (Johns later left Aegis to work solely for Hesse.) LeWitt, Bochner, and others had been encouraging Hesse to fabricate her works, but it was Vollmer who appears to have first accompanied her to do so, a companion Hesse may have felt she needed in such an "utterly male-oriented" industrial space.[40] Both artists were working toward new work for exhibitions that would open days apart in November 1968. Two photographs taken by Vollmer's brother, the fashion photographer Hermann Landshoff, can also be cited as central documents of the artistic dialogue between Hesse and Vollmer (opposite; page 80). In one of these, *The Table in Eva Hesse's Bowery Studio* (November/December 1968), a brochure for Vollmer's 1968 one-person exhibition at the Parsons gallery, "Exploration of the Sphere," and an invitation to Hesse's first solo exhibition at the Fischbach Gallery, "Chain Polymers," can be seen lying on Hesse's worktable.[41]

This relationship can be traced from Hesse's studio to the art magazines, since the following January both artists received reviews by the critic James Mellow in his "New York Letter" column in *Art International* [42] (page 80). Mellow's paragraphs about Hesse's and Vollmer's exhibitions appeared one after the other. One work by each artist, both in fiberglass, were reproduced, one photograph atop the other: Hesse's *Repetition Nineteen III* and Vollmer's *Trigonal Volume* (page 157), both from 1968. Mellow noted "a point of sheer presence and composition-by-accumulation" as an idea present throughout Hesse's exhibition, as he described

the arrangement of the works on the floor and by the wall as "off hand" and "random." To Mellow, the value of the works was a quality he characterized as "a geometric art...that has gone slack for material reasons," this idea serving as a transition to the paragraph devoted to Vollmer: "In Ruth Vollmer's showing of sculptures at the Betty Parsons Gallery, the formal mystique was the opposite and more conventional one—that of acknowledged beauty of the materials and pristine appearance of the forms.... Another quite handsome trigonal volume with the look of polished stone was made of fiberglass." Mellow gave both artists favorable reviews. To Hesse's work he attributed the experimentalist labels of funk art, minimalism, geometric art, and surrealism, in contrast to the purely formal vocabulary he used to describe Vollmer's work. However, one aspect of Vollmer's exhibition, the inclusion of dictionary definitions in her exhibition brochure (page 80), was a strategy unrecognized and therefore dismissed by the critic as "an unnecessary attempt to provide scientific credentials for forms that were interesting enough in and of themselves." In fact, Vollmer credited in her brochure the engineers, craftsmen, and specialized laborers of Grumann Aircraft Engineering for their work on her sculpture. Her titles identified the geometric figures upon which her forms were based, but also reflected the use of other kinds of words, for physical processes such as "fission," or to connote more evocatively physical qualities such as "oscule" (a little mouth or kiss). Titles such as *Fission* and *Oscule* related her use of the dictionary in the brochure to Hesse's own use of a thesaurus for a system for titling her works.[43]

A Discursive Space and a Shift: 1970

Eva Hesse died of a brain tumor at the age of thirty-four on May 29, 1970. In July of that year, *Sol LeWitt*, an artist-organized monograph and collection of writings on the artist's work, was published in conjunction with his second solo museum exhibition, at the Haags Gemeentemuseum.[44] And in December, Vollmer was made the subject of a feature article, authored by LeWitt, in the contemporary art magazine *Studio International*.[45]

Ruth Vollmer:
mathematical
forms
Sol LeWitt

Vollmer's name, the article's title, and the byline were presented in this visual arrangement on the page, creating a

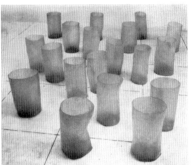

Eva Hesse. *Repetition 19 (Third Version)*, 1968. Fiberglass; each element approx. 12 × 20". Fischbach Gallery

Ruth Vollmer. *Trigonal Volume*. Reinforced fiberglass. Betty Parsons Gallery

THE TABLE IN EVA HESSE'S BOWERY STUDIO, NOVEMBER/DECEMBER 1968
PHOTO HERMANN LANDSHOFF © THE ESTATE OF EVA HESSE. HAUSER & WIRTH, ZURICH/LONDON

FROM JAMES MELLOW, "NEW YORK LETTER,"
ART INTERNATIONAL (JANUARY 1969)

RUTH VOLLMER
SCULPTURE

November 19 - December 7, 1968
Opening Nov. 19, 4-7

BETTY PARSONS
GALLERY

25 WEST 57 STREET N.Y.C.

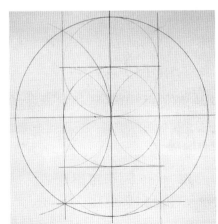

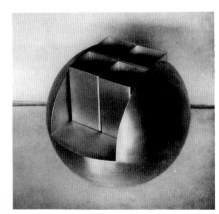

Photo and working drawings of "IN THE RELATION THREE TO FOUR"

BROCHURE, "EXPLORATION OF THE SPHERE: RUTH VOLLMER, SCULPTURE," BETTY PARSONS GALLERY, NEW YORK, NOVEMBER 18–DECEMBER 7, 1968.
PHOTO COURTESY JACK TILTON GALLERY, NEW YORK

relationship of equivalence between Vollmer's name and that of LeWitt. *Ruth Vollmer by Sol LeWitt*. Or *Ruth Vollmer, mathematical, forms, Sol LeWitt*. Read as a list, and not a title and byline, one might take these words to characterize the work of Vollmer and LeWitt, to connect the two artists by the adjective "mathematical" and the noun "forms." Mathematical bodies or series of work produced in a line from Vollmer to LeWitt.[46]

More than associating LeWitt's name and reputation with Vollmer, the article was the result of a collaboration between the two artists, something that would only have been evident to viewers of Vollmer's November exhibition at the Parsons gallery. Such an audience would have recognized the article's descriptive sentences, interspersed with quotations from David Hilbert and Stephan Cohn-Vossen's *Geometry and the Imagination*. These sentences, the quotations, and all of the reproductions of Vollmer's sculptures—the pair of clear acrylic *Tangents*, 1970 (page 184); the small, spun-bronze *Spherical Tetrahedron*, 1970 (page 157); the laminated-wood *Pseudosphere*, 1969 (page 125) and its construction drawing (used for the exhibition's invitation card); the brown acrylic *Heptahedron* (1970), gray plexiglass *Steiner Surface*, 1970 (page 163), and brass-wire *Three Axes and Four Rings* (1970)—were taken directly from a series of one-page sheets Vollmer made to accompany the same works on display in the November exhibition.[47] Due to the liberal quotations from Vollmer's statements, her voice alternates with that of LeWitt throughout the latter half of the article, the perspective shifting from third person to first; here, Vollmer's comment on *Spherical Tetrahedron*: "I consider the small spun bronze piece to suggest a five feet or taller spun aluminum one, to stand outdoors and be rocked by the wind."[48]

"Ruth Vollmer: Mathematical Forms" was a coproduction that LeWitt recalls was done at Vollmer's behest.[49] To produce the article, the two discussed her work at length, which LeWitt enjoyed, though he deferred to Vollmer on the math (it was Vollmer who selected the quotations).[50] In a 1970 interview, Vollmer said, "Although I am not a mathematician...I have friends who help me with mathematics. The wife, for instance, of the man who did all the furniture in here, including the lamp...is a physicist, and she helps me."[51] In the LeWitt article, Vollmer identifies her friend and "math adviser" as Dr. Erna Herrey, a professor of physics and a member of the doctoral faculty at the City University of New York, and mentions Herrey's formula for the Steiner surface.[52] Vollmer also cites a cache of some one hundred mathematical models

shown to her by her friend Jane Sabersky, then curator of collections at Columbia University, as another source for her *Steiner Surface*.

In its use of mathematical definitions, as well as in its broad, factual prose style, the article joins "Paragraphs on Conceptual Art" and other similarly structured period statements and writings by LeWitt that made deft use of the declarative sentence, as if its grammatical units and syntax had a built-in minimal-conceptual integrity unto themselves. The article's accompanying reproductions lend Vollmer's work another set of factual qualities. In this sense the article functions as a kind of captioning for the spatially dominant and visually more allusive display of sculptural form. "These pieces are not sculpture; they are ideas made into solid forms. The ideas are illustrations of geometric formulae; they are found ideas, not invented, and not changed."[53] LeWitt's prose places emphasis on the nonformal, conceptual qualities of the work (even disavowing their inclusion in the category "sculpture"), and argues for their nonarbitrary function as a type of illustration, or, analogous to the quotation that followed from Hilbert's preface to *Geometry and the Imagination*, as explanatory figures or models.

Read in the context of the article's layout, these sentences suggest that LeWitt associated Vollmer's mathematically derived yet still sensuous and humanly scaled works with the period discourse that privileged ideas and process over techniques and finished products. He reminds us that the mathematical forms are "found" and that Vollmer's works are "about art," not mathematics. LeWitt had already indicated in "Paragraphs on Conceptual Art" that the interrelationship of concept and materialization was a crucial aspect of the case against a formal reading of minimalist sculpture:

> New materials are one of the great afflictions of contemporary art. Some artists confuse new materials with new ideas. There is nothing worse than seeing art that wallows in gaudy baubles. By and large most artists who are attracted to these materials are the ones that lack the stringency of mind that would enable them to use the materials well. It takes a good artist to use new materials and make them into a work of art.[54]

In "Ruth Vollmer: Mathematical Forms," LeWitt makes a similar aesthetic judgment about Vollmer's work, though it is a judgment founded on an aesthetic that values conceptual rigor over a perceptually and formally based expressionism. The evidence he provides of Vollmer's process is the decision

making he discerns: "There is a simple and single idea for each form; there is a single and basic material of which the piece is constructed. The material used has physical properties that are evident, useful to the form."[55] These decisions extend to the size and scale of her works, characterized by LeWitt as "small enough to mitigate any expressiveness. They are not gross and pompous." They are of "necessary" size; their scale, he writes, is "perfect." LeWitt's simple yet strong final sentence—"They are works of quality and excellence"—employs words once associated with formalist, evaluative judgments such as "good" and "quality" in an entirely new theoretical context. The "stringency of mind" LeWitt values is borne out by Vollmer's selected quotations and by the commentary she interspersed with them. For example, about the crystalline *Heptahedron* she writes: "The strange characteristic of this form is that in its centre point and along the axis it comes to nothing, but the thickness of a material," thus accounting for her decision to cast the work in acrylic: "Transparent material was chosen to make the form easy to comprehend."[56]

In a letter that dates from earlier in 1970, written by LeWitt to curator Enno Develing about the organization of the catalogue for his upcoming show in The Hague, the artist parsed his materials for the book into the categories "objective" and "subjective": "I hope that there is not too much material and none has to be excluded or cut, so I'd rather use a more condensed or smaller type face to get it all in. I want as much information both objective (photos, drawings) and subjective (statements) as possible."[57] The period's ideas about objectivity and primary information can be taken to inform "Ruth Vollmer: Mathematical Forms." The generous use of illustrative material (seven black-and-white reproductions, that of *Spherical Tetrahedron* filling the first page) are "objective" records of LeWitt's naming, as are the quotations that serve to define the specialized mathematical forms and formulas underlying Vollmer's sculpture. With the publication of Bochner and Smithson's "The Domain of the Great Bear" (1966), Graham's "Homes for America" (1966), and Bochner's "The Serial Attitude" (1967), the model of an objective, or apparently objective, art writing had already been presented by the artist-writers of the group.[58] Bochner spoke about these critical experiments in 2000: "For a long time, I'd had an idea to do an article on contemporary art as if it were an entry in the *Encyclopedia Britannica*...that kind of pseudo-objective writing, information packed, without any value judgments—an antidote to the kind of art writing that

was being done."[59] Such writing proposed a reception of contemporary work beyond the formalist terms LeWitt countered, and beyond "taste"—the word is Bochner's—and he continued to assess the method as "trans-stylistic and meta-critical."[60]

Vollmer's relationship to mathematics, and to the conceiving and making of form, certainly diverges from and exceeds these specific philosophies and positions. There is ample evidence that her belief in mathematics, and in the forms of nature, were akin to earlier modern, optimistic, and universalist models, and that such distinctions were made by these artists at the time.[61] LeWitt and Vollmer's collaborative attempt at attaching her work to this contemporary discourse, whether or not it furthered the reception of Vollmer's work, is significant as an expression of the kind of interest at stake in the period, and among the artistic association of the group, in symbolic terms.

Nineteen seventy brought to a close this formative and intense period of exchange among the artists in the group.[62] LeWitt and Vollmer each lost a best friend in Hesse. LeWitt's 1970 catalogue contained dedications to Hesse in written and drawn form, as well as a statement about his work by Hesse, among the few critical statements by her to be published in her lifetime. Vollmer was not included among the artists and critics asked to contribute texts to this publication. In the context of Vollmer's developing absence in art history, LeWitt's article, "Ruth Vollmer: Mathematical Forms," can be said to materialize a "space of possibles," and, with it, to give form to a moment of history, if not ultimately a moment of art history, for Vollmer and her art.

Notes
Thanks are due to Nadja Rottner for her invitation to work on the Vollmer project, for her contribution of source materials, and for her willingness to exchange ideas during the research and production of this essay. Mel Bochner generously shared his thoughts and perspectives on Vollmer in a telephone conversation, and was kind enough to read a draft of this essay. Sol LeWitt, in telephone conversations with Linda Norden, provided much helpful information. For other important conversations, information, and verifications of facts, I am grateful to Dan Graham, Lucy R. Lippard, Linda Norden, Ann Reynolds, Barry Rosen, and Irving Solero. Rina Carvajal's invitation to view the exhibition "Thinking the Line: Ruth Vollmer and Gego" and to lecture on Vollmer's work at Miami Art Central in October 2004 were early contributions to my research. Lastly, Bennett Simpson and Andrea Fraser offered important responses to drafts of this essay.

My title is taken from the first line of Lawrence Weiner's six-line contribution to the exhibition catalogue *Sol LeWitt* (The Hague: Haags Gemeentemuseum, 1970), p. 35; reprinted in Adachiara Levi, ed., *Sol LeWitt: Critical Texts* (Rome: I Libri di AEIUO, 1995), p. 193. My subtitle is phrasing I use after the practice of Louise Lawler, who recently titled a monograph on her work *Louise Lawler and Others*, ed. Philipp Kaiser (Ostfildern-Ruit and Basel: Hatje Cantz and Kunstmuseum Basel, Museum für Gegenwartkunst, 2004).

1 "Music in Wire: Ruth Vollmer's Four-dimensional Displays," in *Interiors* 106, no. 9 (April 1947): 153. Mannequins of this period were typically constructed of papier-mâché–covered "chicken wire." Vollmer joined the Betty Parsons Gallery in 1959, exhibiting first in Parsons's short-lived Section Eleven annex (1958–60), where her work was introduced by the gallery in a group exhibition in 1959. Parsons mounted solo exhibitions of Vollmer's sculpture in 1960, 1963, 1966, 1968, 1970, and 1973, and of her drawings in 1977 and 1979. Her work was also included in group exhibitions at the gallery in 1960, 1963, 1966, and 1977.

2 Sol LeWitt, "Ruth Vollmer: Mathematical Forms," *Studio International* 180, no. 928 (December 1970): 256.

3 Ibid.

4 Sol LeWitt, "Paragraphs on Conceptual Art," *Artforum* 5, no. 10 (June 1967): 79–83. This special issue, titled "American Sculpture," was formulated in response to "American Sculpture of the Sixties," an exhibition organized by Maurice Tuchman for the Los Angeles County Museum of Art, April 28–June 25, 1967. The issue included a review of the exhibition by editor Philip Leider as well as an array of articles addressing topics in the field of contemporary sculpture, most famously, Michael Fried's "Art and Objecthood." Among the artists' responses commissioned by Leider were LeWitt's "Paragraphs," Smithson's "Towards the Development of an Air Terminal Site," and Morris's "Notes on Sculpture, Part 3."

5 One group in particular is represented in LeWitt's article. Although works by Carl Andre, Donald Judd, and Robert Morris are reproduced, LeWitt, Smithson, Hesse, and Bochner began to show several years later than Judd and Morris, in 1965 and 1966 and afterward, and do not share the movement designation "minimalism" in the same way as these artists, but, rather, a chronological locus or artistic age—the generation after minimalism. In fact, this group could be said to have been galvanized around the formation of a series of artistic and critical responses to minimalism. LeWitt's "Paragraphs" was such a response to the perceptual, formal reading of minimalism, while, as early as spring 1966, Smithson and Bochner each wrote critical reviews of the first museum presentation of minimalism, "Primary Structures: Younger American and British Sculptors," organized by Kynaston McShine and shown in New York at the Jewish Museum in April 1966. See Smithson's "Entropy and the New Monuments," *Artforum* 4, 10 (June 1966): 26–31; and Bochner's "Primary Structures," *Arts Magazine* 40, 8 (June 1966): 32–35. In art critic Lucy R. Lippard's phrasing, part of this group was designated "the Bowery Boys" (though there were among them several artists who were not "boys": Hesse and Sylvia Mangold), a term Lippard, who considered herself one of them, coined. See Lucy R. Lippard, *From the Center: Feminist Essays on Women's Art* (New York: Dutton, 1976), p. 3. James Meyer's *Minimalism: Art and Polemics in the Sixties* (New Haven, Conn.: Yale University Press, 2001) is the first overview of minimalist practice and discourse to demonstrate a historical distinction between first-generation minimalists such as Judd and Morris, and this mostly younger group of artists. Meyer's study is also the first to assess the formation of a social construct within the art world of the period in relation to a theory of the artistic "field."

6 Although LeWitt was an ardent supporter of her work, Vollmer was not of his generation, nor did she share his influences. Born in Germany in 1903 and self-taught, she emigrated in 1935 to New York, where she joined a community of German-Jewish émigrés. In these facts of her upbringing, and in her earlier philosophical orientation toward widely divergent artistic models, including classicism and the work of surrealist sculptor Alberto Giacometti, Vollmer's identity as an artist, and her work, must be differentiated from the aesthetic practices of the generation of LeWitt and company. For a discussion of this aspect of her position within the group, see "In Conversation with Mel Bochner," pp. 212–13 of this volume.

7 This photograph was taken by Hermann Landshoff, Vollmer's brother

and a fashion photographer, who produced much of the still and installation photography of her work. He is better known for his series of portraits from circa 1969 of the artist Eva Hesse, his sister's friend, now in the Hermann Landshoff Collection at the Fashion Institute of Technology, New York. Selected images of Hesse by Landshoff were first published in Lucy R. Lippard, *Eva Hesse* (New York: New York University Press, 1976), and later appeared in Bill Barrette's *Eva Hesse Sculpture: Catalogue Raisonné* (New York: Timken, 1989).

8 The decision to place the reproduction within this grid was most likely made by *Artforum*'s designer at the time, artist Ed Ruscha, though its inclusion among the article's illustrations was due to LeWitt's advocacy of Vollmer's work. LeWitt characterized his participation as follows: "Robert Smithson managed to get *Artforum* magazine to offer some pages for artists to express their ideas. I wanted to counter the current notion of minimal art...written about by critics...in a formal way rather than what I believed was more conceptual." Quoted in Andrew Wilson, "Sol LeWitt Interviewed," *Art Monthly*, no. 164 (March 1993); reprinted in Levi, ed., *Sol LeWitt: Critical Texts*, p. 125.

9 On the feminist question of how to historicize artists who were women and whose work often falls outside the discursive and institutional contexts of their moment in history—or falls complexly within dominant discourses and aesthetic valuations (as in the legitimation and theorization of Hesse and Agnes Martin as minimalists)—see Birgit Pelzer, "Idealities," in Catherine de Zegher and Hendel Teicher, eds., *3 x Abstraction: New Methods of Drawing by Hilma af Klimt, Emma Kunz, and Agnes Martin* (New York and New Haven, Conn.: The Drawing Center and Yale University Press, 2005), p. 63. The foundational work of Lucy R. Lippard in this field is also discussed in this essay.

10 Philip Leider, quoted in Amy Newman, *Challenging Art: Artforum 1962–1974* (New York: Soho Press, 2000), p. 157.

11 LeWitt, "Ruth Vollmer: Mathematical Forms," p. 256.

12 Robert Smithson, "Quasi-Infinities and the Waning of Space," *Arts Magazine* 41, no. 1 (November 1966): 28–31.

13 Robert Smithson, "A Museum of Language in the Vicinity of Art," *Art International* 12, no. 3 (March 1968): 21–27.

14 For a recent and strong reading of Kubler's theories as engaged by Smithson's "Quasi-Infinities and the Waning of Space," see Pamela M. Lee, "'Ultramoderne': Or, How George Kubler Stole the Time in Sixties Art," *Grey Room*, no. 2 (2001): 46–77.

15 Smithson, "A Museum of Language in the Vicinity of Art," p. 26.

16 Robert Storr, "Ruth Vollmer at Jack Tilton," *Art in America* 72, no. 1 (January 1984): 128.

17 Ibid., p. 129. There are exceptions to Storr's point of view and the tendencies toward judgment in the criticism of Vollmer, most often found in artists' writings about her. Richard Tuttle, Thomas Nozkowski, and Stephen Westfall have written on her work. Westfall said it well: "Skirting the very real demands of the marketplace and the artist's own ego, it seems as though art should be something more than an approach to notoriety. But it also seems a shame that Vollmer has yet to become a classroom word (about the most notoriety one can hope for these days)...her work is too wild and weighty for either our patronization or our ignorance." Stephen Westfall, "Preserving the Mystery: The Art of Ruth Vollmer," *Arts Magazine* 58, no. 6 (February 1984): 76.

18 Lippard, *Eva Hesse*, p. 204. In Lippard's first article about Hesse, published a year after her death in 1970, the critic offered the following characterization of Hesse's context: "From this time on, LeWitt, whose planar structures had been shown at the John Daniels Gallery in May 1965, was her strongest supporter. His serial permutations, theoretically logical and often visually illogical, though always starkly geometric in style, were a counterpart of Hesse's introduction of chance and randomness into much looser but still systematic frameworks. In various ways, Mel Bochner, Robert and Nancy Smithson, Ruth Vollmer, and Robert Ryman were also important to her development." Lucy R. Lippard, "Eva Hesse: The Circle," *Art in America* 59, no. 3 (May/June 1971): reprinted

in Lippard, *From the Center*, pp. 156–57.

In *From the Center*, Lippard offered this explanation of the problems of attaching art by women to its discursive context: "Much women's art, forged in isolation, is deprived not only of a historical context, but also of that dialogue with other recent art that makes it possible to categorize or discuss in regard to public interrelationships, aesthetic or professional. It is not that the women weren't aware all that time of the artworld art, so much as those men were not aware of their art. The notoriously late starts of many women artists, late aesthetic developments, and belated success or even attention—these can be attributed to that isolation as well as to more mundane domestic factors and public discrimination" (p. 5).

19 Lippard, *Eva Hesse*, p. 14.

20 Lippard verified in a phone call of July 1, 2005, that she "never did write" another text about Vollmer other than the passages that can be found in "Intersections" (1984), originally published in Olle Granath, ed., *Flyktpunkter/Vanishing Points* (Stockholm: Moderna Museet, 1984), pp. 11–29, and reprinted on pp. 37–47 of this volume. Lippard's *Eva Hesse*, however, does record many significant details about the artistic exchange and friendship between Vollmer and Hesse.

21 Lippard, "Intersections," p. 11.

22 Ibid., p. 20.

23 A distinction must be made between this article's analysis of methods and the materials of artists' reception and one that evaluates Vollmer's work alone, a critical and historical treatment that is strongly deserved and has not yet been undertaken. On the occasion of a retrospective of Hesse's work in 1992, Linda Norden wrote: "Vollmer's importance in this group, to Hesse and Smithson especially, merits more attention. She has been recognized as a kind of maternal figure for Hesse…but little has been said on their retrospective approaches to, and expectations of, their art." Linda Norden, "Getting to 'Ick': *To Know What One Is Not*," in Helen A. Cooper, ed., *Eva Hesse: A Retrospective* (New Haven, Conn.: Yale University Press, 1992), p. 71, n. 13. See also Ann Reynolds, "Space Matters" (2003), an essay, as yet unpublished, written for the catalogue of the 2002 exhibition "Ruth Vollmer: Drawings and Sculpture"; the catalogue, edited by Graham Domke, is forthcoming from Inverleith House, Royal Botanical Garden Edinburgh, in 2006. Many more names accumulate in the writing about Vollmer: Tom Doyle, Dan Flavin, Dan Graham, Hans Haacke, Nancy Holt, Robert Mangold, Sylvia Mangold, Thomas Nozkowski, Robert Ryman, Richard Tuttle. The heterogeneity of this artistic community is vastly distilled in the list of LeWitt, Smithson, Hesse, and Bochner.

Vollmer's bequest of her personal art collection to The Museum of Modern Art in 1983 is one record that reflects the array of relationships Vollmer had with other artists. Here we find Vollmer engaging in collegial conversations through trades of artworks, offering artistic and financial support through purchases, generously expressing her interest in a wide range of artists. Works by her colleagues at the Betty Parsons Gallery are present: Reinhardt, Tuttle, and Parsons (herself an artist). Along with works by Andre, Baer, Bochner, Hesse, and LeWitt, we also find those of Alice Adams, Stephen Antonakos, Robert Barry, Chryssa, Will Insley, Patrick Ireland, Richard Lindner, Matt Mullican, and Vollmer's dear friend Leo Rabkin. Several oil paintings and a small sculpture in plaster by Alberto Giacometti were among the rarest and most valuable of the works in Vollmer's collection, as B.H. Friedman described it in 1965: "On the adjoining walls are works by artists she admires: small unframed oil paintings by Giacometti; watercolors, lithographs, and etchings by Klee and Picasso and Chirico [sic]; a plaque by her friend Chryssa; watercolors by other friends, Leo Rabkin and Richard Lindner. In a corner stands a cat of knotted rope and a camel of screening—both toys made by Ruth Vollmer." B.H. Friedman, "The Quiet World of Ruth Vollmer," *Art International* 9, no. 2 (March 1965): 26. The catalogue accompanying a major exhibition of Vollmer's work at the Everson Museum of Art in 1974 contains similar accounts of her salon; see Peg

Weiss, ed., *Ruth Vollmer: Sculpture and Painting 1962–74* (Syracuse, N.Y.: Everson Museum of Art, 1974).

24 Lippard, "Intersections," pp. 20–21.

25 Ibid., pp. 12–13.

26 Eva Hesse, diary entry dated June 9, 1966, as published in Cooper, ed., *Eva Hesse*, p. 38.

27 Smithson, "Quasi-Infinities and the Waning of Space," p. 30.

28 Ruth Vollmer in conversation with Colette Roberts, "Meet the Artist" adult education program, New York University, Fall 1970; audiocassette transcript, p. 4. Colette Roberts Interviews with Artists, 1961–1971, Archives of American Art, Smithsonian Institution, Washington, D.C.

29 Annette Michelson, "10 x 10: 'Concrete Reasonableness,'" *Artforum* 5, no. 5 (January 1967): 30–31. Michelson developed these ideas in her substantial essay on the period, "Robert Morris—An Aesthetics of Transgression," in the exhibition catalogue *Robert Morris* (Washington, D.C.: Corcoran Gallery of Art, 1969), pp. 7–79.

30 Pierre Bourdieu, *The Rules of Art: Genesis and Structure of the Literary Field*, trans. Susan Emanuel (Stanford: Stanford University Press, 1996); see also Bourdieu, *The Field of Cultural Production: Essays on Art and Literature*, ed. Randal Johnson (New York: Columbia University Press, 1993). My thinking about the position of the work of Vollmer within these relationships with other artists and within the historical structure of the field of art in the sixties was developed from Bourdieu's theory of the field and his writings on the methodology of social history, here practiced in a speculative form as a social art history through an analysis of artists' writings. A 1981 essay by Mary Kelly, "Re-Viewing Modernist Criticism," remains a model for how I endeavor to read exhibitions and publications; see Brian Wallis, ed., *Art after Modernism: Rethinking Representation* (New York and Boston: The New Museum and David R. Godine, 1984), pp. 87–103.

31 These dates were determined by comparing a number of sources. In cases where 1965 appeared too early or was not corroborated, I have used 1966. In 1984, Lippard recounted the dating of the group's acquaintance this way: "In 1965, Smithson and Nancy Holt met Bochner, Hesse, Vollmer (and me). Bochner met Hesse and LeWitt. I had known LeWitt since 1960, which is when he met Hesse, then Doyle in 1961; I met Hesse and Doyle in 1963. Hesse met Graham, Vollmer and Bochner in 1966…and so forth." See Lippard, "Intersections," p. 12. Holt, in a conversation with Nadja Rottner, recalled that it was 1966 when she and Smithson met Vollmer, and that it was through Smithson that Vollmer and Hesse met. Nancy Holt, telephone conversation with Nadja Rottner, May 2, 2003.

32 Though Lippard dates their meeting to 1965, Bochner feels it must have been 1966, since he recalled that the two hadn't met (though both knew of each other through Hesse) when he reviewed "Primary Structures." Mel Bochner, telephone conversation with the author, March 31, 2005. In a May 13, 2003, conversation with Nadja Rottner, Bochner recalled that it was at Vollmer's house that he first met Robert Smithson, and that they "immediately entered into an argument about entropy and mannerism in El Greco."

33 Hesse and Vollmer did not publish this type of artist-written criticism or articles about art theory or other topics. As artists, they published their writing in only a few instances, usually as statements to accompany works in exhibition catalogues or brochures, or in oral form in interviews. Yvonne Rainer was the only woman artist of the group to publish in *Arts Magazine*, in 1967; see Yvonne Rainer, "Don't Give the Game Away," *Arts Magazine* 41, no. 6 (April 1967): 44–47. Judd and Morris published their writing in *Arts Magazine* and *Artforum*, respectively, between 1965 and 1970; Smithson, too, published frequently in *Artforum* from 1967 to 1973, and in other venues.

34 Vollmer/Roberts, interview, p. 3.

35 Smithson, "Quasi-Infinities and the Waning of Space," p. 30.

36 Eugenie Tsai, "Interview with Dan Graham by Eugenie Tsai, New York City, October 27, 1988," in *Robert Smithson: Drawings from the Estate*

(Münster: Westfälisches Landesmuseum für Kunst and Kulturgeschichte, 1989), p. 8.

37 Evidence of the dialogue between Bochner and Vollmer is also largely visual material, in the form of traded artworks. Unfortunately, the research and documentation required to consider these objects for their aesthetic and social value exceeds the scope of this article. As a publishing artist-writer and significant interlocutor within the group during 1966–70, Bochner provided his perspective in numerous contemporary publications of the period and in others about artists' writings that have appeared during the last dozen years, including interviews about both Hesse and Vollmer, the latter conducted by Nadja Rottner for this volume, (see pp. 212–13).

38 Beskind's untitled 16mm film of ca. 1967–68, approximately ten minutes in length, is one of a group of portraits of artists in their studios that she began in 1963.

39 Vollmer/Roberts, interview, p. 7.

40 Lippard, *Eva Hesse*, p. 127.

41 For a discussion of this image, see Ann M. Wagner, *Three Artists (Three Women): Modernism and the Art of Hesse, Krasner, and O'Keeffe* (Berkeley: University of California Press, 1996), pp. 194–95; first published as "Another Hesse," *October*, no. 69 (1994): 49–84.

42 James Mellow, "New York Letter," *Art International* 13, no. 1 (January 20, 1969): 54.

43 Lippard dates Hesse's purchase of a "large thesaurus" to spring 1966; see *Eva Hesse*, p. 65. Bochner's *Wrap: Portrait of Eva Hesse* also dates to 1966, and was composed with the aid of a thesaurus. See Elisabeth Sussman, *Eva Hesse* (San Francisco: San Francisco Museum of Modern Art, 2002), p. 24; p. 38, n. 19.

44 *Sol LeWitt* (The Hague: Haags Gemeentemuseum, 1970).

45 After the work of Hayden White, especially that defining the historiographic model of the chronicle, my analysis of these materials of artistic reception follows the order of events as they occurred rather than a more traditional narrative of an individual artist or artists' movement. Such a characterization of Vollmer through a discrete series of works and events related in chronological order, rather than following a coherent storyline, delineates her position in the historical context by marking the shifts that occurred, which are inconclusive as beginnings or endings. See Hayden White, *The Content of the Form: Narrative Discourse and Historical Representation* (Baltimore: Johns Hopkins University Press, 1987).

Two other articles on Vollmer that could be considered close to features appeared during the period 1965–70: B.H. Friedman's "The Quiet World of Ruth Vollmer" (1965), a biographical sketch rather than an approach to her sculpture; and Rolf-Gunter Dienst's "Ruth Vollmer's Magic of Simplicity," *Das Kunstwerk* 22, nos. 5–6 (February/March 1969): 36–40. Given LeWitt's relationship with Vollmer and his differing approach to her work—that of a fellow artist in the field—"Ruth Vollmer: Mathematical Forms" remains a far more significant contribution to the critical literature on Vollmer. At the time of its publication, LeWitt had already had his first one-man museum exhibition, "Sol LeWitt: Sculptures and Wall Drawings," at the Museum Haus Lange in Krefeld, Germany, in 1969; and his first in the United States had only recently opened, on November 17, 1970, at the Pasadena Art Museum

46 LeWitt's support of Vollmer's work appears significant. The only other instance I have found of his publishing a work of criticism about an individual artist is "I Am Still Alive, On Kawara," published in *Studio International* the same year; however, in place of conventional art criticism, this piece experiments with the text of Kawara's well-known postcards as part of an issue on conceptual art edited by Lucy R. Lippard. See *Studio International* 180, no. 924 (July/August 1970): 37.

47 This note appears with the article: "Ruth Vollmer Recently Exhibited at Betty Parsons Gallery, New York." Illustrations are courtesy Betty Parsons Gallery." The exhibition, titled "Ruth Vollmer Sculpture," was held November 3–24, 1970. Most of these texts can be found in

Vollmer's papers at the Jack Tilton Gallery, New York, which represents her estate.

48 Ruth Vollmer, quoted in LeWitt, "Ruth Vollmer: Mathematical Forms," p. 256.

49 Sol LeWitt, telephone conversation with Linda Norden, March 2005. By reviewing contemporaneous issues of *Studio International*, it can be discerned that Betty Parsons advertised in the magazine, but also that work by LeWitt had previously appeared in its pages; thus, the connection with the editor appears to be LeWitt's, in the absence of evidence in the correspondence between LeWitt or Vollmer and *Studio International*. In addition to "I Am Still Alive, On Kawara" in the July/August 1970 issue, see *Drawing Series 1968 (Fours)*, in *Studio International* 177, no. 910 (April 1969): 189.

50 LeWitt, as told to Norden, March 2005.

51 Vollmer/Roberts, interview, p. 9.

52 LeWitt, "Ruth Vollmer: Mathematical Forms," p. 257.

53 Ibid, p. 256.

54 LeWitt, "Paragraphs on Conceptual Art," p. 83.

55 Ibid., p. 53. The wood-laminate *Pseudosphere* and a working drawing are among the works LeWitt and Vollmer traded, and are now part of the behest of The LeWitt Collection to the Wadsworth Atheneum, Hartford, Connecticut.

56 Ibid., p. 257.

57 Quoted in Enno Develing, "Thoughts on Sol LeWitt's Work," in *Sol LeWitt*; reprinted in Zevi, ed., *Sol LeWitt: Critical Texts*, p. 165.

58 See Robert Smithson and Mel Bochner, "The Domain of the Great Bear," *Art Voices* 5, no. 4 (fall 1966), p. 41; Dan Graham, "Homes for America, Early 20th Century Possessable House to the Quasi-Discrete Cell of '66," *Arts Magazine* 41, no. 3 (December 1966/January 1967): 21–22; and Bochner, "The Serial Attitude," *Artforum* 6, no. 4 (December 1967): 28–33.

59 Mel Bochner, quoted in Newman, *Challenging Art*, p. 232.

60 Ibid., p. 233.

61 See "In Conversation with Mel Bochner," pp. 212–13 of this volume.

62 Bochner has identified 1966–68 as the period during which the group saw each other daily, and 1968 as the year that saw a change in its makeup, partially due to the fact that Smithson developed new relationships with Richard Serra and Michael Heizer, artists associated with the "earth art" group. Mel Bochner, telephone conversation with the author, March 31, 2005. From the existing factual record and archival materials, 1968–70 does appear to be a period during which Hesse and Vollmer's individual friendship was constant and strong. The two traveled to Mexico City together, and were captured in Beskind's film; both were working toward solo exhibitions in November 1968. Bochner has stated he maintained individual friendships with LeWitt, Hesse, and Vollmer throughout; his friendships with LeWitt and Vollmer continued into the seventies and beyond.

RUTH VOLLMER. UNTITLED (RELIEF), 1948
STEEL, COPPER WIRE MESH, AND WIRE ON WOOD,
12 X 12 IN. (30.5 X 30.5 CM)
PHOTO W. AUERBACH
COURTESY JACK TILTON GALLERY, NEW YORK

EVA HESSE. PINK, 1965
SILVER PAINT, ENAMEL, WOOD,
PLASTER, PAINTED COTTON CORD,
AND PAINTED METAL BUTTON ON
MASONITE, 25.7 X 21.7 IN.
(65.3 X 55.1 CM)
SAATCHI COLLECTION, LONDON
© THE ESTATE OF EVA HESSE
HAUSER & WIRTH, ZURICH/LONDON

RUTH VOLLMER. UNTITLED
(RELIEF FOR 575 MADISON AVENUE,
NEW YORK), 1950 (DESTROYED)
STEEL AND COPPER MESHES,
COPPER, PAINTED COPPER SHEET
8 X 17 FT. (2.4 X 5.2 M)
PHOTO HERMANN LANDSHOFF
RUTH VOLLMER PAPERS, 1939-1980,
ARCHIVES OF AMERICAN ART,
SMITHSONIAN INSTITUTION,
WASHINGTON, D.C.

"FRAGMENTS TOWARDS THE SPHERE": THE EARLY CAREER(S) OF RUTH VOLLMER
BY KIRSTEN SWENSON

By the mid-forties, Ruth Vollmer was well established in her "first career" as a designer of interior appointments, department store window displays, and large-scale retail tableaux. Her creations were easy to recognize—she constructed elegant animals and mannequins simply from wire netting, having by then achieved her objective of "being allowed to exhibit, commercially, wire sculpture for its own beauty instead of for its ability to carry papier maché."[1] In 1947, this novel approach warranted a profile of Vollmer in the preeminent design magazine *Interiors*, where readers learned of the occasion when she became aware of her talent:

> A painter in a country village of her native Bavaria was the first to give substantial encouragement. While taking care of four small children, she made them a basket and a raffia doll. The passing painter said, 'If you will make me such a doll, I will give you a watercolor.' In trepidation, she fashioned him a raffia animal, and was surprised that it turned out so well.[2]

Several vivid anecdotes are among the scant evidence of Vollmer's early artistic life in Germany before she and her husband, Hermann, emigrated to New York in 1935, exiles from Hitlerism. This story, in which her artistic origins are spun in the mythic tone of a Germanic fairy-tale, expresses dominant themes of Vollmer's life and art through the fifties—for one, the centrality of children (though she had none of her own) in the meaning and function of her art, and also for her husband, who was a pediatrician. The painter's solicitation—a watercolor in exchange for a doll—describes the ambivalence of Vollmer's production as playthings and objets d'art. Further, the polarity of the young woman fashioning objects from a rustic material and the established male painter suggests the gendered terms by which Vollmer's career unfolded, as an artisan operating within the feminine terrain of children's toys and women's fashion who was recognized as an artist only later in life.

Vollmer gained representation by the Betty Parsons Gallery in 1959, a benchmark in her "second career" as sculptor achieved at the age of fifty-six. She was introduced to the art world as belonging to an iconic European avant-garde tradition. In service of this narrative, a new version of the "raffia doll" story was circulated in connection with her first solo show at Parsons in 1960, suggesting the primitivist vein of German Expressionism as the lineage of the terra-cotta reliefs Vollmer exhibited: "In Germany, where she was born, [Vollmer] once wove a basket for a newborn baby; from the left-over material she made a raffia giraffe which appealed to Emile Nolde."[3] Her prior œuvre—retail design, tactile sculpture for children, and abstract reliefs—was elided to forge a direct connection to prewar modernism.[4]

One aim of this essay is to excavate the lost phase of Vollmer's work, to trace her development as an artist between the raffia doll and her work of the mid-sixties. Her career can be divided into two unequal parts—a chronologically expansive period of relative anonymity occurring outside the scope of art-critical reception; and a shorter span of critical significance, when her work entered a dialogue with the discourses of the American Abstract Artists group and, later, with minimalism. I will extend my inquiry of the first phase up to 1963, the year she officially joined the group and had her second show at the Betty Parsons Gallery, where she exhibited eccentric objects conceived during a period of interest in surrealism and psychoanalytic themes. After this point, explorations of geometry, in particular the sphere, became the unifying theme of her work. But in the decades prior to this, Vollmer, fascinated by the properties of materials, exhaustively explored three media: wire, clay, and then bronze. Over the course of thirty years, she worked through an array of modernist themes from the Bauhaus to surrealism, and invented a mode of sculpture that complicated the traditional status of the art object.

In addition to surveying these mostly unaccounted-for decades of Vollmer's career, I will track two persistent themes in her work of this period: her incorporation of the tactile

dimension, and her pairing of geometric abstraction with bodily metaphor. Even after turning to the fine-art medium of bronze around 1960, she conceived her viewers as participants, dissolving boundaries between subject and object through staged physical encounters—objects were activated when touched and held, rotated, arranged, and, in the case of *Musical Forest*, 1961 (page 134), even played as an instrument. A slippery dual identity characterizes her objects from the fifties and sixties: Forms are erotic and abstract, derived from geometry but alluding to the body. Paradoxically, as Vollmer's sculpture grew more abstract, themes of eroticism and play grew more central. With her embrace of geometry as a formal vocabulary in the early sixties, the sphere could support multiple readings—while remaining just a sphere.

Wire

Having no formal training in art, Vollmer referred to herself as "self-taught," yet she would also describe the extraordinary encouragement and access of her culture-rich upbringing. As a young woman who thought she might become an artist, she was counseled by her father to draw, but she quickly began to experiment with plastic media: "I knew artists, friends of my parents [such as a Berlin sculptor] whose work in wax I had seen.... I wanted to work in wax, and I went to her and asked her how to make a base." [5] The result was a token of courtship: "Her first wax sculpture, a llama, she presented to Dr. Vollmer, whom she met in Berlin." [6]

Dr. Hermann Vollmer was chief physician at one of the world's foremost children's hospitals in Berlin when he and his wife became exiles late in 1935. She was in her early thirties and he was not yet forty years old. The *New York Times* optimistically announced the arrival of Dr. Vollmer—"Child Specialist Here"—suggesting that he had come, in part, "to work out his theories on the health of children, research which has already brought him world-wide fame." [7] Over the next decades he developed cures for children's diseases and innovative diagnostic methods such as "the Vollmer patch test" for tuberculosis. He also became intensely interested in mental health and Freudian psychology, writing on topics ranging from childhood jealously to the "profound human problem" of unhappiness among adults. [8]

Not long after arriving in New York, Ruth Vollmer was designing sculptures for children and as retail props, using wire netting in a wide range of gauges, widths, and metals. It would remain her primary medium through the forties. A dog in brass wire for a collection called "man with spaniel" and

other dogs in aluminum for "tweed window displays" at Saks Fifth Avenue were intended for temporary installation to help move that season's merchandise, and perhaps none have been preserved. [9] Like the raffia dolls meant to be passed on to a child, these were transitory objects that performed a kind of utility, consumable and impermanent like the fashions they promoted. [10]

While she would use wire netting to make model stage sets, abstract relief sculptures, and mannequins throughout the forties, at its origin it was associated with spontaneous creations for children: "A piece of screen picked up in the garden while walking with a child gave her the initial idea for the screen constructions. 'See, you can make something out of everything!' she showed the child enthusiastically." [11] A serendipitous discovery with undertones of wartime privation, wire mesh, though prefabricated and industrial, was a material that, like the raffia basket, defined and enclosed open space. It was an indefinite material, one that barely delineated form while denying mass and substance; the pieces Vollmer made of mesh were potentially collapsible, transparent outlines of space, more temporary maquettes than concrete objects.

One mesh camel made around this time was singled out for display in Vollmer's apartment in the sixties (opposite); the back of a photograph of it is dated 1937–38 and inscribed "Favorite—own sculpture for self." [12] Made from a single piece of mesh, with springs for legs, the camel's fringed mane and humps are unraveled selvedge. Creations like this were just the ingenious transformation of a familiar material intended by the Bauhaus principle of "economy." Vollmer may have discovered the uses of screen while walking in a garden with a child, but she was surely aware that screening was a common non-art material used for heuristic purposes at the Bauhaus. In the twenties, László Moholy-Nagy assembled mesh still lifes for photographic studies of "light and volume"; students of Josef Albers made volumetric shapes out of mesh, and used it to explore optical illusion (opposite). In his Bauhaus course "Concerning Fundamental Design," Albers's aim was to "increase our independence of the traditional use of materials," toward which end students were challenged with "making original constructions out of a great variety of materials; out of corrugated paper and wire netting, for instance...." [13] Vollmer's methods of self-teaching may have derived from her knowledge of the Bauhaus through family friends, among whom was the Bauhaus instructor Paul Klee.

Klee's influence is notable in the case of Vollmer's relief sculpture constructed from mesh; formally constrained, recti-

RUTH VOLLMER. UNTITLED (CAMEL), 1937-38 (DESTROYED)
WIRE MESH AND SPRINGS
RUTH VOLLMER PAPERS, 1939-1980
ARCHIVES OF AMERICAN ART, SMITHSONIAN INSTITUTION
WASHINGTON, D.C.

STUDY IN OPTICAL ILLUSION
WIRE NETTING
PRODUCED IN CONJUNCTION WITH "ALBERS VORLEHRE"
BAUHAUS DESSAU, CA. 1926

RUTH VOLLMER. UNTITLED (MESH LANDSCAPE WITH HORSES), N.D.
RUTH VOLLMER PAPERS, 1939-1980
ARCHIVES OF AMERICAN ART, SMITHSONIAN INSTITUTION
WASHINGTON, D.C.

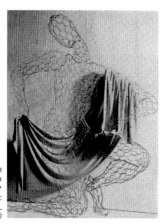

RUTH VOLLMER
CHICKEN-WIRE MANNEQUIN WITH
LORD & TAYLOR SCARF, CA. 1947
FROM "MUSIC IN WIRE:
RUTH VOLLMER'S FOUR-DIMENSIONAL
DISPLAYS," IN INTERIORS (APRIL 1947)

linear compositions with an emphasis on the planar surface, their shapes, textures, and layers developed complex internal relationships. A mesh "landscape" is populated by nearly abstract, wire, horselike figures evoking Kandinsky's familiar motif (below left). The landscape itself is constructed of mesh shapes appliquéd upon a rectilinear mesh panel. Overlapping layers create complex moiré patterns where the mesh grids intersect. Increasingly dense netting results from each layer of mesh, levels of transparency corresponding with a graduated palette. The lightest and most transparent layer is the base, or "background," set against which are increasingly dark, opaque, and high-relief patches built up from as many as four layers of mesh.

The abbreviated horses composed of lyrical wire curves are affixed to the surface and comprise the foremost layer of the relief. But in a cubist paradox, the two horses on the left and right are in the pictorial middle ground; the appliqué and wire horses construct a definite pictorial order valid in certain points across the composition and untenable in others, in the fashion of a landscape by Cézanne. Indeed, Vollmer's interest in the planar surface and pictorial language suggest that she was influenced by painting when making reliefs, perhaps by the Klee landscapes she is said to have admired, in which semirepresentational forms are organized in a similar free-form cubist approach. Such a hybrid object—appliquéd mesh conceived as a kind of "painting"—had precedent in the Bauhaus. Using materials such as mesh, Albers encouraged sensitivity to "qualities of surface" that could be "combined and graduated somewhat as colors are in painting"; his students studied transitions "in the tactile qualities of surfaces" and also "in the visual qualities of surfaces such as wide-meshed and narrow meshed; transparent and opaque clear and clouded."[14] See-through mesh could be layered to create a dense weave; each layer changed the color and level of transparency of the surface. Such experimentation with the limits of materials that, if pushed, would reveal a new category of object, was present in Vollmer's work in bronze and clay as well.

Hints of surrealism had entered Vollmer's practice by 1947, when Lord & Taylor presented her "Life-size chicken wire lady wearing a Lord & Taylor scarf"[15] (left). Vollmer's stripped-bare mannequins—armatures unburdened of the standard papier-maché "flesh"—replaced the traditional solid form with a vestigial outline of the female body. The mannequin was, of course, a famous tool of surrealism, embodying woman-as-object in the creations of Salvador Dalí, Hans

Bellmer, and others. Dalí's debased mannequins, part of the infamous "fur-lined bathtub" tableau, could be seen through a Bonwit Teller window in 1939. In contrast, Vollmer's chicken-wire mannequins were anti-illusionistic— "wire sculpture for its own beauty." The female form was reduced to functional necessity—a shape to fill out clothing, defining the space of the body while denying the illusion of substance.

Displaying the simple industrial elegance of the wire grid, Vollmer's mannequins cultivated a restrained lure, conveying their appeal to social class and femininity largely through abstract principles—medium, line, and proportion. In the case of the Lord & Taylor mannequin, an oblique nod to antiquity is present as well. The mannequin strikes a pose of feminine grace and submission; her elongated neck and tilted ovoid head, and the springlike torque of her limbs, suggest she has been plucked from a Greek vase painting. Allusions to antiquity are amplified by the cascading drapery of the "Lord & Taylor scarf." The figure possessed an understated surrealism: The deceptive naturalism of the well-defined form—her amplitude and even apparent muscularity—gives the transparent body a grotesque edge.

This undertone was exaggerated when, in 1948, Vollmer "enfleshed" chicken-wire mannequins by tossing clumps of wet clay onto the armatures. This was the same year that Jackson Pollock's breakthrough drip paintings were shown at the Betty Parsons Gallery. But the idea to throw clay on her chicken wire mannequins was more likely suggested by Alberto Giacometti's life-size figures made of plaster lumped onto wire armatures, which made their New York debut at the Pierre Matisse Gallery in the first months of 1948. Although Vollmer wasn't sure that Pollock was understood when he first emerged, the work of Giacometti, by comparison, was immediately affecting: "I know we got the Giacomettis because we were just absolutely in love with them! After the show at Pierre Matisse where the first figures were shown...I just couldn't believe what happened."[16]

Later that year, Vollmer began experimenting with abstract surrealism, and her use of materials grew more heterogeneous—several small-scale reliefs were constructed of mesh, wire, and metal cutouts mounted on plywood in shapes resembling the layered biomorphs of Hans Arp's "constructed paintings." Arp's technique involved transferring automatic drawings to plywood forms that were cut out, painted, and "collaged" in an overlapping relief format. Two of Vollmer's relief compositions conjure his "*fleur marteau*" imagery—one

in mesh, and the other a translation of the mesh forms into cut copper. A third relief, also from 1948, is constructed of vaguely anatomical forms made from mesh and steel "sutured" by broad wire stitching that implies penetration of the surface (page 86). A hidden interior space is referenced by the wires; they establish an invisible dimension to the piece while deepening the bodily association of biomorphic imagery.

Reliefs by Eva Hesse, made in Germany in 1965, evince a strikingly similar response to surrealist abstraction. Hesse would meet Vollmer the following year, and there is no evidence that she was aware of Vollmer's reliefs from the late forties. Still, in her "German reliefs"—such as *Pink* (page 86)— Hesse denoted hidden interior spaces by passing coils through decorative exterior surfaces, illuminating a terrain within the composition that was inaccessible to the eye. In this way, the reliefs dramatize a disjunction between "inside" and "outside": While the laced coils assert the actual depth of the reliefs, the gradated pastels that elaborate their surfaces mock illusionistic depth.

Vollmer and Hesse would become close friends, and both artists would continue to create complex, multivalent bodily metaphors that operated well beyond the simple likenesses of form inherent to biomorphic imagery. The body's systems were fictionalized in the work of Vollmer and Hesse, both of whom tended, in their reference to the body's erotic and reproductive potential in particular, to imagine a body of ambiguous gender. As I will discuss later, these references operated as shifting signifiers that frustrated any attempt at a fixed interpretation; in Hesse's words, they were "abstract objects that produce unmistakable sensations attachable to, though not necessarily interpretable as, the erotic."[17]

Vollmer's reliefs mark a shift in her self-perception as an artist: Her turn toward abstraction and away from feminized modes of production indicate a distancing from child-oriented themes and retail demands. She continued to accept design commissions, but her creations became larger in scale and prominence. In 1949, the Persian Room at the Plaza Hotel was redecorated with appointments by Vollmer, including reliefs, rugs, a wire valet at the entrance formed around a bottle of champagne (it was stolen and a new one made more than once), and striking mesh "drapery" bejeweled with chunks of colored glass.[18] After seeing the Persian room in 1950, Richard Roth, a son of architect Emery Roth, commissioned her to create a large-scale figurative mural for the lobby of a newly constructed office building at 575 Madison Avenue.

Vollmer perceived the commission differently. The Bauhaus-influenced firm of Emery Roth & Sons, with which Walter Gropius was affiliated later in his career, had pioneered the Manhattanized "ziggurat" form of International Style architecture. In Vollmer's reading, it called for modernist abstraction imbued with the gravitas and idealism of business in the postwar American economy—a relief with "associations on the theme of industry and life."[19]

She produced a horizontal relief spanning seventeen feet, installed above the elevator bank in the building's lobby (opposite, bottom). The relief's varied components were mounted directly on the wall, framed by the architecture of the space. With its elevated placement and open composition, in photographs it appears to float almost weightlessly above the lobby. This sense of lightness was reinforced by Vollmer's use of wire mesh for the central and largest form, through which the travertine wall tiles are visible. Upon this semitransparent base she layered a second mesh form and an opaque painted-copper cutout. To the left, metal discs appear to float across the wall; on the right, biomorphic "fragments" have a puzzlelike correspondence to the central form, indicating the emergence of Vollmer's fascination with interlocking shapes. To the right of these, three brass rods pull away from the wall plane; they are a linear counterpoint, a nod to the constructivist "counter-reliefs" of Tatlin that exploded relief elements throughout the space of a room, refusing the frame and the constraints of the wall. An artist's statement provided to tenants of the building gently admonished viewers, in the words of T.S. Eliot, "Oh, do not ask, 'What is it'…," and further declared that "none of the shapes are directly representational; they are associations on the theme of industry and life."[20] While establishing her intention to create a fully abstract work of art, the statement also designated a nominal social role for the piece—a visual diversion, given its placement above the elevators, for workers waiting to ascend to their offices.

Clay

The "Madison Avenue relief" was Vollmer's last major work in mesh. Seeing Giacometti's elongated figures in 1948 had been a watershed. Having earlier been impressed by "a beautiful Giacometti…a very early one, also in clay" at Peggy Guggenheim's Art of This Century Gallery (probably in 1945), seeing his plaster-on-armature figures further encouraged her experimentation with a hand-formed medium.[21] The years 1950 and 1951 precipitated changes; Vollmer visited Giacometti in his Paris studio each of these years, and

in 1951 she also acquired a kiln for her studio. After her second visit to his studio she recorded every detail she could remember, describing tiny plaster figures that Giacometti planned to cast in bronze. (She also pulled such a figurine from his trash on this occasion; it would remain a prized possession, displayed in a protective glass vitrine.[22]) The idea of a barely viable object made permanent in bronze seemed to delight her. Giacometti's interest in the transition from instability to permanence, in which cast-bronze figures retained the rapidly worked surface of the original plaster, became an interest of Vollmer's as well.

From clay Vollmer made abstract terra-cotta reliefs—or "tiles," as she called them—which she imagined would eventually comprise "a natural coarse brick wall."[23] To our knowledge, the reliefs were never installed in this format; rather, they became dispersed among friends and collectors, many exhibited at her first solo show at the Betty Parsons Gallery in 1960.[24] This was the first time that Vollmer had worked intensively in a medium other than wire mesh, and the reliefs' highly varied styles suggest that the decade of the fifties was an exploratory period during which Vollmer determined to work in a range of abstract modes. Some are biomorphic and others angular; they are glazed or unglazed. Some are discrete panels with contiguous terra-cotta frames, and in the case of another, rectangular discs span a network of terra-cotta supports connected by a square frame. Most of Vollmer's terra-cotta reliefs are modeled into curvilinear, nonangular forms reminiscent of the soft character of prefired clay (page 93). At least one terra-cotta piece is assembled of several panels in a cagelike construction titled *House*, 1957 (page 118), suggesting the influence of Giacometti's *The Palace at 4 A.M.* (1932). This surrealist sense of space delineated from the surrounding environment would be explored further with bronze in the early sixties.

The clay she used was a rough medium, porous and inconsistent, "dug out of the ground by friends in the country," and Vollmer enhanced its unrefined character by mixing in sand for added texture.[25] Many of the reliefs possess a manufactured archaism—a look of long-term exposure achieved by embedding sand in glazed surfaces, or by raking unglazed clay to create textured scratches. Ancient pottery and potsherds were displayed in her home, and such objects seemed to represent continuity with early civilizations, perhaps a salve for difficulties of the present. "Why is Neolithic and Paleolithic and some Bronze Age art so much stronger—unquestionably ART…in all cultures?" was a question she pre-

pared for students, one of "the great riddles of our art genera-tion."[26] Giacometti similarly cultivated an atavistic regression to the primitive. As Sartre wrote for the catalogue of the artist's 1948 exhibition at Pierre Matisse, "One does not have to look long on the antediluvian face of Giacometti to sense this artist's pride and will to place himself at the beginning of the world. He does not recognize such a thing as Progress in the fine arts...."[27] The reliefs Vollmer showed at Parsons's gallery in 1960 likewise elicited such paradoxical associations, with one critic calling them "organisms of a neo-primitivism born of a surfeit of taste."[28]

In the fifties Vollmer modeled clay with children in the art classes she taught. The medium's association with a kind of crude, unmediated expression, suited to children but similar to Giacometti's plaster, would have pleased her. The artist's autographic gesture—Vollmer's fingerprints—are frozen in the reliefs' surfaces and record the process by which they were formed, suggesting the abstract-expressionist privileging of subjectivity. Unlike prefabricated mesh, terra-cotta did not reference the industrialized world; rather, it offered a nostalgic connection with pre-Duchampian authenticity—art that was "unquestionably ART." In the fifties, this so-called neo-primitivism was inseparable from a fascination with the unconscious mind, whether the archetypal Jungian symbols embraced by Pollock, or the Freudian theories of a vast uncon-scious realm, accessible through play and free-association, that prevailed in émigré intellectual circles.

B.H. Friedman attended the salonlike gatherings at the Vollmers' home in the fifties and recalls that guests included artists, writers, and many "Freudians," among whom were Heinz Hartmann and Rudolph Lowenstein, prominent stu-dents of Freud.[29] The air was thick with psychoanalysis, and many devotees of Freud, including Hermann Vollmer, consid-ered themselves amateur analysts. Ruth Vollmer also read Freud (Friedman notes that the Vollmers had a framed page of one of his original manuscripts). Her use of biomorphic abstraction for many reliefs resembles the Freud-inspired psychic morphologies, or "inscapes," of Matta, and suggests a perceived relationship between her sculpture and theories of the unconscious. As her husband spelled out for a general audience in 1954, "Modern art has a special affinity to the unconscious mind and to dream life.... It results from the rejection of the real world and from substituting for it a newly created different world."[30]

Several terra-cotta reliefs describe abstract veins and vis-cera, and further connote interior space by the apparent pene-tration of the reliefs' surfaces with wormlike ropes of clay (opposite, top). In this way, Vollmer used clay to create depth—her relief sculptures were not simply solid forms with a pictorially carved surface but "transparent" objects (concep-tually, at least) in which the normally invisible interior became a functional and visible dimension. The thickness of clay thus became perforated, dealt with as a network rather than as a solid mass. She explored ways to leaven the dense medium by creating layers that would interact, similar to the way in which she layered mesh to create complex forms and depth. An intri-cate example (opposite, bottom), reproduced in *Interiors* in 1955, was a shallow boxlike base over which a loose layer of clay had been affixed.[31] This slightly sagging layer was pene-trated by numerous gaping slits, revealing an open and lively interior that contained a coursing, wormlike mass. Some of this mysterious content snakes through the slits, generating graphic tension between the breached exterior "skin" and the writhing forms barely contained within. Such themes of interi-ority and containment activated many of Vollmer's bronze sculptures from 1959 and 1962 as well, and were intensified in the new context of her fascination with geometry.

Bronze

Hermann Vollmer had struggled with depression since his arrival in New York, and had, perhaps, never recovered from the trauma of forced emigration and the war. In October 1959, he killed himself in the couple's apartment. Ruth Vollmer, who found her husband's body, told the press he had been despondent because his eyesight was failing.[32] In the spring of 1960, she had her first solo show at Betty Parsons, and sometime around the turn of the decade made her first sphere out of wax, which was then cast in bronze. The trans-formation undergone by Vollmer and her art registered first in several personally symbolic bronzes—*Walking Ball*, 1959 (pages 132–33), two objects called "Ovaloids," 1959 and 1962 (page 95), and the monumental *Obelisk*, 1961–62 (pages 128–29).

Each of these objects, referred to later as a "series," involved phallic or uterine imagery that seemed to be deliber-ate Freudian symbols of "polymorphic perversion," castration, and other condensed violent/erotic associations. At the time, she was close friends with the sculptor Michael Lekakis, whose distorted erotic forms may have emboldened Vollmer to create several assertively symbolic objects of her own. Leo Rabkin remembers the late fifties as a period when Vollmer was actively negotiating what direction her art would take, and that

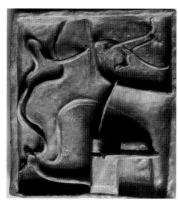

she was influenced by Lekakis, who "thought that Ruth really was a surrealist."[33] The highly fetishistic floorbound *Walking Ball* is an aberrational piece in her œuvre that perhaps emerged most directly from the influence of Lekakis, echoing the absurdist phallic imagery he commonly employed in sculptures like *Phytroma*, 1947–55 (page 94). Not plinth-bound but activating the gallery space in which it was exhibited, the potentially mobile *Walking Ball*—described by one critic as "the soul of geometry out on a whimsical stroll"[34]—with its tumescent legs, is an active male presence amidst the surrounding anchored, passive (and hence symbolically female) sculptures. Indeed, the perverse appendages of the blithely strolling tripod are endangered by the waiting *vagina dentata* of the "Ovaloids" (center and foreground).

Though Vollmer's surrealism rarely suggested potential physical pain as did Giacometti's—exemplified by the dead-pan castration demonstrated in his *Suspended Ball* of 1930–31—the predatory "Ovaloids" were an exception. In 1959 and 1962, Vollmer cast two elliptical shells; a rounded end of each egg form is sliced-off, revealing an organic efflo-rescence within the cavity. Typical of her bronzes of the early sixties, the ovaloids' external surfaces record the rough hewing of the wax from which they were cast, avoiding preciosity and creating the illusion of a weathered surface. Yet, with the "ovaloids," this expressive aging and fictive interior space are pitted against rational geometry. A contradiction between ideal forms—ovals, spheres, cubes—and contained eroticism would emerge in Vollmer's work of the sixties, though nowhere so overtly stated as in the "Ovaloids."

The inside of these faux-prehistoric eggs is fascinating and repellent. What are called "hammers" in the case of one (page 95) resemble fungi thriving in a dank space. The fungi-forms or "paddles" sprout from the interior walls of the ovaloid shell—disturbing because of the vivid womb metaphor and subsequent parasitic or alien identity of the growths. The "hammers" may also reference Arp's surrealist *fleur marteau* theme, so called because the shapes pulled from his subconscious mind appeared a cross between flow-ers and hammers. In any case, the hammers, and spadelike paddles of the "Ovaloids" line menacing orifices in a classic symbol of castration anxiety.

In the installation view of Vollmer's 1963 show at the Betty Parsons Gallery, the "Ovaloids" are oriented horizontally and displayed on plinths at midriff level. However, viewers were invited to upturn and reorient the ovaloids, in a continu-ation of her long-standing interest in tactile sculpture. Vollmer

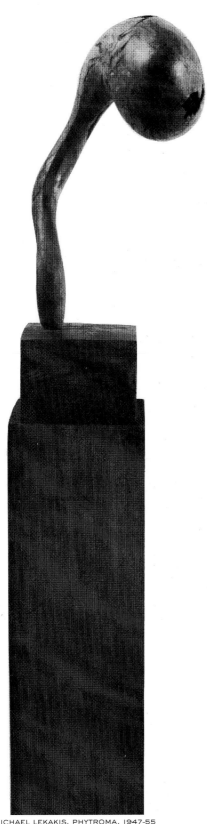

had rarely produced unitary, static objects—her sense of play and interactivity, in which the spectator was a participant, led to objects that, by the sixties, were often comprised of multiple pieces with numerous possible configurations. These objects eschewed the distanced appreciation of an anonymous spectator; rather, the spectator was necessary to activate the objects. Only with the spectator's help could the "Ovaloids" blossom, migrating in sequential photographs from horizontal to upward-facing, like a flower pivoting with the sun.[35]

Also captured in the 1963 installation view is the model for *Obelisk*, a massive bronze sculpture that Vollmer would designate "the culminating piece in the series" of "fragments towards the sphere"—a series that contained the "Ovaloids" and *Walking Ball*, sculptures also "related to the sphere."[36] Given pride of place in this series, the importance of *Obelisk* was demonstrated in other ways as well—Vollmer posed for photographs with the sculpture and asked that it be displayed "on its legs without a base, because my idea was that it is life size, being also an alter-ego"[37] (opposite). Weighing over five hundred pounds and measuring fifty-seven inches in height, it was among the largest object that Vollmer ever produced.

The form of an ancient Egyptian obelisk is augmented with legs and five compartments, or "shelves," housing five variations on the sphere. The bottom sphere is the largest and is distorted by a pendulous bulge, while the middle sphere is a hollow bronze shell (an ovaloid without "teeth"), and the top and most spherical can be removed from the obelisk. As Vollmer described the sculpture in a 1965 statement,

> *Obelisk* relates the sphere to the square. It has [five] rising compartments that are open along the back; in and through them are spherical forms. (The smallest sphere could be taken out of the obelisk and contemplated.)[38]

If *Obelisk* is open along the back, then the frontal view reveals only partial glimpses of the sculpture's complexity: Two small portholes open to the bottom and third compartments. On the left- and right-hand sides, symmetrical "pockets" open onto the compartment, second from the bottom, containing two spheroids. The top two compartments have no pockets at all. *Obelisk* is a riddle of partial disclosure and limited views, offering dramatically different information depending on the viewer's perspective.

The large scale and "monumental" significance of a traditional obelisk are undermined by the odd and imperfect shapes contained in the chambers of Vollmer's human-scale structure, the stressed patina of the bronze surface, and its

RUTH VOLLMER. OVALOID WITH HAMMERS, 1959–62
BRONZE, 10.5 X 11 IN. (26.7 X 27.9 CM), DIAM. 8 IN. (20.3 CM)
SUSAN HORT, NEW YORK
PHOTO HERMANN LANDSHOFF

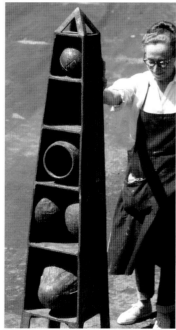

RUTH VOLLMER WITH OBELISK, 1962
BRONZE, 66.9 X 13.9 X 14.5 IN. (169.8 X 35.3 X 36.9 CM)
SMITHSONIAN AMERICAN ART MUSEUM,
WASHINGTON, D.C. GIFT OF ERIC F. GREEN

RUTH VOLLMER. UNTITLED (ELLIPSOID), 1960
BRONZE, 10.3 X 9.9 X 8 IN. (25.8 X 25 X 20.3 CM)
THE MUSEUM OF MODERN ART, NEW YORK.
GIFT OF MR. AND MRS. LEO RABKIN
© SCALA/ART RESOURCE, NEW YORK

touchability. Removing and handling the top spheroid generates a sense of intimate physical connectedness and exchange that art rarely requires. *Obelisk*'s compartments contain blunted, exaggerated reproductive organs that hover between the explicit and the abstract. In the photograph of Vollmer standing behind *Obelisk*, her "alter-ego," it becomes obvious that the sculpture mirrors the body. Yet, while its compartments and spheroids seem to correspond to bodily cavities and organs, they are both female and male. In Vollmer's abstraction, the erotic seems to lose its articulation of gender. Compressed symbols solicit associative responses: The bulging bottom mass is phallic and pregnant, while the open sphere is both orifice and empty womb, and the top sphere, simply a sphere, represents the conceptual and rational—it can be "taken out of the obelisk and contemplated." As critic Lucy R. Lippard wrote in 1966, "Ideally, a bag remains a bag and does not become a uterus, a tube is a tube and not a phallic symbol, a semisphere is just that and not a breast."[39] This theory of "erotic abstraction" that Lippard developed in relation to the work of Hesse also clarifies the logic of Vollmer's geometry, which can provoke and sustain multiple readings. By the early sixties, her use of rational forms like the sphere to suggest eroticism and subjective expression resulted in objects that were both revealing and resistant, laden with meaning but opaque.

The hemisphere (or semisphere) and sphere appear together in *Cluster About Hemisphere*, 1964 (pages 130–31), as ambivalent symbols and simply as their geometric descriptors. This mutable sculpture has no privileged arrangement, but is expressed in serial configurations of the four hollow bronze balls inhabiting, or in proximity to, their hemispheric base. There are virtually unlimited variations that *Cluster About Hemisphere* can assume, and by implicating the viewer as agent in the creation of the sculpture, its symbolic meaning becomes a matter of complicity as well. An individual encountering this sculpture takes on both passive and active roles—spectator and creator—suggesting further-reaching, and more complex, implications of Vollmer's hybrid objects. With its form, and even its authorship, in flux, how does one arrive at a stable designation of meaning? Such intentional diffusing of authorship and interpretive significance might be seen as an artistic strategy elicited by the social and political circumstances of Vollmer's lifetime: to preserve and express identity, while simultaneously shielding it from an unsympathetic hegemony.

Obelisk represented a threshold from which Vollmer would

depart in the direction of restrained, geometric forms that were less indebted to surrealism but still evocative, in the manner of *Cluster About Hemisphere*. Leo Rabkin remembers that

> I told her that she was far, far, far from being a surrealist, that her real angle should have been on geometric forms. And I had a big battle with her. I'm very glad that I did. That's when I brought her the first piece of wax.[40]

Vollmer's major shift to geometry did not occur until 1963, the same year Rabkin became president of the American Abstract Artists (AAA) group and formally extended membership to Vollmer. Since the forties, the organization had been under the long shadow of neo-plasticism and Mondrian. Largely without a program by the sixties, those belonging to the AAA produced hard-edged paintings and, like Rabkin himself, geometric sculptures. As Vollmer's friend Sol LeWitt would later note, he found affiliation with the group acceptable in the mid-sixties because it had "nothing to do with Dada, nothing to do with Pop, nothing to do with surrealism...."[41] The AAA, as a haven of pure abstraction informed by de Stijl and the constructivists, had stylistic interests in common with minimalism, though the conceptual and historical context of minimalism was remote.

It was around 1959 when Rabkin argued for geometry and against surrealism, and brought Vollmer a hunk of wax. It is not clear whether his argument initially held sway, but Vollmer made a grapefruit-size spheroid out of the wax on this occasion, using strips of the material to build up a rounded shape instead of simply forming a ball. She threw this first attempt in the trash can, but Rabkin and his wife, Dorothea, fished it out—an action reminiscent of Vollmer's retrieval of the Giacometti figurine. The Rabkins had the salvaged wax orb cast in bronze; Rabkin recalls that, upon seeing the bronze, his impression was that the seams and complex surface made it seem "very light."[42]

Vollmer would return to this method of wrapping wax strips for the spheroids placed inside *Obelisk*, and in the case of a 1960 bronze acquired by The Museum of Modern Art (page 95). Here, bands of bronze bind an oblong core and their highly visible seams are a record of the object's construction. The resulting ellipsoid is comprised of a network of planar surfaces. This application of wax strips, in which the elliptical surface is as much flat as it is rounded, suggests that Vollmer was attentive to the principles of analytic cubism (and perhaps thinking of Picasso's plaster and bronze heads from 1909, in which he experimented with translating pictorial dimensions into the round). The technique related to Vollmer's fascination with melding disparate formal systems—geometric and biomorphic, planar and volumetric, cubic and spheroid, solid and open—resulting in hybridized objects of flexible identity.

The sphere originated in Vollmer's œuvre as an expressive symbol with—as Hermann Vollmer might have pointed out according to his Freudian interpretive model—an "affinity to the unconscious mind and to dream life." The "Ovaloids," *Walking Ball*, and *Obelisk* all reflect a modernist equation of art and subjectivity, the kind of surrealist engagement with psychic themes that preoccupied European artists, including Giacometti, during and after World War II. The sphere proved to be remarkably flexible; it was the basis for personal and eccentric objects, an expressiveness that in turn disappeared into impersonal, theoretical variants on the sphere. In the mid- and late sixties, her use of the sphere extended art into systems of knowledge based on fixed laws, including math and physics. Formerly the foundation for imagined forms that suggested perversions and desires according to the Freudian morphology of surrealism, the sphere became a mathematically derived concept—the basis for objects LeWitt called "not sculpture" but "ideas made into solid forms. The ideas are illustrations of geometric formulae; they are found ideas, not invented, and not changed."[43]

Vollmer answered minimalism's call for "rational" forms with pieces such as the *Pseudosphere*, 1969 (page 156), a theoretical construction defined by the mathematician Bernhard Riemann as "a surface of negative curvature." Literally a "false sphere," it demonstrated a theoretical construct of the sphere's curvature extended to infinity. Her friend Mel Bochner promoted art arrived at by "a numerical or otherwise systematically determined process" as a means of averting self-expression by drawing on universal concepts.[44] But unlike most sculpture associated with minimalism—for instance, LeWitt's exemplary modular structures—Vollmer's "systematically determined" objects continued to draw on the sphere. While the sphere functioned as a minimalist object, it also signified difference in the context of that milieu. As Lippard noted later, within minimalism, both Vollmer and Hesse "had a sympathy for the biological which the others generally denied." Both "used spheres and compartmentation devices—boxes with things inside" that LeWitt and Bochner "would have thought...'too sculptural, too associative.'"[45]

Looking once more at the photograph of Vollmer's 1963 show at the Parsons gallery, her first bronze orb appears amid

the array of eccentric shapes. Within the composition, it is located at the traditional vanishing point from which the other pieces in the room appear to radiate. While it is perhaps the most unremarkable object in this photograph, and the smallest, its discursive role overshadows its modest form. As sculpture, tactile plaything, mathematical formula, and eternal symbol ("the dimension of time is probably also enclosed" in the sphere, she noted), it came to represent the manifold dimensions of Vollmer's identity and the contradictory narratives of her œuvre.

Notes

This essay was written in residence at the Smithsonian American Art Museum in Washington, D.C., with the support of a Douglass Foundation Predoctoral Fellowship. I am indebted to the museum and to my colleagues in the fellowship program.

1 "Music in Wire: Ruth Vollmer's Four-Dimensional Displays," *Interiors* 106, no. 9 (April 1947): 153. Mannequins of this period were typically constructed of papier-maché–covered chicken wire.
2 *Interiors* was a prominent industrial- and interior-design periodical, to which Andy Warhol contributed free covers in the fifties. Its editor, Bernard Rudofsky, curated design and fashion-related exhibits for The Museum of Modern Art. Ibid., p. 152.
3 Edith Burckhardt, "Ruth Vollmer," *ARTnews* 59, no. 4 (summer 1960): 22.
4 When Betty Parsons distributed a bibliography of Vollmer in the mid-sixties, the first entry was not the *Interiors* tribute but a 1965 article for *Art International* by the artist's friend B.H. Friedman that mentions nothing of her vibrant design career of the forties; see "The Quiet World of Ruth Vollmer," *Art International* 9, no. 12 (March 1965): 26–28.
5 Ruth Vollmer in conversation with Colette Roberts, "Meet the Artist" adult education program, New York University, Fall 1970; audiocassette transcript, p. 2. Colette Roberts Interviews with Artists, 1961–1971, Archives of American Art, Smithsonian Institution, Washington D.C.
6 "Music in Wire," p. 152.
7 "Child Specialist Here," *The New York Times*, December 10, 1935: 30.
8 Hermann Vollmer, "Jealousy in Children," *The American Journal of Orthopsychiatry* (October 1946); quoted in "Jealous Child Is in Need of Special Care," *Chicago Daily Tribune*, February 28, 1948: 12. Vollmer's findings were reported in the popular media, including *The Chicago Tribune* and *The New York Times*. Reflections on adult emotional states appear in Hermann Vollmer, "Tonic for the Unhappy" (review of Martin Gumpert, *The Anatomy of Happiness*), *The New York Times Book Review*, August 19, 1951: 177.
9 "Music in Wire," p. 100.
10 Vollmer's friends Dorothea and Leo Rabkin were given a small mesh dog that Vollmer told them was made in Germany; though this piece could not be found at the time of our interview on August 13, 2004, in New York, they believe it is still in their possession.
11 "Music in Wire," p. 100.
12 The photograph is in the Ruth Vollmer Papers, 1939–1980, Archives of American Art, Smithsonian Institution, Washington, D.C. (hereafter, RVP).
13 "Preliminary Course: Albers," in Herbert Bayer et al., eds., *Bauhaus: 1919–1928* (New York: The Museum of Modern Art, 1938), p. 116.
14 Ibid.
15 "Music in Wire," p. 100.
16 Ruth Vollmer, interview with Susan Carol Larsen, New York, January 30, 1973. In Susan Carol Larsen, "The American Abstract Artists Group: A History and Evaluation of Its Impact on American Art" (Ph.D.

diss., Northwestern University, 1975): 619.
17 Hesse took notes in her journal while reading Lucy R. Lippard's essay "Eros Presumptive," first published in *The Hudson Review* (spring 1967). Eva Hesse Papers, Oberlin College, Oberlin, Ohio.
18 Swenson/Rabkin interview, 2004.
19 Ruth Vollmer and B.H. Friedman, handout prepared for the tenants of 575 Madison Avenue, New York, 1950. RVP.
20 Ibid. The full quote, from Eliot's "The Love Song of J. Alfred Prufrock," reads, "Oh, do not ask, 'What is it?' / Let us go and make our visit."
21 Larsen, "The American Abstract Artists Group," p. 619.
22 According to artist Mary Callery, who knew Giacometti in Paris, "'if you handle them they become dust!'" Quoted in ibid, p. 620.
23 "For Your Information: Vollmer's Ceramic Studies," *Interiors* 114, no. 11 (June 1955): 18.
24 Dorothea and Leo Rabkin own two of Vollmer's terra-cotta pieces from the fifties: a relief and a cagelike construction titled *House*. B.H. Friedman owned a terra-cotta relief that was accidentally destroyed. The low-firing technique resulted in a friable product, and many of the reliefs have not survived.
25 "For Your Information," p. 18.
26 Ruth Vollmer, handwritten teaching notes, undated. RVP.
27 Jean-Paul Sartre, "The Search for the Absolute," in *Alberto Giacometti: Exhibition of Sculptures, Paintings, Drawings* (New York: Pierre Matisse Gallery, 1948), p. 16.
28 "Reviews and Previews: New Names This Month," *ARTnews* 59, no. 4 (summer 1960): 22.
29 B.H. Friedman, interview with the author, New York, September 25, 2004.
30 Hermann Vollmer, "A Wide Roving Intellect" (review of Robert Lindner, ed., *Explorations in Psychoanalysis*), *The New York Times Book Review*, January 31, 1954: 4.
31 "Vollmer's Ceramic Studies: From Wire Display to Clay Relief," *Interiors* 114 (June 1955): 18.
32 "Noted Physician Is Suicide Here," *The New York Times*, October 12, 1959: 27.
33 Rabkin/Swenson interview, 2004.
34 *Arts Magazine* 37, no. 7 (April 1963): 6.
35 The "Ovaloids," as well as the 1962 bronze *Obelisk*, gave vastly different impressions depending on the spectator's vantage point, and were photographed from many angles. "Kinetic sculptures" by Naum Gabo and Antoine Pevsner—so called not because they moved but because they presented radically different information depending on the viewer's vantage point—were photographed sequentially in a similar manner for the catalogue of the 1948 Museum of Modern Art exhibition *Naum Gabo–Antoine Pevsner*. This refusal to select a definitive angle surely appealed to Vollmer, who owned this catalogue.
36 Ruth Vollmer, artist's statement, 1965. RVP.
37 Ruth Vollmer, letter to Harlow Carpenter, Bundy Art Gallery, Waitsfield, Vt., May 11, 1963. RVP.
38 Vollmer, artist's statement, 1965.
39 Lucy R. Lippard, "Eccentric Abstraction," reprinted in *Changing* (New York: Dutton, 1971), p. 100.
40 Rabkin/Swenson interview, 2004.
41 Larsen, "The American Abstract Artists Group," p. 632.
42 Swenson/Rabkin interview, 2004.
43 Sol LeWitt, "Ruth Vollmer: Mathematical Forms," *Studio International* 180, no. 928 (December 1970): 256–57.
44 Mel Bochner, "Serial Art, Systems, Solipsism," *Arts Magazine*, 41, no. 8 (summer 1967). Reprinted in Gregory Battcock, ed., *Minimal Art: A Critical Anthology* (New York: Dutton, 1968), p. 101.
45 Lucy R. Lippard, "Intersections," in Granath, Olle, ed., *Flyktpunkter/Vanishing Points* (Stockholm: Moderna Museet, 1984), p. 20f.

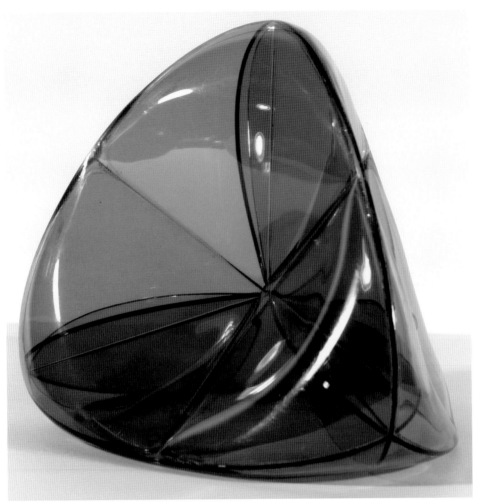

RUTH VOLLMER. STEINER SURFACE, 1970
GRAY TRANSPARENT ACRYLIC, DIAM. 12 IN. (30.5 CM)
COLLECTION DOROTHEA AND LEO RABKIN, NEW YORK
PHOTO OLIVER KLASEN © ZKM KARLSRUHE

NAUM GABO. TRANSLUCENT VARIATION ON A SPHERIC THEME, 1937–51
PLASTIC, 22.4 X 17.6 X 17.6 IN. (56.8 X 44.8 X 44.8 CM)
© THE SOLOMON R. GUGGENHEIM FOUNDATION, NEW YORK

THE REENCHANTMENT OF THE WORLD: RUTH VOLLMER'S SCIENCE
BY ANNA VALLYE

It was what everyone seemed to remember best about her. Friends and acquaintances who had frequented the small "salon" in Ruth Vollmer's New York apartment came away with an impression of a life held vaguely out of time. In the pages of her Jack Tilton Gallery memorial retrospective catalogue,[1] some recited the various accoutrements of a pre–World War II European past that crowded her rooms: the Hermann Herrey–designed furniture, the dishes from Vallauris, the "beautiful old St. Petersburg silver sugarbowl with cover and key-in-the-lock,"[2] the old books on science and archaeology. And, of course, the art: Giacomettis, Klees, Mirós—works by artists whom, in some cases, she had known in that other life on the Continent. Alongside these, "fragments of antiquity": Etruscan figurines and Greek vases, interspersed with fossils, pebbles, and seashells on a mantel.[3] "For me to come in from New Jersey, and [to] feel this deep culture,"[4] Richard Tuttle exclaimed. In this museum of memory, which transfixed her young art-world friends, Vollmer was entirely in her element. "Ruth Vollmer fades slightly into her surroundings," wrote Bernard Friedman. "She becomes part of the gentle ambience which she has created. She is there no more or less forcefully than the shells, plants, pebbles, bits of wood and pottery and plaster: a sketch, maybe only the line of a pencil on paper."[5] These recollections portray experiences both warmly reverent and evanescent, almost elegiac; encounters in a "world of whispers"[6] cultivated by the artist. Susan Carol Larsen, mindful that she was writing in memoriam, put it best:

> [Vollmer] lived...with small exquisite antique works of art, gentle reminders of the now dreamlike past of mankind. I often pondered her small sculpture of slumbering, smiling Etruscans adrift in the ocean of death reclining on their handsome couches holding each other fondly. Such a vision seemed so benign, so natural to her, I often think of her that way now.[7]

One wonders if the ambience of her world was the same through the tumultuous sixties when she was making her now best-known art.

The reminiscences gathered in the Tilton Gallery catalogue work to suspend for a moment the historian's instinctive distrust of too-direct parallels between the person and the work. Rightly or not, a quality of anachronism has been written into the story of Vollmer's career. Although her involvement in art preceded her arrival in the United States in 1935, the most significant critical statement on her work was written in 1970, by a fellow artist more than a generation younger than herself.[8] Sol LeWitt's article in *Studio International* is a truly remarkable example of economy of means: In just nine of his trademark streamlined paragraphs, LeWitt brought Vollmer's work of the sixties firmly into the fold of the previous decade's avant-garde, securing for it a pedigree, and a frame of reference, to which her place in history remains anchored. The discussion involved the mathematically inspired constructions Vollmer started producing in the mid-sixties. At the turn of that decade, she was already in her sixties, and in the twilight of a quiet career as a designer of high-end retail window displays, children's toys, and objets d'art—a résumé now swept under the carpet as Vollmer emerged in the guise of a full-fledged minimalist artist, a like-minded colleague of LeWitt himself.[9] His opening statement confidently plotted this allegiance: "These pieces are not sculpture; they are ideas made into solid forms."[10] The formulation invoked the radical project associated with minimalist art, a categorical break with the conditions of modernist sculpture: its medium-specificity, its formalist aesthetics, its orientation to the visual. But if, repositioned by LeWitt, Vollmer could be understood to participate in this project, it was, from the perspective of her own career, as a latecomer—the asynchronous discovery of a new artistic faith as illogical as a sudden conversion.

The Tilton Gallery reminiscences underscore the disjunctive nature of this proposition, pulling the perceived context of her life and work relentlessly back into that "dreamlike past" of prewar European artistic culture. Indeed, Vollmer's allegiances prior to her sixties work appear to have been securely within the ranks of European modernism; among the artists whose influence she cites are Alberto Giacometti, Paul Klee, and Hans Arp. Of course, one might rightly observe, the particular kind of faith demanded by the avant-garde was never a friend to historical continuity; it is synonymous with a radical break and a categorical rejection of the past. But curiously, Vollmer's case presents itself as a break that came too late. We might say its strange temporality parallels the condition ascribed by Hal Foster to the late-twentieth-century avant-gardes (albeit, to parallel here is not necessarily to repeat). In a book that takes sixties minimalism as its reference point, Foster borrows Freud's concept of "deferred action" (*Nachträglichkeit*) to theorize the neo-avant-garde's perceived historical belatedness.[11] In response to Peter Bürger's influential condemnation of the avant-garde movements of the second half of the twentieth century as a failed repetition of the project formulated by the historical avant-gardes of the twenties,[12] Foster proposes that, rather than negating through repetition the efficacy of the original, these so-called neo-avant-gardes "comprehend" it for the first time through a form of "deferred action," much like an original trauma, in the Freudian view, is only registered in the consciousness through a subsequent event that translates it. The analogy that invites itself in Vollmer's case is perhaps too literal: Could it be that her encounter with the LeWitt circle offered her the insight brought forth in the repetition that, as witness to the original traumatic rupture of the historical avant-garde, she was unable to obtain? As an explanation of the personal belatedness of Vollmer's career this must remain hypothetical (and that only if one accepts the current privileging of her "second career" over her first). Rather, we might lean upon Foster's notion of "deferred action" to approach the rupture written into her project as a historical belatedness, and to propose that upon the ground of her colleagues' neo-avant-garde project, Vollmer's art projects a rearward pull, working to disinter a very recent past—an archeology uniquely able to confront the contradictions embedded within a moment that has just entered history.[13] Her work, therefore, should not be too quickly solicited into the minimalist avant-

garde. If the deferral it performs is not reducible to that of the younger artists, it might cast light on another aspect of the historical unconscious of the sixties.

Consider Vollmer's *Steiner Surface* of 1970 in relation to Naum Gabo's *Translucent Variation on a Spheric Theme* (page 98) of 1937. The latter was reproduced in the catalogue of the 1948 "Naum Gabo–Antoine Pevsner" exhibition at The Museum of Modern Art, New York (MoMA),[14] the same catalogue that Vollmer brought out to show Colette Roberts's students during a taped "Meet the Artist" program at New York University in 1970.[15] As the students were admiring the "simplicity of forms" in Vollmer's own work, the artist mentioned Gabo, whose sculpture seemed to her related to a group of string and sheet-metal models used in universities to study the graphic products of function mathematics in the early twentieth century. She had found a 1902 catalogue of these models at Columbia University, and managed to see the models themselves, although they were no longer in use by the mathematics department. In the MoMA catalogue, she read that Gabo, who was educated as an engineer, had "learned to make three-dimensional models illustrating the exact measurements of mathematical formulas."[16] The coincidence excited her, and she even wrote to Gabo (on the recommendation of Jock Truman), eager to confirm a shared interest.[17] That day with Roberts and her art class, Vollmer leafed through the catalogue, pointing out affinities: "Here is this form, see, this is so similar to some of the [mathematical] forms. It's almost the same. There is one even more—this one here—a beautiful one."[18] Might it have been the *Translucent Variation on a Spheric Theme* that she singled out? It is not one of those steel-and-wire forms common among Gabo's sculpture that appear to emulate the models Vollmer described in method of construction. Although this one is in plastic, the radiating lines etched within it recall the forms of his wire construction of 1937.[19] And the shape is certainly quite similar to Vollmer's *Steiner Surface*, the work that she introduces in one of her artist's statements by mentioning the "Steiner surface" mathematical model she had found at Columbia.[20] While the similarities are striking, however, so, too, are the differences. Vollmer's *Steiner Surface*, in fact, *re-creates* the original in a new material. It is an accurate graphic representation of the mathematical formula for the Steiner surface. The work seems invested with the deadpan literalism privileged by LeWitt's verdict: "They

are ideas made into solid forms. The ideas are illustrations of geometric formulae; they are found ideas, not invented, and not changed."[21] The rejection of subjective investment and the interrogation of formal aesthetics, all-important to the minimalist, are both quite pointedly nonissues in the Gabo work. Though it echoes the elegant swelling trajectory of the Steiner surface, it is obviously not its graphic representation. The rhythmically rising and falling curves, cut into space by the gleaming edges of the plastic form, immaterially transparent but for these markers of light, appear rather as a variation on the theme, as Gabo puts it, an almost musical expression of a mathematical concept. It is certainly "beautiful," one must agree: It has the beauty of a flight into the metaphysical that is an unmistakable attribute of modernist abstraction. The work exemplifies that stubborn allegiance to the "speculative and spiritual essence of art," the ideal of "pure art," as the 1948 catalogue explains it[22]—set as it was against those in the Russian constructivist avant-garde who would advocate a radical redefinition of the artwork—that finally drove Gabo out of the Soviet Union in 1922.[23] While the minimalist neo-avant-garde of the sixties looked to the constructivists, it was precisely those models of rupture developed by Gabo's more radical colleagues, such as Tatlin and Rodchenko, that these artists sought, because it was a way out of the perceived impasse of modernist aesthetics that they were after.[24] Despite Gabo's constructivist affiliations, he cannot be considered a member of the historical avant-garde whose critical renewal constitutes the "deferred action" of the neo-avant-garde. Gabo, as we see, remained an avowed modernist.[25]

And yet it is his work that Vollmer adopts as a point of reference. One might say, of course, that Gabo is rethought here so completely as to constitute a comprehensive reversal of his project. This is almost the case with the two artists' respective relationship to the mathematical model: the former adopting it with the implied intent to accurately reproduce, the latter incorporating it as an inspiration for a subjective aesthetic. Almost; if it were only that Vollmer's work was indeed a readymade, in the sense that LeWitt wants to enlist for it. However, in the case of the Steiner surface, the direct, scientifically objective transcription of the mathematical concept already existed. Vollmer saw it and described it in detail to Roberts. It may have been one of the mathematical models made of "plaster, mainly"; or one of those sheet-metal

and string structures—"with holes so that you can pull the strings through and make the actual shape out of twisted string, straight string, whatever it is"[26]—that Gabo transformed into shimmering nets of spring wire (below). Vollmer's *Steiner Surface* belies their straightforward functionality, their primitive simplicity of construction (so that even math students could make them[27]), and their unselfconscious neglect of their own aesthetic potential. The fact is that the *Steiner Surface* is quite beautiful, too. Dipped in its integument of translucent acrylic, which clings lightly and softly to the ribs of the form, it is just as delicately refined and as seemingly immaterial an object as the Gabo. And it has an insistently *organic* quality—like the tense, frail surfaces of soap bubbles.

It is this organicity, so foreign to the conceptual and aesthetic project of minimalism, that Vollmer and Gabo share. Indeed, although Vollmer may never have known this, she had something besides the mathematical models in common with the artist she so admired. In London, where he spent the war years, Gabo befriended the art historian Herbert Read, who introduced him to D'Arcy Wentworth Thompson's canonical work in biology, *On Growth and Form* (1917).[28] There he would have found a morphological comparison between the skeleton of a microscopic organism, the *Callimitra agnesae* (page 102), and a specific arrangement of film that occurs when a tetrahedral wire cage is dipped into a solution of soap and water (page 105). Both form a small bubble at the heart of several intersecting planes. It is possible to see an echo of both these images, distant but discernible nonetheless, in Gabo's *Translucent Variation*: its incisions that recall the skeletal lattice of the *Callimitra*, and the small nuclear

MATHEMATICAL MODELS AT THE INSTITUT HENRI POINCARÉ, PARIS

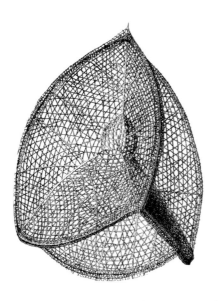

NASSELLARIAN SKELETON, CALLIMITRA AGNESAE
FROM D'ARCY WENTWORTH THOMPSON, ON GROWTH AND FORM (1917)

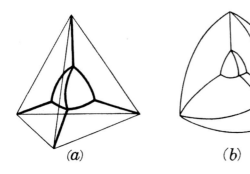

(a) (b)

DIAGRAMMATIC CONSTRUCTION OF THE WIRE-CAGE SOAP FILM
EXPERIMENT AS HOMOLOGOUS TO CALLIMITRA AGNESAE
(A) A BUBBLE SUSPENDED WITHIN A TETRAHEDRAL CAGE
(B) ANOTHER BUBBLE WITHIN A SKELETON OF THE FORMER BUBBLE
FROM D'ARCY WENTWORTH THOMPSON, ON GROWTH AND FORM (1917)

hollow toward which they radiate.[29] Vollmer, too, minded Thompson's bubbles. Following the 1951 exhibition dedicated to Thompson at the London Institute of Contemporary Art, where Read was the director, *On Growth and Form* began to enjoy a degree of popularity among remarkably diverse groups of artists and architects in the fifties and sixties.[30] Vollmer was among those who took interest in the book. In an undated note, she recorded the definitions of two function graphs of spiral curves, called an Archimedes spiral and a logarithmic spiral, and took care to record the source—"D'Arcy W. Thompson, *On Growth and Form*" (opposite). Generally speaking, Thompson's argument was that the morphology of living beings—if not yet their physical life processes—was subject to a finite set of laws, which determined the alteration of their shapes in growth, and which could be expressed mathematically. Among his most familiar examples was that of the nautilus shell (page 104), whose spiral form he considered to be "peculiarly adapted to mathematical methods of investigation."[31] The shell grows incrementally around the body of the mollusk and—to the morphologist's delight—each successive stage of growth is registered intact on its calcified surface. Thompson measured these whorls and found them to increase in breadth from the innermost (and oldest) layer outward in a constant ratio. If one were to imagine this heart of the spiral as the center of a circle whose radius grows with a steadily increasing velocity, the distance from the center of each new whorl thus demarcated would increase in geometric progression.[32] Therefore, the nautilus shell could be described as a logarithmic spiral—a notion that Vollmer jotted down in her notebook. But there was more. Such "generating curves" could be found to exist in a vast range of growth velocities and angle dispositions, producing ratios as varying as the imagination. Therefore, all the conceivable shells presented one with "a certain definite type, or group of forms, mathematically isomorphous, but presenting infinite diversities of outward appearance."[33] In Thompson's view, such mathematical constancy in nature was attributable to the relationships of forces—the pull of gravity, the growth of the columellar muscle—whose tensions work upon the surfaces of things, shaping and reshaping. Not a simple form after all, his snail-shell spiral was, rather, a visual register of tensions and interactions, or a "diagram of forces."[34] Thereby, the snail shell was comparable to the film of soap and water: The latter was

also formed by a dynamic of physical forces registered on its surface—a fact accounting in turn for the isomorphism under given conditions between the soap film and the *Callimitra* organism.

The spiral emerged in Vollmer's work around 1973, and it did so in an apparent revenge of the figurative. The giant hermit-crab cap of *The Shell, II*, 1973 (page 165), or the equally crustacean *Large Archimedean Screw*, 1973 (page 104), is unapologetically mimetic. There is the beached organism of *The Shell, I*, 1973 (pages 172–73), splayed out on its dissection table. Even the slender curlicue of the acrylic *Spiral Base* (page 104) could bring forth a veritable flood of associations from one observer: "space-eaten Giacometti people walking across a plaza, Indian Pipes growing up out of the forest floor, Morning Glory buds and barber poles."[35] Was this a regression, a premature exhaustion? A betrayal by an artist brought into the spotlight by the critical efforts of young avant-garde friends to present her work as programmatically lacking in just this kind of expressive connotative qualities? Was it not meant to embody the dispassionate staccato of LeWitt's sentences, strung along like the proof of a theorem:

> These pieces are not sculpture; they are ideas made into solid forms.
>
> The ideas are illustrations of geometric formulae; they are found ideas, not invented, and not changed....
>
> The geometry is only a mental fact.
>
> There is a simple and single idea for each form; there is a single and basic material of which the piece is constructed.[36]

But there was Vollmer, on site at the Everson Museum of Art in Syracuse, N.Y., where the spiral-themed works were being exhibited as part of her 1974 retrospective, blowing lyrical bubbles. Surrounded by excited kindergarteners, the artist dipped bronze-wire geometric forms into soap solution, watching the shimmering film stretch in mathematically predetermined planes from wire to wire, break free and sail off into the atmosphere as any commonplace soap bubble would (page 105). A *Syracuse Herald Journal* reporter was there to observe the event, and recorded Vollmer's subtle modification of LeWitt's pithy assessment of her sculptures: "They are found ideas, not invented, and

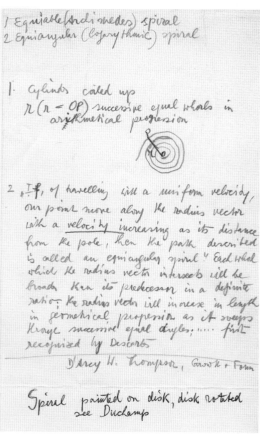

RUTH VOLLMER. NOTES AFTER D'ARCY WENTWORTH THOMPSON, ON GROWTH AND FORM (1917)
RUTH VOLLMER PAPERS, 1939-1980,
ARCHIVES OF AMERICAN ART, SMITHSONIAN INSTITUTION, WASHINGTON, D.C.

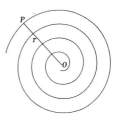

THE SPIRAL OF ARCHIMEDES
FROM D'ARCY WENTWORTH THOMPSON, ON GROWTH AND FORM (1917)

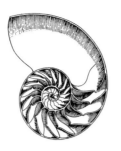

THE SHELL OF NAUTILUS POMPILIUS SHOWING THE CONTOUR
OF THE SEPTA AS A LOGARITHMIC SPIRAL
FROM D'ARCY W. THOMPSON, ON GROWTH AND FORM (1917)

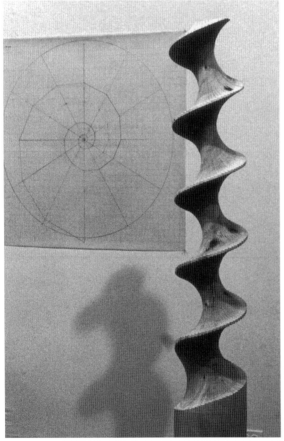

RUTH VOLLMER. LARGE ARCHIMEDEAN SCREW, 1973
WOOD, H. 71.7 IN. (H 182 CM), DIAM. APPROX. 9 IN. (22.9 CM)
JACK TILTON GALLERY, NEW YORK
PHOTO HERMANN LANDSHOFF

RUTH VOLLMER. SPIRAL BASE, 1973
TRANSPARENT ACRYLIC, DIAM. 12 IN. (30.5 CM)
NEW JERSEY STATE MUSEUM, TRENTON, N.J. GIFT OF LEO RABKIN

not changed, *and they relate to our physical universe.*"[37] The soap bubbles, much like the seashells, were another natural phenomenon demonstrating the mathematical constancy of the physical world, exactly as they were discussed in Thompson's book, though now lifted by Vollmer from the domain of natural science and reproduced in the art gallery—a recontextualization that makes these emphatically organic forms speak a language that can almost be recognized as mimetic. An extreme, it should be noted, consistently avoided by Gabo. In fact, Vollmer's work tends toward an impasse between extremes: to be both abstract and organic, "found" and crafted, refined and anti-aesthetic. This oscillation brings to the surface a specific tension in the work. To reach a historical nexus embedded within it, we must examine another set of putative opposites it confronts: art and science.

The soap-film experiment described in *On Growth and Form* is a well-known mathematical investigation of minimal surfaces, invented in the nineteenth century by Joseph Plateau, a physicist. It may have been Vollmer's desire to explore it further that brought her to a popular science book—Peter Stevens's *Patterns in Nature* (1974). According to Stevens, a wire tetrahedron dipped in soap solution allows one to isolate for examination one link of the "minimum network" composed by soap foam—a pattern assumed by its tendency to occupy the least possible surface, forming planes that intersect at 120-degree angles. In films of soapy water, Stevens maintains, the network "manifests its purest form;"[38] but its import lies in the reference it bears to the great mathematical constants of natural form, whose "endless variety is based on one plan,"[39] resultant of those calculable morphogenetic processes discussed by Thompson. It becomes increasingly apparent that Vollmer sought out those scientific texts, which advertised an overarching concept of structural unity in all manifestations of the natural world. Back with Roberts, the Gabo–Pevsner catalogue in front of her, she was searching for that passage from Read's introduction where, she promised, "he says things so much better than I could even think them, about the relation of the artist who [uses] geometric forms and mathematical forms, and what he does and what the scientist does."[40] Having located the reference, she read:

"The particular vision of reality common to the constructivism of Pevsner and Gabo and the neo-plasti-

RUTH VOLLMER ENACTS HER WIRE-CAGE SOAP FILM FORMS, EVERSON MUSEUM OF ART, SYRACUSE, N.Y., 1974
PHOTO HERMANN LANDSHOFF, COURTESY JACK TILTON GALLERY, NEW YORK

cism of Mondrian is derived, not from the superficial aspect of a mechanized civilization, nor from a reduction of visual data to their 'cubic planes' or 'plastic volumes' (all these activities being merely variations of a naturalistic art)"—and this is very interesting—"but from the structure of the physical universe as revealed by modern science. The best preparation for a true appreciation of constructive art is a study of Whitehead or Schrödinger. But it must again be emphasized that though the intellectual vision of the artist is derived from modern physics, the creative construction which the artist then presents to the world is not scientific, but poetic. It is the poetry of space, the poetry of time, of universal harmony, of physical unity. Art—it is its main function—accepts this universal manifold which science investigates and reveals, and reduces it to the concreteness of a plastic symbol."[41]

What Vollmer may or may not have known was that Read was enlisting here for Gabo's work a grounding in specific contemporary developments in the life sciences[42]—developments both artist and critic had a firsthand knowledge of through their contact with some of the scientists who helped set them in motion. During the thirties in London, Read and Gabo met the members of the so-called Theoretical Biology Club—a group of socially engaged scientists established in Cambridge around 1932, whose founders were J.D. Bernal, Joseph Needham, Conrad H. Waddington, and J.B.S. Haldane. The club formed around a shared imperative to develop links between developmental biology, physics, and biochemistry, while challenging the dominant at the time scientific doctrines of mechanism and vitalism. Whitehead, Thompson, and Schrödinger were among their frequent intellectual references. As these scientists saw it, they were working toward what might one day become a unified science of life, encompassing not only its organic and inorganic, but also social, manifestations. The intellectual scaffolding for such an expansive enterprise was the concept of "organism"; and, as Donna Haraway explains in her history of the Theoretical Biology Club, its "central and unavoidable focus" was on form.[43] Although "form" was understood by these scientists in a much more complex way than merely as shape or a distribution of parts, the emphasis of their research on the laws that could describe the generation and maintenance of

form in the organism accounted for their interest in Thompson's morphological theories. It also accounted for their active engagement with visual art.

In 1969, Edinburgh University Press published *Behind Appearance: A Study of Relations Between Painting and the Natural Sciences in This Century* by C.H. Waddington, the developmental biologist and erstwhile member of the Theoretical Biology Club. Arriving thirty years after those initial investigations, the book was, above all, a popularization of a mature and well-established organismic model in the sciences, and a reflection on its relationship to contemporary art. If Thompson, Stevens, and Read confronted Vollmer with arguments belonging to the same school of thought, Waddington would have provided her with a definition of its basic premises.[44] *Behind Appearance* describes the emergence in the second part of the twentieth century of what Waddington calls a Third Science. Drawing on Thomas Kuhn's famous and then recently released *The Structure of Scientific Revolutions*,[45] he describes Third Science as an emerging "paradigm" of thought in which the basic elements of scientific study are no longer isolated interacting entities but properties of organized systems in continuous development. "The concept of organization," Waddington writes,

> has become of focal importance in science, not only in biology but in such branches of physics as deal with the quantum mechanics of molecules, communications theory, and so on. It implies something more than merely reciprocal mutual relationships between the sub-units of the organized entity.... Organization occurs when the relations are of such a kind that they tend to stabilize the general pattern against influences which might disturb it. That is to say, the organization confers on the entity an enduring individuality which a mere assemblage lacks.[46]

Evidently, by 1969 Waddington could claim for the organismic model a remarkably far-reaching significance, and a level of abstraction and precision capable of repeatedly crossing disciplinary boundaries. In fact, as Haraway points out, the paradigm has a complex parentage, possibly traceable to investigations carried out in the first half of the twentieth century in a number of scientific fields and countries.[47] Not only various groups of biologists, but also mathematicians, Gestalt psychologists, linguists, sociologists, and others could lay claim to having participated in

its formulation. In some respects, it was the frequent cross-fertilization of these fields—accelerated around the cusp of World War II—that contributed to the rapid evolution of the paradigm, not to mention the perception of its ubiquity. It certainly looked like the goal of arriving at that "universal manifold" of phenomena accessible to scientific investigation was drawing near.

But something else had occurred in the interdisciplinary evolution of the organismic paradigm in the postwar period. The biologist's characteristic concern with interspecies isomorphisms and the maintenance of *form* in the flux of organic life was supplanted in other disciplines by an emphasis on more abstract structures of self-regulation, or processes of internal cohesion and control accounting for the maintenance of *order* in "systems" whose organicity was now largely metaphorical. Thus, in the hands of the renowned mathematician Norbert Wiener, the organismic model applied to information technology gave rise to the new discipline of cybernetics, which quickly became a key reference for the new sciences. For Wiener, the best analogy to the computer's circuitry was a biomechanical "communicative organism," whose life processes could be described in relation to the laws of thermodynamics.[48] The cybernetics thesis was quickly extended to social theory—the functioning of the "organism" of human society effectively recoded as an exchange of informatic flows.[49] Similar schools of thought were developed elsewhere, as, for example, when the social psychologist Kurt Lewin employed the Gestalt concept of "field" to describe social structures as psychobiological environments, giving rise to a subdiscipline of "group dynamics";[50] or when Talcott Parsons, a Harvard sociologist, defined a society as a self-regulating "total system," able to withstand outside disturbances.[51] Therefore, perhaps an alternative terminology for the Third Science might be more appropriate for the sixties—one formulated by Ludwig von Bertalanffy, a philosophically inclined biologist who coined for it the moniker of "general system theory."[52] In 1969, von Bertalanffy published his own intellectual history of the paradigm, defining it as an "exploration of the many systems in our observed universe" and the study of their "general aspects, correspondences, and isomorphisms."[53] The author described the philosophy of "general systems" as

a reorientation of thought and world view ensuing from the introduction of "system" as a new scientific

paradigm.... The concept of "system" constitutes...a "new philosophy of nature," contrasting the "blind laws of nature" of the mechanistic world view and the world process as a Shakespearean tale told by an idiot, with an organismic outlook of the "world as a great organization."[54]

The "organism" had by now become a "system." In this guise it traveled from the social sciences to the arts.

In *Behind Appearance*, Waddington set out to pave that road. The title—which Vollmer "like[d] very much"[55]—refers rather predictably to the development of abstraction in twentieth-century painting, correlating it to a parallel process of dematerialization in scientific methodology—a transition away from physical entities as subjects of analysis.[56] After a discussion of some more or less familiar landmarks of this history—such as analytical cubism's relationship to the theory of relativity—Waddington arrives at his most innovative formulation when he turns to contemporary science. He reproduces a set of images he considers to be representative of "the shapes of the things with which [contemporary] scientists deal," not with the intent of suggesting mimetic models for the artist, but because "to those of a visualizing turn of mind they may convey the character of Third Science better than many pages of verbal discussion."[57] The images Waddington provides turn out to be diagrams of complex processes plotted with the aid of various computerized imaging devices: a weather map of the Northern hemisphere, for example, calculated from a series of equations describing meteorological phenomena; a field of ultrasound; spectographs of a bird's song and of the word "you" spoken by different people (page 108).

Conceptually incommensurate with such unexpected views as, for instance, may be obtained from a microscope, these images offer nature doubly mediated. Encoded into equations and filtered through the circuits of information technology, these images come up as visual traces of a nature reconceived in its essential structures as a mathematically computable pattern "more [meaningful] than mere appearance."[58] And further, their "meaningfulness," we realize, lies in their submission to a still higher level of mediation: their representation as diagrams of systemic organization. That such is their purpose and their condition of possibility constitutes their claim to "convey[ing] the character of Third Science," or "system theory," as it

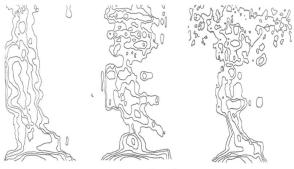

may now be identified. In Waddington's book, Vollmer would have encountered an altogether novel concept of abstraction. No longer was it rooted in the dialectic of essences and appearances that arguably kept modernist abstraction well within the logic of Platonic mimesis. The double mediation of Waddington's images—technological and epistemological—irrevocably severed them from "nature." And yet it was precisely the privileged relationship of art to natural form that, taken for granted by the biologist, made possible his appeal to these images as artistic references. Finally, the effect of Waddington's book was to present the systems paradigm to the artist specifically as *image*.[59] This uncanny transcription of systems logic into image, and of that image into nature, is repeated in Vollmer's works. But insistently, they also register the interferences in that transmission.

Pressed on the subject of those Columbia mathematical models that so intrigued her, Vollmer explained that they were based on "function mathematics."[60] Indeed, the Steiner surface is a graph of a differential equation. It may also be understood as a "system," if one takes von Bertalanffy's definition of the mathematical expression of systems as "described by the theory of differential equations."[61] Vollmer's *Steiner Surface* can be grouped together with her *Spherical Tetrahedron* (page 157) and her *Heptahedron* (left), both of 1970, as a set of topological deformations of polyhedra. Topology—a branch of geometry—concerns itself with relationships between the points of a figure, which remain constant even as the shape of the figure and the quantitative distances between its parts change. Another way of describing this is as the study of topological "invariants," properties of the figure unaffected by distortion. Topology, then, sets up homological equivalences between dissimilar shapes. The tetrahedron, for example, is topologically the same as the sphere, and the heptahedron is topologically identical to the Steiner surface. These are identities of system and not of form, thus topology is related to the theory of complex functions and of groups—also listed by von Bertalanffy as mathematical subsets of general system theory.[62] Vollmer's "shells," like her soap bubbles—inspired as both are by Thompson— are mathematically isomorphous with the rest,[63] a fact only confirmed by the ease with which the artist makes the transition, in conversation with Susan Carol Larsen, from the mathematical models to a group of actual seashells collected on her mantelpiece. As Larsen later reminisced:

Ruth smiled and gently picked up several shells, then turned them around and around in her hands and pointed out a logarithmic spiral common to all of them. I asked out loud how and why they struck us as being so beautiful. Ruth replied, "It just *is* that beautiful because it's *alive*. That's the perfect moral.... Always the same. I have never seen an imperfect one!..."[64]

From bubbles, to Steiner surfaces, to shells—Vollmer's work unfolds through a systematic assembly of that "universal manifold" whose condition as the domain of abstract systemic invariables is assumed as irrevocable and yet, paradoxically, contested by declaring its representational relationship to the natural world. The project appears to depend on two parallel and codependent conditions: recurrence and intelligibility. The emphasis on an almost didactic *visualization* is omnipresent in Vollmer's artist's statements. She adopts as her apparent statement of intention an observation by a writer of a popular mathematics book:

> Hilbert says in the preface to his book *Geometry and the Imagination* that it "should contribute to a more just appreciation of mathematics by a wider range of people than just the specialists...by offering, instead of formulas, figures that may be looked at...."[65]

On the mathematical models, she notes that they "are kept in a cupboard in the Low Library, where nobody ever sees them"[66]—implying for herself a goal to unveil them. Similarly, she writes on an earlier interest: "I am involved with the sphere; exploring it geometrically. I am finding unexpected forms. I suppose they have existed in mathematics before, but they have not been made visible."[67] Her work seems to fluctuate between the didactics of visual demonstration and the aesthetics of visual revelation. The *Large Exponential Tower, II*, 1973 (page 156) sloughs off its transparent layers to articulate the composition of the shell into topologically equivalent spiral envelopes. The transparency of the *Steiner Surface* also, as the artist claims, "make[s] the form easy to comprehend;"[68] but one cannot deny the strong sense of mystery evoked by the smoky color of the acrylic chosen, exposing the parabolic curves of the figure inside as much as it veils them. The enchantment of these forms is rendered a function of their emergence as the visible traces of biomathematical systematicity. This is also the spell inscribed onto their clandestine recurrence. A persistent return of the "same" against a spectrum of formal manifestations, exhibited by topological transformations, also pervades the logic of Vollmer's forms; each recurrence affirms a unity in diversity. "The fantastic thing in nature," she muses on the seashells' logarithm, "is that nature would not be possible unless it could reproduce these over and over."[69] A film of the artist's soap-film performance, made for her Everson Museum exhibition, documents the pull of that "over and over," playing itself out across the polyhedral wire cages, as the bubbles form and break again and again, in the same way, like a visual incantation[70] (page 105).

All this is quite unlike the minimalist preoccupation with serial form. LeWitt's *Serial Project No. 1 (ABCD)* of 1966 (opposite), for example, organizes a fully developed sequence of permutations of two geometrical forms—one enclosed within the other—laid out across four nine-square grids. Here, seriality acts to programmatically dismantle the unity and consistency of the object, instituting in its place a radical fragmentation. The logic of Vollmer's sculptures, on the contrary, is fundamentally synthesizing, as each topological repetition returns the original object in a new form that is nonetheless inviolate in its essential structural identity. Her insistence on making that identity visually intelligible is also contradicted by LeWitt's piece, which—through its dialectic of containment and exposure—institutes a degree of doubt in the visible, as the existence of the concealed object must be inferred, or calculated by reference to its position in the permutation, rather than seen.[71] For Foster, notably, the adoption of a serial paradigm signals minimalism's categorical break with modernism. Seriality, he suggests, expunged the deep-seated humanism of modernist sculpture—residing in the metaphysical claims of pure abstraction as much as in the residual anthropomorphism of gestural expression—"for abstraction tends only to *sublate* representation, to preserve it in cancellation, whereas repetition, the (re)production of simulacra, tends to *subvert* representation, to undercut its referential logic."[72] Foster has in mind Fredric Jameson's discussion of the notion of postmodernism in his "Periodizing the 60's" (1984).[73] He is about to suggest that minimalism, in its break from modernism, "carr[ies] forth" the new socioeconomic stage which Jameson sees as emerging toward the end of the decade.[74] (We might note, then, that Vollmer's 1974

show at the Everson, inaugurating the spiral, coincided with the U.S. withdrawal from Vietnam—one chronological marker proposed by Jameson.) This new order, as per Jameson, takes on the scope of a Third Technological Revolution (whose distinguishing *techné* is computer science and nuclear physics), in which the conquest of nature becomes complete, the spheres of culture and commodity blend indistinguishably, and, following the Marxist economist Ernst Mandel, a "generalized universal industrialization" makes alienation a totality for the first time in history.[75] Jameson's project—and here lies its relevance for Foster—is to show the immersion of intellectual and political culture in these socioeconomic processes, when considered as part of a "unified field theory" of the period.[76] But while the periodizing prefix *post*- intractably adheres in such analyses to the intellectual products of this stage—post-structural, postmodern, postindustrial, postcolonial—within which Foster would ultimately situate minimalism as well, Jameson's discussion becomes most relevant for us when it turns to developments on the other side of the chronological divide.[77] Here, in late-modernist productions as wide-ranging as those of Althusser and Wallace Stevens, Jameson traces the initial response to a recognition of "institution" as a new historical "object," whose problematic is that of "the radically transindividual,"

with its own inner dynamic and laws, which are not those of individual human action or intention...and which will take the definitive form, in competing "structuralism[s]," of "structure" or "synchronic system," a realm of impersonal logic in terms of which human consciousness is itself little more than an "effect of structure."[78]

He thus reminds us of the conceptual parallelism of "general system theory" to the iterations of structuralism in other disciplines at mid-century. In fact, already in 1968, the psychologist Jean Piaget related the systems paradigm in the sciences to the thought of Althusser, Saussure, and Levi-Strauss, among others, and subsumed all these intellectual currents under the term "structuralism."[79] Jameson's goal here is both to identify the paradigm as a late modernist product, and to ground it in the specific socioeconomic circumstances of its historical moment. He proceeds by tracing the maneuvers whereby a residual humanism is preserved at all costs within the solipsistic logic of "systems." Just as in structural linguistics, the

autonomy of the sign's binary is preserved only through its tenuous relationship to a referent in the "real," so all systems must perpetually maintain a ghostly "phantom of reference" as the very guarantee of their coherence and closure.[80] In Foster's translation to the language of art, this is how modernist abstraction manages to preserve representation by "sublating" it. According to Jameson, it is precisely through this humanist salvaging operation that late-modernist logic resolves to confront the emergent socioeconomic order of the "system," by maintaining it as a constitutive "referent" in the heart of its own autonomous structure. In this dialectics, the programmatic autonomy of the late modernist cultural sphere is made possible only through a "reduplication" of the totality of late capitalism's institution as its mimetic "*analogon.*"[81] Could such a phantom haunt Vollmer's seemingly disinterested geometries?

As Vollmer taps into the discourses surrounding system theory and its relationship to the visual arts, she engages—albeit at a certain remove—a community of thought whose public identity was actively shaped through the fifties and sixties by an MIT-based artist-theorist named Gyorgy Kepes. The Vollmer archive preserves a note on which the artist sketched out a fragment of the network marking her entrance onto this discursive field: the addresses of Gabo and Waddington, followed by that of Kepes.[82] Although evidence of Vollmer's connection to Kepes is limited,[83] I take him as the crucial link in this network, since it is on the pages of his books that the late-modernist dynamic analyzed by Jameson may be seen to play itself out most fully.

Kepes met both Gabo and Waddington in London during the thirties. Later, reflecting upon his London sojourn in an interview, he called Waddington and other Theoretical Biology Club scientists his intellectual "fathers" in their devotion to the "task to find links between science and art."[84] He continued to advance this relationship as both writer and editor for a series of books and essay compilations, for which he remains best known.[85] A Hungarian émigré, Kepes was a Bauhausler by proxy. Although he never studied at the German Bauhaus in the twenties, he was brought into its fold by his friend, collaborator, and mentor, László Moholy-Nagy. Kepes arrived in the United States in 1937, invited to teach at the New Bauhaus, established by Moholy-Nagy in Chicago. When that institution proved to be short-lived,

Kepes eventually found himself at MIT's School of Architecture and Planning, where he taught a "visual fundamentals" course based on Bauhaus-inspired principles. The premises of his teaching philosophy were published in 1944 as *The Language of Vision*, a book that brought him his first renown. But by then Kepes was already involved in the project that would occupy him for the rest of his career. At MIT, he discovered "a new cosmology [opened up by the sciences], a new broad vista of the world that for...artists was not given"[86]—a cosmology represented by the systems paradigm. He came to see his project as that of making available to artistic culture the visual riches of this developing scientific conception, together with the epistemological upheaval it appeared to represent.

This was certainly not an unexpected preoccupation for a devoted Bauhaus modernist such as Kepes. One can well see a line of continuity from the technocratic utopia—nourished at Weimar and Dessau in the twenties—of a better society to be brought about through collaboration between the artist and industry, to Kepes's then-current beliefs in the efficacy and beneficence of science garnered and channeled by art. The great paradoxical thematic of Kepes's work—his philosopher's stone—is to posit how resistance to the forces of alienation in the social world could be perpetuated by adopting those very forces as the *modus operandi* of that resistance. Again and again in his writings he would return to the premise of a troubling annihilation of the "natural" in the totally technologized contemporary world, and its relationship to the alienation of the "human." He writes in 1956:

> Rapid expansion of knowledge and technical development have [sic] swept us into a world beyond our grasp; and the face of nature is alien once again. Like the forest and mountains of medieval times, our new environment harbors strange menacing beasts: invisible viruses, atoms, mesons, protons, cosmic rays, supersonic waves. We have been cast out of the smaller, friendlier world in which we moved with the confidence born of knowledge.[87]

In contrast to this estrangement, a scientific complex capable of tying "phenomena which once seemed unconnected...into a unified order" appears as a "confident and vigorous unifying force."[88] Kepes's insightful evaluation of the fundamental characteristics of this complex, furnished with a plethora of representative images, had earned his books Waddington's accolade of being "among the most important means of conveying to painters some inkling of the changes which were bringing about the development of Second Science into Third Science."[89] *The New Landscape in Art and Science* (1956), a volume that would become the most comprehensive statement of Kepes's philosophy, is driven by an extensive compendium of scientific imagery of the kind offered by Waddington himself in *Behind Appearance*—diagrammatic records of the supersensory processes animating various natural "systems." We are meant to intuit the homologies between these disparate sources much as we might intuit the topological identity of Vollmer's *Steiner Surface* to her *Heptahedron*—as part and parcel of an overwhelming morphogenetic continuity of a "new landscape" that "eludes our comprehension except as a chain of organizational levels."[90] But, unlike Vollmer, whose appeal to the visual logic of the Third Technological Revolution culminates in its absorption by the autonomous art object, Kepes proposes to thrust it back into the social world where, activated by artistic consciousness, it would serve as the vehicle of a new perceptual "reorientation." Were these novel scientific artifacts to be "assimilate[d] with the scientist's brain, the poet's heart, the painter's eyes," the alienation of the natural world would be overcome through a "domestication" of the newly mediated environment.[91] Thus, Kepes remains committed to the Bauhaus utopia of social transformation through the industrial product humanized by the artist's intervention—with one significant difference: His own role is no longer that of the producer, but that of the educator. Consequently, the central tool of his utopian action is not the consumer object, but the found image filtered through an organizing pedagogical consciousness, where it is set in motion as a technique of "pattern-seeing." In Foster's terminology, Kepes can be said to "comprehend" the Bauhaus project through the medium of a historical delay. The Bauhaus assumption that the salvation of a humanist cultural sphere (and thus of its critical potential) within an antagonistic regime of capital must be premised upon its entrance into industrial production is restated in Kepes's call for an autonomous "vision" that would have the power to preserve the "human" and the "natural" precisely through a reduplication, in its very heart, of the antihumanist (late-capitalist) system pressing upon it its model of autonomy. The systems paradigm in the sciences offered a welcome demonstration that, not only might both the nat-

ural and the human survive a passage through this absolute mediation, but, more forcefully, that their very existence was dependent on such a recoding.[92] This logic became the scaffolding of Kepes's pedagogical project. But once set in motion—and it seems below the threshold of the author's awareness—it proceeded to spell out a different destiny for the "human:" to survive the protective mechanism of "pattern seeing" only as *image*.

In his analysis of the systems paradigm as it manifests itself in Kepes's project, Reinhold Martin locates an unrecognized "aporia" pervading the products of the artist's appeal to the visual traces of Third Science.[93] His recontextualization of these scientific images, Martin observes, strips them of their original instrumentality, as the former representations of organic structures or processes are now caught up in a drift toward the purely aesthetic. There is little surprise in finding this remarkably like the abstraction performed by Waddington upon the scientific image in its passage onto the field of art. This emptying out of reference is a prerequisite for its adaptation to systems logic: The same transcription of nature as informational pattern takes place in the conceptual depths of systems methodology. But the loss of instrumentality, given here as pendant to the loss of reference in the real, closes off the emancipatory aspirations of the project of "pattern seeing" itself. The visual vistas of Kepes's "new landscape," to Martin's eye, communicate a pervasive sense of "exhaustion," where, "amidst an endless proliferation of aestheticized patterns, the project to organize perception can only resolve itself in a tautological loss of meaning."[94] Thus, we might say, Kepes fulfills the destiny of Jameson's humanist phantom within the closure of the system: to implode within that system's absolute abstraction—becoming pure image, a sign without referent—and to simultaneously explode into the absolutely reified social reality, where "the last vestiges of Nature…are at length eliminated."[95] This is, for Jameson, the "second moment" of a completed cultural passage to postmodernism, for which he wants to preserve the sense of a radical break, while at the same time articulating its dialectical relationship with its late modernist, and structuralist, precursor. But we might also read here the ultimate closure of a cultural "schism" perceived by Benjamin H.D. Buchloh in the postwar art of Naum Gabo, "between a public, socially utilitarian art and a modernist, constructivist aesthetic that remains within the dimensions of the pictorial frame or the sculptural volu-

metric body."[96] To mend the contradiction between these two ideological conditions of art—its autonomy and its social utility—was the monumental goal of Kepes's postwar project as well; ironically, his success marked a passage onto a new sociocultural regime wherein both would become an impossibility.

If the postwar projects of Kepes and Gabo are to play out the seminal contradiction unresolved by the Bauhaus-constructivist strand of twenties modernisms, then Kepes resolves it, whereas Gabo succeeds only in stating it as such. Vollmer's entry into this problematic, it seems, demarcates the precipice only to resolutely pull away from it. She echoes Kepes's recoding of the Bauhaus principle of social utility as the pedagogical project of "pattern seeing," where the promise of instrumentality offered by industry then, and by science now, has been effectively channeled by systems logic into image. Indeed, Vollmer embraced the same didactic premise of visual legibility as social utility: "It should contribute to a more just appreciation of mathematics by a wider range of people than just the specialists."[97] On the other hand, her works diligently catalogue the alienation of the natural within the systems paradigm only to indefinitely forestall its final collapse into image. The film of her soap-film forms captures this broken momentum. The rainbow-colored refractions of these membranes, layered kaleidoscopically by the camera's intervention, dissolve their forms in an optical phantasmagoria of endlessly multiplying recurrences; but then comes the intermittent "pop" of the bubble, denying the image its mediated atemporal immateriality. That periodic rupture insistently returns an organic fragility to the form, even as it institutes the pause necessary to mark the rhythm of the repetition. Similarly, in all of Vollmer's works, the evacuation of a referential basis in the "real" by the implacably mediated artificial intelligence logic of systems science is suspended against the already anachronistic humanism of modernist abstraction. But this is also not the kind of historical "delay" proposed by Foster for the minimalist neo-avant-garde. In Foster's model, minimalism both completes and supercedes the modernist project; it "becomes the historical crux in which the formalist autonomy of art is at once achieved and broken up, in which the ideal of pure art becomes the reality of one more specific object among others."[98] Minimalism's appeal to the historical avant-gardes effects its closure of the modernist precedent—this is what pushes its dynamic

implacably forward, toward the "postmodern" avant-gardes of the seventies, eighties, and nineties. Foster's "crux of minimalism" must be aligned with Jameson's "second moment"—dialectically dependent on the first, yet superceding it. Vollmer's work, perhaps because it invokes alternate historical models in their contemporary replay, embodies a different temporality. The pull of her constructions is implacably toward the past, toward the aspirations of an erstwhile utopia whose failure is nonetheless inscribed within their diagrammatic flows. Thus, they emphatically refuse the inevitable eclipse of historicity ushered in by the advance of a new episteme.[99] The ultimate import of her work may be to articulate the second "deferred" return of that utopia as myth, a reenchantment of the world—an insight approached only in the heightening of historical awareness.[100]

Notes

1 The Jack Tilton Gallery, which had a memorial exhibition of Vollmer's works in 1983, collected reminiscences by friends of the artist for its catalogue: *Ruth Vollmer, 1903–1982* (New York: Jack Tilton Gallery, 1983). I am relying on these in what follows. At least two authors referred to the occasional gatherings at her apartment as "salons": "For about twenty years before she died on New Year's day in 1982, I was a participant in a very unpretentious but, nevertheless, authentic and stimulating 'salon' in New York at Ruth Vollmer's apartment on Central Park West. The gatherings, of never more than six or eight people, took place every few months, or oftener if an interesting personality appeared in town" (Alicia Legg, untitled contribution, p. 11). And: "Ruth Vollmer entertained with an old-world grace—she brought people together—a kind of salon..." (Richard Francisco, untitled contribution, p. 17).

2 Dorothea Rabkin, untitled contribution, in ibid., p. 14.

3 See B.H. Friedman, "The Quiet World of Ruth Vollmer," in *Ruth Vollmer 1903–1982*, p. 5; originally published in *Art International* 9, no. 12 (March 1965): 26–28.

4 Richard Tuttle, "Ruth's Sculpture," in *Ruth Vollmer, 1903–1982*, p. 13.

5 Friedman, "The Quiet World of Ruth Vollmer," p. 5.

6 Ibid.

7 Susan Carol Larsen, "A Reminiscence of Ruth Vollmer," in *Ruth Vollmer, 1903–1982*, p. 9.

8 Sol LeWitt, "Ruth Vollmer: Mathematical Forms," *Studio International* 180, no. 928 (December 1970): 256–57.

9 For a discussion of her "first career," and the schism established between it and her work in the sixties, see Kirsten Swenson, "'Fragments Towards the Sphere': The Early Career(s) of Ruth Vollmer," pp. 86–97 in the present volume.

10 LeWitt, "Ruth Vollmer: Mathematical Forms," p. 256.

11 Hal Foster, *The Return of the Real: The Avant-Garde at the End of the Century* (Cambridge, Mass.: MIT Press, 1996), pp. 28–32.

12 Peter Bürger, *Theory of the Avant-Garde* (1974), trans. Michael Shaw (Minneapolis: University of Minnesota Press, 1984).

13 Indeed, what allows Foster to adopt the psychoanalytic analogy is a conception of modernist history "on the model of the individual subject," capable of demise as well as of evolution or regression. Ibid., p. 28.

14 *Naum Gabo–Antoine Pevsner*, introduction by Herbert Read (New York: The Museum of Modern Art, 1948), p. 38.

15 Colette Roberts in conversation with Ruth Vollmer, "Meet the Artist" adult education program, New York University, Fall 1970; audiocassette transcript. Colette Roberts Interviews with Artists, 1961–1971, Archives of American Art, Smithsonian Institution, Washington, D.C.

16 *Naum Gabo–Antoine Pevsner*, p. 17. Vollmer's instinct was correct. In their recent monograph on the artist, Martin Hammer and Christina Lodder confirm that Gabo's method of stringing to create three-dimensional form was adopted from mathematical models he first encountered as an engineering student in Munich, and later studied more fully at the Institut Henri Poincaré in Paris, during his stay there in the early thirties. See Martin Hammer and Christina Lodder, *Constructing Modernity: The Art and Career of Naum Gabo* (New Haven, Conn.: Yale University Press, 2000), pp. 389–92.

17 See Ruth Vollmer, undated letter to Naum Gabo. Ruth Vollmer Papers, 1939–1980, Archives of American Art, Smithsonian Institution, Washington, D.C. (hereafter, RVP).

18 Vollmer/Roberts interview, p. 9.

19 Hammer and Lodder relate the "Spheric Theme" series of works specifically to mathematical models; see their *Constructing Modernity*, p. 391. They argue, however, that the concept for these arose as a result of Gabo's experimentation with the joining of two flat planes to comprise a single plane of continuous curvature; see pp. 264–66.

20 Ruth Vollmer, statement in Peg Weiss, ed., *Ruth Vollmer: Sculpture and Painting, 1962–1974* (Syracuse, N.Y.: Everson Museum of Art, 1974), p. 14.

21 LeWitt, "Ruth Vollmer: Mathematical Forms," p. 256.

22 Ruth Olson and Abraham Chanin, curatorial statement, in *Naum Gabo–Antoine Pevsner*, p. 18.

23 The MoMA curator offered a brief and somewhat biased summary of the ideological conflicts within Russian constructivism that led, in part, to Gabo's and Pevsner's emigration. For a more comprehensive analysis of the various factions within the Russian avant-garde circa 1921, see Christina Lodder, *Russian Constructivism* (New Haven, Conn.: Yale University Press, 1983), pp. 109–30.

24 As Hal Foster argues, the conceptual appeal of Russian constructivism to the sixties neo-avant-garde consisted precisely in those aspects of its project most antagonistic to Gabo's work, and associated rather with the work of Vladimir Tatlin, Alexandr Rodchenko, and other like-minded artists and theorists of the twenties. Their attempt to transform (bourgeois) artistic practice by confronting it with modes of industrial production and collective reception attracted the neo-avant-garde in its own interrogation of the institutional conditions of art. Gabo, on the contrary, remained "a bourgeois proponent of pure art." In Foster's analysis, "[t]hough both his early Cubistic sculptures and later abstract constructions involve a quasi-constructivist analysis of structure..., they are hardly materialist in a Marxian sense—on the contrary, they tend toward dematerialization. Especially after his 1923 emigration, Gabo was resolutely committed to Art, indeed to Spirit." See Hal Foster, "Some Uses and Abuses of Russian Constructivism," in *Art into Life: Russian Constructivism, 1914–1932* (Seattle: The Henry Art Gallery, 1990), pp. 242–43.

25 For a more complex analysis of the evolution of Gabo's modernist ideology in the context of the critical reception of Russian constructivism in postwar United States, see Benjamin H.D. Buchloh, "Cold War Constructivism," in Serge Guilbaut, ed., *Reconstructing Modernism: Art in New York, Paris, and Montreal 1945–1964*, (Cambridge, Mass.: MIT Press, 1990), pp. 85–113.

26 Vollmer/Roberts interview, p. 8.

27 As Vollmer explains it, "The forms were made by the mathematics professors, were devised by mathematics professors. For instance, the methods in how to make it and what the sense of the form is. And the students made them. And in most instances, the names of both are mentioned" (ibid.).

28 For Gabo's engagement with *On Growth and Form*, see Hammer and

Lodder, *Constructing Modernity*, pp. 385–88.

29 In their discussion of Gabo's relationship to Thompson, Hammer and Lodder compare *Translucent Variation on Spheric Theme* with this image of the microscopic organism. Ibid., p. 387.

30 The *Growth and Form* exhibition, dedicated to Thompson, was curated by Richard Hamilton of the Independent Group, and was accompanied by a symposium, which brought together professionals in the arts and the sciences to reflect on the subject of morphology. The symposium gave rise to a subsequent collection of essays published as *Aspects of Form*, ed. Lancelot Law Whyte, preface by Herbert Read (London: ICA and Percy Lund Humphries & Co., 1951).

31 D'Arcy Wentworth Thompson, *On Growth and Form* (Cambridge: The University Press, 1917), p. 493.

32 This can be expressed as r = a_ where (a) is a constant quantity, and (_) is the angle through which it has revolved. See ibid., p. 504.

33 Ibid., p. 585.

34 Ibid., p. 11.

35 Thomas Nozkowski, "Ruth Vollmer," manuscript for Betty Parsons Gallery, (1974), p. 8 (RVP). See also pp. 194–95 of the present volume.

36 LeWitt, "Ruth Vollmer: Mathematical Forms," p. 256.

37 Ruth Vollmer, cited in Emily Butterfield, "Math Becomes Art Form," *Syracuse Herald Journal*, November 10, 1974: n.p. (RVP). Author's emphasis.

38 Peter Stevens, *Patterns in Nature* (London: Penguin Books, 1974), p. 169.

39 Ibid., p. 153.

40 Vollmer/Roberts interview, p. 8.

41 Ibid. The citation is from Read, introduction to *Naum Gabo–Antoine Pevsner*, p. 11.

42 Vollmer's husband, Hermann Vollmer, was a noted physician who published widely. One might assume his knowledge of recent developments in the fields of biology and biochemistry, which he may have shared with his wife.

43 Donna Haraway, *Crystals, Fabrics, and Fields: Metaphors of Organicism in Twentieth-Century Developmental Biology* (New Haven, Conn.: Yale University Press, 1976), p. 39.

44 Vollmer mentions the book during her conversation with Roberts: "And the title of the book," she observes, "is *Behind Appearance*, which I like very much" (p. 6).

45 Thomas C. Kuhn, *The Structure of Scientific Revolutions* (Chicago: University of Chicago Press, 1962). Kuhn proposed that developments in science are driven by dramatic changes in worldview, or "paradigm," that determine the framework for scientific activity. Interestingly, Haraway also identifies the scientific model worked out by the Theoretical Biology Club as a Kuhnian "paradigm," and the Club itself as a "paradigm community"; see her *Crystals, Fabrics, and Fields*, pp. 1–32.

46 C.H. Waddington, *Behind Appearance: A Study of the Relations Between Painting and the Natural Sciences in This Century* (Edinburgh: Edinburgh University Press, 1969; reprint, Cambridge, Mass.: MIT Press, 1970), p. 118 (page citations are to the reprint edition).

47 See Haraway, *Crystals, Fabrics, and Fields*, pp. 33–63.

48 See Norbert Wiener, *Cybernetics; or, Control and Communication in the Animal and the Machine* (Cambridge, Mass.: Technology Press, 1948).

49 See Norbert Wiener, *The Human Use of Human Beings: Cybernetics and Society*, 2nd ed. (Garden City, N.Y.: Doubleday, 1954). An insightful reading of Wiener's contribution to the organismic paradigm can be found in Reinhold Martin, *The Organizational Complex: Architecture, Media, and the Corporate Space* (Cambridge, Mass.: MIT Press: 2003), pp. 21–23.

50 See Kurt Lewin, *A Dynamic Theory of Personality* (New York: McGraw-Hill, 1935).

51 See Talcott Parsons, *Structure and Process in Modern Societies* (Glencoe, Ill.: Free Press, 1960). On Parsons's relationship to cybernetics, see

52 Martin, *The Organizational Complex*, pp. 35–36.

53 Ludwig von Bertalanffy, *General System Theory: Foundations, Development, Applications* (New York: George Braziller, 1969).

54 Ibid., p. xix.

55 Ibid. p. xxi. Von Bertalanffy is citing his own *Robots, Men, and Minds* (New York: George Braziller, 1967).

56 See n. 44.

57 "Science no longer conceives [the world] as consisting of solid lumps of matter which can be organized into straightforward machines. The matter first thinned out into atoms, then into electrons and protons, and now into…waves of probability, [or] elementary particles…" (Waddington, *Behind Appearance*, p. 1).

58 Ibid., p. 119.

59 Ibid., p. 120. The full citation reads: "The impact of scientific images on painting is first through what Whitehead called the mode of causal efficacy and only secondarily through presentational immediacy. It is for this reason that, when offering some images to indicate the character of Third Science, I shall show few photographs of appearances taken through scientific instruments, but shall present a number of diagrams which exhibit the underlying causal structure of events, or recordings of characteristics which are more causally efficacious than mere appearance."

60 Haraway points out the constitutive role played by the image in the thought of the Theoretical Biology Club. She writes that "knowledge…interwoven with sense images…'initiates a powerful emotional drive towards the solution of the problem, perhaps through the unconscious perception that some part or all of that system of images by which we represent the natural world to our minds, and which is the basis of our common sense, is about to undergo metamorphosis.' Precisely such a metamorphosis of image was occurring in the work of Harrison, Needham, and Weiss. Their attention to aesthetic standards and the problem of form was no accident" (Haraway, *Crystals, Fabrics, and Fields*, p. 42). She cites C.F.A. Pantin, *The Relations Between the Sciences* (London: Cambridge University Press, 1968). See also, Martin, *The Organizational Complex*, p. 52. However, it may be argued that the systems paradigm was strongly image-based across the sciences.

61 Ruth Vollmer, interview with Susan Carol Larsen, New York, January 30, 1973. In Susan Carol Larsen, "The American Abstract Artists Group: A History and Evaluation of Its Impact on American Art" (Ph.D. diss., Northwestern University, 1975): 615. Asked what kind of mathematics these models were based on, Vollmer responded: "On mathematical formulas, not on geometry! It is very interesting" (p. 616).

62 A differential equation is the equation of a function that includes its derivatives. Von Bertalanffy writes: "A system may be defined as a set of elements standing in interrelation among themselves and with environment. The behaviour of the system is described by the theory of differential equations…" (*General System Theory*, p. 253).

63 See David Hilbert and Stephan Cohn-Vossen, *Geometry and the Imagination* (New York: Chelsea Publishing Company, 1990), p. 289. Vollmer frequently cited this book: see, for example, the statement on *Steiner Surface* in Weiss, ed., *Ruth Vollmer*, p. 14. For relations to general system theory, see von Bertalanffy, *General System Theory*, p. 21.

64 Thompson's influential "theory of transformations," outlined in the last chapter of *On Growth and Form*, relies on topology.

65 Larsen, "A Reminiscence of Ruth Vollmer," p. 9.

66 Ruth Vollmer, undated draft statement prepared for the artist's November 1970 exhibition at the Betty Parsons Gallery, New York (RVP). Also quoted in LeWitt, "Ruth Vollmer: Mathematical Forms," p. 256. The citation is to Hilbert and Cohn-Vossen's *Geometry and the Imagination* (1990).

66 Vollmer, statement on *Steiner Surface*, p. 14.

67 Vollmer, undated draft statement (RVP).

68 Ibid.

69 Larsen, "A Reminiscence of Ruth Vollmer," p. 9.

70 *Soap Film Forms* (1974) was produced cooperatively by the Everson

Museum of Art and Synapse of Syracuse University for screening as part of *Ruth Vollmer: Sculpture and Painting, 1962–1974*, the retrospective mounted at the Everson in 1974.

71 Lucy R. Lippard discusses this dialectic in LeWitt's work in her "Sol LeWitt: Non-Visual Structures," in *Artforum* 5, no. 8 (April 1967): 42–46. See also her "The Structures, the Structures and the Wall Drawings, the Structures and the Wall Drawings and the Books," in *Sol LeWitt* (The Hague: Gemeentemuseum, 1970), pp. 25–27.

72 Foster, *The Return of the Real*, p. 63.

73 Fredric Jameson, "Periodizing the 60's," in Sohnya Sayres et al., eds., *The Sixties Without Apology* (Minneapolis: University of Minnesota Press, 1984). Reprinted in Fredric Jameson, *The Ideologies of Theory: Essays, 1971–1986*, vol. 2: *Syntax of History* (Minneapolis: University of Minnesota Press, 1988), pp. 178–208.

74 This argument is made more forcefully in an early version of Foster's text; see Hal Foster, "The Crux of Minimalism," in Howard Singerman, ed., *Individuals: A Selected History of Contemporary Art, 1945–1986* (New York: Abbeville Press, 1986), pp. 162–83.

75 Jameson, *The Ideologies of Theory*, pp. 205–07. The citation is to Ernst Mandel, *Late Capitalism* (London and Atlantic Highlands, N.J.: NLB and Humanities Press, 1978).

76 Ibid, p. 207. See also, pp. 178–79.

77 More accurately, Foster's intention is to situate minimalism at the "crux" of modernism and its aftermath—both the apogee of formalist autonomy and its break into "one more specific object among others." See Foster, *The Return of the Real*, p. 54.

78 Jameson, *The Ideologies of Theory*, p. 190.

79 Piaget defined "structure" as "a system of transformations." See Jean Piaget, *Le Structuralisme* (1968); published in English as *Structuralism*, trans. Chaninah Maschler (New York: Basic Books, 1970), p. 5. Haraway observes that, among the former members of the Theoretical Biology Club, Waddington "perhaps more than anyone else has built the foundation for viewing developmental biology as a structuralism related philosophically to the psychology of Piaget and anthropology of Levi-Strauss" (Haraway, *Crystals, Fabrics, and Fields*, p. 16).

80 Jameson, *The Ideologies of Theory*, pp. 197–98.

81 Ibid., p. 199.

82 Ruth Vollmer, undated note (RVP).

83 Vollmer saw at least one of the essay compilations produced and edited by Kepes, *Module, Proportion, Symmetry, Rhythm* (1966), and was sufficiently impressed by the contribution on "The Modularity of Knowing" (1966), by physicist Philip Morrison, to copy out a citation for her files (RVP). The Vollmer archive holds a draft of a note she sent to Kepes in 1970, together with an invitaton to her 1970 exhibition: "I thought this may be interesting to you and possibly to your students" (RVP). Furthermore, Kepes's name was certainly not unknown in the New York circle of artists of Vollmer's acquaintance.

84 Gyorgy Kepes, transcript of a tape-recorded interview with Robert Brown, March 1972–January 1973. Gyorgy Kepes Papers, 1825–1985, Archives of American Art, Smithsonian Institution, Washington, D.C. Cited in Martin, *The Organizational Complex*, p. 51.

85 These include *The New Landscape in Art and Science* (Chicago: Paul Theobald, 1956) and the "Vision and Value" series published by George Braziller circa 1965–72.

86 Gyorgy Kepes, "A Painter's Response to the Idiom of Science," minutes of the Columbia University Seminar on Technology and Social Change, New York, December 9, 1965, p. 4. Gyorgy Kepes Papers.

87 Kepes, *The New Landscape in Art and Science*, p. 19.

88 Ibid.

89 Waddington, *Behind Appearance*, p. 53.

90 Kepes, *The New Landscape in Art and Science*, p. 371.

91 Ibid, p. 20.

92 It should be noted that the postwar political activism of a number of prominent scientists contributed to an already widespread belief in the unique ability of the sciences to counter those very destructive forces which they have unleashed, and whose looming symbol was the atom bomb. See, for example, Paul Boyer, *By the Bomb's Early Light: American Thought and Culture at the Dawn of the Atomic Age* (New York: Pantheon Books, 1985), pp. 266–74. Vollmer was personally acquainted with Leo Szilard, a nuclear physicist active in the progressive scientists' movement to control nuclear energy. See letter, Mrs. Leo Szilard to Ruth Vollmer, July 1964 (RVP).

93 Martin proposes that, already in *The New Landscape in Art and Science*, Kepes "was not merely subordinating art... to the rigors of science. He was encountering an aporia implicit in the conjunction he would try so hard to effect between these two arenas, an aporia in which the authority of scientific knowledge is undone by the constitutive role played by aesthetic form in its visualization" (Martin, *The Organizational Complex*, p. 52).

94 Ibid., pp. 72–79.

95 Jameson, *The Ideologies of Theory*, p. 207. Martin reaches a similar conclusion about the ultimate destination of Kepes's project; see his *The Organizational Complex*, pp. 42–79.

96 "That schizophrenic shifting between the two positions becomes intensified in the postwar period.... At that point, you can read any two statements by Gabo and you are very likely to find one which says that art is completely devoted to utilitarian functions and another one which insists on the absolute purity, self-sufficiency, and autonomy of art" (Buchloh, "Cold War Constructivism," p. 111).

97 See n. 65.

98 Foster, *The Return of the Real*, p. 54.

99 The condition ascribed by Jameson to postmodern art: "the eclipse, finally, of all depth, especially historicity itself, with the subsequent appearance of pastiche and nostalgia art" (*The Ideologies of Theory*, p. 195). Foster claims that the minimalist object both reflects and critiques this condition; see *The Return of the Real*, p. 62.

100 In their seminal critique of positive thought, the Dialectic of Enlightenment (1947), Theodor Adorno and Max Horkheimer oppose art to science as alone able to reveal the paradoxes obscured in the advance of history, but only at the price of a total loss of agency. See Max Horkheimer and Theodor W. Adorno, *Dialectic of Enlightenment*, trans. John Cumming (New York: The Continuum Publishing Company, 2002). They rewrite the advance of Western history as the progress of Enlightenment, or a spirit of rational-technocratic domination of nature. The Enlightenment proceeds from a foundational abolition of myth—a "disenchantment of the world." But in the process, it must also negate any awareness of this origin and of the historical dialectic of its overcoming. "What men want to learn from nature," Adorno and Horkheimer write, "is how to use it in order wholly to dominate it and other men. That is the only aim. Ruthlessly, in despite of itself, the Enlightenment has extinguished any trace of its own self-consciousness. The only kind of thinking that is sufficiently hard to shatter myths is ultimately self-destructive.... There is to be no mystery—which means, too, no wish to reveal mystery" (ibid., pp. 4–5). Such historical insight is allowed to art, but only as long as its disruptive power is neutralized and it is sequestered away from practice as an object of contemplation. Art's wisdom of historical insight is therefore dialectically opposed to science's privilege of agency. This dialectic may still offer a productive model for a reading of postwar artistic experiments in engaging the sciences, as well as their inevitable (and perhaps occasionally programmatic) failure.

CHRONOLOGY
BY MEREDITH DAVIS

The Ruth Vollmer Papers, 1939–1980, Archives of American Art, Smithsonian Institution, Washington, D.C., are cited as RVP.

1903

Ruth Landshoff is born in Munich to Ludvig and Phillipine Landshoff. Her father is a well-known musicologist and conductor, and her mother is an opera singer; the family is Jewish. Her paternal aunt Hedwig Landshoff is married to Samuel Fischer, founder of the renowned S. Fischer Verlag. Established in Berlin in 1886, Fischer Verlag first published the work of Henrik Ibsen, Gerhart Hauptmann (the German dramatist who won the Nobel Prize in 1912), and Thomas Mann, as well as German editions of works by Walt Whitman, Eugene O'Neill, John Dos Passos, and Joseph Conrad.

1905

Ruth's brother, Hermann Landshoff, is born; he will later become an accomplished fashion photographer. The Landshoff family travels extensively in the decade before World War I, living for many years in Italy.

1919

Walter Gropius founds the Bauhaus in Weimar. Lyonel Feininger, László Moholy-Nagy, Paul Klee, and Anni and Josef Albers are among its earliest lecturers and students.

The ideas, innovations, and general approach developed by the Bauhaus was a central influence on German art education and on the artistic culture in general, and both Ruth and her brother Hermann had numerous personal connections to its teachers and students. One of the most concrete of these was with the son of Lyonel Feininger, photographer Andreas Feininger, who emigrated to New York in 1939. Beginning in 1943, Feininger worked on the staff of *Life* for several years, and he was a close friend and frequent collaborator of Hermann Landshoff.

1922

By the early twenties, S. Fischer Verlag had become one of the most prominent publishers of music and literature of the time. The Fischer and Landshoff homes are gathering places for family friends and leading figures in music, literature, and science, including Hauptmann, Rilke, Thomas Mann and his family, musicologist Alfred Einstein, and Albert Einstein.

Ruth, now nineteen, begins to work as an artist. With no formal schooling, she starts by following her father's advice to do a drawing every day (she would later state that she did not think she learned much from this practice). Some time after this, she moves to Berlin, where she works as an au pair for the family of a well-known musician. She begins to construct toys and small objects out of paper, wire, and other materials. She will remain in Berlin throughout the twenties.

1930

Ruth Landshoff marries Hermann Vollmer, a pediatrician, whom she met in Berlin. Hermann Vollmer had practiced pediatric medicine in Heidelberg in the early or mid-twenties, and had a wide-ranging interest in many branches of science, including physics. In Berlin, the Vollmers become friends with George Grosz.

1933

Adolf Hitler is appointed Chancellor, and Germany withdraws from the League of Nations. As Hitler consolidates his power and that of the National Socialist Party, the government encourages the boycott of Jewish shops and businesses. The Bauhaus, labeled "un-German" for its advocacy of modernist styles, is closed.

1935

Ruth and Hermann Vollmer leave Germany for New York. They bring with them their Bauhaus-inspired furniture designed by Hermann Herrey, as well as a number of works of art. At first, the Vollmers are hosted and aided by Carmen and Jackson Phillips, a Quaker family with whom they remain close friends. Hermann Vollmer immediately falls into a severe depression, and is unable to work. Ruth Vollmer begins to work right away, designing window displays for Bonwit Teller. Tom Lee, art director for Tiffany's, is impressed by her imaginative figures of animals made of paper, wire, and other simple materials, and hires her. She continues to work for Tiffany's, Lord & Taylor, and other department stores, constantly experimenting with new materials including wire and steel and copper mesh to create animal and human forms. These materials continue to be a part of both her art and her design work until the late fifties.

1940

Vollmer participates in an exhibition of refugee artists at the Friendship House in New York. Hermann Herrey and his wife, Erna, emigrate to the U.S. at the invitation of Walter Gropius, where they reconnect with the Vollmers. Hermann Herrey had worked as a stage designer, playwright, furniture designer and architect in Germany and England. His wife Erna became a professor of physics at Queens College, and would be Vollmer's advisor and tutor on mathematical issues, specifically those related to geometry. Vollmer also introduced Herrey to Sol LeWitt, who also consulted with her on mathematical questions.

1941

Vollmer's brother Hermann Landshoff emigrates to the U.S. from France, where he had been working as a fashion photographer since the mid-thirties. In Paris, Landshoff was closely associated with the surrealists and the Dadaists, and photographed many of the most active and important artists working at the time. He continued these associations in New York, where many of the surrealists lived during the forties. In New York, Landshoff, already a well-established photographer, was hired by Alexy Brodovich's *Harper's Bazaar* as well as by *Mademoiselle* and *Vogue*. He also continued to photograph working artists, most famously, perhaps, a series of iconic images of Vollmer's close friend Eva Hesse in her studio. Vollmer and her brother shared many lifelong interests, and Landshoff would produce almost all of the photographic documentation of his sister's work.

1943

Vollmer becomes a U.S. citizen.

RUTH VOLLMER
RUTH VOLLMER PAPERS, 1939–1980,
ARCHIVES OF AMERICAN ART,
SMITHSONIAN INSTITUTION,
WASHINGTON, D.C.

HERMANN LANDSHOFF
SELF-PORTRAIT, FEBRUARY 17, 1953
© MUSEUM AT FIT, NEW YORK

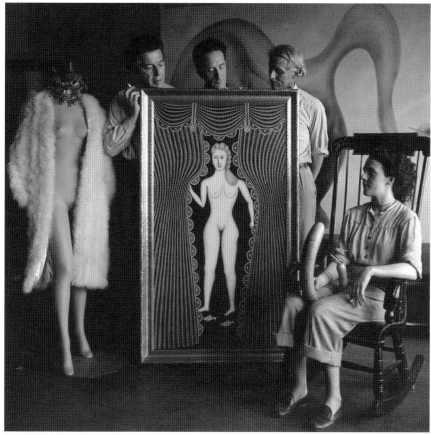

HERMANN LANDSHOFF. UNTITLED, N.D.
LEFT TO RIGHT: ANDRÉ BRETON, MARCEL DUCHAMP, MAX ERNST, AND LEONORA CARRINGTON WITH
MORRIS HIRSHFIELD'S NUDE AT THE WINDOW, 1941
© MUSEUM AT FIT, NEW YORK

RUTH VOLLMER. UNTITLED (RELIEF), 1955
BRONZE, 11.5 X 16 IN. (29.2 X 40.6 CM)
GREY ART GALLERY, NEW YORK UNIVERSITY ART COLLECTION
GIFT OF DR. CARMEN H. PHILLIPS
PHOTO HERMANN LANDSHOFF

RUTH VOLLMER AND ALBERTO GIACOMETTI IN HIS STUDIO, PARIS, 1951
RUTH VOLLMER PAPERS, 1939-1980, ARCHIVES OF AMERICAN ART, SMITHSONIAN INSTITUTION,
WASHINGTON, D.C.

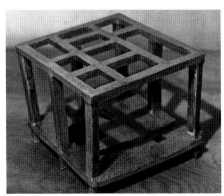

RUTH VOLLMER. HOUSE, 1957
FIRED CLAY, CA. 12 X 12 IN. (30.5 X 30.5 CM)
COLLECTION DOROTHEA AND LEO RABKIN, NEW YORK
PHOTO HERMANN LANDSHOFF

1944

Through Victor D'Amico, then head of educational programming at The Museum of Modern Art (MoMA), Vollmer receives a commission from the museum for its fifteenth-anniversary exhibition, "Art in Progress." She will continue to work with D'Amico frequently over the next decades, creating learning tools and models for children and working on a variety of educational projects.

1945

Vollmer sees Alberto Giacometti's *The Palace at 4 A.M.* at Peggy Guggenheim's Art of This Century Gallery in New York.

1948

Vollmer works extensively with wire mesh of all types, including copper, brass, and steel. The layered abstract reliefs she constructs from these materials have both lightness and complexity, and the play of light and color is subtle and dynamic. She shows the wire-mesh construction *Composition in Space* in an exhibition at MoMA titled "Elements of Stage Design."

Continuing to work commercially, Vollmer creates a scandal with a design for the windows at Lord & Taylor that feature a group of wire mannequins with clumps of clay thrown onto their armatures.

Herbert Read mounts the exhibition "Naum Gabo–Antoine Pevsner" at MoMA. Vollmer may well have become acquainted with the artists' work and with constructivist ideas while still in Germany, but it is also likely that she saw this show in New York. (In an interview with Colette Roberts conducted as part of the adult education program "Meet the Artist" at New York University [NYU] in Fall 1970, Vollmer read from the catalogue, and cited Gabo's probable use of mathematical models as an inspiration.)

1949

Vollmer designs the installation of the annual Children's Holiday Carnival at MoMA, making toys and "creative playthings" for the annual event. These include puppets and tactile toys made out of wire, paper, and fabric.

Vollmer designs reliefs, moldings, and rugs for the redecoration of the Persian Room at the Plaza Hotel. Among the more elaborate aspects of the project are the wall decorations, which consist of drapery made of wire mesh encrusted with large chunks of colored glass.

1950

Vollmer is commissioned to create a mural for the lobby of 575 Madison Avenue. As B.H. Friedman explains, "The architect had seen ...the then recently redecorated Persian Room of the Hotel Plaza" and sought her out ("The Quiet World of Ruth Vollmer," *Art International* 9, no. 12 [March 1965]: 26).

For 575 Madison, Vollmer creates a large-scale wall relief that further developed the play on light, texture, and transparency that she had been experimenting with in both her small biomorphic reliefs and in her design work. The relief consisted of metal screening or mesh and rods "used at both right angles and parallel to the surface." Before the public unveiling of the work, Vollmer distributes a handout to the tenants of the building that begins with an epigraph from T.S. Eliot— "Oh, do not ask, 'What is it?' / Let us go and make our visit"—and also states that "none of the shapes and forms are directly representational; they are associations on the theme of industry and life" (RVP).

After encountering the work of Alberto Giacometti for the second time at the Betty Parsons Gallery in New York, Vollmer visits the artist in Paris that summer.

1951

Vollmer purchases a kiln for her studio near Columbus Circle. Friedman recounts that she "tried to explain to me what the kiln meant to her. She showed me some of the things that had happened in a temperature of 2000 degrees Fahrenheit; the way soft and organic became permanent" ("The Quiet World of Ruth Vollmer," p. 27). Her work from the early fifties includes many fired clay reliefs that use both biomorphic and more schematic forms, and reveal her new interest in the various properties of clay.

In the summer, she visits Giacometti for a second time, at his studio in Paris, and makes copious notes on their conversation (she will later send these to Giacometti's biographer,

James Lord. She finds that they share an admiration for Anton Lehmbruck, and she retrieves a small plaster figure from Giacometti's trash can. It will remain a prized possession, carefully protected in a glass vitrine, until her death, when it entered MoMA's collection as part of the Ruth Vollmer Bequest.

1954

Vollmer creates a number of shallow reliefs in white or red terra-cotta, both painted and unpainted. Some are to be hung on the wall, others to be placed face-up on a flat surface or suspended from the ceiling. These relief works have strong affinities with early Giacometti "gameboard" pieces, and with some of Max Ernst's surrealist forms. One of these, in terra-cotta and wood, is later cast in bronze (opposite); it is purchased by Carmen Phillips, a friend of the Vollmers and an early sponsor, and donated to NYU for the Loeb Student Center in 1960.

Vollmer travels to Greece, the first of six trips that she will describe in a 1971 statement as crucial to her development and thinking: "My visit to Greece and Crete and direct experience of Minoan, Cycladic, Mycenaean and Geometric art led me to delve further into the pre-Christian art of the cultures of Asia Minor" (RVP). She became an avid collector, and visitors to her Upper West Side apartment in the sixties, Richard Tuttle and Lucy R. Lippard among them, would comment on the provocative ways in which she arranged these objects alongside seashells and works of contemporary art.

Vollmer works at the Children's Art Center at the Fieldston School in Riverdale; she will continue to teach there until the mid-sixties. Her involvement in art education parallels her interest in models and in objects that serve as demonstrations of specific ideas, a central concern in her own artistic production.

1957

Vollmer continues to work in ceramics. One of the best surviving works from this year is *House* (opposite), a structure made of varying rectangles, fired with a warm wood-toned glaze, and sprinkled with carborundum powder, giving a sandy texture to the otherwise slick surface. This work, though small (less

than twelve inches in any dimension), is strongly reminiscent of Giacometti's *The Palace at 4 A.M.*, which Vollmer deeply admired and often mentioned in written and spoken interviews. Yet in its solidity and its handmade quality, *House* is decidedly not a surrealist work but a more abstract one, revealing a concern with materials and structure.

For the Department of Commerce, she designs and creates the U.S. display for the "International Samples Exhibition," which travels to industrial fairs in Milan and Barcelona.

1958

Vollmer is close with a group of American-based artists at this time, including Gabe Kohn, Leo Rabkin, Michael Lekakis, and Richard Lindner. Lindner, who she and Hermann Landshoff may have known in Germany, remains a close friend. She designs a "Children's Creative Center" for the U.S. Pavilion at the Brussels World's Fair, and creates two of her earliest works in bronze, *Hard and Soft* and *Form in Flux* (the latter also known as *Push and Pull,* according to Leo Rabkin).

1959

Continuing to explore the representation of movement and gesture in bronze, Vollmer creates *Walking Ball,* one of her strongest early works. A short, anonymous notice on Vollmer's work in *Arts Magazine* in April 1963 calls *Walking Ball* "the soul of geometry out on a whimsical stroll." As in her bronze spheres of the sixties, *Walking Ball* is unpolished. It has a rough, irregular surface rich in texture and detail, and invites intimate perusal.

After suffering from depression for some time, Hermann Vollmer commits suicide in the Vollmers' home on the Upper West Side of Manhattan.

1960

Vollmer rents a studio on Union Square, which she keeps until the mid-seventies. Leo Rabkin brings her a large chunk of wax, encouraging her to work in this medium, and he also casts the first piece she makes from it—a spherical ball about the size of a grape-

fruit, with a complexly textured surface.

Vollmer has her first one-person exhibition at Betty Parsons's Section Eleven gallery space, an adjunct to the main gallery that was devoted to emerging artists. The exhibition consists of several of the terra-cotta and metal reliefs Vollmer had been making over the previous five years, as well as several new bronze works.

At the invitation of Howard Conant, she participates, along with her friend Robert Motherwell, in the NYU discussion series "Artists on Art" on December 1.

1961

Vollmer produces a large number of highly varied, relatively small-scale sculptures in bronze. Among these is *The Lovers,* which consists of a single shaft of bronze split near the halfway point. Like *Walking Ball, The Lovers* is both animated and nonfigurative. Other works, including *The Dance,* also evoke animate forms while remaining resolutely solid and material; these reflect a growing interest in geometric forms, particularly the sphere, and in what she referred to as "nature." Vollmer's conception of nature was a Romantic one, emphasizing the irregular, irrational, ideal, and "mysterious" qualities of material reality, rather than rational, empirical facts.

Vollmer creates *Musical Forest* (page 134), a title given to the work by Betty Parsons. A semicircular, bowl-like bronze piece with projecting tines, meant to be struck with a wooden mallet. *Musical Forest* evokes Vollmer's earlier reliefs while also foreshadowing some of her best mature work: It has a strong sense of play, reveals a conception of the aesthetic experience that is not limited to opticality, and demands that the viewer participate in the work of art, rather than merely view it.

1962

Vollmer completes one of her largest bronze works, *Obelisk,* which is exhibited at Betty Parsons the following year and later acquired by the Smithsonian American Art Museum. Like *Musical Forest, Obelisk* is characterized by Vollmer's participatory aesthetic: It consists of a large structure pierced by compartments that are open in the back and that contain spherical forms. At the top of the obelisk, the

smallest spherical form, is meant, Vollmer wrote, to be "taken out and contemplated."

1963

In a joint exhibition with Sasson Soffer at the Betty Parsons Gallery, Vollmer shows a number of small bronze sculptures that explore spherical and "ovaloid" shapes, including *Ovaloid with Hammers,* a semicircular form with mushroomlike "hammers" inside of it; *Sphere with Small Square Cutout;* and *Cyclops.* "I started out in a roundabout way exploring the sphere in a series of sculptures.... These were related to the sphere, like the *Walking Ball,* gourdlike forms, ovaloids, and a culminating major piece, *The Obelisk,* relating the sphere to the square.... The next step was to explore the sphere geometrically" (artist's statement, 1966; RVP).

Vollmer becomes a member of the American Abstract Artists (AAA) group and participates in their exhibitions from this time forward. Among the members of AAA that she is close with or admires are Leo Rabkin, Ilya Bolotowski, and Beate Huelsenbeck, wife of the psychotherapist and former Dadaist Richard Huelsenbeck.

1964

Vollmer continues to explore the possibilities of the sphere. She makes a series of small-scale (nine or ten inches in diameter) bronze casts—some are unique, and others are produced in limited editions. Among these are *Wedding of Sphere with Cube (Series I), Golden Luned Sphere (Series I),* and *Interposed Cross (Series I),* each in an edition of six. *Cluster About Hemisphere* consists of several pieces that can be taken out and then put back together in a number of configurations, allowing the participant an active role.

Musical Forest is included in the exhibition "For Eyes and Ears," curated by Nicolas Calas at the Cordier & Ekstrom Gallery.

1965

Vollmer produces more than fifteen bronze works in this year. Most of these, including *Mirrored Stirrings, Sphere Minus C,* and *Rumblings Within,* are between ten and fifteen inches in diameter and are based on her continued exploration of the sphere form, focus-

ing more and more on its inner volumes and cavities, and their relationship to the outer surface of the form.

Vollmer completes *Untitled (Icosahedron)* (page 122) around this time, a work acquired by her friend Robert Smithson. It reveals the two artists' shared interests in geometry, mapping, and abstraction as well as inorganic and geometric forms. An icosahedron is a solid containing twenty planes, and is one of the five Platonic solids, convex polyhedra with equivalent faces composed of congruent convex regular polygons. As Plato notes in his *Timaeus*, there are five of these forms. (In this work, Plato equated the tetrahedron with the "element" fire, the cube with earth, the icosahedron with water, the octahedron with air, and the dodecahedron with the stuff of which the constellations and heavens were made.) Euclid later made them a central concern of his geometry in his *Elements*. Here Vollmer seems to have returned to the materials—wire and wire mesh—with which she worked a great deal in the previous decade, although her concerns are now much different.

Mel Bochner has stated that for him and many other younger artists, Vollmer was an important connection to a pre–World War II European avant-garde. Lucy R. Lippard (who writes that it was around this time that she saw Vollmer's work in the home of Leo and Dorothea Rabkin) suggests that Vollmer "provided a bridge between the Bauhaus and European constructivists like Gabo and Pevsner to the younger artists" ("Intersections," in *Flyktpunkter/Vanishing Points* [Stockholm: Moderna Museet, 1984]: 20).

In March, Ad Reinhardt exhibits his "black paintings" at the Betty Parsons Gallery. Shortly thereafter, Vollmer meets Reinhardt through Leo Rabkin and purchases a small black painting, which she kept carefully protected (as Reinhardt requested) under a specially made cardboard cover in a dark room.

1966

Throughout the sixties, Vollmer hosts a series of informal "salons" at her home on the Upper West Side, bringing together artists, writers, scientists, and other intellectuals. Around this time, she meets Robert Ryman, Robert and Sylvia Mangold, and Richard Tuttle, as well as

Eva Hesse, with whom she remains close until the younger artist's death. Mel Bochner has said that it was at Vollmer's house that he first met Smithson, and that they "immediately entered into an argument about entropy and mannerism in El Greco" (interview with Nadja Rottner, May 13, 2003). Vollmer knew Sol LeWitt from before 1966.

Vollmer continues to explore the sphere form in a varied group of works in bronze, including *Bound Sphere Minus Lune*, *Skewed Hemispheres*, and *Octahedron Piercing Spheres*. In an artistic statement written this year, probably to accompany her exhibit at Betty Parsons titled *Ruth Vollmer: Sculpture, Spheres*, Vollmer writes: "Being immersed in this mysterious form, I perceive an endless variety of cosmic and earthly, biologic and crystalline manifestations." For her exhibit this year at Betty Parsons, Vollmer had wanted to scatter the works on the floor, without pedestals of any kind. According to several sources, Parsons would not agree to this, and so Vollmer and Mel Bochner designed and built a six-foot-square plywood base for most of the spheres to rest on (Rottner interviews with Bochner, May 13, 2003, and Thomas Nozkowski, June, 21, 2004).

Of her exhibition this year, a *New York Herald Tribune* review states that the works "seem, at first, like variously pierced or split bronze bowling balls. But Vollmer's spheres soon take on another aspect. They're seedpods bursting with life. They're the music of the spheres given physical form (with a small mallet provided so one may strike rods inside them). They're the earth itself, making an ominous reverberating sound at the slight touch. This is an immensely imaginative, personal expression by an artist still little known" (Emily Genauer, "Sculpture, Spheres By Ruth Vollmer," *New York Herald Tribune*, January 26, 1966: 9).

Robert Smithson reproduces Vollmer's *Obelisk* in his essay "Quasi-Infinities and the Waning of Space." In it he cites a description by Giacometti of his *Palace at 4 A.M.*, originally published in *Minotaur* and translated into English by Vollmer for the short-lived magazine *Transformations*. He compares Vollmer to Giacometti, Hesse, and Lucas Samaras. According to Smithson, all of these artists dis-

play an affinity for a "detemporalized" aesthetic, furthermore "this attitude towards art is more 'Egyptian' than 'Greek,' static rather than dynamic." Of Vollmer, he states that her works, like those of Giacometti, "evoke both the presence and absence of time. Her *Obelisk* is similar in mood to *The Palace at Four A.M.*... Matter in this *Obelisk* opposes and forecloses all activity—its future is missing" (*Arts Magazine* 41, no. 1 [November 1966]: 30).

Vollmer participates in several group exhibits, including the Pennsylvania Academy Annual and a two-person show at Drew University with Leo Rabkin.

1967

While continuing to work in bronze, Vollmer begins experimenting with several new materials including acrylic, spun aluminum, and laminated wood. She also begins to work with reinforced fiberglass. Her *Trigonal Volume* is produced in bronze and, in 1968, in reinforced orange Fiberglas (the latter, executed by Doug Johns, was owned by Hesse).

She receives a commission from the U.N. Committee for Economic Development for a work in an edition of 15 to be given to those trustees who were founding members. The work, *Trenchant Sphere*, is composed of three separate pieces: a sphere, a "collar" and a stand. Due to arthritis in her hand that makes some of the finish work difficult, Vollmer engages Thomas Nozkowski (who worked for Betty Parsons at the time) to help her polish the pieces. Nozkowski and his wife, Joyce Robins, remain close friends of Vollmer's until her death.

Sol LeWitt reproduces Vollmer's *Skewed Hemispheres*, also known as *2/2 Spheres*, on the opening spread of his article "Paragraphs on Conceptual Art," published in *Artforum* in June.

Vollmer spends the summer in Southold, Long Island, where Eva Hesse visits her.

1967–68

Vollmer creates several large-scale works out of spun aluminum, which was the material used in aviation at the time because it was very lightweight. Vollmer was able to convince the

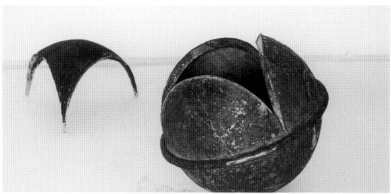

RUTH VOLLMER. BOUND SPHERE MINUS LUNE, 1966
BRONZE (UNIQUE CAST), DIAM. 7.5 IN. (19 CM)
PHOTO HERMANN LANDSHOFF
COURTESY JACK TILTON GALLERY, NEW YORK

JASPER JOHNS. MAP (BASED ON R. BUCKMINSTER FULLER'S DYMAXION AIROCEAN WORLD),
1967
ENCAUSTIC AND COLLAGE ON CANVAS, 186 X 396 FT. (56.7 X 120.7 M)
© VG BILD-KUNST, BONN 2004

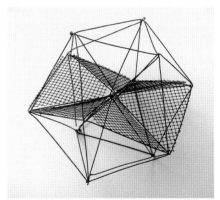

RUTH VOLLMER. UNTITLED (ICOSAHEDRON),
CA. 1965
STEEL WIRE, 2 X 12 X 12 IN. (5.1 X 30.9 X 30.9 CM)
COLLECTION THE ESTATE OF ROBERT SMITHSON
PHOTO HERMANN LANDSHOFF © NANCY HOLT

only manufacturer in the area, the Grumman Aircraft Engineering factory in Bethpage, N.Y., to construct several large-scale sculptures out of spun aluminum for her. According to Leo Rabkin, she convinced Grumman to fabricate the sculptures through persistence and by always showing up with a box of European chocolates (interview with Nadja Rottner, June 10, 2004). Works created in this material include *Figure of Half Revolution* (1968), which, at seventy-six inches in diameter, is much larger than the majority of her works, and required the assistance of a team of engineers and craftsmen at Grumman; *Reciprocals* (1968); and *In the Relation Three to Four* (1968). Like so many of her smaller pieces, *Figure of Half Revolution*, also invited the participation of the viewer: The piece, which had a round base, could be rocked back and forth, as could her *Trigonal Volume.*

Filmmaker Dorothy Levitt Beskind visits the studio of Eva Hesse, where she films Eva's work as well as Eva and Vollmer together (the only extant film of Vollmer known today).

1968

Vollmer has a one-person show at Betty Parsons that includes many of the new works in acrylic and spun aluminum. She is also included in an exhibition of Parsons's own collection at the Finch College Museum of Art in New York.

Robert Smithson once again discusses Vollmer's work in "A Museum of Language in the Vicinity of Art," citing it as an example of the salience of cartography for contemporary art, writing that *Bound Sphere Minus Lune* (opposite) "may be seen as a globe with a cut away Northern Region. Three arcs in the shape of crescents intersect at the 'bound' equator. The 'lune' triangulation in this orb detaches itself and becomes secondary 'sculpture'" (*Art International* 12, no. 3 [March 1968]: 93–94). This observation is followed by a discussion of R. Buckminster Fuller and of a work by Jasper Johns (opposite) that is clearly influenced by Fuller and by new cartographic concepts.

Vollmer's interest in new materials influences her young friend Eva Hesse. Lucy R. Lippard writes that at this time Vollmer took Hesse to a marine supply store, where Hesse bought

stuffed "bumpers" used on the bow of a boat; to these, she added multiple pieces of dangling string. Hesse makes three of these pieces, one of which, coated in epoxy, she gives to Vollmer. Vollmer also gives Hesse a type of yellow clay that the younger artist uses to make a work that she also gives to Vollmer (see Lucy R. Lippard, *Eva Hesse* [New York: Da Capo Press, 1976], pp. 100, 120). Vollmer and Hesse travel to Mexico together.

Hermann Landshoff produces the photographs for *The Shell: Five Hundred Million Years of Inspired Design*, with texts by Hugh and Marguerite Stix and R. Tucker Abbott.

1969

Vollmer works with architectural model maker and master craftsman Bob Geiger to produce works in both wood and acrylic.

She creates the *Pseudosphere* (page 125), based on a concept developed by the nineteenth-century mathematician Bernhard Riemann (whose work would later become crucial to Einstein). Riemann's work was probably of particular interest to Vollmer because of the emphasis he placed on the sphere. The underlying significance of his focus on the sphere was that "the elements for a geometry which will satisfy the surface of the earth are identical with those of Riemannian geometry." Riemann's geometry thus suited Vollmer's interests, since it united her interest in mathematics with her concern with nature and natural forms. His pseudosphere, Vollmer wrote in 1970, "is a 'false' surface of negative curvature" in which "the curve is constructed on many equal circles, centred [sic] on equidistant points on a longitudinal axis." (Here, Vollmer may have been quoting David Hilbert and Stephan Cohn-Vossen's popular 1952 book, *Geometry and the Imagination*, which she knew well, and which she may have read in the original German.) Vollmer's *Pseudosphere* was produced in laminated and turned wood (later acquired by Sol LeWitt), as well as on a large scale in spun aluminum. Other works from this year also draw quite literally on geometric principles, illuminating them and making them accessible and relevant to the public through Vollmer's unconventional and provocative use of color and materials. Vollmer's work *Reciprocals* (1968),

appears on the cover of a textbook by David G. Crowdis titled *Introduction to Mathematical Ideas*, published by McGraw-Hill (page 124). Just two years later, Vollmer's *Intersecting Ovals* of 1970, which represents the four-dimensional geometric form known as a "Steiner surface," is reproduced on the cover of *Calculus and Analytic Geometry* (page 124).

Jane Sabersky, curator of the collections of Columbia University, shows Vollmer a set of over one hundred mathematical models in the Columbia collection, which enchanted and inspired her. Vollmer mentions the models frequently in both interviews and written documents. The idea of a model as a form that illustrates or embodies a particular idea or proposition is crucial to her later work and is a departure from her earlier, more intuitive explorations of geometric forms.

Vollmer participates in the Whitney Annual. She shows *In the Relation Three to Four* (1968), a work of spun aluminum twenty inches in diameter.

Rolf-Gunter Dienst features Vollmer's art in "Ruth Vollmer's Magic of Simplicity" (*Das Kunstwerk* 22, nos. 5–6 [February/March 1969]).

1970

Vollmer continues her involvement with complex geometrical forms and mathematical concepts. Of particular interest to her at this point are spirals and platonic solids. Vollmer draws on a number of sources to broaden her understanding of geometry in nature and in theory. First among these is her friend and fellow émigré Erna Herrey, who Vollmer credits as her math tutor. Other sources include D'Arcy Wentworth Thompson's 1917 *On Growth and Form*, which offers a scientific vision of space itself; *On Growth and Form* (which had also been a source of inspiration, much earlier in the century, for Naum Gabo, an artist who Vollmer deeply admired) had been abridged and republished in 1961, and then reprinted many times throughout the sixties. In her notes, Vollmer quotes Thompson's observations on spiral forms and patterns in nature. Other sources she is known to have consulted include Hilbert and Cohn-Vossen's *Geometry and the Imagination*, Morrison's "The Modularity of Knowing" (1966), and, probably

most importantly, Peter S. Stevens's *Patterns in Nature* (1974). Vollmer quotes Stevens at length in her notes, transcribing passages such as the following:

"Of all the constraints on nature, the most far-reaching are imposed by space. For, space itself has a structure that influences the space of every existing thing...the immense variety that nature creates emerges from the working and reworking of only a few formal themes...in matters of form we sense that nature plays favorites. Among the darlings are spirals, meanders, branching patterns and 102 degree joints..." (RVP),

Among the geometrically attuned works created in this year are *Spherical Tetrahedron*, *Heptahedron*, and *Steiner Surface*. In several cases, Vollmer produces more than one version of these works, using a different material for each. She begins to work in translucent acrylic, which reveals the forms more fully. Acrylic had been widely used in aircraft windows and canopies during World War II, and in the decade following the war, experimentation with different kinds of plastics was fast-paced. Along with acrylic, (marketed by DuPont as Lucite, by Rohm & Haas as Plexiglas), Fiberglas and vinyl were also developed for commercial use after the war, as were techniques of injection molding that were inexpensive and efficient. Model makers quickly adopted acrylic because it allowed for high-precision cutting and because pieces were easily attached. Vollmer adopts transparent acrylic because it particularly suits her interest in flexibility and transparency.

Sol LeWitt writes a short essay on Vollmer's work for *Studio International* titled "Ruth Vollmer: Mathematical Forms," in which he states: "The pieces are not about mathematics; they are about art. Geometry is used as a beginning just as a nineteenth-century artist might have used the landscape. The geometry is only a mental fact" (*Studio International* 180, no. 928 [December 1970]: 256).

1971

Vollmer writes to Thomas Messer, director of the The Solomon R. Guggenheim Museum, to protest the cancellation of the Hans Haacke exhibition. She writes, "I left the country of my birth, exchanging book burnings and "degen-

erate art" exhibitions, among other things, for freedom of speech and conscience."

1972

Vollmer participates in the Artists Benefit for Civil Liberties at the Leo Castelli Gallery. She is included in the exhibition "Women Artists" at Williams College, curated by Joyce Robins.

Several of Vollmer's sculptures are reproduced in the book *Acrylic in Sculpture and Design* by Clarence Bunch.

1973

Vollmer has a one-person show at the Betty Parsons Gallery that features several works that deal with the spiral, as well as other works derived from mathematical concepts of the sphere in the fourth dimension, including *Steiner Surface* and a large-scale *Pseudosphere*.

It is likely that the spiral form had been of interest to Vollmer for some time, considering her longtime interest in shells. In fact, two works in the show, derived from logarithmic spirals, are specifically titled *The Shell, I* and *The Shell, II*. In the catalogue to the Betty Parsons exhibition, Vollmer describes these as follows: "Logarithmic, equiangular spiral in conical form. The individual rungs of these shells can be taken off, indicating a characteristic of the growth of the real sea shells. When the house becomes too small the shell grows one rung. Each consecutive rung becomes larger than the former in a logarithmic sequence. One can find shells of the same species with one, two or five rungs."

She creates several other works that explore logarithmic spirals, including *Large Exponential Tower, I* and *II*, and two versions of the *Archimedean Screw*, in clear acrylic. The sculptures were meant to be turned clockwise and counterclockwise, so that the viewer could observe the motion. The "towers" are made of rolled sheets of Mylar that, when inserted into a solid acrylic base, take a spiral form.

In *The Shell, II*, Vollmer affixed blue graph paper to the interior surface of the acrylic forms, giving the surface more articulation. As Thomas Nozkowski explains, "The grid has no mathematical meaning, it is meant to serve solely as a skin. By removing these pieces, one at a time, we are given a very clear idea of the

RUTH VOLLMER. RECIPROCALS, 1967
COVER IMAGE FROM DAVID G. CROWDIS
AND BRANDON W. WHEELER
INTRODUCTION TO MATHEMATICAL IDEAS (1969)

CALCULUS AND ANALYTIC GEOMETRY

RUTH VOLLMER. SIX INTERSECTING OVALS, 1970
COVER IMAGE FROM WILLIAM H. DURFEE
CALCULUS AND ANALYTIC GEOMETRY (1971)

changes in height and volume that accompany the natural growth of this form" (Rottner interview, June 21, 2004).

1974

Vollmer has a one-person exhibition of sculpture and drawings at the Everson Museum of Art in Syracuse, N.Y., that features work from the previous four years. Vollmer included in this exhibit a series of wire forms that, when dipped into soapy water, create geometric forms, including the five platonic solids. Vollmer's interest in soap bubbles, which had been the subject of scientific and geometric inquiry for centuries, was probably long-standing, dating back to her earlier explorations of the sphere. Thomas Nozkowski remembers seeing them in her studio in 1967 (Rottner interview, June 21, 2004). Among the sources she referred to on the topic of bubbles was Charles Vernon Boys's 1911 book, *Soap Bubbles*, reprinted by Dover in the sixties. Several other artists, including Sol LeWitt, remember these wire forms to be among her strongest works (Nadja Rottner, interview with Sol LeWitt, May, 13, 2003). The soap forms epitomize Vollmer's sensibility in that they combine a deep intellectual interest in ideal forms and natural phenomena, and an appreciation of the possibilities of "child's play," while requiring the viewer to take part in the artistic object.

1975

Vollmer visits Greece. From Delphi, she writes a postcard to Mel Bochner, on which she notes that the "stadium is all in numbers: 12-6-4."

1976

Vollmer has a large one-person exhibition at the Neuberger Museum of Art, at the State University of New York at Purchase. The works include *5 Regular Polyhedra, 5 Spheres, 1 Large Mirrored Sphere* (pages 186–87), from 1975. Materials used include spun aluminum, acrylic, mirrored acrylic, and brass-laminated acrylic.

1978

Vollmer leaves her Union Square studio and establishes a working studio in her home, focusing to an increasing extent on drawing. She exhibits her drawings at the Adler Gallery

in Los Angeles. Since the mid-seventies, drawing had taken an increasingly central role in Vollmer's art. During this time she became more and more involved with numerical ideas, relations, and series, and these concerns are evident in the works on paper she produced. Her pencil drawings are largely on graph paper, and work out numerical relations, including addition and multiplication tables, that reference Leonardo da Vinci's studies of geometry in the Codice Arundel. She also takes the Fibonacci series as a subject. These numerical progressions dictate the structure of many natural forms, including the spirals found in seashells and the arrangement of a sunflower's seeds. Susan Carol Larsen writes in *Artweek*: "This show at the Adler Gallery is something of a departure for Vollmer. In the past two years her drawings have become looser, more involved with the expressive idiosyncrasies of individual lines and forms.... These variations are reminiscent of Eva Hesse and the aberrant Platonism of Sol LeWitt's casual handmade drawings" ("Ruth Vollmer— Drawing As Thinking," *Artweek,* October 7, 1978: 1, 20).

Vollmer participates in a conference at The Metropolitan Museum of Art, "The Teaching of Mathematics Through Art," and her *Pseudosphere* is used as a model.

1979

Vollmer exhibits her pencil drawings at the Betty Parsons Gallery. By the winter of 1979–80, she suffers from severe symptoms of Alzheimer's disease.

1982

At age eighty, Ruth Vollmer dies on New Year's Day after a long sickness and struggle with Alzheimer's. Her extensive art collection is donated in large part to MoMA. Vollmer's bequest is comprised of over one hundred works of painting, sculpture, drawing, and graphic arts, including works by Carl Andre, Mel Bochner, Eva Hesse, Patrick Ireland, Robert Mangold, Sol LeWitt, Robert Smithson, Ad Reinhardt, Leo Rabkin, Frank Stella, Richard Tuttle, Agnes Martin, Chryssa, and Matt Mullican.

RUTH VOLLMER. UNTITLED (PSEUDOSPHERE ON CANVAS), N.D.
PENCIL ON TRANSPARENT PAPER
20.9 X 8.3 IN. (53 X 21 CM)
JACK TILTON GALLERY, NEW YORK
PHOTO KOINEGG/NEUE GALERIE GRAZ

RUTH VOLLMER
PSEUDOSPHERE, 1969
LAMINATED WOOD, MAX. L. 25 IN. (58.4 CM),
DIAM. 10.5 IN. (26.7 CM)
THE LEWITT COLLECTION, CHESTER, CONN.
PHOTO HERMANN LANDSHOFF

Thanks to Nadja Rottner and Almut Haboeck for their extensive research on Ruth Vollmer, which informed this chronology.

PLATES

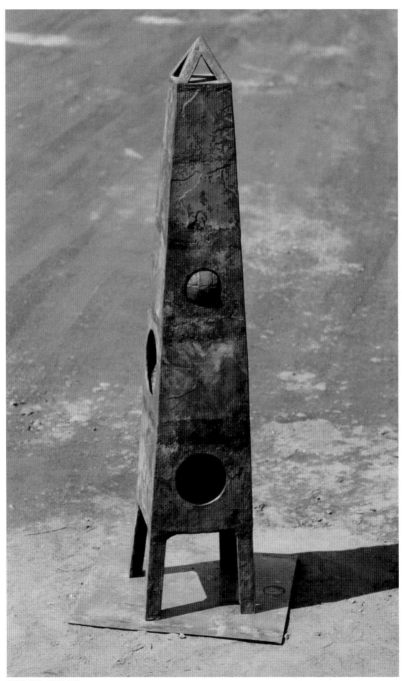

OBELISK, 1961-62
BRONZE (UNIQUE CAST), 66.9 X 13.9 X 14.5 IN. (169.8 X 35.3 X 36.9 CM)
SMITHSONIAN AMERICAN ART MUSEUM, WASHINGTON D.C. GIFT OF ERIC F. GREEN
PHOTOS HERMANN LANDSHOFF

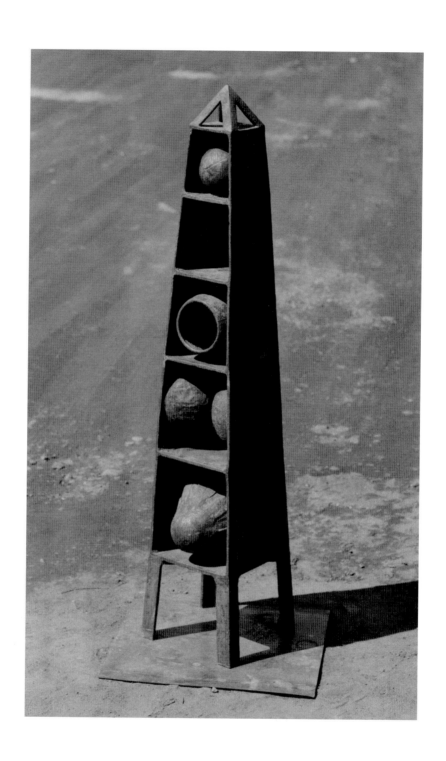

PAGES 130-31
CLUSTER ABOUT HEMISPHERE, 1964
BRONZE (UNIQUE CAST), DIAM. 8 IN. (20.3 CM)
PHOTOS HERMANN LANDSHOFF

129

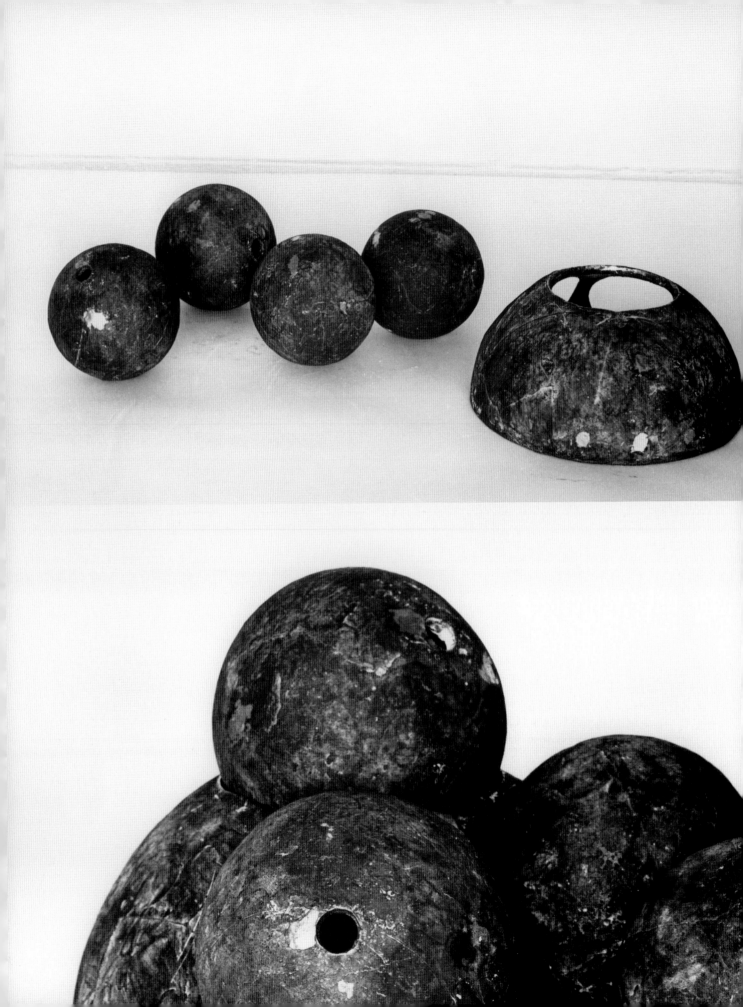

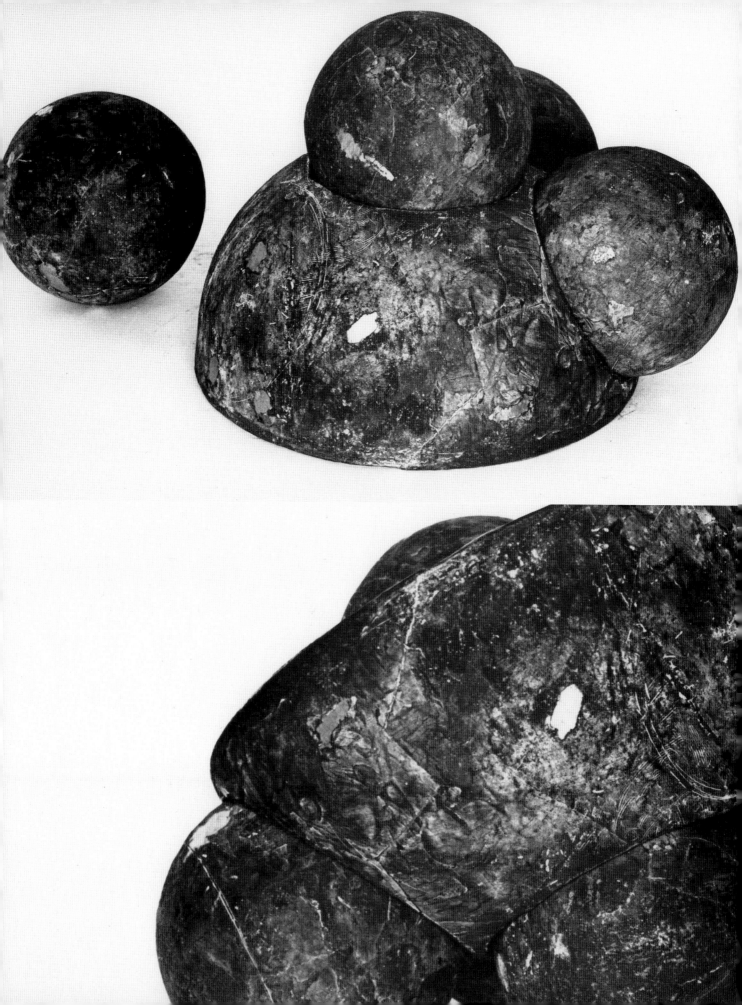

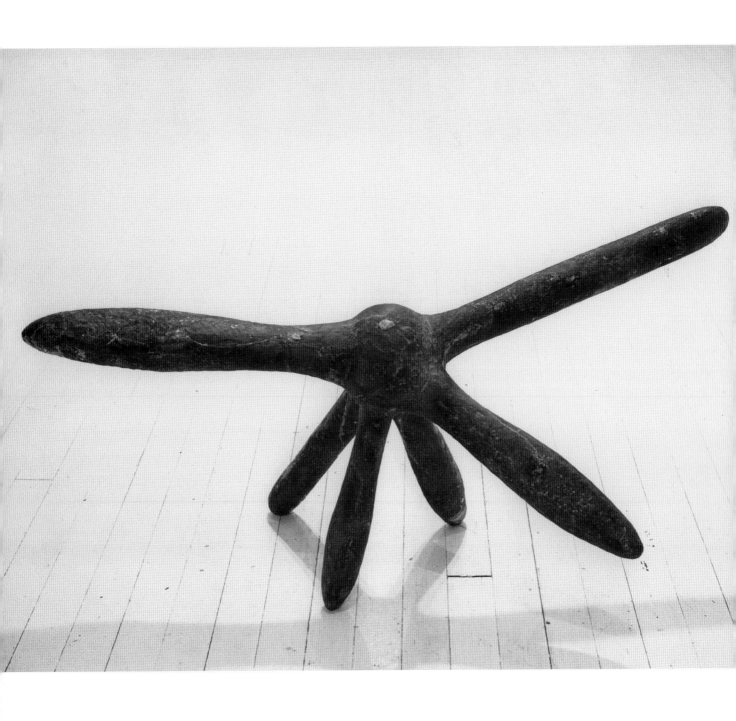

WALKING BALL, 1959
BRONZE (ED. OF 5), 18 X 37 IN. (45.7 X 94 CM)
JACK TILTON GALLERY, NEW YORK
PHOTOS HERMANN LANDSHOFF

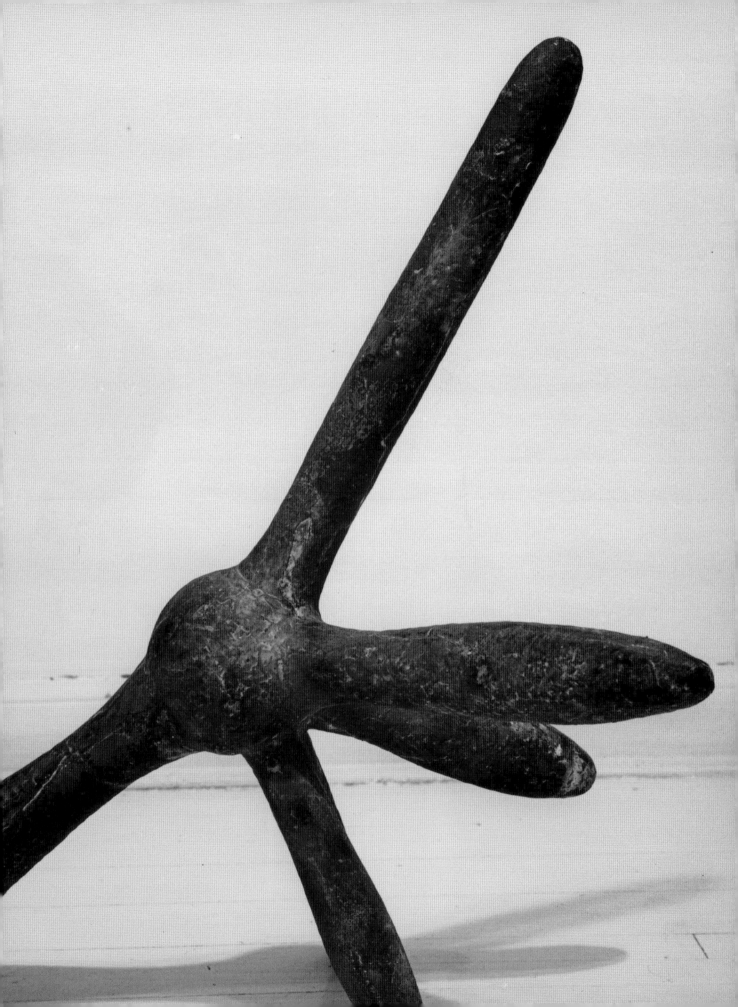

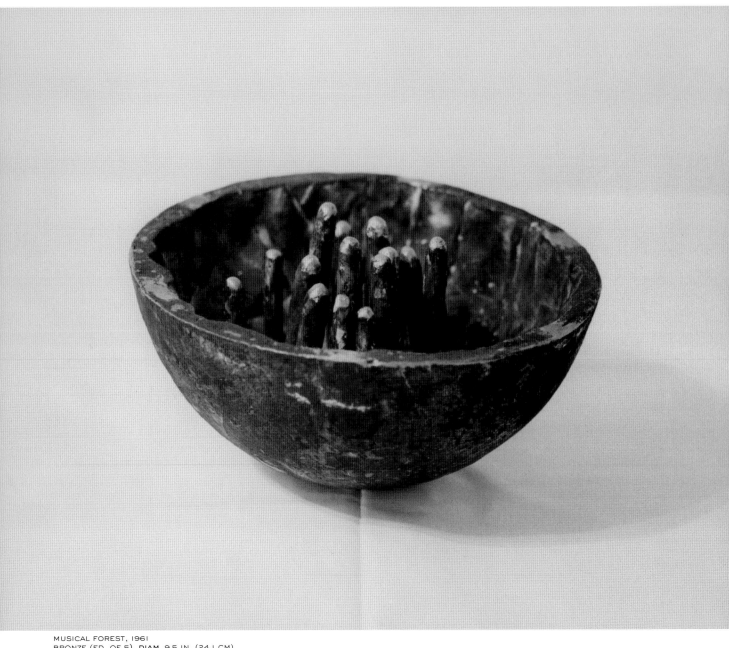

MUSICAL FOREST, 1961
BRONZE (ED. OF 5), **DIAM.** 9.5 IN. (24.1 CM)
COLLECTION PHILIP MCCARTER TIFFT, NEW YORK
PHOTO HERMANN LANDSHOFF

134

COSMIC FRAGMENTS, 1962
BRONZE, DIAM. 16.5 IN. (41.9 CM)
JACK TILTON GALLERY, NEW YORK
PHOTO HERMANN LANDSHOFF

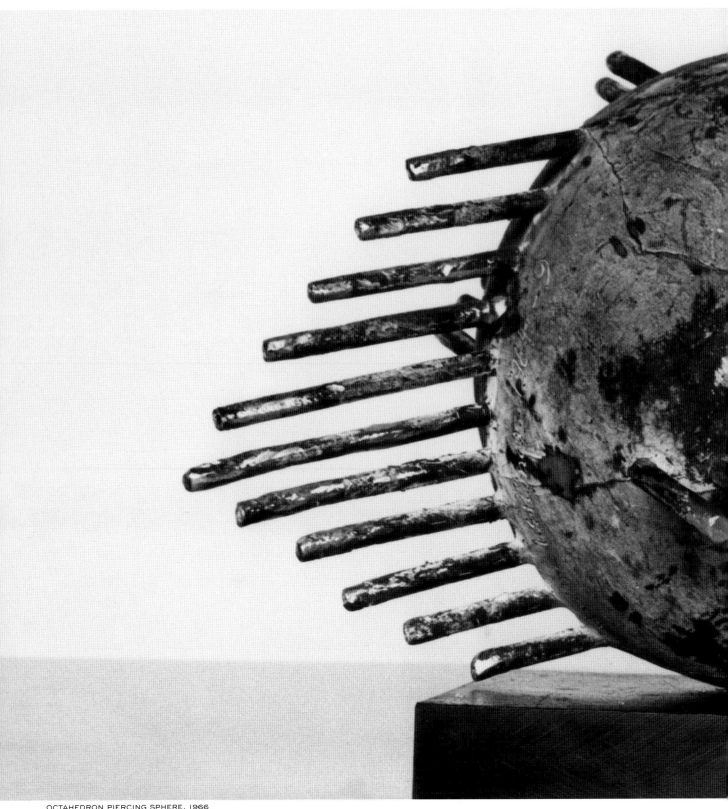

OCTAHEDRON PIERCING SPHERE, 1966
BRONZE (UNIQUE CAST), 14 X 14 X 14 IN. (35.6 X 35.6 X 35.6 CM), DIAM. 7.5 IN. (19 CM)
PHOTO HERMANN LANDSHOFF
RUTH VOLLMER PAPERS, 1939-1980, ARCHIVES OF AMERICAN ART, SMITHSONIAN INSTITUTION, WASHINGTON, D.C.

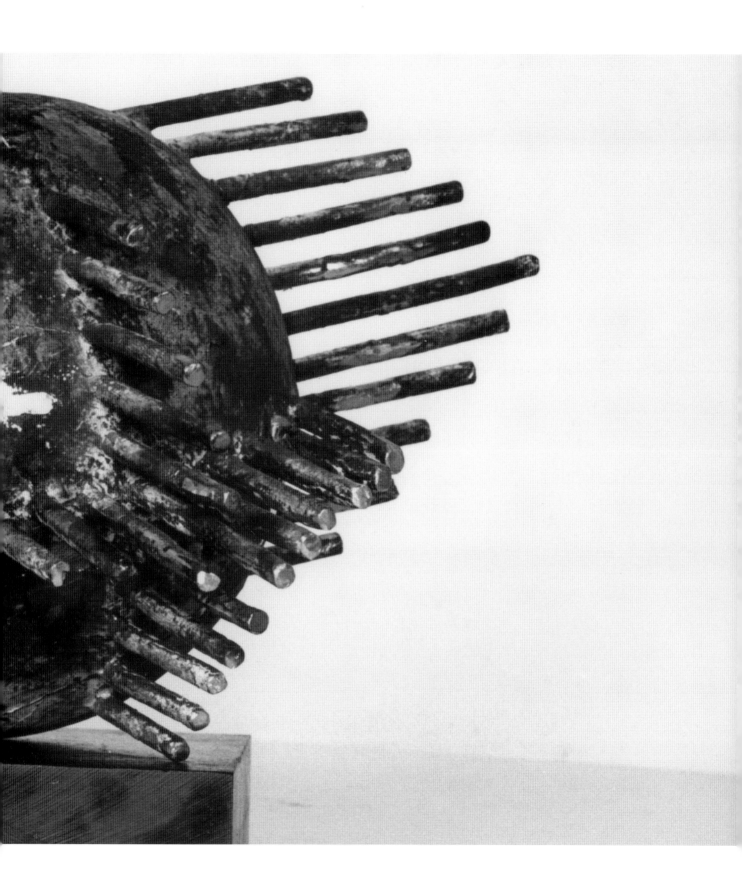

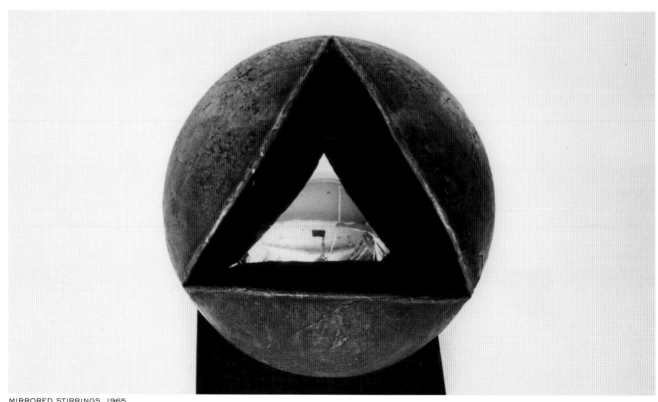

MIRRORED STIRRINGS, 1965
BRONZE (UNIQUE CAST), SELF-REFLECTIVE FOIL, DIAM. 10 IN. (25.4 CM)
PHOTO HERMANN LANDSHOFF
RUTH VOLLMER PAPERS, 1939-1980, ARCHIVES OF AMERICAN ART, SMITHSONIAN INSTITUTION, WASHINGTON, D.C.

LOGARITHMIC SPIRAL IN SPHERE, 1965
BRONZE (UNIQUE CAST), DIAM. 13 IN. (33 CM)
PHOTO HERMANN LANDSHOFF
RUTH VOLLMER PAPERS, 1939-1980, ARCHIVES OF AMERICAN ART, SMITHSONIAN INSTITUTION, WASHINGTON, D.C.

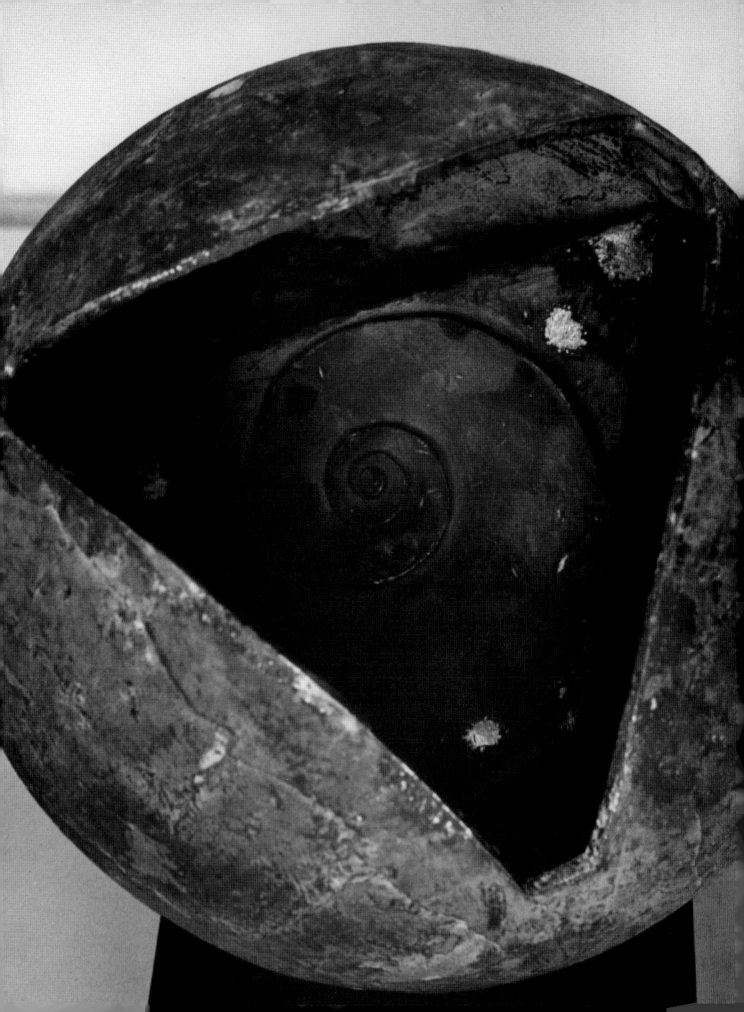

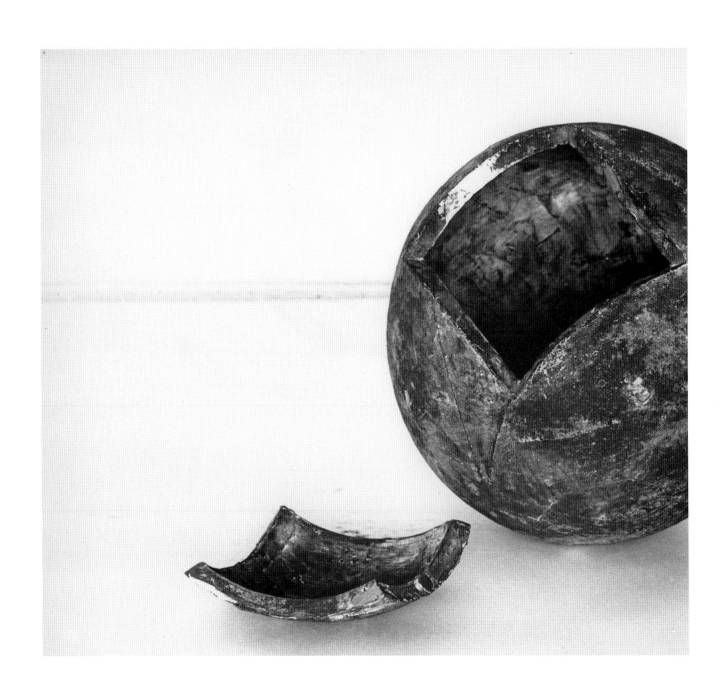

SPHERE WITH SMALL SQUARE CUTOUT, 1963
BRONZE (UNIQUE CAST), DIAM. 9.5 IN. (24.1 CM)
COLLECTION JANE TIMKEN, NEW YORK
PHOTO HERMANN LANDSHOFF

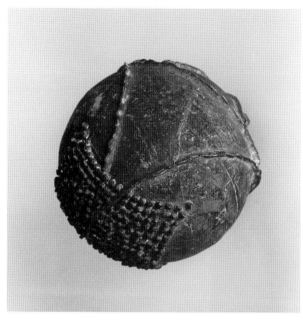

UNTITLED (WOUNDED SPHERE), N.D.
BRONZE (UNIQUE CAST), DIAM. 6.7 IN. (17 CM)
COLLECTION PHILIP MCCARTER TIFFT, NEW YORK
PHOTO HERMANN LANDSHOFF

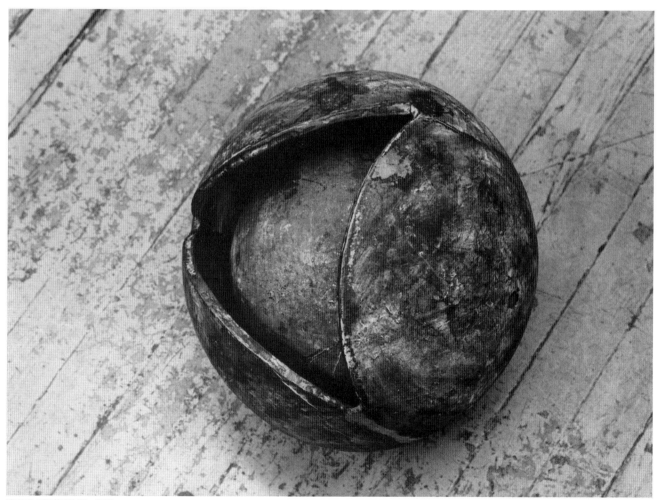

RUMBLINGS WITHIN, 1965
BRONZE (UNIQUE CAST), DIAM. 12 IN. (30.5 CM)
COLLECTION THOMAS NOZKOWSKI AND JOYCE ROBINS, NEW YORK
PHOTO HERMANN LANDSHOFF

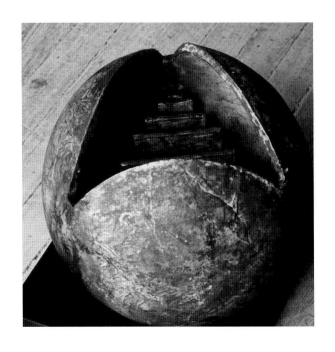

SOUND CENTER, 1964
BRONZE (UNIQUE CAST), DIAM. 13 IN. (33 CM)
PHOTO HERMANN LANDSHOFF
COURTESY JACK TILTON GALLERY, NEW YORK

STRIPS AROUND C (SERIES II), 1965
BRONZE (UNIQUE CAST), DIAM. 10 IN. (25.4 CM)
PHOTO HERMANN LANDSHOFF
COURTESY JACK TILTON GALLERY, NEW YORK

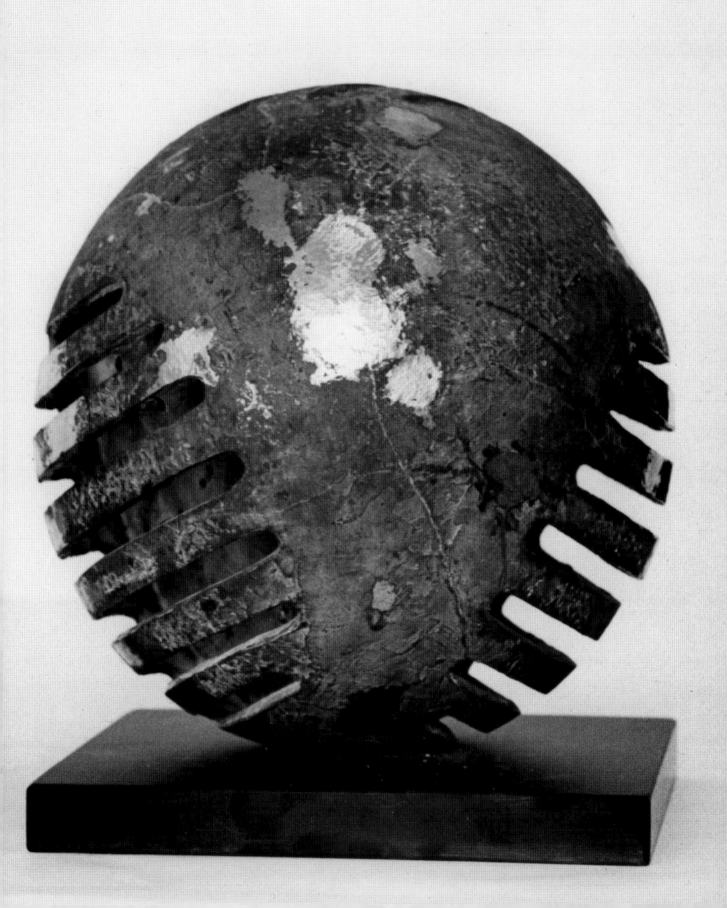

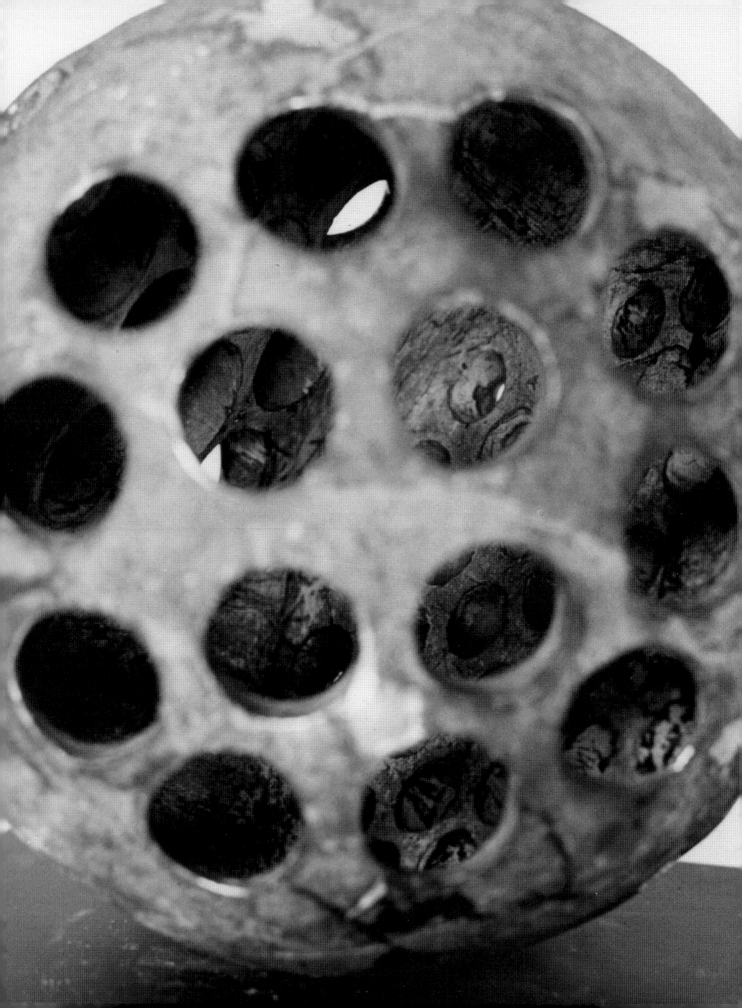

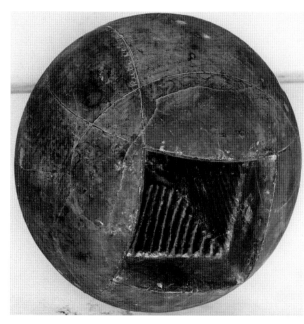

WEDDING OF SPHERE WITH CUBE (SERIES I), 1964
BRONZE (ED. OF 6), DIAM. 9 IN. (22.9 CM)
JACK TILTON GALLERY, NEW YORK
PHOTO HERMANN LANDSHOFF

OPPOSITE:
COMPLEXITY (SERIES II), 1965
BRONZE (UNIQUE CAST), DIAM. 9.5 IN. (24.1 CM)
ROSE ART MUSEUM, BRANDEIS UNIVERSITY, WALTHAM, MASS.
PHOTO HERMANN LANDSHOFF
COURTESY JACK TILTON GALLERY, NEW YORK

BELOW:
INTERPOSED CROSS (SERIES I), 1964
BRONZE (ED. OF 6), DIAM. 9 IN. (22.9 CM)
JACK TILTON GALLERY, NEW YORK
PHOTO HERMANN LANDSHOFF

PAGE 146
MONOMER, 1965-66
BRONZE (ED. OF 6), DIAM. 13 IN. (33 CM)
PHOTO HERMANN LANDSHOFF
COURTESY JACK TILTON GALLERY, NEW YORK

PAGE 147
DIMER, 1965
BRONZE (ED. OF 6), DIAM. 13 IN. (33 CM)
JACK TILTON GALLERY, NEW YORK
PHOTO HERMANN LANDSHOFF

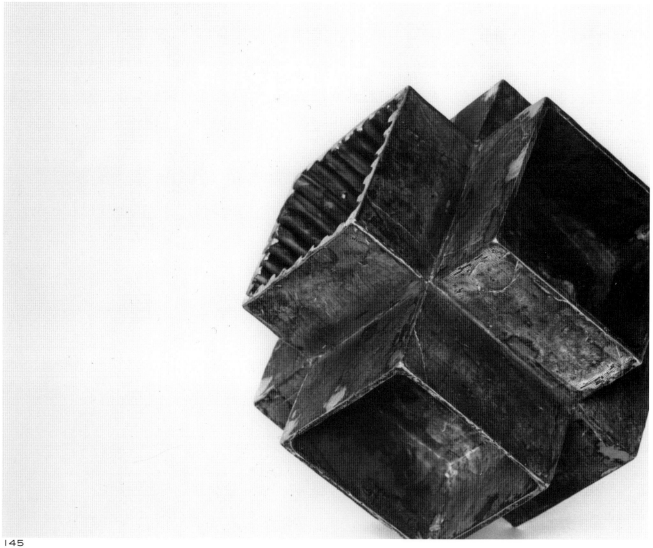

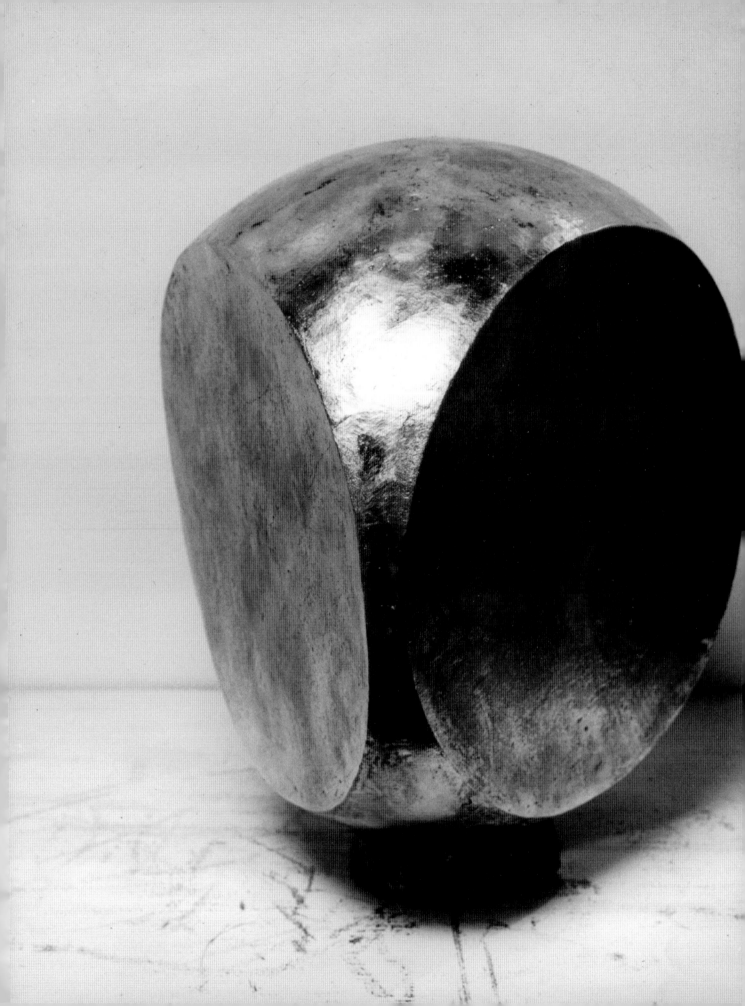

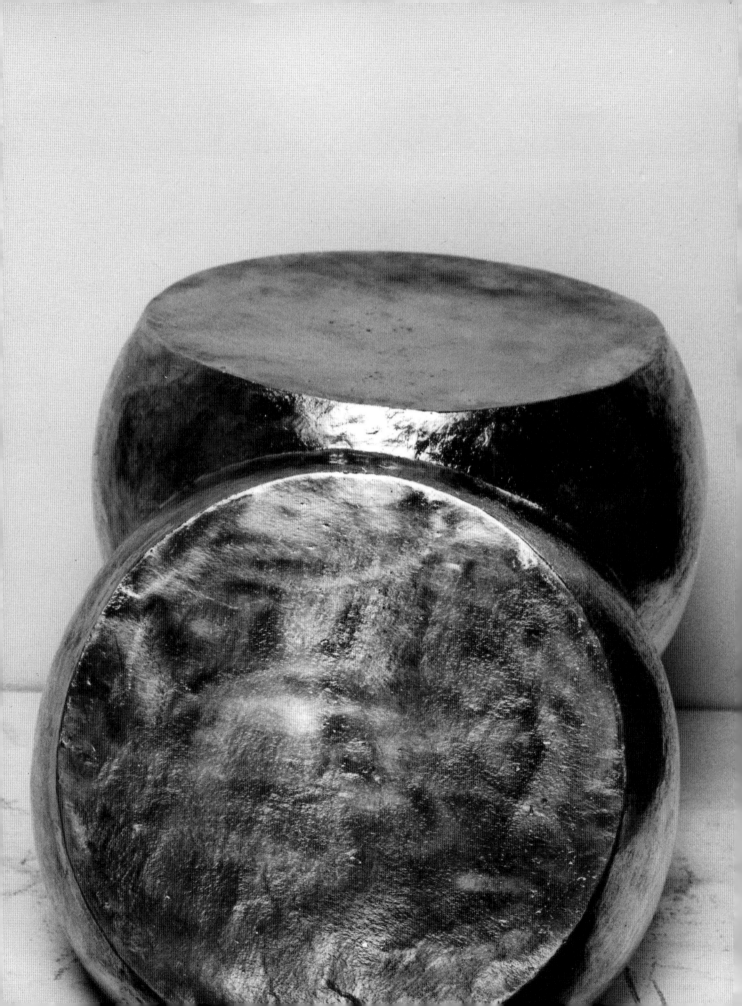

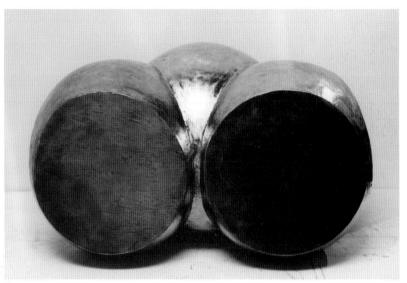

TRIMER, 1965
BRONZE (ED. OF 6), **DIAM.** 13 IN. (33 CM)
PHOTO HERMANN LANDSHOFF
COURTESY JACK TILTON GALLERY, NEW YORK

PENTAMER, 1965
BRONZE, 25 X 10 X 8.5 IN. (63.5 X 25.4 X 21.6 CM)
KUNSTMUSEUM WINTERTHUR

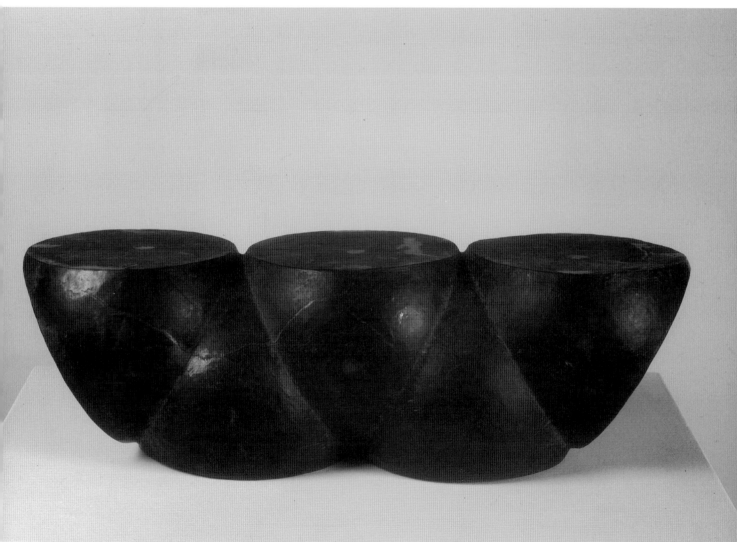

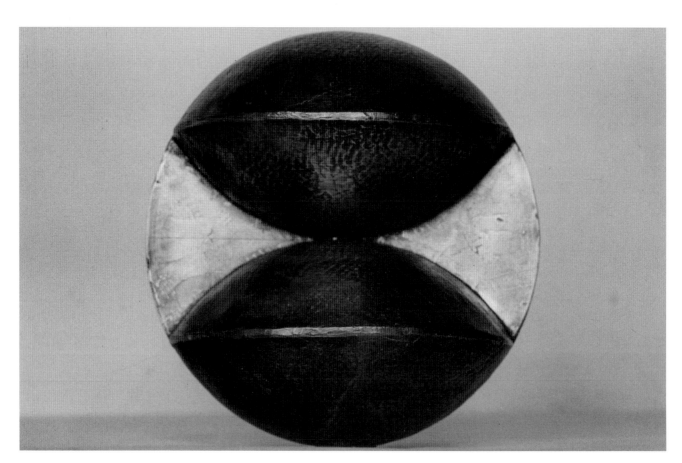

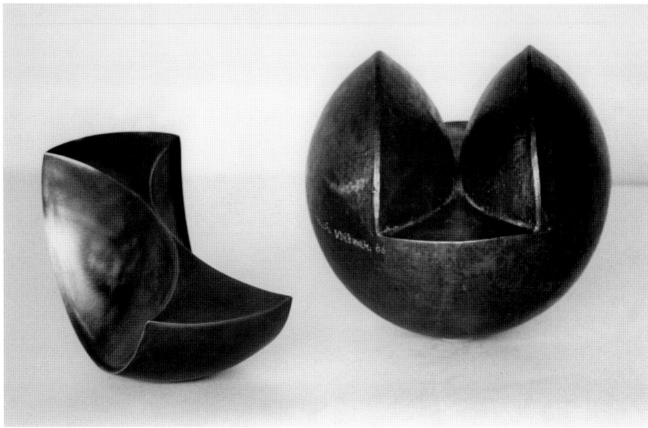

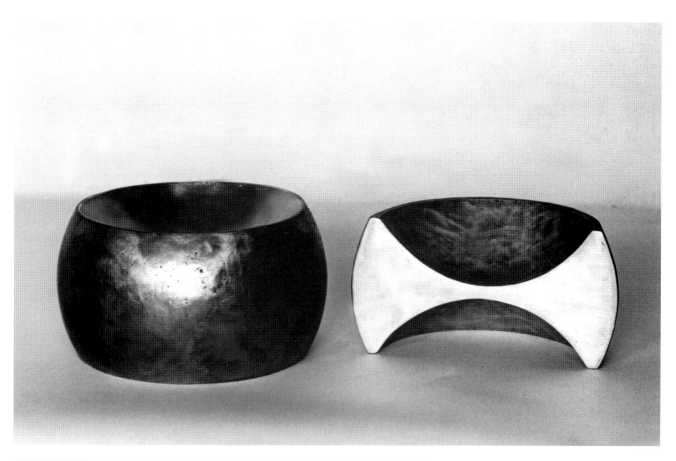

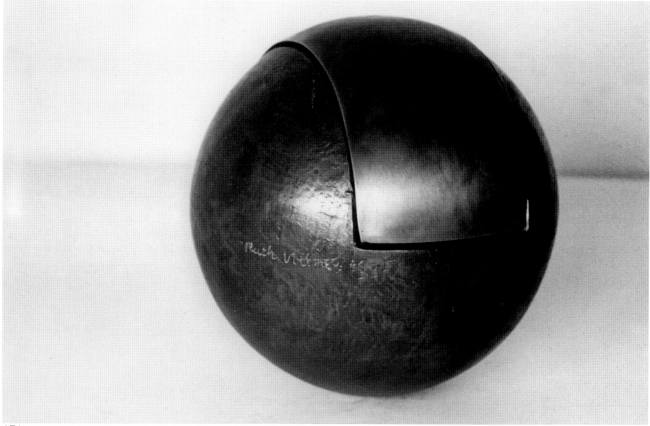

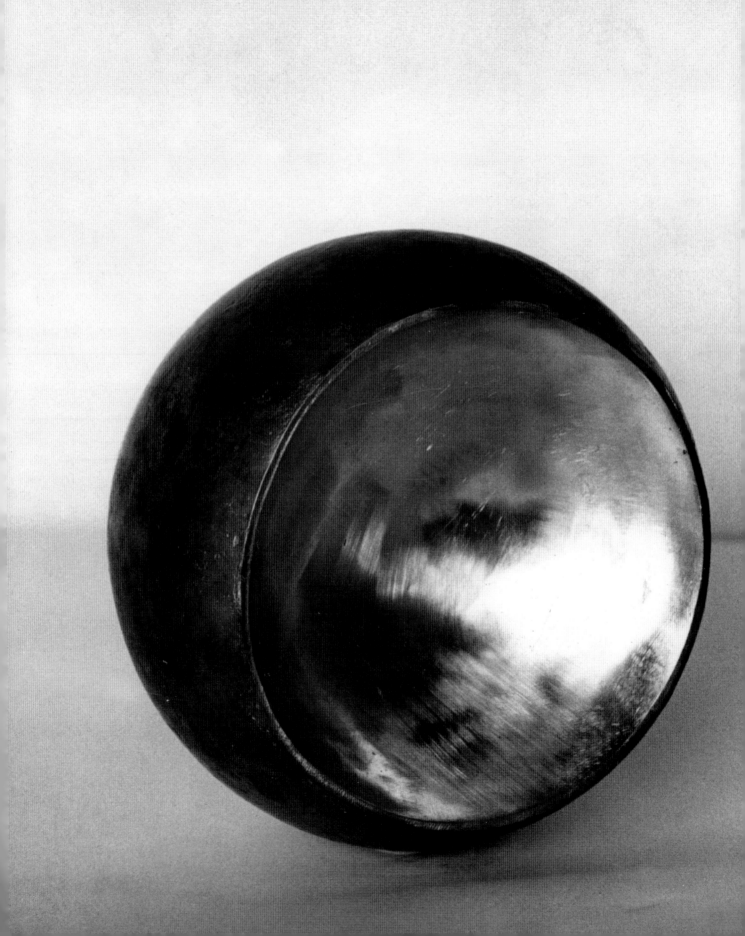

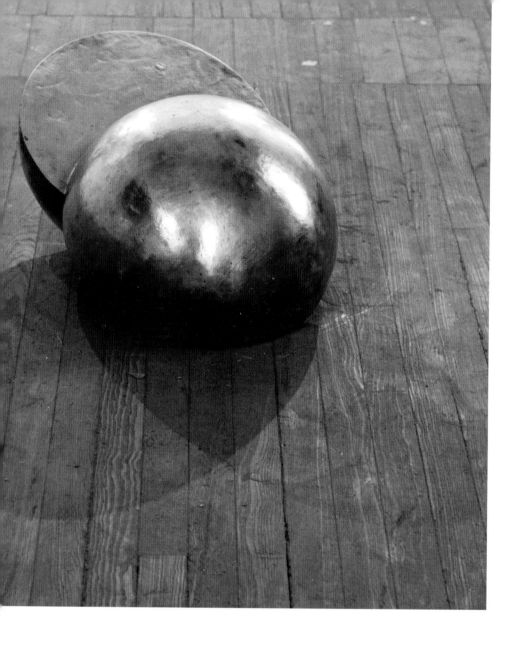

SKEWED HEMISPHERES, 1966
BRONZE, 10.5 X 7 X 7 IN. (26.7 X 17.8 X 17.8 CM)
COLLECTION THOMAS NOZKOWSKI AND JOYCE ROBINS, NEW YORK
PHOTO HERMANN LANDSHOFF

OPPOSITE:
BICONCAVITY, 1967
BRONZE, DIAM. 9.5 IN. (24.1 CM)
PHOTO HERMANN LANDSHOFF
COURTESY JACK TILTON GALLERY, NEW YORK

PAGES 154-55
FIGURE OF HALF REVOLUTION, 1968
SPUN BRONZE, DIAM. 76 IN. (193 CM)
PHOTO HERMANN LANDSHOFF
COURTESY JACK TILTON GALLERY, NEW YORK

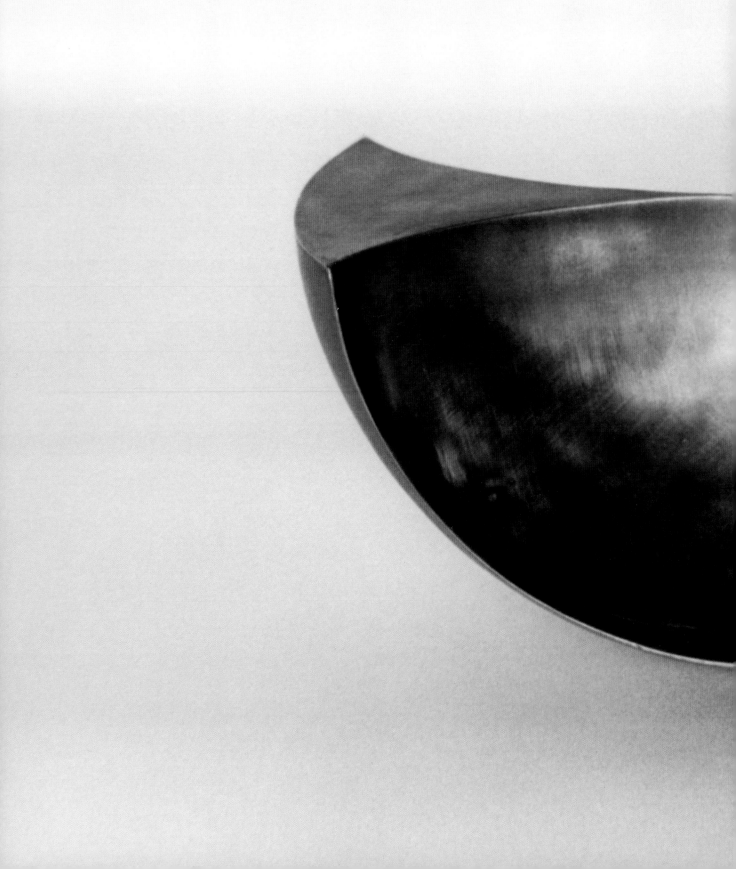

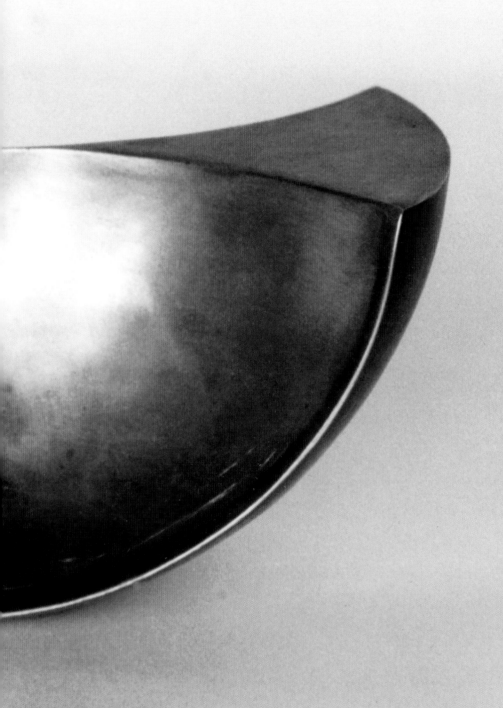

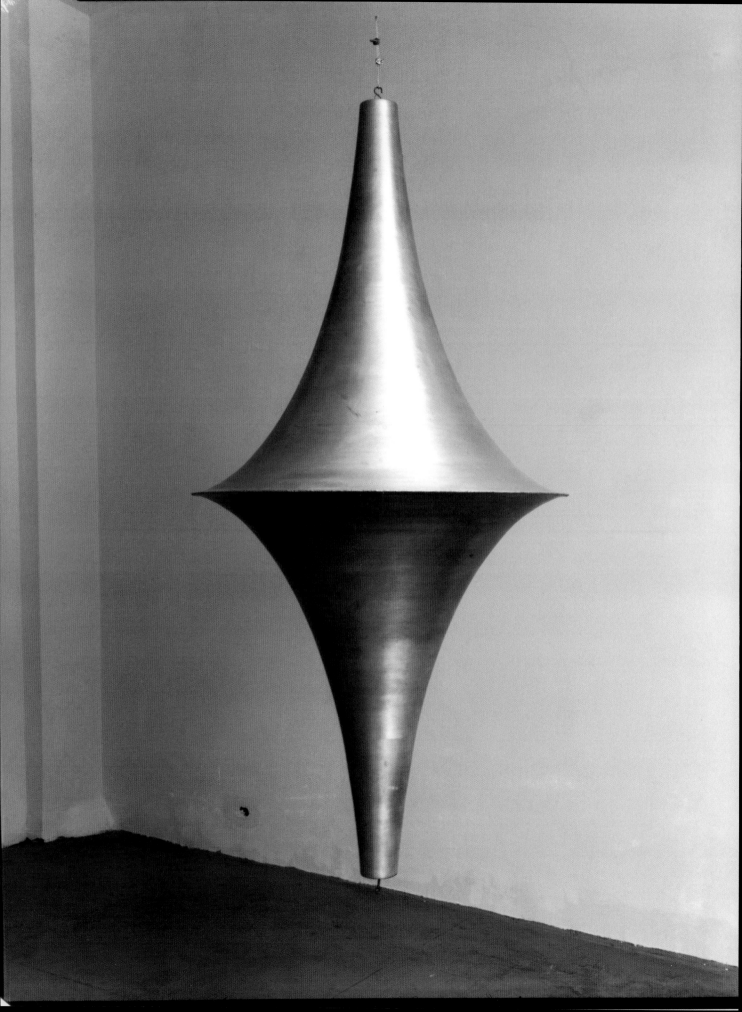

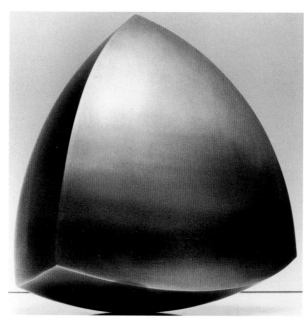

SPHERICAL TETRAHEDRON, 1970
SPUN BRONZE, DIAM. 12 IN. (30.5 CM)
COLLECTION DR. HANS AND MRS. MEDI KRAUS
PHOTO HERMANN LANDSHOFF

OPPOSITE:
PSEUDOSPHERE, 1969
SPUN ALUMINUM, 80 X 40 X 40 IN. (203 X 101.6 X 101.6 CM)
COLLECTION ADAM BARKER-MILL, SOUTHAMPTON/LONDON
PHOTO PETER BELLAMY

BELOW:
TRIGONAL VOLUME, 1967
BRONZE, 12.2 X 20.1 X 12.2 IN. (31 X 51 X 31 CM)
KUNSTMUSEUM WINTERTHUR

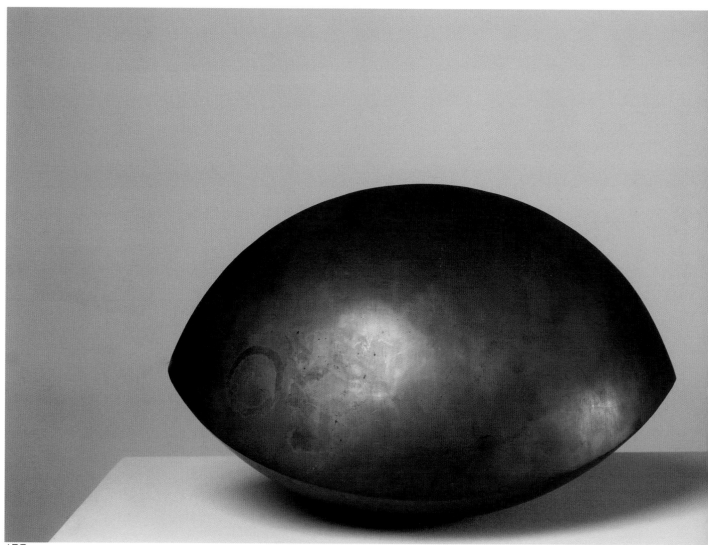

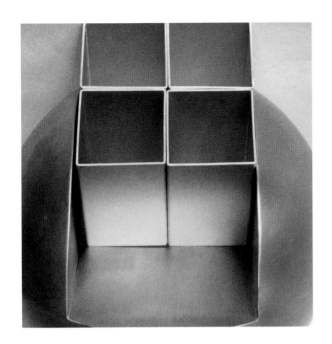 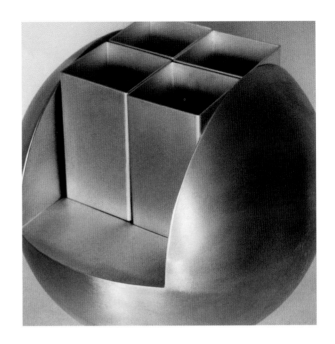

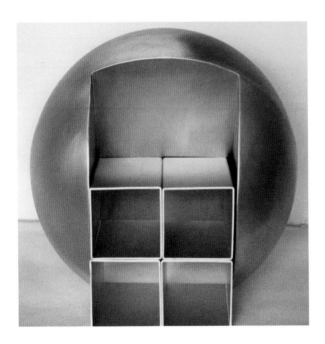 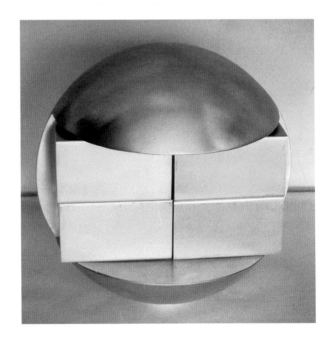

IN THE RELATION THREE TO FOUR, 1968
SPUN ALUMINUM, DIAM. 20.1 IN. (51 CM)
JACK TILTON GALLERY, NEW YORK
PHOTOS HERMANN LANDSHOFF

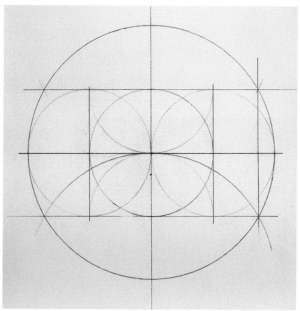

IN THE RELATION THREE TO FOUR (VERSION III), 1968
PENCIL ON TRANSPARENT PAPER (CONSTRUCTION DRAWING)
17 X 17 IN. (43.2 X 43.2 CM)
PHOTO HERMANN LANDSHOFF
COURTESY JACK TILTON GALLERY, NEW YORK

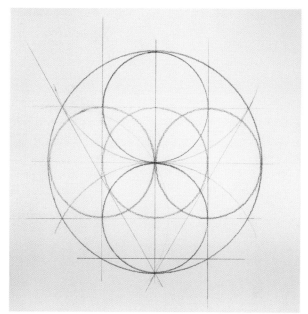

IN THE RELATION THREE TO FOUR (VERSION II), 1968
PENCIL ON TRANSPARENT PAPER (CONSTRUCTION DRAWING)
16.9 X 16.9 IN. (43 X 43 CM)
COLLECTION DOROTHEA AND LEO RABKIN, NEW YORK
PHOTO HERMANN LANDSHOFF

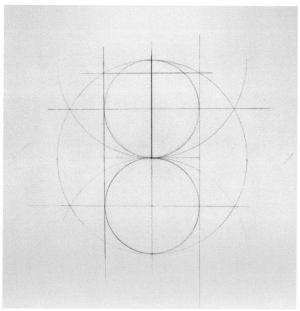

IN THE RELATION THREE TO FOUR (VERSION I), 1968
PENCIL ON TRANSPARENT PAPER (CONSTRUCTION DRAWING)
16.9 X 16.9 IN. (43 X 43 CM)
COLLECTION DOROTHEA AND LEO RABKIN, NEW YORK
PHOTO HERMANN LANDSHOFF

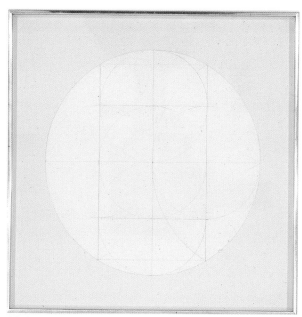

CONSTRUCTION DRAWING, N.D.
PENCIL ON TRANSPARENT PAPER
12 X 12 IN. (30.5 X 30.5 CM)
THE LEWITT COLLECTION, CHESTER, CONN.
PHOTO KOINEGG/NEUE GALERIE GRAZ

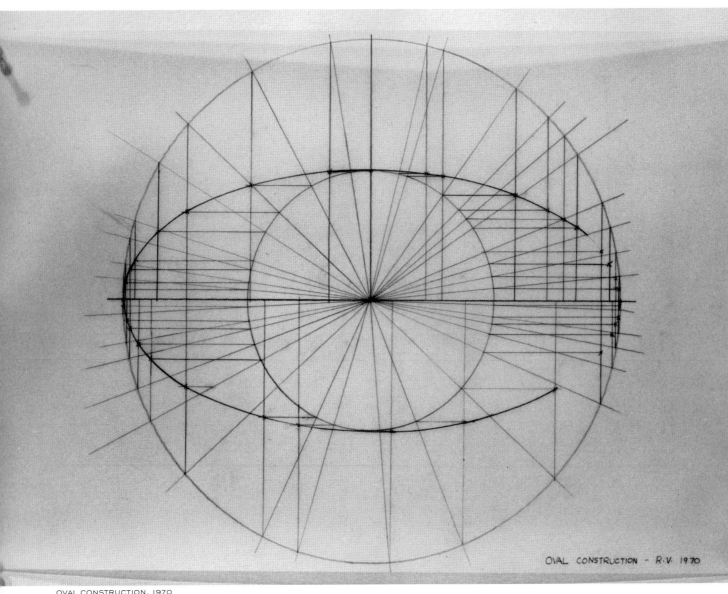

OVAL CONSTRUCTION — R.V. 1970

OVAL CONSTRUCTION, 1970
PENCIL ON MYLAR (CONSTRUCTION DRAWING), 12.8 X 12.8 IN. (32.5 X 32.5 CM)
COLLECTION DOROTHEA AND LEO RABKIN, NEW YORK
PHOTO HERMANN LANDSHOFF

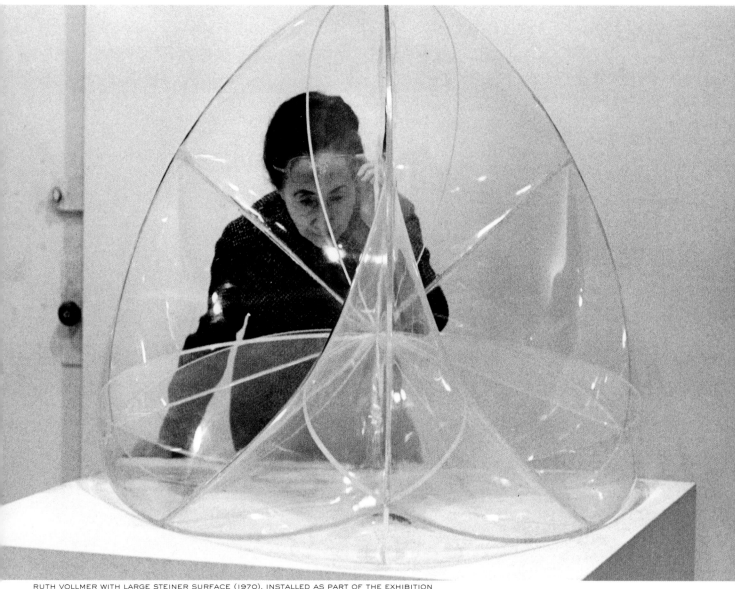

RUTH VOLLMER WITH LARGE STEINER SURFACE (1970), INSTALLED AS PART OF THE EXHIBITION
"RUTH VOLLMER: SCULPTURE AND DRAWINGS," BETTY PARSONS GALLERY, NEW YORK, 1973
PHOTO HERMANN LANDSHOFF
COURTESY JACK TILTON GALLERY, NEW YORK

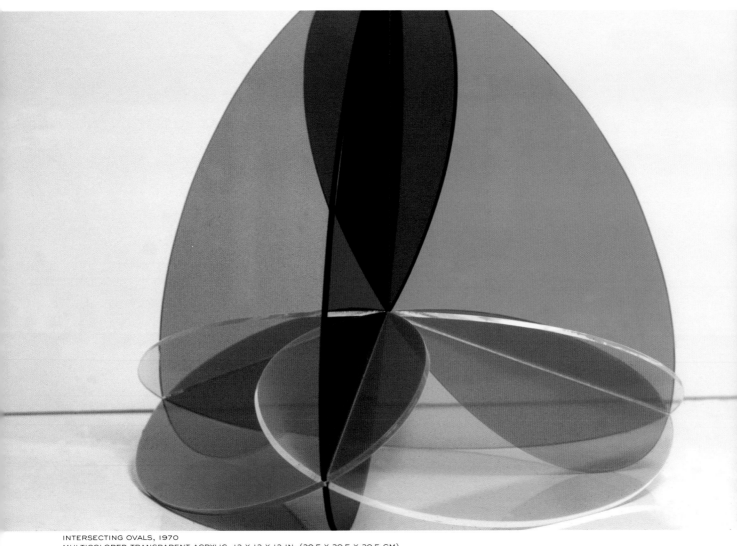

INTERSECTING OVALS, 1970
MULTICOLORED TRANSPARENT ACRYLIC, 12 X 12 X 12 IN. (30.5 X 30.5 X 30.5 CM)
COLLECTION JANE TIMKEN, NEW YORK

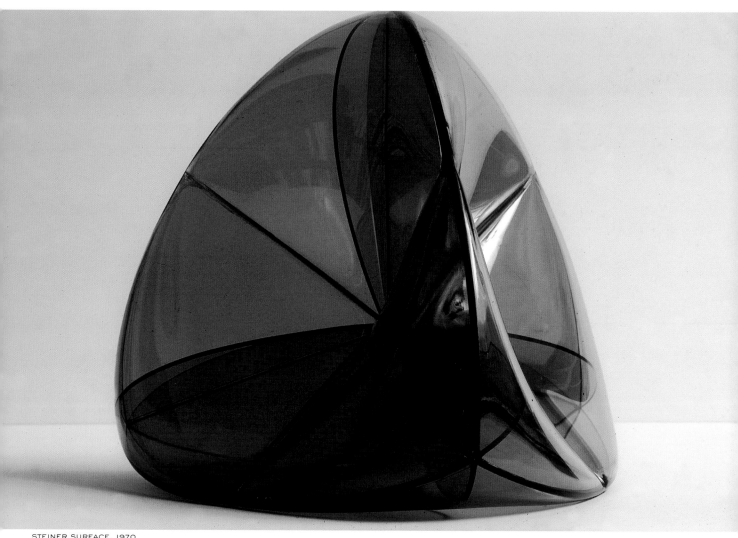

STEINER SURFACE, 1970
GRAY TRANSPARENT ACRYLIC, 12 X 12 X 12 IN. (30.5 X 30.5 X 30.5 CM)
COLLECTION DOROTHEA AND LEO RABKIN, NEW YORK

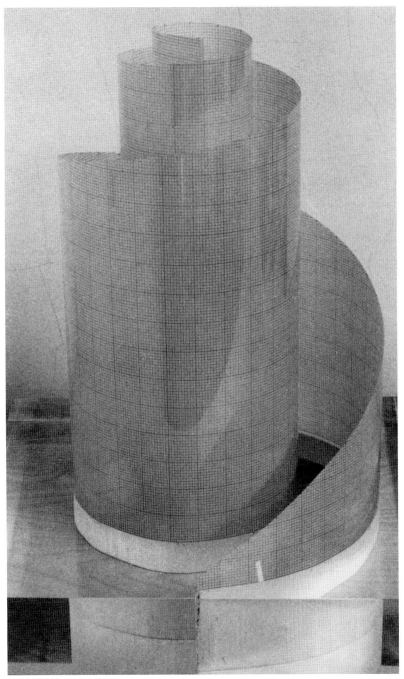

LARGE EXPONENTIAL TOWER, II, 1973
PRINTED MYLAR; UNROLLED, 67 X 20 IN.(170.2 X 50.8 CM)
BASE: SOLID, CLEAR ACRYLIC, 16 X 16 X 3 IN. (40.6 X 40.6 X 7.6 CM)
EVERSON MUSEUM OF ART, SYRACUSE, N.Y.
PHOTO HERMANN LANDSHOFF

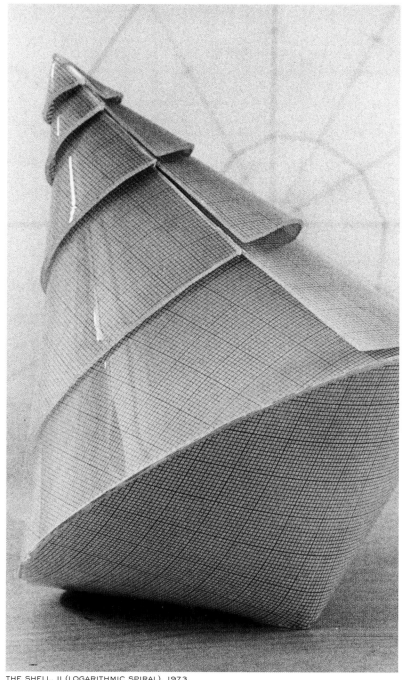

THE SHELL, II (LOGARITHMIC SPIRAL), 1973
BLUE INK PRINTED ON MOLDED ACRYLIC, H. 15 IN. (38.1 CM), DIAM. 12 IN. (30.5 CM)
COLLECTION ADAM BARKER-MILL, SOUTHAMPTON/LONDON
PHOTO HERMANN LANDSHOFF

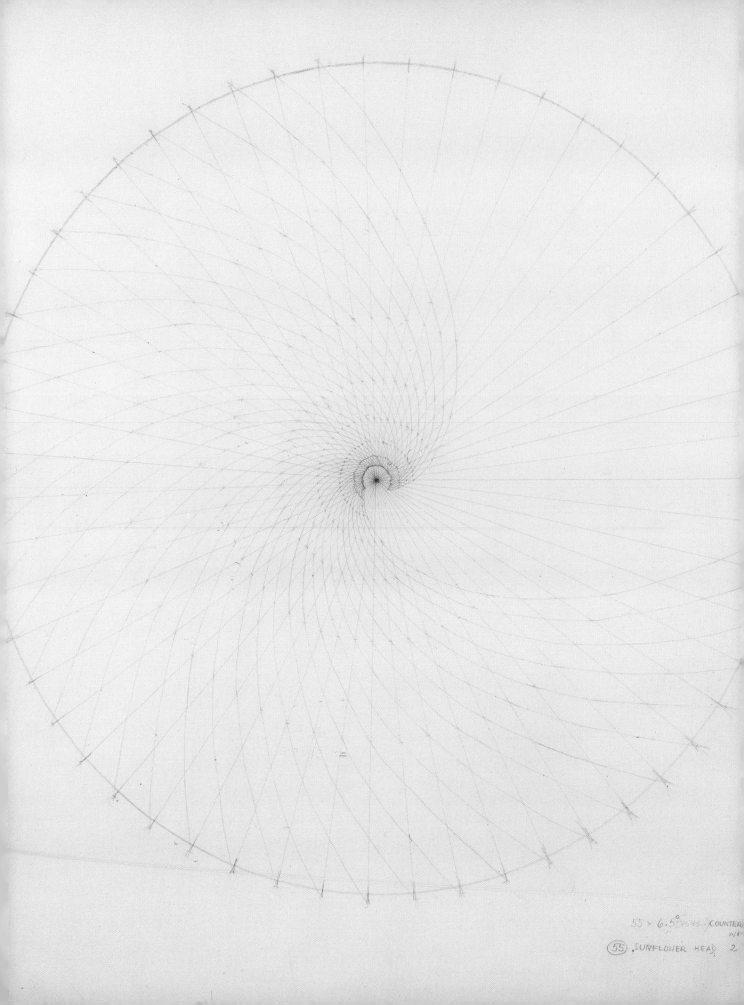

55 × 6.5° views...COUNTER
w

55 SUNFLOWER HEAD 2

SUNFLOWER HEAD 2, 1972
PENCIL ON TRACING PAPER
24 X 17.8 IN. (61 X 45.7 CM)
KUNSTMUSEUM WINTERTHUR

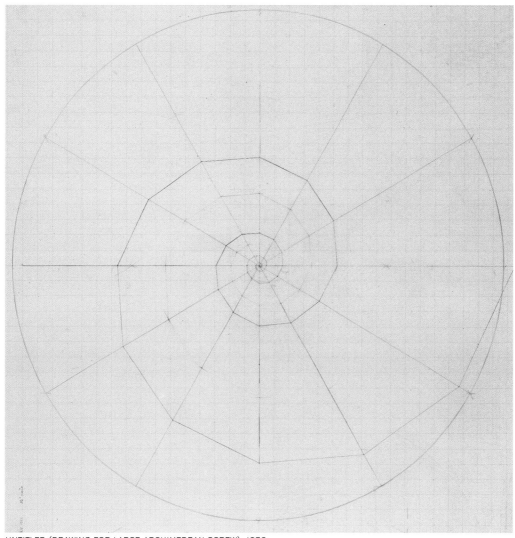

UNTITLED (DRAWING FOR LARGE ARCHIMEDEAN SCREW), 1973
PENCIL ON TRANSPARENT PAPER, 35.6 X 36.6 IN. (90.5 X 93 CM)
JACK TILTON GALLERY, NEW YORK
PHOTO KOINEGG/NEUE GALERIE GRAZ

UNTITLED (SWIRL), N.D.
PENCIL ON TRANSPARENT PAPER
17 X 18 IN. (43.3 X 45.7 CM)
JACK TILTON GALLERY, NEW YORK
PHOTO KOINEGG/NEUE GALERIE GRAZ

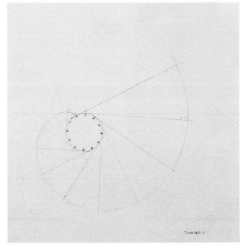

INVOLUTE OF A CIRCLE, COUNTERCLOCKWISE, 1972
PENCIL ON TRANSPARENT PAPER
17 X 14 IN. (43.2 X 35.6 CM)
JACK TILTON GALLERY, NEW YORK
PHOTO KOINEGG/NEUE GALERIE GRAZ

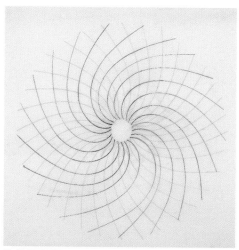

21 CLOCKWISE AND 34 COUNTERCLOCKWISE, 1972
PENCIL ON TRANSPARENT PAPER
16.5 X 13.6 IN. (42 X 34.5 CM)
JACK TILTON GALLERY, NEW YORK
PHOTO KOINEGG/NEUE GALERIE GRAZ

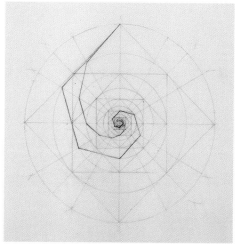

UNTITLED (PAUL KLEE), 1973
PENCIL AND BLACK CRAYON ON TRANSPARENT PAPER
16.5 X 13.6 IN. (42 X 34.5 CM)
JACK TILTON GALLERY, NEW YORK
PHOTO KOINEGG/NEUE GALERIE GRAZ

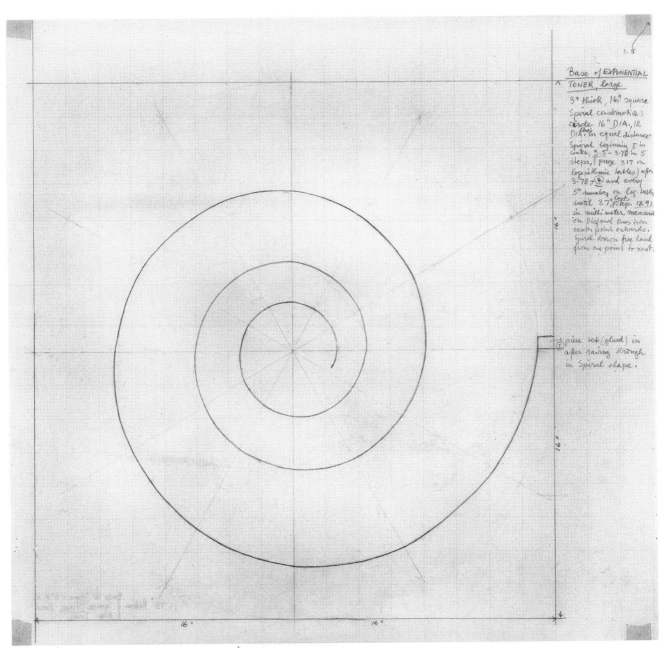

UNTITLED (DRAWING FOR LARGE EXPONENTIAL TOWER), 1973
PENCIL ON TRANSPARENT PAPER, 18.3 X 19.7 IN. (46.5 X 50 CM)
JACK TILTON GALLERY, NEW YORK
PHOTO KOINEGG/NEUE GALERIE GRAZ

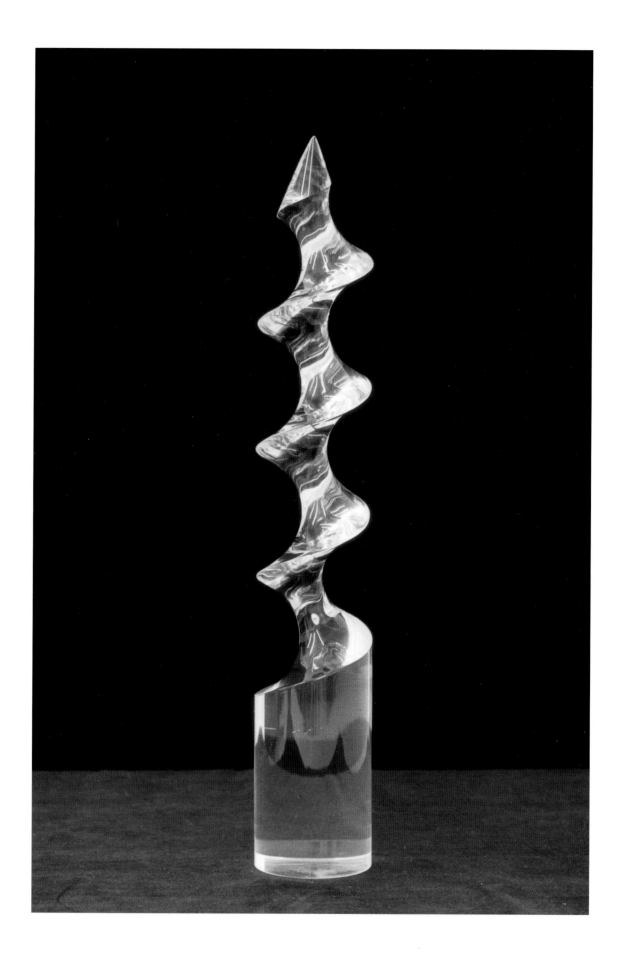

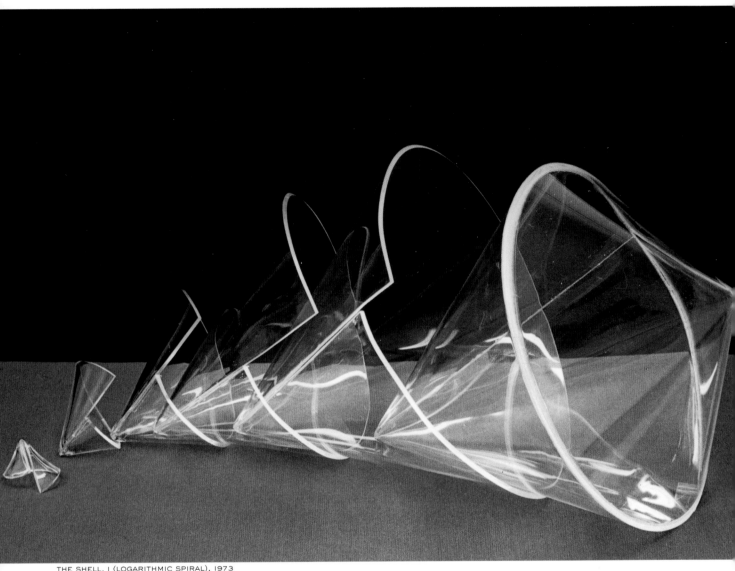

THE SHELL, I (LOGARITHMIC SPIRAL), 1973
CLEAR ACRYLIC, H. 18 (45.7 CM), DIAM. 15 IN. (38.1 CM)
NEW JERSEY STATE MUSEUM, TRENTON
PHOTOS HERMANN LANDSHOFF

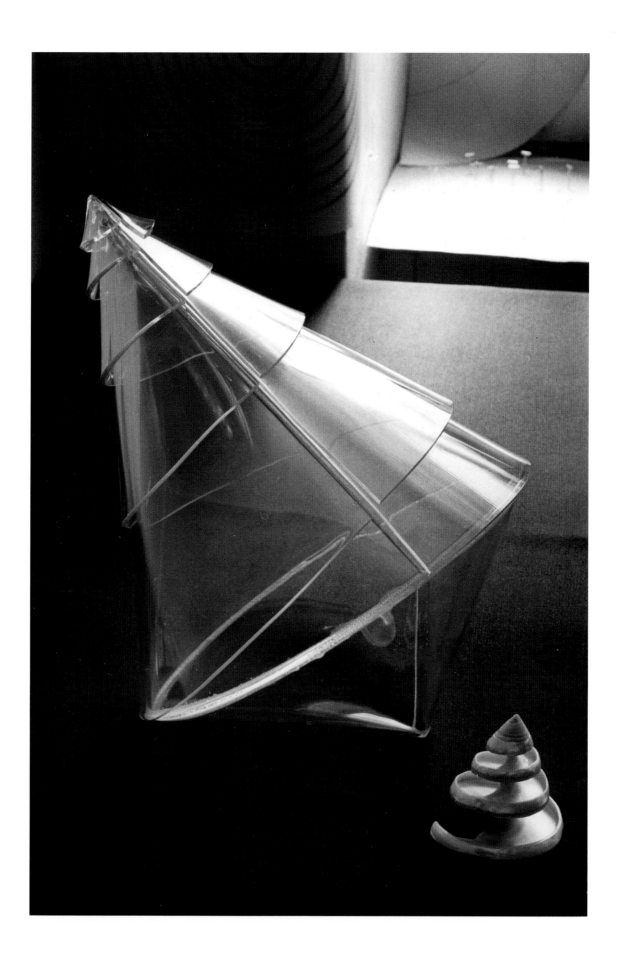

UNTITLED (12 SWIRLS), N.D.
PENCIL AND COLORED CRAYON ON TRANSPARENT PAPER
11 X 14 IN. (28 X 35.5 CM)
JACK TILTON GALLERY, NEW YORK
PHOTO KOINEGG/NEUE GALERIE GRAZ

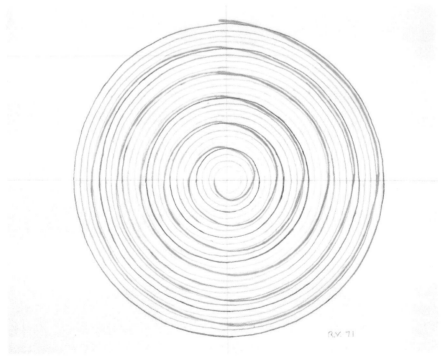

UNTITLED (1 SWIRL), 1971
PENCIL AND COLORED CRAYON ON TRANSPARENT PAPER
16.9 X 13.8 IN. (43 X 35 CM)
JACK TILTON GALLERY, NEW YORK
PHOTO KOINEGG/NEUE GALERIE GRAZ

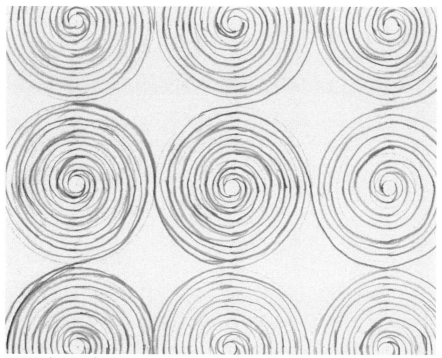

UNTITLED (9 SPIRALS), 1971
PENCIL AND COLORED CRAYON ON VELLUM
11 X 14 IN. (28 X 35.5 CM)
COLLECTION PROFESSOR JOSEPH MASHECK, NEW YORK
PHOTO KOINEGG/NEUE GALERIE GRAZ

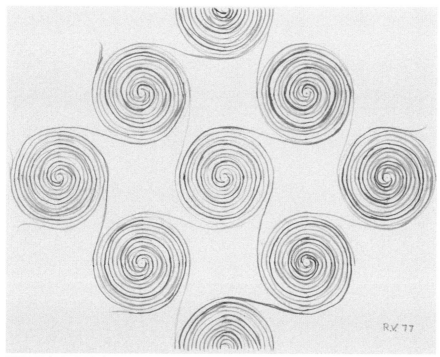

UNTITLED (9 SPIRALS, 1), 1977
PENCIL AND COLORED CRAYON ON TRANSPARENT PAPER
8.3 X 10.8 IN. (21 X 27.5 CM)
PRIVATE COLLECTION, EDINBURGH
PHOTO KOINEGG/NEUE GALERIE GRAZ

LEONARDO DA VINCI, N.D.
PENCIL ON TRANSPARENT PAPER
16.7 X 13.8 IN. (42.5 X 35 CM)
JACK TILTON GALLERY, NEW YORK
PHOTO KOINEGG/NEUE GALERIE GRAZ

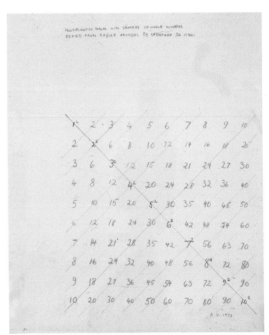

AFTER CODICE ARUNDEL, 1973
PENCIL AND COLORED CRAYON ON PAPER
17.1 X 13.8 IN. (43.5 X 35 CM)
COLLECTION PHILIP MCCARTER TIFFT, NEW YORK
PHOTO KOINEGG/NEUE GALERIE GRAZ

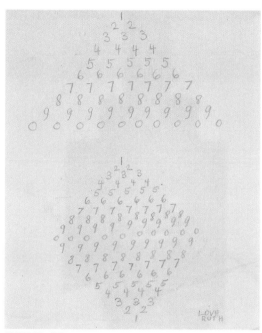

UNTITLED, N.D.
PENCIL ON TRANSPARENT PAPER
7.7 X 5.7 IN. (19.6 X 14.6 CM)
THE LEWITT COLLECTION, CHESTER, CONN.
PHOTO KOINEGG/NEUE GALERIE GRAZ

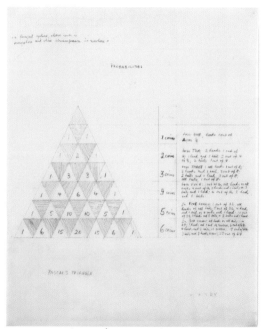

PROBABILITIES/PASCAL'S TRIANGLE (3.11.1971), 1971
PENCIL ON TRACING PAPER,
17 X 14 IN. (43.2 X 35.6 CM)
KUNSTMUSEUM WINTERTHUR

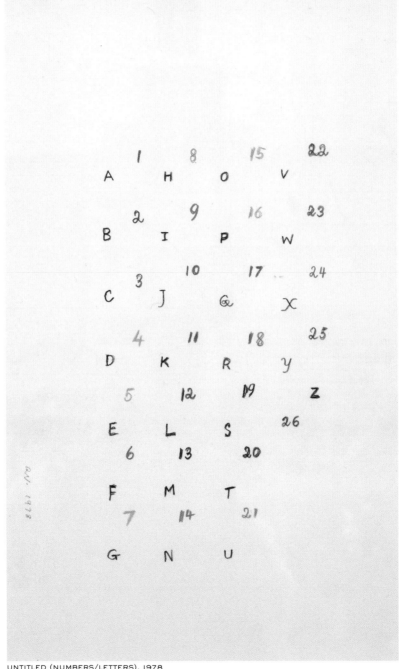

UNTITLED (NUMBERS/LETTERS), 1978
PENCIL AND COLORED CRAYON ON TRANSPARENT PAPER
16.9 X 11 IN. (43 X 28 CM)
JACK TILTON GALLERY, NEW YORK
PHOTO KOINEGG/NEUE GALERIE GRAZ

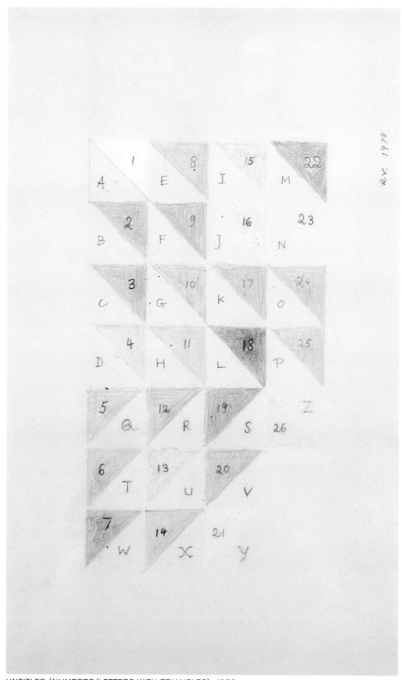

UNTITLED (NUMBERS/LETTERS WITH TRIANGLES), 1978
PENCIL AND COLORED CRAYON ON TRANSPARENT PAPER
16.9 X 11 IN. (43 X 28 CM)
JACK TILTON GALLERY, NEW YORK
PHOTO KOINEGG/NEUE GALERIE GRAZ

UNTITLED, 1972
COLORED CRAYON, BROWN PENCIL ON TRANSPARENT PAPER
8.5 X 11 IN. (21.5 X 28 CM)
COLLECTION PHILIP MCCARTER TIFFT, NEW YORK
PHOTO KOINEGG/NEUE GALERIE GRAZ

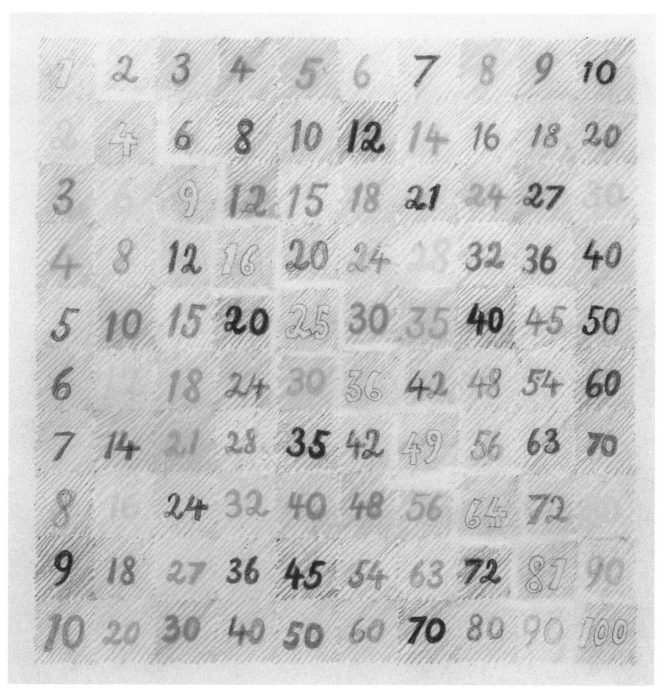

UNTITLED, 1972
PENCIL AND COLORED CRAYON ON TRANSPARENT PAPER
18 X 24 IN. (45.7 X 61 CM)
KUNSTMUSEUM WINTERTHUR

PAGES 182-83
UNTITLED, 1978
PENCIL ON TRANSPARENT PAPER
9.1 X 11.8 IN. (23 X 30 CM)
COLLECTION PHILIP MCCARTER TIFFT, NEW YORK
PHOTO KOINEGG/NEUE GALERIE GRAZ

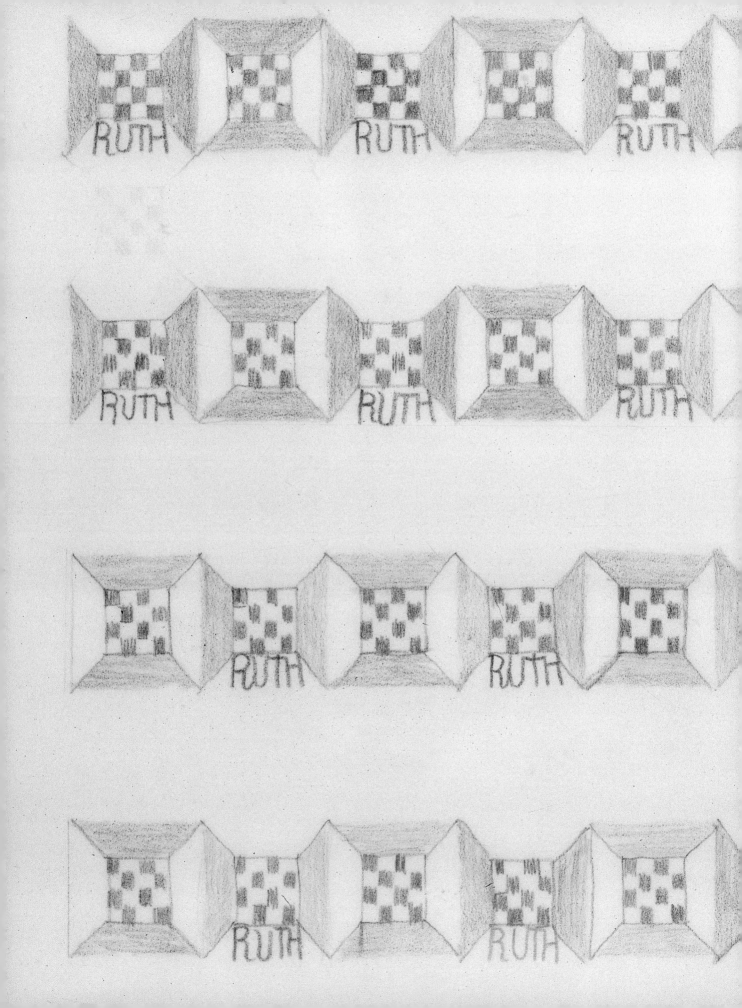

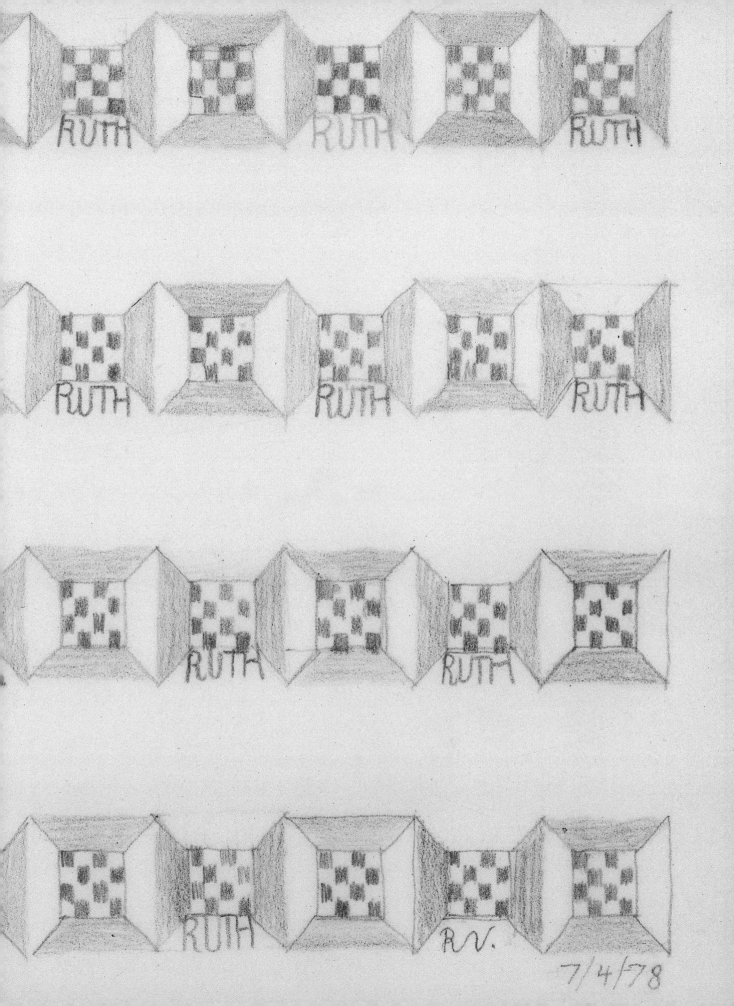

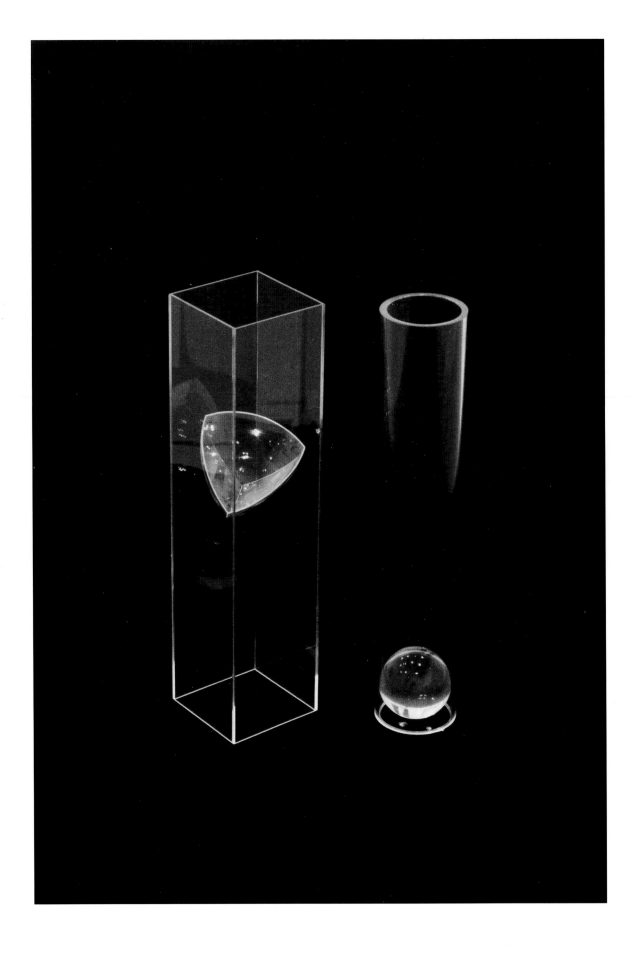

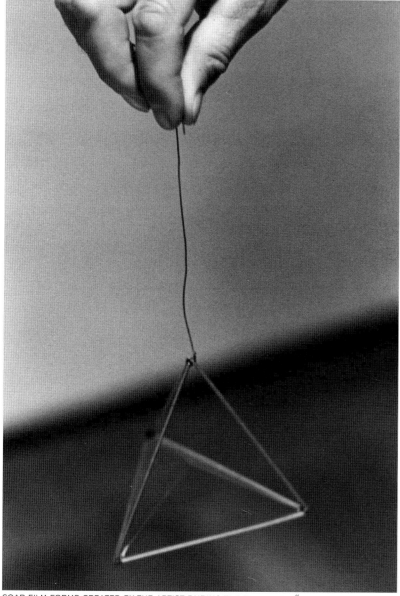

SOAP FILM FORMS CREATED BY THE ARTIST DURING THE EXHIBITION "RUTH VOLLMER:
SCULPTURE AND DRAWINGS," AT THE EVERSON MUSEUM OF ART, SYRACUSE, N.Y., 1974
PHOTOS HERMANN LANDSHOFF

OPPOSITE:
TANGENTS, 1970
CLEAR ACRYLIC, LEFT: 17.9 X 4.3 X 4.3 IN. (45.5 X 11 X 11 CM)
CLEAR ACRYLIC, RIGHT: H. 18 IN. (45.8 CM), DIAM. 3.1 IN. (8 CM)
JACK TILTON GALLERY, NEW YORK
PHOTO HERMANN LANDSHOFF

PAGES 186-87
5 REGULAR POLYHEDRA, 5 SPHERES, 1 LARGE MIRRORED SPHERE, 1975
LARGE MIRRORED SPHERE, DIAM. 72 IN. (182.9 CM)
NEUBERGER MUSEUM OF ART, SUNY AT PURCHASE, N.Y.
PHOTO HERMANN LANDSHOFF

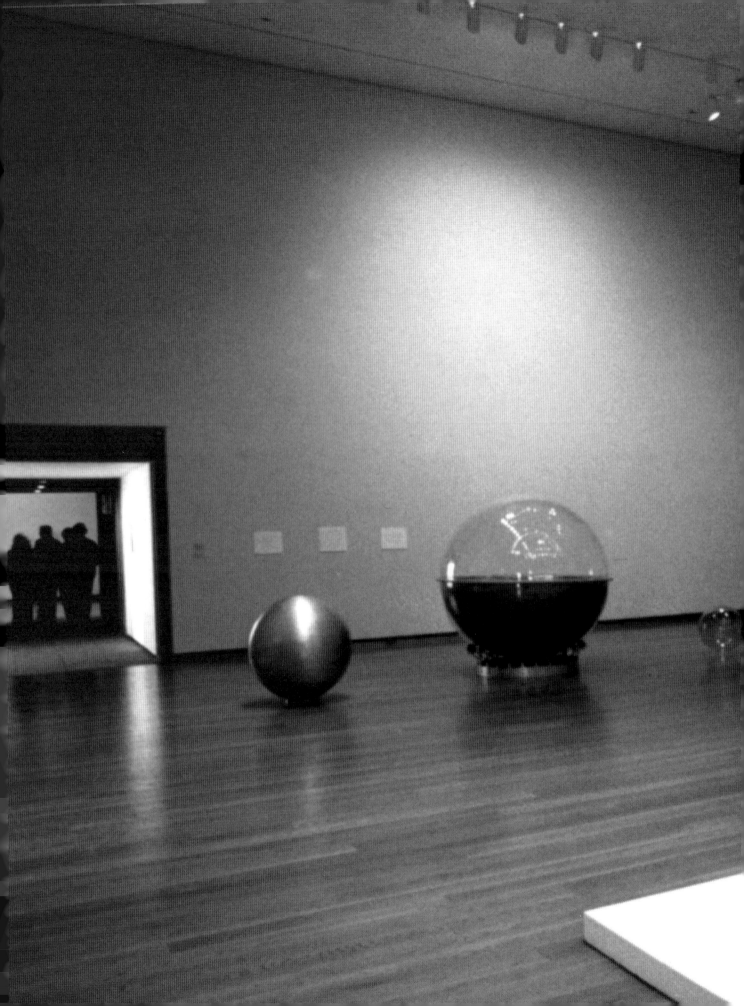

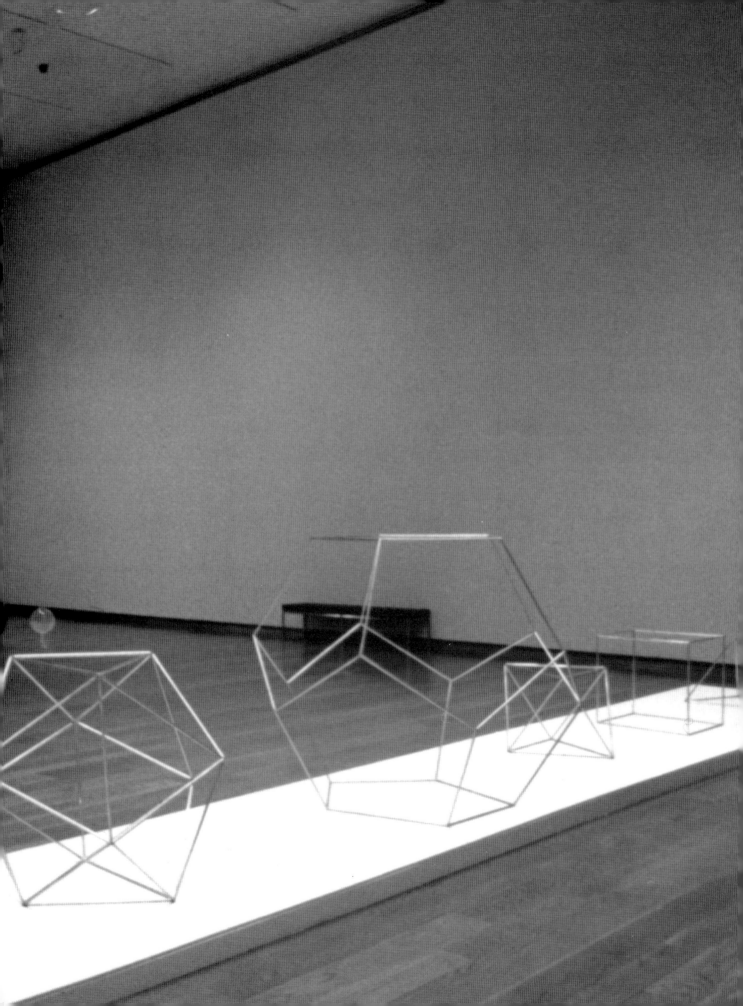

EARLY CRITICISM

RUTH VOLLMER'S MAGIC OF SIMPLICITY
BY ROLF-GUNTER DIENST

The magic of the simple geometric form, in which esthetic propositions can be demonstrated individually, is recognized in numerous constructivist works of art over recent years. Joseph Albers chose as his theme the square, which, through his selection of color combinations, he raised to quiet color spaces. Minimal art—in which the art is reduced to few plastic sensations—has given preference to calculated, reproducible, stereometric forms. Robert Morris and Ronald Bladen, for instance, have not taken over plastic-constructive form; rather, they have subjected it to unreal static (Bladen), or conscious disturbance through the use of materials: fiberglass, wire screening, neon light (Morris). The simple form lost in the process its self-evidence, and came to suggest or define an architectural-space formulation.

The sculptor Ruth Vollmer must be viewed in the context of this young American art. Her forms, also, are reduced, strictly geometric, built with calculation, and renounce the pretension of any superficial attraction. The basic element in all her recent work is the sphere. The sphere is cut and falls into two parts; segments of the sphere are coupled, or grouped in sequences; the sphere's surface is notched or scored. All this is done with esthetic intelligence. Each piece develops the logic of a mathematical concept, yet never becomes merely an illustration of a scientific formula. The prevailing dialectic in her work: inside-outside, concave-convex, open-closed. The cast bronze spheres—not large, not small—each encased in a finely structured skin, either darkly patinated or highly polished, remain closed bodies, brilliant in their simplicity. The conviction of the stereometric symbol is particularly explicit where the developed sphere elements lock together into one block—as, for instance, in the pieces *Pentamer* of 1965 (page 149), and *Trimer* of 1965 (page 148). The surface of the forms are scored in an equirhythmic manner; the connections seem to be equal constrictions, and remain invisible.

Ruth Vollmer came to these strong, heraldic forms after already realizing architecturally organized sculptures: dishes, spirals and obelisks with scaly mantles and inserted with concise elements. The later simplification announces itself most unmistakably in works like the bronze *Ovaloid [with Hammers]*, 1959–62 [page 95], inserted with symmetrically organized leaf forms (here, nature associations are aroused: plant-like growth is directed into preconceived paths). In a related work, *Musical Forest* [page 134] stick-like elements are rhythmically ordered in a dish.

In a text she wrote for The Museum of Modern Art in New

York, Ruth Vollmer describes her work: "At this time, my specific interest is in the exploration of the sphere. This then leads me, in the process of working, deeper and deeper into myself: into my loves and idiosyncrasies in relation to this form. After I have made many pieces, in the pursuit of exploring the sphere, I come out not understanding an iota more about this mysterious form than when I first started. I suppose that the sphere does have a more *general*, a basic, or symbolic meaning, like the cosmos, earth, womb, etc.—but even if I had 'an artistic program in relation to society,' my real activity would always lead me to find myself."

This text points up the high measure of self-reflection and awareness intrinsic to Ruth Vollmer's work. Her aim is not the abstraction of her individuality—as is often the aim among minimal artists—but identification with the artistic process, or "doing." Yet without a suggestion of indulgent self-expressionism.

Born in Germany, Ruth Vollmer was forced during the Nazi regime to emigrate to America. She has lived in New York since the thirties, and there, in close contact with numerous contemporary American artists, experienced her development as a sculptor. The intellectuality and wisdom of her friend, the late Ad Reinhardt, who became a father figure of the new American art, is also hers and radiates from her work. Like Reinhardt's paintings, her sculptures are simple things, difficult to make.

Reprinted with permission of the author. Rolf-Gunter Dienst, "Ruth Vollmers Magie der Einfachheit," *Das Kunstwerk* 22, nos. 5–6 (February/March 1969): 36–40.

 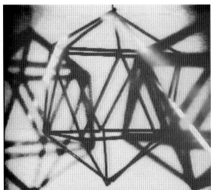 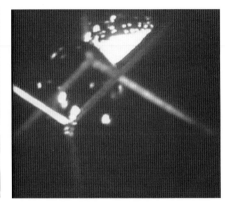

RUTH VOLLMER. SOAP FILM FORMS, 1974
NTSC FILM TRANSFERRED TO DVD. SILENT; COLOR. APPROX. 16 MIN.
EVERSON MUSEUM OF ART, SYRACUSE, N.Y.
FILM STILLS © ZKM KARLSRUHE

RUTH VOLLMER: MATHEMATICAL FORMS
BY SOL LEWITT

These pieces are not sculpture; they are ideas made into solid forms.

The ideas are illustrations of geometric formulae; they are found ideas, not invented, and not changed.

The pieces are not about mathematics; they are about art. Geometry is used as a beginning

just as a nineteenth-century artist might have used the landscape.

The geometry is only a mental fact.

There is a simple and single idea for each form; there is a single and basic material of which the piece is constructed.

The material used has physical properties that are evident, and useful to the form.

The pieces have a size small enough to mitigate any expressiveness. They are not gross and pompous.

They are of the necessary size, neither large nor small; the form is in harmony with the idea.

The scale is perfect.

They are works of quality and excellence.

Reprinted with permission of the artist. Sol LeWitt, "Ruth Vollmer: Mathematical Forms,"

Studio International 180, no. 928 (December 1970): 256–57.

RUTH VOLLMER
BY THOMAS NOZKOWSKI

*Hurrah for positive science! long live exact demonstration! /
Fetch stonecrop mixt with cedar and branches of lilac, / This is
the lexicographer, this the chemist, this made a grammar of the
old cartouches, / These mariners put the ship through danger-
ous unknown seas. / This is the geologist, this works with the
scalpel, and this is a mathematician. // Gentlemen, to you the
first honors always! / Your facts are useful, and yet they are not
my dwelling, / I but enter by them to an area of my dwelling.*
—Walt Whitman, *Song of Myself,* s. 23

Ruth Vollmer's position in a hierarchy of contemporary sculp-
tors is a puzzling one. If we were to judge an artist by the
amount of attention they elicit, we would be left in this case
with the feeling that Vollmer is an "interesting" artist with a
few pieces that deserve a close examination. If, however, we
look back on our own we would be surprised to discover
something else: a body of fresh and unique works, an inquisi-
tive mind rigorously pursuing many of the ideas in contem-
porary sculpture and a *personal* art of the highest order.

 An artist once criticized some pieces of Vollmer's as "edu-
cational toys." This is at once unfair (in that it slights the art)
and correct: It shows us the direction we must go to under-
stand the making of this art. There has been a pedagogical

impulse here from the beginning. Vollmer's sculptures can
often serve as mathematical descriptions. One, in fact, is
reproduced on the cover of a standard mathematical text
[*Introduction to Mathematical Ideas,* 1963]. Some pieces do
things: They make noise or they are meant to roll about.
Other works demand our participation. We must remove a
section or put an element in place. Some pieces are variable
and open to our own arrangements. None of this is frivolous:
We are meant to learn something—how a spiral is construct-
ed or the sounds of differing lengths of bronze, many differ-
ent things. Hopefully we will be taught something about the
nature of objects. The important thing to see is that art is not
sheltered here. It is the secret part of these things, but it is
not a secret that is hidden away by the construction of the
piece or the temperament of the artist. The smallest sphere in
the *Obelisk* (1962), for example, was made to be removed
and examined. Writing in 1965 about some Chinese
Buddhist sculptures in the Boston Museum, Vollmer noted
that "the surfaces of these sculptures are beautiful, [but] they
are not elaborate. It is as if the surfaces exist just to *contain*
the spirit which sits in the center of each work."

 Vollmer has made every effort to avoid mystification. In
the catalogue of her last show [at the Betty Parsons Gallery in

1970] she went so far as to give us the mathematical formula for the piece called the *Steiner Surface*. The entire physical structure is available to our understanding. This kind of candor leaves us disarmed.

Sol LeWitt described the works in this last show as "found ideas." It can be applied to much of her mature work and it is exactly right. There is an extraordinary paragraph at the end of the catalogue of [this] show, after pages of mathematical description: "The 'Steiner Surface' is one of approximately one hundred mathematical models at Columbia University. They were used in the mathematics department but are now kept in a cupboard in the Low Library, where nobody ever sees them." At least, they didn't see them until the artist liberated one and set it before us. This is a found object as well as a "found idea." A similar found object would be Vollmer's new drawings of a multiplication table from the Codice Arundel of Da Vinci.

Faced with the Absurd, what are we to make art of? The art- or aesthetic-part we know will exist irregardless of context. We can make Virgins or we can make Brides and the art appears, sometimes. Our problem is to find a pretext, a way to keep our hands moving. Vollmer has chosen science.

The shift from the early sculptures to her current work has been gradual. Spheres first appeared in her work as simply another image in a large repertoire of symbols. At some point in the early sixties, probably in response to ideas that were current then, she started to explore the sphere geometrically. "I looked inside. I was looking for proportions.... I have found forms within the sphere." A whole range of cut, skewed, and hollowed spheres followed.

Throughout minimalism we heard much of the banishing of the base. In reality, facing these works of Judd, Morris, LeWitt, and others, we found the *size* of these pieces functioning much as the base would. Work removed from the world...this is to say that one could neither pick them up nor live in them. They came in a middle size, a size we associate with nothing so much as the art of our day. The real end of the base is to be found in the work of other artists: some of Hesse's wrapped pieces, some of Samaras's boxes, and in Vollmer's spheres that could be carried or rolled or dissembled. These objects existed almost militantly in the real world. They are separated from our saucepans and lamps and clocks solely by the intensity of their art.

Vollmer's spheres seem today to be an achievement that is still little recognized. When they appeared in the midst of minimalism, what attention they received was largely from

other artists. The sphere, seemingly a perfect minimalist image (it is the least surface of any given volume), was not accepted as the cube or tetrahedron was. Perhaps the difficulty in constructing a sphere is the reason other artists didn't allow themselves the use of this form. Another factor could be the rather romantic vision that one can find in the patina of the first bronze spheres or, more directly, in Vollmer's writing. Minimal romanticism is a concept that makes more sense today then was possible at the time. With the real coolness of conceptualism upon us, it is now possible to look back and detect a real romantic impulse at work in some minimal artists. Recent works of Morris and Smithson serve to further highlight this tendency. It is a weakness of our age if we find something strange in an artist who can describe a piece as "$y^2 z^2 + z^2 y^2 + zyx = 0$" and who can also ask if our "native sphere...is solid or fire or rock?" Goethe, for one, saw no discrepancy between scientific observation and poetry.

Vollmer's use of materials has always been a bit perverse. Given our cultural set, we can be shocked by the use of bronze in a group of examinations of the sphere, or the use of laminated wood for a mathematical model, or, in her recent work, the use of graphed plastic for the depicting of a shell. It is hard to be sure of the reasons for these choices aside from the beauty of the matcrials. It may be that they are useful as "distancing" devices.

Whatever the reasons, the spherical pieces were not seen enough, and, when seen, not in the proper context: a body of work that added something to minimalism and took nothing away. They are among the most beautiful works of the sixties.

It appeared possible at the time of these works that Vollmer, like Ad Reinhardt, had found a great image that one could pursue endlessly, an image of total serenity. One thought at the time that the next step would be for her to make a show of hundreds of spheres, cut and whole and of many different materials. Instead, she chose to leave the sphere and pursue the mathematics.

She followed the spheres with a show in 1970, that included the magnificent wood *Pseudosphere* and the *Steiner Surface*. This was her most rigorous presentation of work that used mathematics as its premise. There was a certain dryness here: a collection of sculptures that possessed no visual references to give our eyes the chance at the comparisons they seem to seek. It is certainly not fashionable to say that if one sees a sculpture of a cube one thinks of, say, architecture, or if you see a sculpture of latex you think of skin—but to an extent this is true. Unthinking viewers will keep after these

first visual connections and trained viewers will not...still, it seems to be everyone's first step in seeing an artwork. There are also levels of sophistication here: One can see a symbol or one can make a visual comparison with another work of art. This group of Vollmer's sculptures seemed to lack all immediate visual correlatives. What is one to make of the *Pseudosphere*? We see a strong, self-possessed image. It is obviously intact, and equally obvious that it is perfect. It is simple. But our eyes move restlessly over it. We can assign no function to it. With its simplicity and directness we know that this is not an image of self-expression by any conventional standards. We may guess from its name that this is the mathematical *opposite* of a sphere, but, unless we are very familiar with mathematics, we have never seen anything like this before. The experience becomes disquieting. This genuine "strangeness" worked very much to the advantage of the *Spherical Tetrahedron* as well as the *Pseudosphere*. The more complex works in this show (the two "Steiner Surfaces," *Intersecting Ovals*) were oddly more acceptable to our eyes. Their complexity allowed a kind of immediate equation with other works of art.

The current work of Ruth Vollmer is concerned with the shell and the spiral. In several ways these pieces represent a synthesis of the different ideas that have appeared in her art. The spiral is an image with a long history of human use as a religious symbol and an artistic source. It is also an exact mathematical form open to that kind of analysis. It is a form produced in many living organisms. Papa Ubu has a spiral on his belly. The first pieces that Vollmer made in this vein are two only slightly abstracted sculptures of shells. The shell is a logarithmic or equiangular spiral. The curve of the spiral intersects any radii from the central point at the fixed angle. These pieces were executed in plastic from paper models of great beauty.

Models have a very nice sort of tension that is created by the fragility of the material and the power of the image. For years Vollmer has had in her studio a bowl of soapy liquid that she uses to make soap films on geometric wire constructions to examine their minimum surfaces. These modified soap bubbles have the same sort of visual tension. One of the final plastic versions of the shell is clear and the other is imprinted with a blue grid. The grid has no mathematical meaning, it is meant to serve solely as a skin. Each full turn of the spiral of the shell is removable. By removing these pieces, one at a time, we are given a very clear idea of the changes in height and volume that accompany the natural growth of this form.

The *Exponential Tower* (two versions) takes the idea of preliminary drawings for sculpture and carries it to its logical conclusion. We are given here two things: a base of thick poured plastic with a channel cut into it, and a sheet of Mylar with a grid printed on it. The sheet has been cut on one side on an angle. This cut side represents a curve of exponential growth as plotted on a flat graph. By taking this "drawing" and inserting it into the spiral channel of the base we create a tower. The flat image becomes the sculpture that it has depicted.

In the past few years drawing has come to play an important role in this artist's work. The reason is obvious: Drawing is the place where science and art meet most freely. An equation plotted on a graph is a kind of drawing. It is an abstraction made visible. The mathematician does not think of this as drawing, for he is so familiar with the method, he sees only the equation. By most of our definitions this is a very successful drawing: It is clear, universal, and accurate.

Vollmer's drawings are very strange when we consider the degree of formalization involved. We are used to the rendering of familiar forms in today's art. Their use is generally understood as a means of shifting the emphasis from the object to the making of the object. Here, not only is the form familiar but so are the means of constructing it. There are no new ways of making a spiral. There seem to be two reasons for the artist choosing such a restricted kind of drawing. The first would be for purposes of rediscovery, an examination of the first construction of the spiral. There is a hesitancy to the hand in these pictures that speaks of the extraordinary effort and care that was required by the first Greek geometricians. The other reason, the more important one, is that in a drawing or a spiral, the beautiful logic of the growth of this form can be seen most clearly.

The works in this show least involved with teaching us something are the "Archimedean Screws" cut out of clear cast-acrylic rod. They are startling images of this Archimedean (as opposed to logarithmic) spiral. Functioning as final images, needing no participation to fulfill them, these different-sized spirals standing in a group call up in our minds a whole range of visual correlatives. They remind us of the space-eaten Giacometti people walking across a plaza, Indian Pipes growing up out of the forest floor, Morning Glory buds and barber poles. They are as strong a piece of sculpture as Vollmer has ever made.

We associate the spiral with something hidden. In his *Primitive Mythology,* Joseph Campbell quotes W.F. Jackson:

"[It] gives a long indirect path from the outside of an area to the inside.... Its principle seems to be the provision of a difficult but possible access to some important point." The spiral of mathematics, the spiral of the natural world—transformed by an artist's hand, [they] have a secret within them like the Buddhist sculptures Vollmer wrote about. No matter how exacting the representation, we are constantly directed toward something else, the secret, the art.

New York, 1974

Originally written as a submission to *Arts Magazine*, this article is published with permission of the author and the Ruth Vollmer Papers, 1939–1980, Archives of American Art, Smithsonian Institution, Washington, D.C.

ON RUTH VOLLMER'S WORK
BY RICHARD TUTTLE

The past is the present in the work of Ruth Vollmer, and the future derives from the past. Much stress is often placed on mathematics in discussing her work, but that is only important relative to the nature of the work as based on mathematics. It does not necessarily denote derivation from formalist thinking. I must differ from those who are interested in *how* she does, instead of in *what* she is doing, for in the time sequence pressed into unity by her work, I wonder just what it is she is doing. Unless I miss my guess, it is formal unity as opposed to the chaos of thought that has fascinated her and will continue to fascinate her in her continuing exploration of the world as presented to her in the twentieth century.

Unity through material means suggests unity of mind and matter. That is a very difficult position to maintain at present, although no one despises it, for it promises something for the future. With the maturity of Ruth Vollmer's compassion and wisdom, we who are more used to practical thinking, had better find some use for her way of approaching reality, or change our minds about it. It is a European experience, a dialectical experience, challenging our placement of form before matter, yet still making form the cause of the form-through-matter.

Form is derived from the experience of nature for Ruth Vollmer, yet the forms she most relies upon, the Platonic solids, were not derived so much as made "according" to nature. They are a kind of "given" which allow her to, at times, see nature according to them. Their place in history, if I understand it, is a kind of cross between observed reality and existence in reference to time's reality, which to the Greeks was soul. Soul was a reference to the ultimate unity of time and space, but for us such a proof puts "the cart before the horse," for the logical consequence of Greek thinking is loss of psychological self, which we have come to consider as "the essence of being." Instead of being freed by love, we desire to be loved like love. Whether this is the same as seeing nature ordered, as the Greeks saw it, or different in part or parts, I don't know. Formally speaking, they are opposite points of view, I know this.

The show at the Everson is an expression of the two aspects of Ruth Vollmer's thinking. The first is Platonic in the pre-Christian sense of one idea begetting another in evolution toward an unknown goal. The second is psychological "one-ment," or things as known through perception of controlled matter, i.e., all that we know. The sphere is the elementary arrangement of matter, and it is uniquely defined by its diameter; but ultimately it is unknown as a repository of essence, nature, in the Chinese sense. The repository is filled with won-

der, and when Ruth Vollmer finds delight, it is in this sense. Her delight is in finding that wonder, even in an equation. What is brilliant in her is the ability to transfer this type of wonder into an ontology of nature in the Western sense; victim after God's will, i.e., God created the universe, therefore, we can know God. Generally, our will is the reverse: We have broken the chain of direct experience with God, the Creator. Thus it may seem difficult to see nature in Ruth Vollmer's work. In the work at hand we find as extension of reality, through the development of idea, which pleases to be thought of as "system." The merit of the work is in the very way the *artist* sees the work, and here is the crux of the statement: The form is what *we* see. In the work of Ruth Vollmer, the form is imperative in the context of the whole. The whole is justified by the means, and she knows the means justify her place in the universe because the means are a reflection of divine origin in man. The more this is in evidence, the more successful the work—for example, the large, wood Archimedean spiral.

But are not things past knowing, also past being? Can we know a context/realm in which a work such as Ruth Vollmer's finds significance? We might, as it were, suggest the facts ourselves, but we might never know if those facts are real, or merely reflections of our sense of displacement in a universe of abstract quantities or qualities, depending on the mind of the observer. But here we have the answer of choice, and in this reference there is the choice made by Ruth Vollmer. What do we do with that? If we have no function of abstract thought in our minds, we must accept her decision as real and decisive, but if we comprehend the least abstraction, we must comprehend the greatest flaw in her work—the failure to be in unity with the fact of ourselves as displacements in a universe of doubt, doubt concerning the possibility of becoming something other than what we in fact know. Herein also lies the strength of her work, for the work confirms the concrete, which, in the face of the extreme possibility of nothingness, comes as welcome relief. It is, therefore, my hope that she is approaching the end goal initially set by the context she has chosen, without actually closing the door to that other world of thought.

Athens, 1974

Written on the occasion of the Ruth Vollmer retrospective at the Everson Museum of Art in Syracuse, N.Y., 1974. Published with permission of the author and the Ruth Vollmer Papers, 1939–1980, Archives of American Art, Smithsonian Institution, Washington, D.C.

SELECTED DOCUMENTS

THREE STATEMENTS
BY RUTH VOLLMER

Fragments Towards the Sphere: A Statement, 1965

My present involvement in exploring the sphere had this origin: In a roundabout way, I started a series of sculptures that were exhibited in the Betty Parsons Gallery in 1963. Some of these sculptures, like the "Walking Ball" and the "Ovaloids," are related to the sphere.

The culminating piece in that series, the "Obelisk," relates the sphere to the square: It has four rising compartments that are open along the back; in and through them are spherical forms. (The smallest sphere could be taken out of the obelisk and contemplated.)

Next, I explored the sphere geometrically. I looked inside. I was looking for proportions. After the exhibit of the first spheres, I stated that I had still not gained one iota of understanding of this mysterious form.

I feel now that I have made the first step. I have found forms within the sphere. Being immersed in the mystery of the sphere, I can vaguely perceive a variety of manifestations: cosmic and earthly, biological and crystalline. But my concern while exploring the sphere is to maintain, not destroy, its mystery.

A bubble is also a sphere. When bubbles are clustered, their separating sides make a flat wall. The pressure in the smaller bubble is stronger than the pressure in the larger bubble. An experiment shows that the smaller bubble blows out the larger one.

The sphere is the smallest possible surface of a given volume. The circumference of a circle is the longest outline of a plane.

We have never seen the interior of our native sphere, the earth. Is it solid—or fire—or rock?

Of all forms, the sphere is the most purely three-dimensional. A cube, having six sides (six flat planes), can be constructed from a flat pattern. A sphere, on the other hand, touches any plane at only one point. And a sphere can never be constructed from planes. The inside surface of a sphere is smaller than the outside surface. The dimension of time is probably also enclosed in the sphere.

In the Boston Museum there is a room containing early Chinese Buddhist sculptures. They indicate that the reawakened spirituality of the Chinese was due to contact with Buddhism.

Though the surfaces of these sculptures are beautiful, they are not elaborate. It is as if the surfaces exist just to *contain* the spirit which sits in the center of each work.

Painting demonstrates and expresses; it translates the three-dimensional into *one* view. Sculpture, however, *contains* what it has to reveal. To contemplate the three-dimensionality of a sculpture requires time.

It takes time to discover how to relate oneself to the spiritual core of a sculpture.

Statement: 1966

I started in a roundabout way a series of sculptures, exhibited at the Betty Parsons Gallery in 1963, exploring the sphere. Being immersed in this mysterious form, I perceive an endless variety of cosmic and earthly, biologic and crystalline manifestations. I am concerned not to destroy the mystery while exploring geometrically.

The sphere is the smallest possible surface of a given volume.... The bubble is a sphere, in a cluster the walls between bubbles are flat.... The surface of the sphere is smaller inside than outside...The sphere touches any plane only on one point...it cannot be constructed out of planes.... The cube has six sides, six flat planes, and can be constructed out of one flat pattern while the sphere cannot.... It is the most purely three-dimensional form.

It takes time to find out how one can relate oneself to the sphere.

Statement: 1968

I am involved with the sphere; exploring it geometrically, and finding unexpected forms. I suppose they have existed in Mathematics before, but they have not been manifested visibly.

The sphere is a *bubble*—or a *drop*: It is the smallest surface of a given volume—it touches the plane only on one point, regardless of its size. A true sphere cannot be constructed of a flat pattern as can the cube, the tetrahedron, etc.—it has no front or back, no top or bottom, no sides—it seems always to be stirring and in motion, not a static form:

"A [fearful] sphere, whose center is everywhere and whose circumference is nowhere."—Pascal

Published with permission of the Ruth Vollmer Papers, 1939–1980, Archives of American Art, Smithsonian Institution, Washington, D.C.; and Jack Tilton Gallery, New York.

GIACOMETTI, JULY 1951
BY RUTH VOLLMER

These notes were taken during a visit by Ruth Vollmer and James Lord to the studio of Alberto Giacometti in Paris in July 1951. Lord is Giacometti's biographer.

He loves Lehmbruck, thinks he will survive – not so much Brancusi – Liberman is now undervaluated, will possibly gain a little in value, likes him and likes him better than Kokoschka. Thinks that Picasso is overrated now, particularly so in comparison with Braque. Giacometti is very fond of Braque as a person and sees him very much – in the past year almost daily.

The figure which we saw last year in his studio, where the plaster had been knocked off almost entirely, "The Burglar" in Matisse's show in N.Y. (1947 or 1948), which he (Giacometti) wants to remake, had been returned to G. because it was not sold. When I said that it had been (was?) my favored figure, he said that it is also his (favored). – The sitting figure which he had just finished in its first form (state) last August, when we visited him – he had left unfinished and had not yet continued working on it. The 4 figures (very small) which he is having cast now – of which we hopefully will get one to take with us – (I suddenly remember that I was to write with pen + ink) seem to be the same that originally were standing on the high pedestal (base) – I will have to ask him about that.

– "That Picasso was not at all the first cubist, but has taken over the idea from Braque (which is known), that"…"(not Kahnweiler) Dérain was the very first one to originate the new painting – whom he (Giacometti) likes very much and who is still now underestimated as is Juan Gris whose cubist paintings he finds particularly beautiful" (me too). "Cézanne is really still the most advanced painter – there is no one who has gone one step further."

– "Paris is truly like Venice, really all dead by now, but he (G.) likes the decay and the muckiness of the houses and the people, he feels at home with all that – and he really prefers, decisively does prefer to live at the end of an old period rather than at the beginning of a new one." – "Picasso is doing a lot in party (political) affairs – he is not working very much any more – recently all he has done are the lithographs." – I told him about Modigliani drawings, which he did not know and Brancusi's which he did not know either. – He does not like to go away – he would not go to New York in case it should become necessary to seek refuge but he would like to visit N.Y. – When he was at the biennale the year before where he had an exhibit (besides one in Switzerland and one in Italy) he did not look around much and returned directly. He lives in the same house since he is in Paris. – G. was very surprised and very satisfied with the success of his show at Maeght. Vollmer said that one needs success, Giacometti: that he does surely not need it, that he is rather too self-assured – it made him happy but he does not need it. "In the 15 years when he was working on the figures, when he had used up all his money to the last penny – when all his friends had doubts about him – he knew that he was doing the right thing – and then when the figure became smaller and smaller – it was truly embarrassing when they crumbled in one's hand – he, Giacometti, knew that he would be able to achieve them."

"One really never changes at all" – G. has something on his mind now, that he thinks he shall accomplish in one year – "that it will be finished in one year." – "One should start at the beginning again" – he would like not to have the things he has been doing now, around in his studio any longer, not to see them any more – he wants to do something else – start anew again…. "One really does the things only to bring them to an end and to be free again and able to make something (other) different, to start all over again."

"Dalí is through (done with), he once said to G. that he would like to be a rich faker." – "He, G., really met all these people, the art of Braque, Gris, etc. only much later; when he came to Paris and during the first year there, he did not become aware of them, was not interested, that came much later – he did not know them personally then either. – He finds Leiris good."

We saw a childhood painting of G., which he had done when he was 11 years old (David and Saul). There are many of this kind, made at the same time, the bible stories, Old Testament. – In his studio was, in plaster, the cat, the dog, a horse's head, the four small figures and a very beautiful light painting – a sitting man in the center – and smaller scenes, things, portraits, all around, beautifully and excitingly spaced – many things on one (upright) surface. – Still another painting, that he himself finds beautiful, in relatively strong colors but painted in the same way as his other paintings and drawings.

Ruth Vollmer

Mr. James Lord
19, rue de Lille
Paris 7ième
France *my sender*

Published with permission of the Ruth Vollmer Papers, 1939–1980, Archives of American Art, Smithsonian Institution, Washington, D.C.

ALBERTO GIACOMETTI. BUST, CA. 1950.
PAINTED PLASTER, 7.7 X 6.6 X 2.1 IN. (19.7 X 14.2 X 5.3 CM)
THE MUSEUM OF MODERN ART, NEW YORK. RUTH VOLLMER BEQUEST
© SCALA /ART RESOURCE, NEW YORK

AN INTERVIEW WITH RUTH VOLLMER

BY SUSAN CAROL LARSEN

SUSAN CAROL LARSEN: Mrs. Vollmer, how many years have you been associated with American Abstract Artists?

RUTH VOLLMER: I am not an old member, I joined around 1963.

SCL: Has the group changed from its original character? I have noticed that quite a number of young artists now in their thirties are exhibiting with AAA. How did that come about?

RV: It was Leo Rabkin who accomplished that! He asked many young people to join those who were friends and knew each other already. Also many we did not yet know.

Of the younger generation there is Bob Ryman, Robert Mangold.... Mangold, I'm not sure, but I think also Jo Baer. Actually, this painting of Jo Baer I had seen in an American Abstract Artists show and fell in love with it. It didn't occur to me it could be hers because it was different from all the ones that I knew. And finally at the end of the show I looked to see whose it is. And it was hers.

SCL: She had taken a new direction?

RV: Yes, that was it. I am very happy to have it.

SCL: I am trying, in looking at the later members and their work, to see if there is any continuity of outlook between older original members and those younger people. Perhaps it isn't a good idea to try to construct parallels.

RV: It isn't hard, I think. You mean, along with this young generation?... They all are friends, they are aware, they talk together. They know each other, they pull on the same string.

SCL: Just as happened in the thirties with the original group?

RV: Yes, the abstractness is not their theme—that is, so to say, self-understood. I don't know, actually, where their meeting comes. Maybe in the mathematical, the rhythmical, the rhythmical repeats. In the importance of line and drawing.

In this one, Ryman's white painting that is taped to the wall, I asked him what gave him

the idea. I saw it in his studio with a...square one higher than this. An enormous one that he painted with a brush that was about this big. And he also had an enormous taped one on the wall. The same thing. It was white and the white was put on like this, in directions, only it was a little clearer than here.

Then I asked him, "What about this track?" And he said, "You know, there is a painting by Seurat in The Museum of Modern Art where he continued the painting over the frame." It was loaned to the museum for an exhibit. I remember having seen the painting, and it was a surprise that it was really that way. He had continued the painting over the frame. And it was so alive!...

SCL: In looking at this painting by Ryman I notice the direction of the brushstroke plays an important part in separating one area from another, even though they are all white. Ilya Bolotowsky does this in his paintings, particularly the later ones. I spoke to him about it.

RV: In general, Ryman always paints white paintings. Because he is interested in things like the edge of the painting, like what the painting is painted on, on steel, or on masonite or on something softer. Soft, more fluid paint—how do you put the paint on?—and then the edge. All of these things interest him, but then he has started to work on a show for the Guggenheim of enormous paintings. They are also white. It was a painting that has a top, or tops—[it was in] some article in *Artforum* with interviews.

(Vollmer showed me a sculpture by Sol LeWitt, together with several LeWitt drawings, an Ad Reinhardt "cross" composition in black and black-brown, and works by other artists in her circle of friends. She also showed me two Klee etchings, a small plaster figure by Giacometti no more than three inches high, and several early Greek figures in clay.)

RV: Some work goes with writing. This lends itself perfectly for writing. In fact, I just had

to write it to see really what it is.

SCL: Is that *Art International*?

RV: *Studio International*.

(I discussed my previous conversation with Ilya Bolotowsky and some of the early activities of AAA, mentioning Bolotowsky's article in an edition of Leonardo *magazine.)*

RV: What does he say about his work? Is it geometrical or...?

SCL: He says it is not geometric, because a geometric shape on a canvas tends to break apart from the totality of the picture plane. I'm trying to paraphrase him. Likewise, something that relies on saturation points of color or linear configurations that change through perception also is an image, because it detaches itself from the picture plane. He would rather work with this flat surface and keep all of the elements together at all times rather than having one thing detach itself from the rest.

RV: Then he would say that he wants it static?

SCL: No, I think it can be dynamic.

RV: Dynamic without moving?

SCL: Or without considering one element apart from the others. We were discussing Hélion's work and Léger and Picasso. And he was explaining to me what he saw as the differences between their work and neoplasticism.

RV: Oh, yes, there is pull. The pull front and back.

SCL: Especially in the American work from the thirties, where so many artists were learning from cubism and neoplasticism, it is sometimes difficult to sort out the various influences.

RV: But if you learn from the cubist tradition, you don't need this. Because it's there anyway, although you have to learn it in the sense of construction. I really shouldn't talk about this, because I don't really understand painting the way a painter does. I have always done sculpture.

SCL: And I have always had difficulty with sculpture because I love painting so much, and the instinct toward the two-dimensional is basic to me.

RV: I like to look at painting more than to look at sculpture.

SCL: Oh, you do? That's fascinating.

RV: In general, in general…. There are very few really great sculptors. Outside of Brancusi, who is dead. There are really very few compared to the many painters who are very interesting. The sculptors immediately are not interesting at all.

SCL: I agree with you, especially in the nineteenth and twentieth centuries.

RV: Yes. I notice in the sculpture books, I often don't like a thing. And I ask myself when I look at the illustrations, "What has that got to do with anything?"

SCL: Do you think that sculpture is harder, that it is harder to do a fine work of sculpture than to achieve a similar success in a painting?

RV: It has nothing to do with it. But, you know, hardness usually makes a thing better. If you have to try harder, you apply yourself.

SCL: You get down to business?

RV: Yes.

SCL: Do you think in the American Abstract Artists [group] that there are generally more painters than sculptors? Some people have written that; I thought I should ask you, since you are one of the sculptors.

RV: Much more painting, but that's not surprising. It is always a mix. For example, Betty Parsons always had too many artists. There was always the trouble that there were too many people who wanted shows. And she got all nervous and didn't know what to do, because she felt bad if she couldn't give them all a show. So she threw out all the artists and said, "Nobody come in!" But she didn't throw out the sculptors because she said they don't produce enough, anyway, to count! And I was concerned and asked why not, but I learned that she always handles it the same way, and it all works out.

But the idea is true. Because those sculptors who do large sculpture and have to pay for it before they sell it, or can't pay for it because they can't earn anything while it is in progress—these are insurmountable problems unless you can afford to do it. Only since I'm old can I afford to do the sculpture, to

some extent. It's terrible, transport alone…in the making of one piece, without which I could not have done that sculpture, I got some help. They made that piece and did not charge me a cent out of sheer niceness! So you understand…I did not even know them.

Some people said, "Call up Grumman Aircraft, they do so many experiments and they may have something that they threw away that you can use. Ask them!" So I did, and they thought they had something and I went there. I got a truck to pick it up. The truck cost $105, even though Hicksville is very close to New York, because it has to be a truck that goes down very close to the floor, because otherwise it cannot go under the highway bridges and there is no other way to go. So, all right.

And they cut it the right shape and they wrapped it. And they stressed it and they said we have an old man who can still do the hammering. We will have him hammer out a piece for you. And he did. One piece had to be connected to the other, and I wondered how it would work. They said, "We have a way." When I did not see it too, they said all the engineers have figured it out and that of course it would be right. But I was right. The piece doesn't exist anymore.

SCL: Did it fall apart?

RV: It could stand up, but it could not take transport and museum exhibits and so on.

SCL: Their intentions were good, but perhaps they didn't use the right material.

RV: Now, the future of these young people who show with us—they are all not so anxious to show because they are already very successful. Ryman also exhibits in Europe. Mangold is going to Europe to show for several shows. LeWitt constantly has shows in Europe, and he is just back. So they aren't anxious to show.

SCL: And that was the original purpose of American Abstract Artists: There wasn't any place to show.

RV: Yes. Well, we coax them from time to time, and they do come, but by their own desire. They like it, but it doesn't make too much difference to them.

SCL: It is not an economic necessity?

RV: Yes.

SCL: Do you go to meetings? Are they held often?

RV: We do have meetings. Sometimes they are very good. Betty Parsons spoke at the last one and it was very interesting. She is a painter, she is one of the older members, as I understand. Charmion von Wiegand was there.

SCL: How did you become interested in joining American Abstract Artists?

RV: Through [Richard] Huelsenbeck—the [family is] called Hulbeck here. They are old friends; he was one of the first Dadaists in Germany. I don't know if he was in Dada from the beginning. He was one of the founders of Dada in Zurich, Huelsenbeck and one other. Was he a Dadaist before he was a surrealist?

SCL: I think so. He wrote poems, I know.

RV: Yes. As a movement, Dada was earlier in Zurich, but the art in the *Minotaur,* I think, was surrealist. By the way, if you want to study that period, *Cahiers d'Art* and the *Minotaur* would give you much.

SCL: Mr. Bolotowsky was talking about *Cahiers d'Art* as an influence upon American artists of the thirties. They would read it and discuss it together; the illustrations, especially, had a great impact. Often one would say to the other, "That looks like something I saw in *Cahiers d'Art,*" and the other would say, "I don't think so." But it was true, though, because they were all learning from it and from each other.

RV: Oh, that's very nice. I didn't know that; it is interesting. I have a beautiful thing in the original, not a letter but a text which when it was published in *Cahiers d'Art* was signed by Giacometti. But in the original it is handwritten and it is by Breton, who was the director of the surrealists. And Giacometti was a terribly good pupil. It's ridiculous how he was anxious to do everything right!

SCL: To be a correct Dadaist?

RV: Yes. But that is very beautiful. It must have started as an interview, where he was asked, "How do you do sculpture?" And then he says how he does sculpture, and it is so fascinating! He says that if he has it worked out in his mind entirely…entirely before he starts…it comes. His favorite word. That is the first part.

He then goes on to the second part, which is a description of how he got that piece…do you know the one in The Museum of Modern

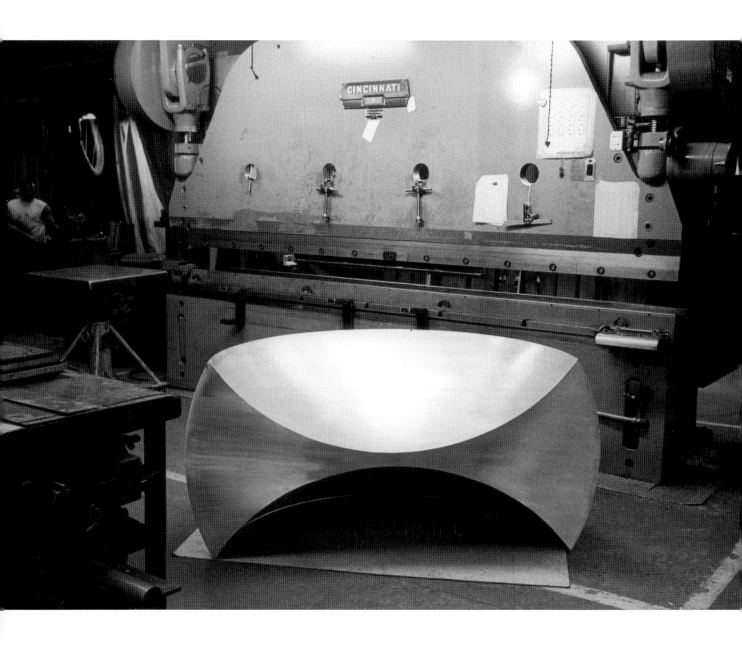

RUTH VOLLMER. FIGURE OF HALF REVOLUTION, 1968
SPUN ALUMINUM, DIAM. 76 IN. (193 CM)
PHOTO HERMANN LANDSHOFF
COURTESY JACK TILTON GALLERY, NEW YORK

Art [*The Palace at 4 A.M., 1932–33*]? It is a wood construction.

(*Vollmer brought out a book on Giacometti to show me an illustration of this piece.*)

RV: There are such strange things...there is a mathematical thing I found in here but I can't find anywhere else. I can't imagine it was invented by [the author of] this book. [Giacometti] was a famous thinker. I have been told by people who should know that.

(*She then pointed to some small white plaster figures by Giacometti. I asked her if they were studies for larger works.*)

RV: No, no. That is the *sculpture*! It was cast in bronze because people refused to buy it. The Americans...they refused. And do you know, they also refused to buy the ceramic sculptures of Picasso. I remember I went to a show and I saw that the clay walls were of some beautiful pigeons, in places very thin. He had just squeezed them into shape.
SCL: I am not familiar with these tiny plaster figures of Giacometti. They have not been on exhibit in any museum that I can remember.
RV: These are early; they come before the figures. And the figures at that time...so few people looked at it that those people [who did]...didn't mind if it was a small piece. That is the way he makes a clay model, and you constantly hope for bronze to cast it. They are not realistic figures, though he worked from the model for, I think, fifteen years. The first show was figures. And do you know, I think all his life, ever since he was a child, he worked in these small plaster ones.
SCL: That is quite a difference, when so often one sees the large bronze figures, often over life-size. But the texture constantly plays on the silhouette; his forms are almost ethereal sometimes.
RV: Yes. And also, this is like drawing.
SCL: One does have that response to it.
RV: And the flow, the flow! Well, I think we have gotten off the subject.
SCL: When did you join American Abstract Artists?
RV: In the sixties sometime.
SCL: In one book I have, it said that you began exhibiting with the AAA in 1963.
RV: That should be approximately right.

Because with Betty I showed, I think, from 1960, and I had pieces in group shows before.
SCL: Do the sculptors in the group get together more often, apart from the other members?
RV: I think [Julian] Stanczak is one member I like very much.
SCL: Richard Lippold is another sculptor in AAA.
RV: I like him very much too. [Leo] Rabkin, now he belongs more to these people, although he was was there before they came. [Roger] Jorgensen I like. [Harold] Krisel I like. Lassaw is very strange, in that he never changes.
SCL: His work from about 1935 to 1942 is quite interesting, because it had two elements which worked together. Sometimes it was very clear-cut and sharp, structural.
RV: You mean, the structure, then, was really like that edge?
SCL: Yes. There seems to be a development. There are two on display at the Washburn Gallery from that period. But after the early forties he does settle down into a pattern.

(*Vollmer had on her living room table a copy of the catalogue that accompanied Sol LeWitt's 1972 show at the Kunsthalle Berne. It is titled* Arcs, from Corners & Sides, Circles, & Grids and All Their Combinations.)

RV: The numbers always stay the same and make these combinations.
SCL: Is it mathematical?
RV: Rhythmic. It is all combinations of lines in four directions. Both the drawings and in the large room—all the lines. There are these diagonals and the vertical. But here also he adds the arcs, and then it becomes more complicated. And I think these are expressions of the arcs.
SCL: So they are all the variables of a single theme and themes in combinations.
RV: Yes. You see here what he has to say is... "One: Arcs from corners and sides, from two adjacent sides, from two corners, from four corners..." And so on.
SCL: All very logical.
RV: It is absolutely logical, but it makes very strange and different pictures somehow. And he has also done these things with boxes. Small boxes, flat boxes, with two screens close to each other making variations. And then he

has put a chemical mass on a cardboard surface. He lights it with ordinary light, and then when he shuts off the light it is still gleaming.
SCL: And then it slowly dies out?
RV: Yes, it dies out pretty fast.
SCL: I wondered if you know if it is true that Julian Stanczak studied with Josef Albers. There is a great fascination with color as well as with optics in his work.
RV: That could be. I was probably mistaken when I thought he was a sculptor.
SCL: His work is optical, but it isn't tricky.
RV: Would you call this (*referring to the LeWitt book*) optical?
SCL: It seemed so to me, but now that you have shown me the rationale behind it, it seems more serious. The end product may have some optical effects, but they are obviously not LeWitt's aim or primary intention.
RV: You mean because it makes a vibration?
SCL: Yes, but this way of going about it reminds me much more of Mr. Bolotowsky's comment about having a certain number of variables and using them in combinations. Although LeWitt is more dispassionate and less conscious about the aesthetic aspect of the work while it is in progress, I think.
RV: Why don't you find out from him how he thinks about the process?
SCL: LeWitt has a very interesting way of going about his work. It isn't so intuitive as it is logical.
RV: But you see, it is the same. Whether he does it there or here (*referring to several catalogues of shows in which LeWitt showed drawings, sculpture and mixed-media work*). He uses something else, but it is every time the same variations he uses, the same principles.
SCL: I am writing about the history of the American Abstract Artists, so I am interested in the different kinds of work current members are doing...as well as the work of the thirties.
RV: You should find somebody who could tell you who has written about this, because I don't know it. Strangely, because it's something that concerns me very much too!
SCL: Is it because of the form that results that you and Mr. LeWitt and others use mathematical procedures? Are mathematical formulas and procedures seen as a surer road to something aesthetically satisfying to the mind as well as to the eye?

RV: I can't say I do the mathematical form because of mathematics. Mathematics, yes, because of one point of view. But that's not the whole story. The mathematical form is so beautiful because it's so objective! It is not beautiful because it is made by a person, or looked at by a person. It is outside of the particular.

By the way, all of the mathematical forms that exist are all of the same kind of mathematics, a function of that mathematics. That is really the reason for it.

There is a textbook I found in the Columbia library. Columbia has one hundred or over one hundred mathematical forms, which are kept in a cupboard in the Low Library. The mathematics department is not interested in them anymore. They are not interested in function mathematics but in entirely different kinds of mathematics. So it has no meaning for them.

But for years and years I have been interested in mathematical forms, in geometry, and for a long time in mathematics. And somebody told me Columbia has mathematical forms. And everybody who told me I asked, "Where are they, because I haven't been up there." And I went immediately when I was told where they were. Well, they had moved the mathematics department to a new building and the new building had no room for them.

SCL: Are they models based upon formulas?

RV: On mathematical formulas, not on geometry! It is very interesting.

SCL: Is that why you have the seashells here? I notice this whorl or spiral pattern is common to all of them, even though some are much bigger than others.

RV: No, the seashells are...the mathematical forms I did for my last show just recently. The seashells go way back into my life. I got these out at Betty Parsons's beach. Monday morning I got up and no one was there yet, and I went out on the beach. All week nobody had been out there. I didn't know it existed. And it was filled with these shells! And I got more and more intrigued. And I couldn't tell quite what it is that was in all of these shells the same. Until I finally got it: that it was the logarithm.

SCL: That's what I meant—there is something about this shape that makes it appear over and over again.

RV: It's absolutely fantastic! You see this one? Do you know what a cat's-eye is? What is under the foot of the shell...and this is an enormous shell. This is just a piece that was under the foot of a big shell. A cat's-eye is about the size of this, the usual cat's-eye. Dick Tuttle found this on a beach, on a...beach going south of Japan. It's on an archipelago of small islands. And one of them was all filled with these, but they were on the foot of a very poisonous conch shell.

SCL: Are they the kind you listen to?

RV: No, no. They are so poisonous that in [the journals of] Captain Cook there is a remark that a native girl, in picking up one of these shells and raising her arm, fell down and was dead. And the others, even bigger than this, had black goo on them, so he didn't want to touch [them]. But I love this one. I asked my brother [Hermann Landshoff] to take one of these small ones...and to photograph it and enlarge it as much as he could. He is a photographer.... I will show you a picture of it. They have a strange thing, they always make, like, a pointed oval. See—here, too. The shape comes from both sides and then becomes a point.

SCL: It echoes and re-echoes itself. It looks like marble.

RV: Yes, yes. This here is probably polished over by the animal. Do you know, when the foot is the lowest...it is never visible. [The animal] travels on it, underneath.

SCL: The sand polishes it?

RV: Here it is not polished—I think the sand would rather do that—but here by the animal it is. Where the shell starts, the foot sticks out, unless the animal is scared of something. Then it pulls this in and that closes up the shell, so the aggressor cannot get to the animal. But not all shells have it.

SCL: I have never seen that.

RV: Oh, the little cat's-eyes you find everywhere. And where the shell touches the animal, that is the point where the shell material is growing. On this edge of the animal grows the shell—the mantle of the animal, this is called.

SCL: I wonder what it is that makes that so perfectly beautiful.

RV: Isn't it! It just *is* that beautiful, because it's *alive*. That's the perfect moral.

SCL: I wonder what stresses operate in nature, so perfectly calculated to make such a beautiful line and shape.

RV: That I would like to know too.

SCL: And then, to do this again and again in different sizes and places....

RV: Always the same. I have never seen an imperfect one! Look at this one. It is a bivalve.

SCL: It has two sides.

RV: But to make it fun and a little different, it is not symmetrical. The back here is left out. And this is charming.

SCL: There is a certain expressive quality in some of them, and in others a kind of elegant universality in nature.

RV: And this here, this is a fossil much older than man. This makes me absolutely mad!

SCL: Is it a fossil of a shell?

RV: Yes, sure. And this is similar to that. Isn't that fantastic! You should look at it through this magnifying glass; you will really see the material is so beautiful. This is close to 26,000 years [old].

SCL: And there are so many points on it...so perfect.

RV: It is not so perfect anymore as it was.

SL: It has been knocked around through time.

RV: No, it is always in this cotton, but it may be that they may have repaired it a little bit— you know, like the Greeks do by repairing these lines as they do in clay. They do it well. You see well these little effects of clay.

SCL: You mean these little lines to fill in the cracks.

RV: Yes. You have to hold it so that light gets on the piece....

SCL: These kinds of things, and the fascination with it, isn't very different from mathematics.

RV: That's what I think! It is not at all different. The fantastic thing in nature is that nature would not be possible unless it could reproduce these over and over.

SCL: That is a very wonderful way of looking at the world, because you don't feel foreign to anything. Have you read any of the essays of Irene Rice Pereira? She writes about science and art and how she sees them as both revealing truths, but through a different process.

RV: I recall only once seeing something of hers. I think it was in Saks's window. I remember being very impressed with it. Impressed...but also mixed-up.

SCL: Sometimes it is very difficult to link theory or philosophy with the production of art. The effort to put the two closely together often fails.

RV: If it is an effort it isn't any good. Isn't it surprising that there are not more artists in American Abstract Artists from the early years? I wonder why Pollock wasn't in it, but perhaps they never asked him. You know something, we forget that there were not very many people who were sure...about Pollock.

SCL: Or about each other.

RV: Yes. It always takes a little longer. I know we got the Giacomettis because we were just absolutely in love with them! After the show at Pierre Matisse where the first figures were shown...I just couldn't believe what happened. I was terribly impressed with Giacometti long before that, from the time I saw the first one.

It was at Ullman, I think.... I loved the show there. Somebody took me to about fifteen galleries, mostly on Fifty-Seventh Street—the galleries which you know, the basic galleries to which I used to go.... Then [it] changed so much, because Berenson came in.... I also knew Wunderlich. After the first two, somebody took me to Peggy Guggenheim's gallery. I went there, and there was a beautiful Giacometti. It was a very early one, also in clay. And I asked her, "What has Giacometti done? Who is he? I know nothing about him."

And she said, "He has done very little and nobody knows much about him. And I know also little about him. I'll show everything together if you like. I will get together everything I can find and I'll keep it here, then you can come back." I didn't know her then; I knew her much better later. She was terribly nice, and she did it....

And she showed me everything that existed. There were very few catalogues. That was all I knew. And then I remember a show before the end of the war. I went to Peggy Guggenheim['s], and there was Mary Callery. She had just come from Paris. Do you know who she is? Mary Callery is a sculptor. She was a friend of Picasso, possibly a lover of Picasso, before the woman who wrote the book.

Anyway, I came in and asked the same question again. "Do you know anything about Giacometti?" And [Callery] said, "Oh, nothing will come of him because he makes figures that are only that size"—about two inches high—"and if you handle them they become dust! I have a few of those.".... And they are really that bad.

SCL: She wasn't exaggerating?

RV: She wasn't exaggerating. I have seen them. How she kept them alive is a piece of art.

New York, January 30, 1973

Published with permission of the author. Susan Carol Larsen, "The American Abstract Artists Group: A History and Evaluation of Its Impact upon American Art" (Ph.D. diss., Northwestern University, 1975): 606–20.

IN CONVERSATION WITH MEL BOCHNER
BY NADJA ROTTNER

Nadja Rottner: In the fall of 1965 you were working for Ruth as a studio assistant, after having already worked with Jack Tworkov and Robert Motherwell. How was it that you came to know Ruth? And what was the nature of the work you did for her? You also mentioned that it was Ruth who introduced you to Robert Smithson.

Mel Bochner: I don't really remember how I met Ruth. Basically, she hired me to build sculpture stands for her upcoming show at Betty Parsons. She was remarkably patient with me because I wasn't much of a carpenter. But she knew I needed the job, and eventually the bases got done. Anyway, we spent a lot of time together in her studio, and sometimes after work she would invite me over to her house for dinner. I had only been in New York for a little over a year, and was living a pretty isolated, hand-to-mouth existence. So getting to know Ruth and spending time at her apartment, seeing all the wonderful things she owned, and the way they were integrated into her life, was a great experience for me. I learned a lot from Ruth, particularly about music. Her father had been a famous musicologist in Germany at the beginning of the twentieth century, very central in the Bach revival. Ruth grew up in that rarified German-Jewish world of classical music and high culture. She was worldly in a way I had never seen before, didn't even know existed. Art, music, literature, science, and politics all fit seamlessly together in her life. Ruth really lived the life of the mind. Later on I met other people of her generation who shared those same interests, but never anyone so unthreatened by young people or so intoxicated by new ideas.

And, yes, I did meet Smithson at a party at Ruth's. We fell into a heated argument about entropy and mannerism, which, fueled by too much alcohol, lasted until Ruth finally threw us out at around three A.M.

NR: What were your artistic concerns when you met Ruth?

Did they in any way involve her as an artist?

MB: When I first saw Ruth's work, I found her ideas interesting, but not the way the objects were fabricated. The association of bronze with antiquity was problematic for me. Remember, I was only twenty-five years old, and my ambitions were to change things, not to preserve them.

NR: In your 1966 review of the "Primary Structures" exhibition you wrote: "Old Art attempted to make the non-visible (energy, feelings) visual (marks). The New Art is attempting to make the non-visual (mathematics) visible (concrete)" [*Arts Magazine* (June 1966): 35]. You told me that Ruth represented a connection to a different generation, the generation of Ad Reinhardt, Ellsworth Kelly, and Betty Parsons. Wouldn't this place Ruth within both the New as well as the Old?

MB: That's an interesting point. Ruth's work could be seen as a bridge in two senses. First, she was trying to hold on to a set of cultural markers that both did and did not connect her content to her forms. There was her sense of order (the old) battling her love of adventure (the new). That was the aspect of her work that I came to find most engaging. And the second sense was her ability to maintain friendships with artists across such radically different generations, like Reinhardt, Kelly, Parsons, and Agnes Martin, on the one hand, and Hesse, Smithson, LeWitt, and myself on the other.

NR: There is definitely an ambiguity in her work—a split, if you like. Her cultural background—her upbringing in the twenties, the Bauhaus, et cetera—is helpful in locating this split historically. But, if I understand you correctly, what you are saying is that this is visible on the level of the work—this tension between the "newness" of the content and her traditional employment of expressionistic forms, her adherence to unpolished bronze objects.

MB: Well, yes, it is visible on the face of the earlier work. But the "expressionism" always seemed a bit of an add-on, a

stylistic trope, rather than integral to the idea itself. I'm not sure that was her intention, but I found it almost conceptualized, and related to the use, or the abuse, of expressionism in Eva Hesse.

NR: Ruth never accepted the schism between ideas and sensibilities. Predominantly, her work takes on found mathematical ideas evolving around possible geometries of the circle. Whereas you were interested in the triangle and the cube for its potential to be stripped bare, to the bone, Ruth had chosen the circle, the sphere, the spiral, for its richness of association, its universal potential. Were the differences between her and a younger generation of artists such as yourself greater than the affinities?

MB: In my case, the differences probably outweighed the similarities. I have no vested interest in triangles or cubes, and no belief that they have any "universal" or essentialist meaning. I use shapes, or numbers, or even words, merely as grammatical objects, because the subject of my work is the syntax. Ruth in many ways was closer to Alfred Jensen, an artist who shared her background and neo-Pythagoreanism, if not her sensibility. Ruth was part of that idealistic, pre–World War II generation that, in spite of everything, believed that art and science still held out the possibility of explaining the structure of the world, that someday we would *understand*. I think Paul Klee's notebooks are the great document of that worldview. So, in that sense, Ruth was really a romantic. And in terms of generational differences, I would say that her romanticism was the most significant difference. Of course, at the same time, that was what made her so attractive as a person—that, along with her unquenchable optimism and generosity.

NR: I fully agree with you about her inherently romantic character. In Ruth there was no skepticism of vision, but, rather, a full belief in the nature of representation, in its communicative potential. Her interest in complex mathematical models was, through the power of visualization, to lend them single shapes in the form of objects that are still abstract, yet tangible. But, wouldn't you rather connect that to minimalism's use of a hidden, geometric structure in building visual, phenomenologically present objects?

MB: I don't really see any need to connect her work to minimalism, certainly not for morphological reasons. First of all, there were no "complex mathematical models" at work in minimalism. The goal in the sixties was to use forms that were self-evident, or in Jasper Johns's words, "Things the mind already knows." Ruth, on the other hand, did believe in the veracity of scientific images. It was she who first introduced me to D'Arcy Thompson's *On Growth and Form*. While those images are, without a doubt, fascinating as images, they are tied to specific cultural and temporal systems of representation, which is the source of one's skepticism. That was one of the main points of the magazine piece that Smithson and I did together in 1966, "The Domain of the Great Bear," in which we looked at the Hayden Planetarium as a cultural, time-based construction that was under pressure from constantly evolving changes in the way science was socially manipulated and visually depicted.

I myself look at Ruth's work as an interpretation of the mind behind those scientific representations, almost as if the word *mind*, in a Platonic sense, should be spelled with a capital *M*. I see her work as closer to Kepler's concept of " the music of the spheres," a quest for a mathematical harmony between mind and nature. While it may be difficult today to believe in those concepts, that doesn't alter the quality of Ruth's profoundly integrated and deeply moving vision of art and the world.

New York, January 2005

EXHIBITION HISTORY

Solo Exhibitions

1960

"Ruth Vollmer: Sculpture." Betty Parsons Gallery, Section Eleven, New York (May 24–Jun 11)

1966

"Ruth Vollmer: Sculpture, Spheres." Betty Parsons Gallery, New York (Jan 25–Feb 12)

1968

"Exploration of the Sphere: Ruth Vollmer, Sculpture." Betty Parsons Gallery, New York (Nov 19–Dec 7) (catalogue)

1970

"Ruth Vollmer." Betty Parsons Gallery, New York (Nov 3–24)

1971

Drew University, Madison, N.J. (Mar 3–31)

1973

"Ruth Vollmer: Sculpture and Drawings." Betty Parsons Gallery, New York (Apr 3–21)

1974

"Ruth Vollmer: Sculpture and Painting, 1962–1974." Everson Museum of Art, Syracuse, N.Y. (Mar 29–Apr 16) (catalogue)
Curated by Peg Weiss

1976

"Ruth Vollmer." Neuberger Museum of Art, State University of New York, Purchase (Jan 6–Mar 14) (catalogue)

Sullivant Gallery, Ohio State University, Columbus

1978

"Ruth Vollmer: Drawings." Adler Gallery, Los Angeles (Sep 16–Oct 18)

1979

"Ruth Vollmer: Pencil Drawings." Betty Parsons Gallery, New York (Feb 13–Mar 3)

1983

"Ruth Vollmer (1903–1982)." Jack Tilton Gallery, New York (Oct 18–Nov 12) (catalogue)

1985

"Ruth Vollmer: An Exhibition of Spheres." Jack Tilton Gallery, New York (Apr 2–27)

2002

"Ruth Vollmer: Drawings and Sculpture." Inverleith House, Royal Botanical Garden Edinburgh (Mar 24–May 5) (catalogue)
Curated by Graham Domke

Selected Group Exhibitions

1944

"Art in Progress: 15th Anniversary Exhibition." The Museum of Modern Art, New York (May 24–Sep 17) (catalogue)
Artists in "Dance and Theater" (selected): Boris Aronson, Cecil Beaton, Eugene Berman, Georges Braque, Horacio Butler, Paul Cadmus, Marc Chagall, Giorgio de Chirico, Max Ernst, Natalie Gontscharova, Robert Edmond Jones, Richard Lindner, André Masson, Pablo Picasso, Oskar Schlemmer, Kurt Seligman, Pavel Tchelitchew, Ruth Vollmer

1947–48

"World of Illusion: Elements of Stage Design." The Museum of Modern Art, New York (Oct 14–Jan 4). Traveling exhibition
Curated by George Amberg
Artists with stage models: Georges Braque, Edward Burra, Fernand Léger, Lothar Schenk von Trapp, Kurt Schmidt, Léopold Survage, Charlotte Trowbridge, Ruth Vollmer, Wing Stage (anonymous)

1948–49

"Children's Holiday Fair of Modern Art." The Museum of Modern Art, New York (Dec 2–Jan 4). Traveling exhibition
Organized by Victor D'Amico

1956

"Annual Sculpture Show." Village Art Center, New York

1957

"International Samples Exhibition." Traveled to industrial trade fairs in Milan and Barcelona.

1957–58

Children's Holiday Carnival. The Museum of Modern Art, New York (Dec 9–Jan 12)
Organized by Victor D'Amico

1958

U.S. Pavilion, World's Fair, Brussels

1959

"Drawings, Gouaches, Sculpture." Betty Parsons Gallery, Section Eleven, New York (Feb 24–Mar 17)
Artists (selected): Lyman Kipp, Richard Lindner, Seymour Lipton, Agnes Martin, Jesse Reicheck, Ad Reinhardt, Hedda Sterne, Ruth Vollmer, Hugo Weber

1960–61

"Guest Show." Betty Parsons Gallery, Section Eleven, New York (Dec 20–Jan 7)
Artists: R. Cooper, Garston, Gego, Lamantia, Leake, Gerd Leufert, Mather, Merinoff, Niewald, Sirvonen, Elaine Sturtevant, Ruth Vollmer

1961

"Summer Exhibition (14th Annual Creative Arts Program)." University of Colorado, Boulder (catalogue)

1962

"Painting and Sculpture." Wolfson Studio, Salt Point, N.Y. (Aug 19–Sep 21)
Artists: Dusti Bonge, Clavert Coggeshall, Paul Feeley, Jose Guerrero, Lyman Kipp, Alexander Liberman, Elisabeth McFadden, Walter Murch, Eduardo Paolozzi, Ad Reinhardt, Ethel Schwabacher, Thomas Sills, Sasson Soffer, Hedda Sterne, Ruth Vollmer, Sidney Wolfson, Jack Youngerman

1963

"Sasson Soffer/Ruth Vollmer." Betty Parsons Gallery, New York (Mar 11–30)

"American Abstract Artists (27th Annual Exhibition)." East Hampton Gallery, New York (May 7–Jun 1)
Artists: Alice Adams, Mildred Aissen, Josef Albers, L. Alcopley, Will Barnet, Herbert Bayer, Maurice Berezov, Barbara Blair, Ilya Bolotowsky, Henry Botkin, Rhys Caparn, Eve Clendenin, Jean Cohen, Robert Conover, Doris Cross, Eleanor De Laittre, Ruth Eckstein, Perle Fine, Adolf Fleischman, Suzy Frelinghuysen, Maurice Golubov, Jose Guerrero, John Grillo, Beate Hulbeck, Roger Jorgensen, Jerry Kajetanski, Herbert Kallem, Nikolai Kasak, Paul Kelpe, Harold Krisel, Ibram Lassaw, Irving Lehman, Michael Loew, Robert MacFarland, Leo Manso, Alice T. Mason, Joseph Meert, Joseph Meierhans, Lily Michael, Jeanne Miles, George L.K. Morris, Louise Nevelson, Betty Parsons, Henry Pearson, Leo Rabkin, Hans Richter, Rivkah, Raymond Rocklin, Antonio Rubino, John Sennhauser, Charles Shaw, Esphyr Slobodkina, Hyde Solomon, Max Spivak, Harry Tedlie, Ruth Vollmer, John von Wicht, Charmion von Wiegand, Jean Xceron

"Outdoor Sculpture Show." Bundy Art Gallery, Waitsfield, Vt. (Jun–Aug)

Obelisk Gallery, Boston (sculpture competition)

"Toys by Artists." Betty Parsons Gallery, New York (Dec 15–Jan 4)
Artists (selected): Richard Anuskeiwicz, Nell Blaine, Boghosian, Alexander Calder, Chryssa, Bruce

Connor, Elaine De Kooning, Helen Frankenthaler, Mary Gordon, Robert Indiana, Ellsworth Kelly, Lyman Kipp, Alexander Liberman, Richard Lindner, Sven Lukin, Marisol, Walter Murch, Kenso Okada, George Ortman, Alfonso Ossorio, Lanny Powers, Leo Rabkin, Onni Saari, Sylvia Sleigh, Sasson Soffer, Ruth Vollmer, Andy Warhol, Jack Youngerman

"14th Annual New England Exhibition." The Silvermine Guild of Artists, New Canaan, Conn.

1964
"For Eyes and Ears." Cordier & Ekstrom Gallery, New York (Jan 3–25)
Organized in collaboration with Nicolas Calas; sound installation by Billy Klüver
Artists: Peter Agostino, Paul Brach and Morton Feldman, George Brecht, Alexander Calder, Chryssa, Bruce Connor, Allan D'Arcangelo, Jim Dine, Marcel Duchamp, Herbert Gesner, Jasper Johns, Joe Jones, Aaaron Kuriloff, Michael Lekakis, Man Ray, Walter de Maria, Robert Morris, George Ortman, Alfonso Ossorio, Barbro Ostlihn, Robert Rauschenberg, Larry Rivers, Richard Stankiewicz, Takis and Earl Brown, Jean Tinguely, Ruth Vollmer, Bob Watts

"American Abstract Artists (28th Annual Exhibition)." Contemporary Arts Gallery, Loeb Student Center, New York University, New York (Jan 8–23)
Artists: Alice Adams, Mildred Aissen, Josef Albers, L. Alcopley, Will Barnet, Herbert Bayer, Maurice Berezov, Barbara Blair, Ilya Bolotowsky, Henry Botkin, Rhys Caparn, Eve Clendenin, Jean Cohen, Robert Conover, Doris Cross, Eleanor De Laittre, Ruth Eckstein, Perle Fine, Adolf Fleischman, Suzy Frelinghuysen, Maurice Golubov, Jose Guerrero, Beate Hulbeck, Roger Jorgenson, Jerry Kajetanski, Herbert Kallem, Nikolai Kasak, Harold Krisel, Ibram Lassaw, Irving Lehman, Michael Loew, Alice Robert MacFarland, Leo Manso, Alice T. Mason, Joseph Meert, Joseph Meierhans, Lily Michael, Jeanne Miles, George L.K. Morris, Betty Parsons, Henry Pearson, Leo Rabkin, Hans Richter, Rivkah, Raymond Rocklin, John Sennhauser, Charles Shaw, Louis Silverstein, Esphyr Slobodkina, Hyde Solomon, Max Spivak, Harry Tedlie, Ruth Vollmer, John von Wicht, Charmion von Wiegand, Jean Xceron

"Art Auction." 5th Annual Event, New York Society for Ethical Culture and the Ethical-Fieldston Alumni Association, New York (Apr 26)

"10th Street Invitational." Aegis Gallery, New York (Sep 18–Oct 8)

"Sculptors Guild Exhibition." Lever House, New York

Washington Square Gallery, New York

1964–65
"Annual Exhibition of Contemporary American Sculpture, Watercolors and Drawings." Whitney Museum of American Art, New York (Dec 9– Jan 31)

1965
"American Abstract Artists (29th Annual Exhibition)." Riverside Museum, New York (Mar 14–April 25)
Artists: Alice Adams, Mildred Aissen, Josef Albers, L. Alcopley, Richard Anuszkiewicz, Will Barnet, Herbert Bayer, Maurice Berezov, Barbara Blair, Ilya Bolotowsky, Henry Botkin, Rhys Caparn, Eve Clendenin, Jean Cohen, Robert Conover, Doris Cross, Eleanor De Laittre, Ruth Eckstein, Perle Fine, Adolf Fleischman, Suzy Frelinghuysen, Tibor Freund, Maurice Golubov, John Goodyear, Charles Hinman, Beate Hulbeck, Robert Huot, Roger Jorgenson, Jerry Kajetanski, Herbert Kallem, Nikolai Kasak, Paul Kelpe, Harold Krisel, Leroy Lamis, Ibram Lassaw, Irving Lehman, Michael Loew, Robert MacFarland, Leo Manso, Alice T. Mason, Joseph Meert, Joseph Meierhans, Lily Michael, Jeanne Miles, George L.K. Morris, Betty Parsons, Henry Pearson, Leo Rabkin, Hans Richter, George Rickey, Rivkah, Raymond Rocklin, Robert Ryman, Salvatore Scarpita, John Sennhauser, Charles Shaw, Louis Silverstein, Esphyr Slobodkina, Hyde Solomon, Max Spivak, Julian Stanzcak, George Sugarman, William Talbot, Harry Tedlie, Ruth Vollmer, John von Wicht, Charmion von Wiegand, Neil Williams, Jean Xceron

U.S. Mission to the U.N., New York

1966
"161st Annual Exhibition." Pennsylvania Academy of Fine Arts, Philadelphia (Jan 21– Mar 6)
Jurors: Jack Levine, Karl Knaths, John Heliker, Harry Bertoia, Bruno Lucchesi, Milton Hebald
Artists (selected): Helen Frankenthaler, Ibram Lassaw, Conrad Marca-Relli, Jane Piper, George Rickey, George Tooker, Ruth Vollmer, Neil Welliver

"Sound Exhibit." Contemporary Arts Gallery, Loeb Student Center, New York University, New York (Mar 4–18)
Curated by Hermine Benheim
Artists: William Anastasi, Baschet, Paul Brach and Morton Feldman, John Carswell, Joseph Cornell, Jasper Johns, Joe Jones, Joe Moss, Michael Ponce

De Leon, George Segal, Jason Seley, Marina Stern, Tal Streeter, Jean Tinguely, Ruth Vollmer, Bob Watts, Tom Wesselman, Yoshimura

"Two-Person Show with Leo Rabkin." Drew University, Madison, N.J. (Mar)

"Art Auction." New York Society for Ethical Culture and the Ethical-Fieldston Alumni Association, New York (Apr)

"Recent Acquisitions: Paintings and Sculpture." The Museum of Modern Art, New York (Apr 6– Jun 12)
Curated by Dorothy C. Miller
Artists (selected): Larry Bell, Billy Al Bengston, André Derain, George Grosz, Hans Hoffman, Robert Indiana, Frederick Kiesler, Roy Lichtenstein, Agnes Martin, Michelangelo Pistoletto, Bridget Riley, Nicolas Schöffer, Mark Tobey, Victor Vasarely, Ruth Vollmer, Andy Warhol, Walter Zehringer

"West Side Artists." Goddard-Riverside Auditorium, Goddard-Riverside Community Center, New York (Apr 19–May 8)

"Artists for Core." Grippi & Wadell Gallery, New York (Apr 27–May 7)

"2ème Salon International de Galeries Pilotes: artistes et découvreurs de notre temps," Musée Cantonal des Beaux-Arts, Palais de Rumine, Lausanne, Switzerland (Jun 12–Oct 2) (catalogue)
Artists from Betty Parsons Gallery: William Congdon, Paul Feeley, Thomas George, Minoru Kawabata, Lyman Kipp, Alexander Liberman, Walter Murch, Robert Murray, Kenzo Okada, Ad Reinhardt, Hedda Sterne, Bradley Walker Tomlin, Richard Tuttle, Ruth Vollmer, Jack Youngerman

"'Yesterday and Today' 1936–1966." American Abstract Artists (30th Anniversary Exhibition). Riverside Museum, New York (Sep 25–Nov 27) (catalogue)
Artists: Alice Adams, Mildred Aissen, Josef Albers, L. Alcopley, Richard Anuszkiewicz, Will Barnet, Herbert Bayer, Maurice Berezov, Barbara Blair, Ilya Bolotowsky, Henry Botkin, Rhys Caparn, Eve Clendenin, Jean Cohen, Robert Conover, Doris Cross, Eleanor De Laittre, Ruth Eckstein, Perle Fine, Adolf Fleischman, Suzy Frelinghuysen, Maurice Golubov, Beate Hulbeck, Roger Jorgenson, Jerry Kajetanski, Herbert Kallem, Nikolai Kasak, Paul Kelpe, Harold Krisel, Leroy Lamis, Ibram Lassaw, Irving Lehman, Michael Loew, Robert MacFarland, Leo Manso, Alice T. Mason, Joseph Meert, Joseph

Meierhans, Lily Michael, Jeanne Miles, George L.K. Morris, Dahnis Nossos, Betty Parsons, Henry Pearson, Leo Rabkin, Hans Richter, Rivkah, Robert Ryman, John Sennhauser, Charles Shaw, Louis Silverstein, Esphyr Slobodkina, Hyde Solomon, Max Spivak, Julian Stanzcak, Harry Tedlie, Ruth Vollmer, John von Wicht, Charmion von Wiegand, Jean Xceron

"Constructed Works." Betty Parsons Gallery, New York (Oct 4–21)
Artists: Enrico Castellani, Paul Feeley, Lyman Kipp Jr., Alexander Liberman, Robert Murray, Robert Smithson, Paul Tuttle, Ruth Vollmer, Jack Youngerman

"The Sculptors Guild: Annual Exhibition." Lever House, New York (Oct 23–Nov 20) (catalogue)

1967
"American Abstract Artists (31st Annual Exhibition)." Loeb Student Center, New York University, New York (Jul 10–Aug 7)

"The Sculptors Guild: Thirtieth Anniversary Exhibition." Lever House, New York (Oct 22–Nov 19); Lamont Gallery, Exeter, N.H. (Nov 24–Dec 20) (catalogue)
Artists (selected): Anne Arnold, Helen Beling, Ivan Biro, Louise Bourgeois, Doris Caesar, Kenneth Campell, Rhys Caparn, Martin Craig, Franc Epping, Dorothea Greenbaum, Peter Grippe, Chaim Gross, Cleo Hartwig, Nathaniel Kaz, Joseph Konzal, Ezio Margoulies, Katherine Nash, Charles Salerno, Louis Schanker, Marie Taylor, Ruth Vollmer, Harvey Weiss, Helen Wilson, Nina Winkel, William Zorach

1968
"Betty Parsons' Private Collection." Finch College Museum of Art, New York (Mar 13–Apr 29) (catalogue)

"Sculpture Now." Heckscher Museum of Art, Huntington, N.Y. (Jun 29–Sep 1) (catalogue)
Artists: Harry Bertoia, Alexander Calder, John Chamberlain, Nathan Cabot Hale, Roger Jorgensen, Lyman Kipp, Fritz Koenig, Dennis Leon, Isamu Noguchi, Beverly Pepper, Charles Ross, Walter Satkovski, Julius Schmidt, Ruth Vollmer, Harvey Weiss

"American Abstract Artists (32nd Anniversary Exhibition)." Riverside Museum, New York (Oct 6–Dec 1)
Artists: Alice Adams, Mildred Aissen, Josef Albers, L. Alcopley, Will Barnet, Herbert Bayer, Maurice Berezov, Barbara Blair, Ilya Bolotowsky, Henry

Botkin, Sydney Butchkes, Rhys Caparn, Eve Clendenin, Jean Cohen, Robert Conover, Doris Cross, Nassos Daphnis, Eleanor De Laittre, Ruth Eckstein, Perle Fine, Suzy Frelinghuysen, Maurice Golubov, Beate Hulbeck, Roger Jorgenson, Jerry Kajetanski, Herbert Kallem, Nikolai Kasak, Paul Kelpe, Harold Krisel, Leroy Lamis, Ibram Lassaw, Irving Lehman, Michael Loew, Leo Manso, Alice T. Mason, Joseph Meert, Joseph Meierhans, Lily Michael, Jeanne Miles, George L.K. Morris, Betty Parsons, Henry Pearson, Leo Rabkin, Hans Richter, Rivkah, Robert Ryman, John Sennhauser, Charles Shaw, Louis Silverstein, Esphyr Slobodkina, Robert Smithson, Hyde Solomon, Max Spivak, Julian Stanzcak, Harry Tedlie, Ruth Vollmer, Mac Wells, John von Wicht, Charmion von Wiegand
Guests: Peter Agostino, Jo Baer, Ray Donarski, Casper Henselman, Ralph Humphrey, Edward McGowan, Steven Montgomery, Salvatore Romano, Richard Serra, Keith Sonnier, Mark di Suvero, Richard Tuttle, Jaqueline Windsor

Betty Parsons Gallery, New York

1968–69
"1968 Annual Exhibition: Sculpture." Whitney Museum of American Art, New York (Dec 17–Feb 9)
Artists (selected): Ronald Bladen, Lee Bontecou, John Goodyear, Robert Graham, Robert Grosvenor, Donald Judd, Ellsworth Kelly, Lyman Kipp, Rockne Krebs, Roy Lichtenstein, Robert Morris, Louise Nevelson, Barnett Newman, Claes Oldenburg, Kenneth Price, Carlos Ramos, José de Rivera, James Rosati, Alan Saret, George Segal, Sylvia Stone, George Sugarman, Mark di Suvero, Ruth Vollmer

1969
"American Abstract Artists (33rd Annual Exhibition)." North Carolina Museum of Art, Raleigh (Feb 9–Mar 9) (catalogue)
Artists: Alice Adams, Will Barnet, Herbert Bayer, Maurice Berezov, Ilya Bolotowsky, Henry Botkin, Sydney Butchkes, Rhys Caparn, Eve Clendenin, Jean Cohen, Robert Conover, Doris Cross, Ruth Eckstein, Perle Fine, Suzy Frekinghuysen, Beate Hulbeck, Roger Jorgensen, Jerry Kajetanski, Herbert Kalem, Nicolai Kasak, Harold Krisel, Michael Loew, Alice T. Mason, Lily Michael, Betty Parsons, Henry Pearson, Leo Rabkin, Robert Ryman, John Sennhauser, Louis Silverstein, Esphyr Slobodkina, Robert Smithson, Ruth Vollmer, Mac Wells, Charmion von Wiegand

"Dealer's Choice: An International Loan Exhibition at the Northern Arizona University Art Gallery During the Fourth Annual Flagstaff*

Summer Festival 1969." North Arizona State University, Flagstaff (Jul 25–Aug 15)

"Bryant Park Sculpture Exhibition: A Salute to New York City." Bryant Park, New York (Oct 30–Nov 3)

1969–70
"The Expressive Line." Heckscher Museum of Art, Huntington, N.Y. (Dec 21–Jan 25) (catalogue)
Artists: Leonard Baskin, Mel Bochner, Kenneth Callahan, Giorgio de Chirico, Samuel Czafranc, Adolph Dehn, André Derain, Arthur G. Dove, Lyonel Feininger, Sue Fuller, Thomas George, Alberto Giacometti, Fritz Glarner, Leon Goldin, Arshile Gorky, John Graham, William Gropper, John Hartell, John Heliker, Eva Hesse, Will Insley, Lyman Kipp, Paul Klee, James Lechay, Sol LeWitt, Richard Lindner, André Masson, Karl Mattern, Pablo Picasso, Leo Rabkin, Jesse Reichek, Robert Ryman, Karl Schrag, Moses Soyer, Raphael Soyer, Saul Steinberg, Graham Sutherland, Pavel Tchelitchew, Jacques Villon, Ruth Vollmer

1970
"Contemporary Women Artists." The National Arts Club, Skidmore College, Saratoga Springs, N.Y. (Feb 2–8)
Artists (selected): Edna Andrade, Mary Bauermeister, Tova Beck-Friedman, Isabel Bishop, Lee Bontecou, Dorothy Dehner, Sue Fuller, Suzi Gablik, Nancy Grossman, Grace Hartigan, June Harwood, Barbara Hepworth, Eva Hesse, Lee Krasner, Doris Leeper, Loren McIver, Joan Mitchell, Alice Neel, Louise Nevelson, Beverley Pepper, Bridget Riley, Niki de Saint Phalle, Toko Shinoda, Hedda Sterne, Ruth Vollmer

"American Abstract Artists (34th Annual Exhibition)." Contemporary Arts Gallery, Loeb Student Center, New York University, New York (Feb 2–Mar 4)
Artists: Mildred Aissen, Josef Albers, L. Alcopley, Will Barnet, Maurice Berezov, Barbara Blair, Ilya Bolotowsky, Henry Botkin, Sydney Butchkes, Rhys Caparn, Eve Clendenin, Jean Cohen, Robert Conover, Doris Cross, Nassos Daphnis, Eleanor De Laittre, Ruth Eckstein, Perle Fine, Suzy Frelinghuysen, Maurice Golubov, Alice Adams Gordy, Beate Hulbeck, Roger Jorgenson, Jerry Kajetanski, Herbert Kallem, Nikolai Kasak, Paul Kelpe, Harold Krisel, Leroy Lamis, Ibram Lassaw, Irving Lehman, Michael Loew, Leo Manso, Alice T. Mason, Joseph Meert, Joseph Meierhans, Lily Michael, Jeanne Miles, George L.K. Morris, Betty Parsons, Henry Pearson, Leo Rabkin, Hans Richter, Rivkah, Robert Ryman, John Sennhauser, Charles

Shaw, Louis Silverstein, Esphyr Slobodkina, Robert Smithson, Hyde Solomon, Max Spivak, Julian Stanzcak, Harry Tedlie, Ruth Vollmer, Mac Wells, John von Wicht, Charmion von Wiegand

"Sculpture in the Spring." Museum of Art, The University of Connecticut, Storrs (Apr 4–May 30)

"Middle Room Exhibition." Betty Parsons Gallery, New York (Sep 22–Oct 10)
Artists: Andrea Cascella, Emil Hess, Alexander Liberman, Walter Murch, Kenzo Okada, Stephen Porter, Richard Poussette-Dart, B.W. Tomlin, Ruth Vollmer

"Indoor-Outdoor Sculpture Exhibition." Muhlenberg College, Allentown, Pa.

"Mr. and Mrs. Hirshhorn Select." Greenwich Museum, Greenwich, Conn.

1970–71
"Editions in Plastic." University of Maryland Art Gallery, Baltimore (Dec 3–Jan 31) (brochured checklist)
Curated by Marchal E. Landgren and Josephine Withers
Artists (selected): Stephan Antonakos, Arakawa, Arman, Richard Artschwager, Billy Al Bengston, John Cage, Christo, Allan D'Arcangelo, Philip Guston, Eva Hesse, Les Levine, Roy Lichtenstein, Robert Morris, Louise Nevelson, Barnett Newman, Claes Oldenburg, Bridget Riley, Ruth Vollmer, Andy Warhol, Tom Wesselmann

"Sculpture: The Artists Plus Discoveries." Betty Parsons Gallery, New York (Dec 15–Jan 9)

1971
"American Abstract Artists (35th Annual Exhibition)." Contemporary Arts Gallery, Loeb Student Center, New York University, New York (Feb)

"Sculpture in the Park." Festival 70, New Jersey Cultural Council, Van Saun Park, Paramus (Jun 13–Sep 26) (catalogue)
Artists (selected): Alexander Calder, Mary Callery, Charles Ginnever, John Goodyear, Robert Grosvenor, Lyman Kipp, Bernard Kirschenbaum, Alexander Liberman, Ursula Meyer, Robert Morris, Philip Pavia, Ruth Vollmer

"Recent Acquisitions." Whitney Museum of American Art, New York (May 27–Jun 16)

"Art and Science." Tel Aviv Museum of Art. Traveling exhibition

"New American Sculpture." United States Information Agency, New York. Traveling exhibition

"Projected Art: Artists at Work." Finch College Museum of Art, New York
Artists (selected): Vito Acconci, Tom Blackwell, Peter Campus, Agnes Denes, Dan Graham, Patricia Johanson, Pat Lipski, Hedda Sterne, Ruth Vollmer, Jud Yalkut

"Sculpture Exhibition." The Members' Gallery/Sculptors Guild, Albright-Knox Art Gallery, Buffalo, N.Y.

1972
"American Abstract Artists (36th Anniversary Exhibition)." Library Gallery, Fairleigh Dickinson University, Madison, N.J. (Feb); and Contemporary Arts Gallery, Loeb Student Center, New York University, New York (Oct 31–Nov 22)
Artists: Alice Adams, Mildred Aissen, Josef Albers, L. Alcopley, Will Barnet, Herbert Bayer, Maurice Berozov, Barbara Blair, Ilya Bolotowsky, Henry Botkin, Sydney Butchkes, Rhyse Caparn, Eve Clendenin, Jean Cohen, Robert Conover, Doris Cross, Eleanor De Laittre, Nassos Daphnis, Ruth Eckstein, Perle Fine, Suzy Frelinghuysen, Maurice Golubov, Beate Hulbeck, Roger Jorgensen, Jerry Kajetanski, Herbert Kallem, Nikolai Kasak, Paul Kelpe, Harold Krisel, Ibrahim Lassaw, Irving Lehman, Sol LeWitt, Michael Loew, Leo Manso, Joseph Meierhans, Lily Michael, Jeanne Miles, George L.K. Morris, Betty Parsons, Henry C. Pearson, Leo Rabkin, Rivkah, Robert Ryman, John Sennhauser, Charles Shaw, Louis Silverstein, Esphyr Slobodkina, Robert Smithson, Hyde Solomon, Harry Tedlie, Richard Tuttle, Ruth Vollmer, Mac Wells, Charmion von Wiegand

"Women Artists." Williams College, Williamstown, Mass. (Nov 27–Dec 15)
Curated by Joyce Robbins
Artists: Sarah Draney, Sharon Gilbert, Audrey Hemenway, Helene Hui, Kazuko, Ann Marshall, Elizabeth Murray, Joyce Robins, Paula Tavins, Ruth Vollmer

Junior Museum, Louisville, Ky.

1974
"Illuminations and Reflections." Whitney Museum of American Art, New York (Apr 10–May 16) (catalogue)
Organized by nine Helena Rubinstein Fellows participating in the Whitney Museum's Independent Study Program
Artists: Peter Alexander, Stephen Antonakos, Larry Bell, Hans Breder, Chryssa, Fred Eversley, Dan Flavin, Robert Irwin, Robert Craig Kauffman, Leroy Lamis, Stanley Landsman, Claudio Marzollo,

Barbara Mortimer, Louise Nevelson, Earl Reiback, Sylvia Stone, Ruth Vollmer, David Weinrib

"Drawings Old–Drawings New." Parsons-Truman Gallery, New York (Dec 3–21)
Artists (selected): Natalie Alper, Helen Aylon, André Breton, Andrea Cascella, Charles Chase, Emilio Cianfoni, Eugene Delacroix, Elaine De Kooning, Jim Dine, Susan Eisler, Paul Feeley, Leonor Fini, Tsugoharu Foujita, Lee Friedlaender, Thomas George, Michael Gitlin, Cleve Gray, Jan Groth, Sylvia Guirey, Lee Hall, Dorothy Heller, Hans Hofmann, Jean Hugo, Patrick Ireland, Mark Lancaster, Alexander Liberman, Gregory Masurovsky, Henri Matisse, Robert Motherwell, Walter Murch, Greg Otto, Betty Parsons, Henry Pearson, Vita Petersen, Camille Pissarro, Marc Riboud, Hans Richter, James Rosen, Mark Rothko, Yehiel Shemi, Stephen s'Soreff, Saul Steinberg, Hedda Sterne, Thomas Stokes, Richard Tuttle, Ruth Vollmer, Bradley Walker, Abraham Walkowitz, Jack Youngerman

1974–75
"American Art in Upstate New York." Albright-Knox Gallery, Buffalo, N.Y.; Memorial Art Gallery, University of Rochester, N.Y.; Herbert F. Johnson Museum of Art, Cornell University, Ithaca, N.Y.; Everson Museum of Art, Syracuse, N.Y.; Munson-Williams Proctor Institute, Utica, N.Y.; Albany Institute of History and Art, Albany, N.Y. (Jul 12–Apr 27) (catalogue)

1975
"2 by 34." Parsons-Truman Gallery, New York (May 20–Jun 6)
Artists (selected): Emilio Cianfoni, Kathleen Cooke, Kreeger Davidson, Susan Eisler, Lee Friedlaender, Michael Gitlin, Jan Groth, Allan Hacklin, Lee Hall, Richard Hawmi, Dorothy Heller, Gregory Masurovsky, Walter Murch, Greg Otto, Betty Parsons, Henry Pearson, Arthur Pierson, James Rosen, Toko Shinoda, Stephen s'Soreff, Saul Steinberg, Richard Tuttle, Ruth Vollmer

"C.W. Post Center Art Faculty Invitational Exhibition of Painting, Sculpture and Graphics." Post Center Art Gallery, School of the Arts, Long Island University, Greenvale, N.Y. (Sep 7–28)
Artists: Sara Amatniek, Jon Colburn, Jose DeCreeft, Dorothy Heller, Jim Hughes, David Jacobs, Susan Kaprov, Helen Meyrowitz, Ruthellen Pollan, Christina Stadelmeier, Don Sunseri, Stanley Twardowicz, Ruth Vollmer

"Two by Twenty." Oliver Wolcott Library, Litchfield, Conn. (Sep 20–Oct 28)

Artists: Kathleen Cooke, Kreeger Davidson, Susan Eisler, Richard Francisco, James del Grosso, Allan Hacklin, Lee Hall, Richard Hamwi, Gregory Masurovsky, Eliza Moore, Walter Murch, Greg Otto, Betty Parsons, Michael Robbins, James Rosen, Elfi Schuselka, Stephen s'Soreff, Saul Steinberg, Richard Tuttle, Ruth Vollmer

"Calculated Drawings." Parsons-Truman Gallery, New York (Sep 30–Oct 18)
Artists: Bergamini, Patrick Ireland, Stephen s'Soreff, Richard Tuttle, Ruth Vollmer, Sibyl Weil

"American Abstract Artists. (40th Annual Exhibition)." Westbeth Gallery, New York

"Line." Visual Arts Museum, School of Visual Arts, New York

1975–76

"Painting, Drawing, and Sculpture of the 60's and 70's from the Dorothy and Herbert Vogel Collection." Institute of Contemporary Art, University of Philadelphia (Oct 7–Nov 18); The Contemporary Arts Center, Cincinnati (Dec 17–Feb 15) (catalogue)
Artists: Vito Acconci, Carl Andre, Stephen Antonakos, Richard Artschwager, Jo Baer, Jared Bark, Robert Barry, Bernd and Hilla Becher, Lynda Benglis, Jake Berthot, Joseph Beuys, James Bishop, Ronald Bladen, Mel Bochner, William Bollinger, Gary Bower, Daniel Buren, Peter Campus, John Chamberlain, Christo, Michael Clark, Chuck Close, Kathleen Cooke, Hanne Darboven, Ron Davis, Ad Dekkers, Agnes Denes, Jan Dibbets, Allan Erdman, Benni Efrat, Paul Feeley, Janet Fish, Dan Flavin, Richard Francisco, Michael Goldberg, Ronald Gorchov, Dan Graham, Nancy Graves, Robert Grosvenor, Eva Hesse, Douglas Huebler, Ralph Humphrey, Peter Hutchinson, Will Insley, Patrick Ireland, Donald Judd, Steven Kaltenbach, Joseph Kosuth, Sol LeWitt, Robert Lobe, Richard Long, Robert Mangold, Sylvia Mangold, Andy Mann, Brice Marden, Antonio Miralda, Robert Morris, Robert Motherwell, Forrest Myers, Bruce Nauman, Richard Nonas, Claes Oldenburg, Dennis Oppenheim, Nam June Paik, Raymond Parker, Betty Parsons, Philip Pearlstein, Henry Pearson, Richard Pettibone, Lil Picard, Howardena Pindell, Larry Poons, Katherine Porter, Lucio Pozzi, David Rabinowitch, Edda Renouf, Judy Rifka, Klaus Rinke, Dorothea Rockburne, Stephen Rosenthal, Dieter Roth, Robert Ryman, John Salt, Lucas Samaras, Alan Saret, Richard Serra, Joel Shapiro, Alan Shields, Robert Smithson, Eva Sonneman, Robert Stanley, Gary Stephan, Mark di Suvero, Richard Tuttle, Richard Van Buren, Ruth Vollmer, Andy Warhol, Lawrence

Weiner, Jack Youngerman, Mario Yrissary

1977

"Recent Acquisitions." The Ohio State University Gallery of Fine Art, Sullivant Gallery, Columbus (Feb 17–Mar 18)

"Ruth Vollmer/Jeanne Miles." Parsons–Dreyfuss Gallery, New York (Mar 29–Apr 16)

"Group Show." Betty Parsons Gallery, New York (Dec 20–31)
Artists (selected): Mino Argento, Helene Aylon, Calvert Coggeshall, Richard Francisco, Thomas George, Cleve Gray, Jan Groth, Lee Hall, Dorothy Heller, Minoru Kawabata, Mark Lancaster, Jean Miles, Eliza Moore, Walter Murch, Kenzo Okada, Vita Petersen, Jim Rosen, Yehiel Shemi, Toko Shinoda, Saul Steinberg, Hedda Sterne, Tom Stokes, Riduan Tomkins, Bradley Walker Tomlin, Richard Tuttle, Ruth Vollmer, Robert Yasuda, Zuka

1978

"Objects!" Marian Goodman Gallery, New York
Organized and curated by Nicolas Calas
Artists: Vicente Agnetti, Arakawa, Richard Artschwager, George Brecht, Marcel Broodthaers, Luis Camnitzer, Cesar, Chryssa, Marina Donati, Jean Dupuy, Övyind Fahlstrom, Robert Filliou, Bernhard Heidsieck/Ruth Francken, Jasper Johns, Kris Krohn, Emile Laugier, Jeffrey Lew, Liliane Lijn, Robert Malaval, Marisol, Robert Morris, Daniel Pommereuille, Stephen Porter, Robert Rauschenberg, Jeanne Reynal, Rodanski/Monory, James Rosenquist, Dieter Roth, Joel Shapiro, Hyde Solomon, Ruth Vollmer, Andy Warhol, Robert Watts, H.C. Westermann, Hannah Wilke, Robert Wilson

"Art of the Space Era: An Exhibition Commemorating the 20th Anniversary of America's First Satellite, Explorer I." Huntsville Museum of Art, Huntsville, Ala. (Jan 16–Jul 30) (catalogue)
Curated by Carolyn H. Wood
Artists: Martha Boto, Frederick J. Eversley, Robin Thomas Grossman, Edrea and Bob Hanson, Howard Jones, Judith Karelitz, Kenneth Knowlton, Harold Lehr, Len Lye, Clyde Lynds, Robert Mallary, Phyllis Mark, Anthony Martin, Boyd Meffert, Lowell Nesbitt, Alberto Notarbartolo, Gerald Oster, Otto Piene, Chuck Prentiss, Charles Pritchie and Robert Morriss, Earl Reiback, James Seawright, Alan Sonfist, Keith Sonnier, Thomas Tadlock, Thomas Tiffany, Takis Vassilakis, Ted Victoria, Ruth Vollmer, Charles Waldeck

"Indoor-Outdoor Sculpture Show." P.S.1, Queens, N.Y.

1979

"New York: Last Ten Years." Otis Institute, Los Angeles (Jun 14–14)
Curated by Betty Parsons for the Parsons School of Design, New York

"The Language of Abstraction As Presented By The American Abstract Artists: Works from the Fifties, Sixties, 1970's." Betty Parsons Gallery and Marilyn Pearl Gallery, New York (Jun 19–Aug 3) (catalogue)
Artists: Alice Adams, Josef Albers, L. Alcopley, Will Barnet, Maurice Berezor, Leslie Bohnenkamp, Ilya Bolotowsky, Power Boothe, Henry Botkin, Sydney Butchkes, Rhys Caparn, Doris Cross, Nassos Daphnis, Burgoyne Diller, Ruth Eckstein, Katherin Ferguson, Perle Fine, Adolf F. Fleischmann, Suzy Freilinghuysen, A.E. Gallatin, Helen Gilbert, Fritz Glarner, Gary Golkin, Robert Goodnough, Balcomb Greene, Gertrude Greene, Budd Hopkins, Ralph Iwamoto, Ward Jackson, Roger Jorgensen, Jerry Kajetanski, Nicolai Kasak, Paul Kelpe, Alan Kleiman, Harold Krisel, Ibram Lassaw, Irving Lehman, Michael Loew, Alice Trumbull Mason, Jeanne Miles, George L.K. Morris, Hiroshi Murata, Betty Parsons, Henry Pearson, Joan Webster Price, Raquel Rabinovich, Leo Rabkin, Ad Reinhardt, Gabriel Ross, Judith Rothschild, Irene Rousseau, Robert Ryman, Louis Silverstein, Esphyr Slobodkina, Racelle Strick, Albert Swinden, Jack Tworkov, Ruth Vollmer, Mac Wells, Charmion von Wiegand, Wilfred Zogbaum

1979–80

"Group Show." Betty Parsons Gallery, New York (Dec 18–Jan 12)
Artists: Mino Argento, Helene Aylon, Leslie Bohnenkamp, Lisa Bradley, Fanny Brennan, Andrea Cascella, Calvert Coggeshall, John Cunningham, Richard Francisco, Lisa Fonssagrives-Penn, Tom George, Michael Gillen, Maria Gooding, George Grant, Cleve Gray, Jan Groth, Sylvia Guirey, Lee Hall, Dorothy Heller, Deborah Hildreth, Minoru Kawabata, Mark Lancaster, Edvard Lieber, Michael Malpass, Richard Miller, Eliza Moore, Maud Morgan, Kenzo Okada, Glen Ostergaard, Vita Petersen, Arthur Peirson, Aline Porter, Stephen Porter, Marilyn Price, Risa, Yehiel Shemi, Toko Shinoda, Saul Steinberg, Oliver Steindeker, Tom Stokes, Bill Taggart, Marie Taylor, Bruce Tippett, Riduan Tomkins, Richard Tuttle, Barbara Valenta, Ruth Vollmer, Sibyl Weil, Robert Yasuda, Zuka

1984

"Flyktpunkter/Vanishing Points." Moderna Museet, Stockholm (Apr 14–May 27) (catalogue)

Curated by Olle Granath
Artists: Mel Bochner, Tom Doyle, Dan Graham, Eva Hesse, Sol LeWitt, Robert Smithson, Ruth Vollmer

1986
"Natural Forms and Forces: Abstract Images in American Sculpture—Precedents." Bakalar Sculpture Gallery, List Visual Arts Center, Massachusetts Institute of Technology, Boston (May 9–Jun 29) (catalogue)
Organized by the MIT Committee on the Visual Arts and Fine Arts Planning Group
Artists: Eva Hesse, Michael Lekakis, Theodore Roszak, Robert Smithson, Ruth Vollmer

1987
"Grace Is the Better Part of Valour." Sharpe Gallery, New York
Curated by Beth Biegler and Andrea Rosen
Artists: John Duff, Tom Nozkowski, Robin Rose, Ruth Vollmer, Tad Wiley

1991–92
"Stubborn Painting: Now and Then." Max Protetch Gallery, New York (Dec 19–Jan 25)
Curated by Ruth Kaufmann and Mike Metz
Artists: Forrest Bess, Paul Feeley, Philip Guston, Mary Heilmann, Jonathan Lasker, Elizabeth Murray, Thomas Nozkowski, Philip Taaffe, Richard Tuttle, Ruth Vollmer

2002
"Works by 29 Artists from Moderna Museet's Permanent Collection." Magasin 3 Stockholm Konsthall (Mar 23–Jun 16)
Curated by David Neuman and Richard Julin
Artists: Olle Bonniér, Lee Bontecou, Robert Breer, Viking Eggeling, Lars Englund, Max Ernst, Annika Eriksson, Lucio Fontana, Eric Grate, Gary Hill, Arne Jones, Louise Lawler, Sivert Lindblom, LG Lundberg, Carl Axel Lunding, Man Ray, Ebba Matz, Lars Millhagen, Louise Nevelson, KG Nilson, Claes Oldenburg, Palle Pernevi, Francis Picabia, Ulf Rollof, Jesús Rafael Soto, Georges Vantongerloo, Victor Vasarely, Ruth Vollmer, Nell Walden

2003
"Unexpected Dimensions: Works from the LeWitt Collection." Davison Art Center, Weseleyan University, Middletown, Conn. (Sep 3–Oct 9)
Curated by Janet Passehl
Artists: William Anastasi, Arlan Huang, Sol LeWitt, Tom Marioni, Maurizio Nannucci, Nicholas Pearson, Ruth Vollmer

2003–04
"Thinking the Line: Ruth Vollmer and Gego." Ursula Blickle Stiftung, Kraichtal, Germany (Sep

13–Oct 19); ZKM | Center for Art and Media Karlsruhe (Jan 16–Mar 21); Neue Galerie Graz (Jul 2–Aug 29); Miami Art Central (Sep 21–Nov 14) (catalogue)
Curated by Nadja Rottner and Peter Weibel

2005
"Evergreen." Inverleith House, Royal Botanical Garden Edinburgh (April 2–Jul 3)
Curated by Graham Domke
Artists: Carl Andre, Lothar Baumgarten, Douglas Gordon, Callum Innes, Agnes Martin, Thomas Struth, Cy Twombly, Ruth Vollmer, Lawrence Weiner, Franz West

Compiled by Almut Haboeck

BIBLIOGRAPHY

Solo Exhibition Catalogues

Domke, Graham, ed. *Ruth Vollmer: Drawings and Sculpture*. Edinburgh: Inverleith House, Royal Botanical Garden Edinburgh, forthcoming. Texts by Ann Reynolds, Alan Johnston, Ruth Vollmer, ("Explorations of the Sphere"), and Graham Domke.

Exploration of the Sphere: Ruth Vollmer, Sculpture. New York: Betty Parsons Gallery, 1968.

Ruth Vollmer, 1903–1982. New York: Jack Tilton Gallery, 1983. Texts by Alicia Legg, Richard Francisco, Marianne Hauser, Sol LeWitt, Leo Rabkin, Jack Tilton, Richard Tuttle, et al.

Weiss, Peg, ed. *Ruth Vollmer: Sculpture and Painting, 1962–1974*. Syracuse, N.Y.: Everson Museum of Art, 1974. Texts by Richard Tuttle and Lee Hall.

Weiss, Peg. *Ruth Vollmer*. Purchase, N.Y.: State University of New York, Neuberger Museum of Art, 1976.

Selected Group Exhibition Catalogues

American Abstract Artists. Foreword by Leo Rabkin. Raleigh, N.C.: North Carolina Museum of Art, 1969.

American Art in Upstate New York: Drawings, Watercolors, and Small Sculpture from Public Collections in Albany, Buffalo, Ithaca, Syracuse and Utica. Introduction by June A. Wood and Douglas G. Schultz. Buffalo, N.Y.: Fine Arts Academy, 1974.

Art in Progress: A Survey Prepared for the 15th Anniversary of The Museum of Modern Art. New York: The Museum of Modern Art, 1944. Texts by James Thrall Soby, Alfred H. Barr Jr., Nancy Newhall, Iris Barry, Elizabeth Mock, Monroe Wheeler, et al. Stage proscenium and wire figures designed and executed by Ruth Vollmer displaying dance costumes by Marc Chagall, Salvador Dali, Fernand Léger, Xanti Schawinsky, and Kurt Seligman; see p. 233.

Editions in Plastic. Baltimore: University of Maryland Art Gallery, University Press, College Park, 1970. Brochured checklist.

The Expressive Line. Huntington, N.Y.: Heckscher Museum, 1969. Cover illus. by Vollmer.

Olle Granath, ed. *Flyktpunkter/Vanishing Points*. Stockholm: Moderna Museet, 1984. Incl. reprints of B.H. Friedman, "The Quiet World of Ruth Vollmer"; Ruth Vollmer, "Fragments Towards the Sphere"; Sol LeWitt, "Ruth Vollmer: Mathematical Forms"; and Steingrim Larsen, "Ruth Vollmer."

Goossen, Eugene C., and Elayne H. Varian. *Betty Parsons' Private Collection*. New York: Finch College Museum of Art, 1968.

Illuminations and Reflections. New York: Whitney Museum of American Art, 1974. Illus. only.

The Language of Abstraction. New York: American Abstract Artists, 1979. Text by Susan Carol Larsen.

Natural Forms and Forces: Abstract Images in American Sculpture. Cambridge, Mass.: MIT Committee on the Visual Arts, 1986. Texts by Douglas Dreishpoon and Katy Kline.

Objects! Foreword by Nicolas Calas and Elena Calas. New York: Marian Goodman Gallery, 1978.

Painting, Drawing, and Sculpture of the 60's and 70's from the Dorothy and Herbert Vogel Collection. Foreword by Suzanne Delehanty. Philadelphia: Institute of Contemporary Art, 1975.

Sculpture 1966. New York: The Sculptors Guild, 1966.

Sculpture Now. Foreword by Eva Ingersoll Gatling. Huntington, N.Y.: Heckscher Museum of Art, 1968, 255.

The Sculptors Guild: Thirtieth Anniversary Exhibition. New York: The Sculptors Guild, 1967. Illus. only.

Wood, Carolyne H. *Art of the Space Era: An Exhibition Commemorating the 20th Anniversary of America's First Satellite, Explorer I*. Huntsville, Ala.: Huntsville Museum of Art, 1978. Incl. a biography of Ruth Vollmer and a reprint of Peter Frank, "Syracuse: Ruth Vollmer at the Everson Museum."

Selected Reviews and Articles

Adlow, Dorothy. [Review]. "Sculptors Vie with Painters in Gotham Galleries [Parsons, Section Eleven]." *Christian Science Monitor* (Boston), May 28, 1960: 6.

Anderson, Laurie. [Review]. "Vollmer, Ruth [Parsons]." *ARTnews* (New York) 72 (May 1973): 91–92.

Ashton, Dore. [Review]. "Paintings and Sculpture Are Featured at Betty Parsons' Section Eleven." *The New York Times*, February 26, 1959: 28.

Benedick, M. [Review]. [Parsons]. *Art International* (Lugano) 10, no. 4 (April 1966): 84.

Burckhardt, Edith. [Review]. "Ruth Vollmer [Parsons, Section Eleven]." *ARTnews* (New York) 59, no. 4 (summer 1960): 22.

Butterfield, Emily. "New York Sculptor: Math Becomes Art Form [Neuberger]." *Syracuse Herald Journal* (Syracuse, N.Y.), November 10, 1977: n.p.

Campbell, Lawrence. [Review]. "Ruth Vollmer [Parsons]." *ARTnews* (New York) 69, no. 8 (December 1970): 63.

Campbell, Lawrence. [Review]. "Ruth Vollmer [Parsons]." *ARTnews* (New York) 67, no. 9 (January 1969): 64.

Criss-Cross Art Communications (Boulder, Colo.), nos. 7–9 (1979): 20–27. Repr. seven of Vollmer's untitled drawings, 1977–78.

Dienst, Rolf-Gunter. "Ruth Vollmers Magie der Einfachheit." *Das Kunstwerk* (Stuttgart) 22, nos. 5–6 (February/March 1969): 36–40.

Domingo, Willis. [Review]. [Parsons]. *Arts Magazine* (New York) 45, no. 2 (November 1970): 64.

Frank, Peter. [Review]. "New York Art Notes [Parsons]." *The Columbia Owl* (New York), December 4, 1968: 6.

Frank, Peter. [Review]. "Syracuse: Ruth Vollmer at the Everson Museum." *Art in America* (New York) 63, no. 2 (March/April 1975): 98, 105.

Faunce, Sarah C. [Review]. "Ruth Vollmer [Parsons]." *ARTnews* (New York) 62, no. 1 (March 1963): 15.

Friedman, Bernard H. [Review]. "The Quiet World of Ruth Vollmer [Parsons]." *Art International* (Lugano) 9, no. 2 (March 1965): 26–28.

Genauer, Emily. [Review]. "Kemeny Sculpture Highlights Shows [Parsons, Section Eleven]." *New York Herald Tribune*, May 29, 1960: n.p.

Genauer, Emily. [Review]. "Sculpture, Spheres by Ruth Vollmer [Parsons]." *New York Herald Tribune*, January 29, 1966: 9.

Gillespie, Neil. [Review]. "A Quiet World: Ruth Vollmer: Drawings and Sculptures [Inverleith]." *Architects' Journal* (London) 215, no. 14 (April 11, 2002): 48.

Glueck, Grace. [Review]. "Art: Haunting Moods of Edwin Dickinson [Tilton]." *The New York Times*, November 11, 1983: C26.

Kramer, Hilton. [Review]. [Parsons]. *The New York Times*, February 5, 1966: 24.

Kramer, Hilton. [Review]. "Retrospective on Sculpture of Ruth Vollmer [Neuberger]." *The New York Times*, February 28, 1976: 8.

Larsen, Susan C. [Review]. "Ruth Vollmer— Drawing As Thinking [Adler]." *Artweek* (Castro Valley, Calif.), October 7, 1978: 1, 20.

Larsen, Susan C. [Review]. "Intimate Mathematics [Adler]." *ARTnews* (New York) 77, no. 10 (December 1978): 113–17.

LeWitt, Sol. "Paragraphs on Conceptual Art." *Artforum* (New York) 5, no. 10 (June 1967): 79–83.

LeWitt, Sol. "Ruth Vollmer: Mathematical Forms."

Studio International (London) 180, no. 928 (December 1970): 256–57.

Mellow, J.R. [Review]. "New York Letter [Parsons]." *Art International* (Lugano) 13, no. 1 (January 1969): 54.

Moira, Jeffrey. [Review]. "A Bubble That Won't Burst [Inverleith]." *The Herald* (Glasgow), March 29, 2002, Arts Features sect.: 17–18.

Muchnic, Suzanne. [Review]. "La Cienega Area [Adler]." *Los Angeles Times*, September 22, 1978: 8.

Muchnic, Suzanne. [Review]. "First Postmerger Show at Otis/Parsons." *Los Angeles Times*, July 3, 1979: V7.

"Music in Wire: Ruth Vollmer's Four-Dimensional Displays." *Interiors* (New York) 106 (April 1947): 98–101: 152–54.

[Obituary]. *Art in America* (New York) 70, no. 3 (March 1982): 208.

[Obituary]. "Ruth Vollmer, Sculptor, 80, Designed Window Displays." *The New York Times*, January 8, 1982: B7.

Ratcliff, Carter. [Review]. "New York Letter [Parsons]." *Art International* (Lugano) 15, no. 1 (January 1971): 29.

[Review]. "Exhibition at Section 11 Gallery." *Arts Magazine* (New York) 34, no. 9 (June 1960): 62.

[Review]. "Cordier & Eckstrom Gallery: For Eyes and for Ears." *Village Voice* (New York), January 9, 1964: 9, 16.

[Review]. "Art: Two Exhibitions Go in Search of the Future [Eckstrom]." *The New York Times*, January 17, 1964: 40.

[Review]. [Parsons]. *Arts Magazine* (New York) 43, no. 3 (December 1968/January 1969): 61.

Smith, Roberta. [Review]. "Ruth Vollmer: Everson Museum of Art, Syracuse, N.Y.; Robert Cronin, Robert Lobe, Zabriskie Gallery; Jim Roche, Whitney Museum of American Art; Robert Gordon, Bykert Gallery Downtown." *Artforum* (New York) 13, no. 4 (December 1974): 71–72.

Smithson, Robert. "Quasi-Infinities and the Waning of Space." *Arts Magazine* (New York) 41, no. 1 (November 1966): 28–31.

Smithson, Robert. "A Museum of Language in the Vicinity of Art." *Art International* (Lugano) 12, no. 3 (March 1968): 21–27.

Tillim, Sidney. [Review]."Ruth Vollmer [Parsons]." *Arts Magazine* (New York) 37, no. 7 (April 1963): 61.

Storr, Robert. [Review]. "Ruth Vollmer at Jack Tilton." *Art in America* (New York) 72, no. 1 (January 1984): 128–29.

"Vollmer's Ceramic Studies: From Wire Display to Clay Relief." *Interiors* (New York) 114 (June 1955): 18.

Wasserman, Emily. [Review]. [Parsons]. *Artforum* (New York) 7, no. 6 (February 1969): 68–69.

Westfall, Stephen. "Preserving the Mystery: The Art of Ruth Vollmer." *Arts Magazine* (New York) 58, no. 6 (February 1984): 74–76.

Selected Books

Ashton, Dore. *Modern American Sculpture.* New York: Harry N. Abrams, 1967. Vollmer ref., p. 40; pl. XLV: Vollmer, *Sphere Minus C* (1965), *Wedding of Sphere with Cube, Series I* (1964), and *Complexity* (1965).

Bunch, Clarence. *Acrylic for Sculpture and Design.* New York: Van Nostrand, 1972. Illus. with works by Vollmer.

Calas, Nicolas. *Icons and Images of the Sixties.* New York: E. P. Dutton, 1971. Chapter 18: "Systems Elementary and Complex" (LeWitt, De Maria, Andre, Vollmer, Mallary), pp. 271–79; Vollmer, *Steiner Surface* (1970), illus. p. 277.

Crowdis, David G., and Brandon W. Wheeler. *Introduction to Mathematical Ideas.* New York: McGraw-Hill, 1969. Cover: Vollmer, *Reciprocals* (1968); photograph by Hermann Landshoff.

Durfee, William H. *Calculus and Analytical Geometry.* New York: McGraw-Hill, 1971. Cover: Vollmer, *Intersecting Ovals* (1970), used to illustrate the Steiner surface; photograph by Hermann Landshoff.

Gurin, Ruth, *American Abstract Artists, 1936–1966.* New York: The Ram Press, 1966. Pl. 25: Vollmer, *Trimer* (1965).

Hall, Lee. *Betty Parsons: Artist, Dealer, Collector.* New York: Harry N. Abrams, 1991. Vollmer ref. pp. 13, 123, 129, 132, 135–36, 167; Vollmer, *Spherical Tetrahedron* (1970), illus. p. 135.

Lippard, Lucy R. *Eva Hesse.* New York: Da Capo Press, 1976. Vollmer ref. pp. 68, 72, 100, 105, 114, 120, 127, 154, 199, 203, 204; fig. 256: Vollmer, *Trigonal Volume* (bronze, 1966), formerly collection of Eva Hesse (n. 20).

Rubinstein, Charlotte Streifer. *American Women Artists: From Early Indian Times to the Present.* Boston: G.K. Hall & Co and Avon Books, 1982. Summary of Vollmer's life as an artist in "The Sixties: Pop Art and Hard Edge," pp. 359–61; figs. 8–13: Vollmer, *The Shell* (1973), photographed by Hermann Landshoff.

Rubinstein, Charlotte Streifer. *American Women Sculptors: A History of Women Working in Three Dimensions.* Boston: G.K. Hall and Avon Books, 1990. Summary of Vollmer's life as an artist in Chapter 7, "High Tech and Hard Edge: The Sixties," p. 391; Vollmer, *Steiner Surface* (1970), illus. p. 392.

Compiled by Almut Haboeck

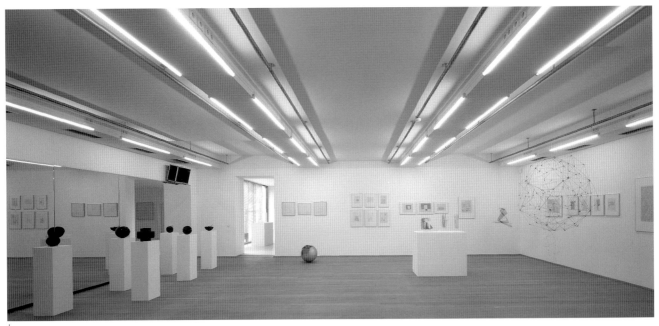

1

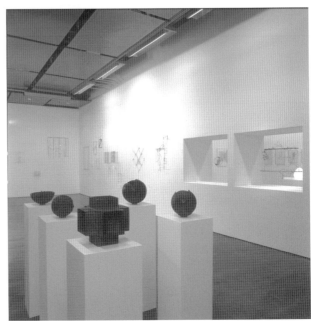

2

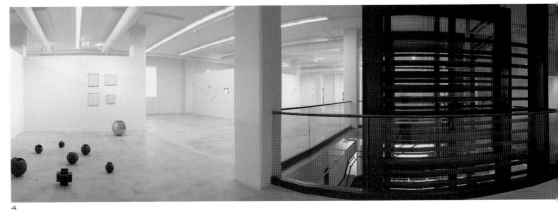

4

INSTALLATION VIEWS, "THINKING THE LINE: RUTH VOLLMER AND GEGO"

I
URSULA BLICKLE STIFTUNG, KRAICHTAL, SEPTEMBER 13–OCTOBER 19, 2003
© URSULA BLICKLE STIFTUNG, KRAICHTAL

2
ZKM | CENTER FOR ART AND MEDIA KARLSRUHE, JANUARY 16–MARCH 21, 2004
© CHRISTOF HIERHOLZER, KARLSRUHE

3
NEUE GALERIE AM LANDESMUSEUM JOANNEUM, GRAZ, JULY 2–AUGUST 29, 2003
© DIPL. ING. ANGELO KAUNAT, GRAZ

4
MIAMI ART CENTRAL, SEPTEMBER 21–NOVEMBER 14, 2004
© MIAMI ART CENTRAL

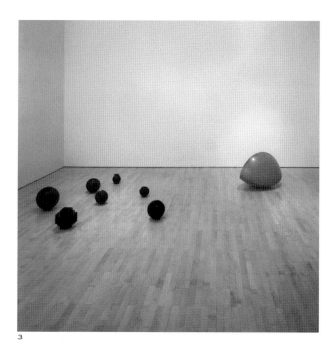

3

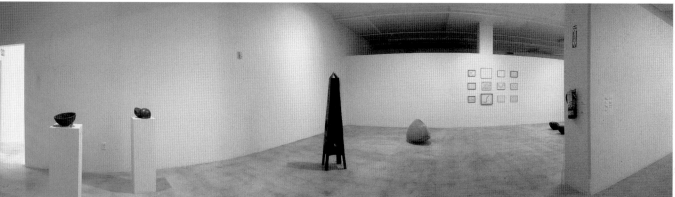

CHECKLIST OF THE EXHIBITION

Height precedes width precedes depth.

Christopher Wren, n.d.
Pencil on transparent paper
16.7 x 13.8 in. (42.5 x 35 cm)
Jack Tilton Gallery, New York

Construction Drawing, n.d.
Pencil on transparent paper
12 x 12 in. (30.5 x 30.5 cm)
The LeWitt Collection, Chester, Conn.
[page 159]

Fibonacci Sequence 1, n.d.
Pencil on paper
8.5 x 11 in. (21.5 x 28 cm)
Jack Tilton Gallery, New York

Fibonacci Sequence 2, n.d.
Pencil on paper
8.5 x 11 in. (21.5 x 28 cm)
Jack Tilton Gallery, New York

In the Relation Three to Four (construction drawing), n.d.
Pencil on transparent paper
14 x 16.9 in. (35.5 x 43 cm)
Jack Tilton Gallery, New York

Leonardo da Vinci, n.d.
Pencil on transparent paper
16.7 x 13.8 in. (42.5 x 35 cm)
Jack Tilton Gallery, New York
[page 176]

Untitled (Pseudosphere on canvas*)*, n.d.
Pencil on transparent paper
20.9 x 8.3 in. (53 x 21 cm)
Jack Tilton Gallery, New York
[page 125]

Untitled (Pseudosphere on canvas*)*, n.d.
Graphite, ink on paper
100 x 40 in. (254 x 101.6 cm)
Jack Tilton Gallery, New York

Skewed Hemispheres, n.d.
Bronze, unique (model)
5 x 3.8 x 3.5 in. (12.7 x 9.5 x 8.9 cm)
Jack Tilton Gallery, New York

Untitled, n.d.
Pencil on transparent paper
7.7 x 5.7 in. (19.6 x 14.6 cm)
The LeWitt Collection, Chester, Conn.
[page 177]

Untitled, n.d.
Metal wire and mesh
4 x 2.1 x 2.1 in. (10.2 x 5.4 x 5.4 cm)
The LeWitt Collection, Chester, Conn.

Untitled (drawing for Intersecting Ovals), n.d.
Pencil on transparent paper
10.7 x 22 in. (27.3 x 56 cm)
Jack Tilton Gallery, New York

Untitled (drawing for Large Exponential Tower), n.d.
One pencil drawing and three blueprints
15 x 20.2 in. (38 x 51.4 cm)
Jack Tilton Gallery, New York

Untitled (Swirl), n.d.
Pencil on transparent paper
17 x 18 in. (43.3 x 45.7 cm)
Jack Tilton Gallery, New York
[page 168]

Untitled (12 Swirls), n.d.
Pencil and colored crayon on transparent paper
11 x 14 in. (28 x 35.5 cm)
Jack Tilton Gallery, New York
[page 174]

Untitled (Waves), n.d.
Pencil on transparent paper
9 x 12 in. (22.9 x 30.5 cm)
Jack Tilton Gallery, New York
[pages 2–3]

Untitled (Wounded Sphere), n.d.
Bronze, unique cast
Diam. 6.7 in. (17 cm)
Philip McCarter Tifft, New York
[page 141]

Walking Ball, 1959
Bronze, ed. of 5
18 x 37 in. (45.7 x 94 cm)
Jack Tilton Gallery, New York
[pages 132–33]

Musical Forest, 1961
Bronze, ed. of 5
Diam. 9.5 in. (24.1 cm)
Philip McCarter Tifft, New York
[page 134]

Obelisk, 1961–62
Bronze, unique cast
66.9 x 13.9 x 14.5 in. (169.8 x 35.3 x 36.9 cm)
Smithsonian American Art Museum, Washington, D.C. Gift of Eric F. Green
[pages 128–29]

Cyclops, 1963
Bronze, unique cast
Diam. 7.5 in. (19 cm)
Jack Tilton Gallery, New York

Sphere with Small Square Cutout, 1963
Bronze, unique cast
Diam. 9.5 in. (24.1 cm)
Jane Timken, New York
[page 140]

Interposed Cross (Series I), 1964
Bronze, ed. of 6
Diam. 9 in. (22.9 cm)
Jack Tilton Gallery, New York
[page 145]

Sphere and Square Juxtaposed, 1964
Bronze
H. 6.9 in. (17.5 cm), diam. 4.7 in. (12 cm)
Collection Dorothea and Leo Rabkin, New York

Dimer, 1965
Bronze, ed. of 6
Diam. 13 in. (33 cm)
Jack Tilton Gallery, New York
[page 147]

Dimer, 1965
Bronze, ed. of 6
Diam. 13 in. (33 cm)
Philip McCarter Tifft, New York

Dimer (two models), 1965
Bronze
4.8 x 3 x 3 in. (12.1 x 7.6 x 7.6 cm)
Jack Tilton Gallery, New York

Mirrored Stirrings, 1965
Bronze, unique cast; self-reflective foil
Diam. 8.3 in. (21 cm)
Jack Tilton Gallery, New York

Rumblings Within, 1965
Bronze, unique cast
Diam. 12 in. (30.5 cm)
Collection Thomas Nozkowski and Joyce Robins,
New York
[page 141]

Trimer (model), 1965
Bronze, ed. of 6
5.25 x 2.25 x 3 (13.3 x 5.7 x 7.6 cm)
Philip McCarter Tifft, New York

Monomer (model), 1965–66
Bronze, ed. of 6
3 x 2.3 x 2.8 (7.6 x 5.7 x 7 cm)
Philip McCarter Tifft, New York

Skewed Hemispheres, 1966
Bronze
10.5 x 7 x 7 in. (26.7 x 17.8 x 17.8 cm)
Collection Thomas Nozkowski and Joyce Robins,
New York
[page 153]

In the Relation Three to Four (Version I)
(construction drawing), 1968
Pencil on transparent paper
16.9 x 16.9 in. (43 x 43 cm)
Collection Dorothea and Leo Rabkin, New York
[page 159]

In the Relation Three to Four (Version II)
(construction drawing), 1968
Pencil on transparent paper
16.9 x 16.9 in. (43 x 43 cm)
Collection Dorothea and Leo Rabkin, New York
[page 159]

In the Relation Three to Four, 1968
Spun aluminium
Diam. 20.1 in. (51 cm)
Jack Tilton Gallery, New York
[page 158]

Trigonal Volume, 1968
Reinforced orange Fiberglas
24 x 39 x 24 in. (61 x 99.1 x 61 cm)
Wexner Center for the Arts, The Ohio State
University, Columbus, Ohio. Gift of Ruth Vollmer

Pseudosphere, 1969
Laminated wood
Max. l. 25 in. (58.4 cm), diam. 10.5 in. (26.7 cm)
The LeWitt Collection, Chester, Conn.
[page 125]

Intersecting Ovals, 1970
White opaque acrylic
12 x 12 x 12 in. (30.5 x 30.5 x 30.5 cm)
Jack Tilton Gallery, New York

Oval Construction (construction drawing), 1970
Pencil on Mylar
12.8 x 12.8 in. (32.5 x 32.5 cm)
Collection Dorothea and Leo Rabkin, New York
[page 160]

Oval Construction (model), 1970
Colored acrylic
Diam. 4.7 in. (12 cm)
Collection Dorothea and Leo Rabkin, New York

Spiraled Out, 1970
Pencil on transparent paper
16.1 x 13.4 in. (41 x 34 cm)
The LeWitt Collection, Chester, Conn.

Steiner Surface, 1970
Gray transparent acrylic
12 x 12 x 12 in. (30.5 x 30.5 x 30.5 cm)
Collection Dorothea and Leo Rabkin, New York
[page 163]

Tangents, 1970
Clear acrylic
17.9 x 4.3 x 4.3 in. (45.5 x 11 x 11 cm)
H. 18 in. (45.8 cm), diam. 3.1 in. (8 cm)
Jack Tilton Gallery, New York
[page 184]

Three Axes and Four Rings (model), 1970
Metal, brass wire
H. 4.9 in. (12.5 cm), diam. 6.3 in. (16 cm)
Collection Dorothea and Leo Rabkin, New York

Untitled (construction drawing), 1970
Pencil on paper
10.8 x 12.6 in. (27.5 x 32 cm)
The LeWitt Collection, Chester, Conn.

Untitled (October 26), 1971
Pencil on transparent paper
17 x 14 in. (43.2 x 35.5 cm)
Jack Tilton Gallery, New York

Untitled (9 Spirals), 1971
Pencil and colored crayon on vellum
11 x 14 in. (28 x 35.5 cm)
Collection Professor Joseph Masheck, New York
[page 175]

Untitled (1 Swirl), 1971
Pencil and colored crayon on transparent paper
16.9 x 13.8 in. (43 x 35 cm)
Jack Tilton Gallery, New York
[page 174]

Involute of a Circle, Counterclockwise, 1972
Pencil on transparent paper
17 x 14 in. (43.2 x 35.6 cm)
Jack Tilton Gallery, New York
[page 168]

21 Clockwise and 34 Counterclockwise, 1972
Pencil on transparent paper
16.5 x 13.6 in. (42 x 34.5 cm)
Jack Tilton Gallery, New York
[page 169]

Untitled, 1972
Colored crayon, brown pencil on transparent paper
8.5 x 11 in. (21.5 x 28 cm)
Philip McCarter Tifft, New York
[page 180]

After Codice Arundel, 1973
Pencil and colored crayon on paper
17.1 x 13.8 in. (43.5 x 35 cm)
Philip McCarter Tifft, New York
[page 176]

Large Archimedean Screw, 1973
Wood
H. 71.7 in. (182 cm), diam. approx. 9 in.
(22.9 cm)
Jack Tilton Gallery, New York
[page 104]

Small Archimedean Screw, 1973
Clear acrylic
H. 24.1 in. (61.3 cm), diam. 3.5 in. (9 cm)
Philip McCarter Tifft, New York
[page 171]

Untitled, 1973
Pencil on vellum
17 x 14 in. (43.2 x 35.6 cm)
Jane Timken, New York

Untitled (drawing for Large Archimedean Screw),
1973
Pencil on transparent paper
35.6 x 36.6 in. (90.5 x 93 cm)
Jack Tilton Gallery, New York
[page 167]

Untitled (drawing for *Large Exponential Tower*),
1973
Pencil on transparent paper
18.3 x 19.7 in. (46.5 x 50 cm)
Jack Tilton Gallery, New York
[page 170]

Untitled (Paul Klee), 1973
Pencil and black crayon on transparent paper
16.5 x 13.6 in. (42 x 34.5 cm)
Jack Tilton Gallery, New York
[page 169]

Untitled (Sunflower Head), 1973
Pencil on transparent paper
24 x 18.1 in. (61 x 45.9 cm)
Jack Tilton Gallery, New York

13 Soap Film Forms, 1974
Aluminum wire
Variable dimensions
Jack Tilton Gallery, New York
[page 185]

Untitled, 1977
Pencil on transparent paper
8.5 x 10.8 in. (21.5 x 27.5 cm)
Philip McCarter Tifft, New York
[pages 6–7]

Untitled (9 Spirals, I), 1977
Pencil and colored crayon on transparent paper
8.3 x 10.8 in. (21 x 27.5 cm)
Private collection, Edinburgh
[page 175]

Untitled (Pencil: Grid, Shapes, Shading), 1977
Pencil on transparent paper
8.3 x 11 in. (21 x 28 cm)
Jack Tilton Gallery, New York

Untitled (Squares, Shaded), 1977
Pencil on transparent paper
10.6 x 13.8 in. (27 x 35 cm)
Jack Tilton Gallery, New York
[pages 8–9]

Untitled, 1978
Pencil on transparent paper
9.1 x 11.8 in. (23 x 30 cm)
Philip McCarter Tifft, New York
[pages 182–83]

Untitled (Grid, Shaded Shapes), 1978
Pencil on transparent paper
8.7 x 11 in. (22 x 28 cm)
Jack Tilton Gallery, New York

Untitled (Numbers/Letters), 1978
Pencil and colored crayon on transparent paper
16.9 x 11 in. (43 x 28 cm)
Jack Tilton Gallery, New York
[page 178]

Untitled (Numbers/Letters with Triangles), 1978
Pencil and colored crayon on transparent paper
16.9 x 11 in. (43 x 28 cm)
Jack Tilton Gallery, New York
[page 179]

Untitled (Rows of Shaded Rhombus), 1978
Pencil on transparent paper
8.5 x 10.8 in. (21.5 x 27.5 cm)
Jack Tilton Gallery, New York
[pages 10–11]

Untitled (Shaded Circles), 1978
Pencil on transparent paper
8.5 x 12 in. (21.5 x 30.5 cm)
Jack Tilton Gallery, New York
[pages 12–13]

Untitled (Snake), 1978
Pencil on transparent paper
13 x 16.1 x 1.2 in. (33 x 41 x 3 cm)
Jack Tilton Gallery, New York

Untitled (Wave of Vertical Line), 1978
Pencil on transparent paper
8.9 x 11.8 in. (22.5 x 30 cm)
Jack Tilton Gallery, New York

Untitled (Waves), 1978
Pencil on transparent paper
14.2 x 16.7 in. (36 x 42.5 cm)
Jack Tilton Gallery, New York
[pages 4–5]

Untitled (Rows of Triangles), 1978
Pencil on transparent paper
8.3 x 10.8 in. (21 x 27.5 cm)
Jack Tilton Gallery, New York
[pages 16–17]

Films in the Exhibition

Dorothy Levitt Beskind. *Untitled*, 1967–68
16mm film. Silent; color. Approx. 10 min.
Documentary of Eva Hesse and Ruth Vollmer in
Hesse's Bowery studio in New York
[pages 48, 57]

Soap Film Forms, 1974
NTSC film transferred to DVD. Silent; color.
Approx. 16 min.
Filmed on the occasion of the Ruth Vollmer
retrospective at the Everson Museum of Art,
Syracuse, N.Y.
[page 105]

Compiled by Andrea Harrich

Lenders

Dorothy Levitt Beskind, New York
Everson Museum of Art, Syracuse, N.Y.
The LeWitt Collection, Chester, Conn.
Professor Joseph Masheck, New York
Thomas Nozkowski and Joyce Robins, New York
Private collection, Edinburgh
Smithsonian American Art Museum,
Washington, D.C.
Dorothea and Leo Rabkin, New York
Philip McCarter Tifft, New York
Jack Tilton Gallery, New York
Jane Timken, New York
Wexner Center for the Arts, The Ohio State
University, Columbus, Ohio

CONTRIBUTORS

Rhea Anastas is Visiting Assistant Professor of Art History, the Center for Curatorial Studies, Bard College, Annandale-on-Hudson, N.Y. Coeditor of *Dan Graham: Works 1965–2000* (2001). Recent publications include "The Reconstruction Process: Barry Le Va, 1968–1975," in Ingrid Schaffner et al., *Accumulated Vision: Barry Le Va* (2005). Her article "The First Work of Dan Graham and Its Moment of (Social) History: Homes for America, 1966–69," as well as the books *The Artist and Her Public* (coedited with Michael Brenson) and *Untitled by Andrea Fraser/A Short History of Response*, are forthcoming. She is a founding member of the co-op gallery Orchard, in New York.

Meredith Davis is a writer and art historian. She currently lives in New York, where she is completing a dissertation at Columbia University on illusionism in American art. Recent publications include a catalogue essay for Glen Goldberg's 2002 exhibition of large-scale paintings, titled *Antidotes*. She teaches nineteenth- and twentieth-century art at Ramapo College in New Jersey.

Rolf-Gunter Dienst is a painter and art critic. Copublisher of the literary magazine *Rhinozeros*, 1960–65, and editor-in-chief of *Das Kunstwerk*, 1965–91. His publications include *Pop Art* (1965), *Positionen–Malerische Malerei, Plastische Plastik* (1968), *Deutsche Kunst: Eine Neue Generation* (1970), and *Noch Kunst* (1970), as well as monographs on the painters Peter Brüning, Karl Fred Dahmen, and Konrad Klapheck. Dienst has taught at universities in the United States, Australia, and Germany, and in 1992 was appointed Professor for Painting at the Akademie der Bildenden Künste, Nürnberg, a position he still holds. His paintings have been shown in numerous solo exhibitions in galleries and museums in the United States and Europe. He has been a freelance writer for the *Frankfurter Allgemeine Zeitung* since 1982.

Susan Carol Larsen is an art historian and critic who holds a doctorate in art history from Northwestern University, Chicago. She taught art history at the University of Southern California for many years and has served as curator at the Whitney Museum of American Art, New York, and the Farnsworth Art Museum, Rockland, Me. Larsen is currently Collector of Documents for the Archives of American Art, Smithsonian Institution, Washington, D.C.

Lucy R. Lippard has been a columnist for the *Village Voice*, *In These Times*, and *Z Magazine*. She is a cofounder of Printed Matter in New York, and the editor of several independent publications. Lippard has curated more than fifty exhibitions and is the author of eighteen books, and she has edited or contributed essays to more than twenty others. In addition to monographs on Eva Hesse (1976) and Ad Reinhardt (1981), her books include *Six Years: The Dematerialization of the Art Object from 1966 to 1972* (1973), *From the Center: Feminist Essays on Women's Art* (1976), *Get the Message?: A Decade of Art for Social Change* (1984), *A Different War: Vietnam in Art* (1990), and *The Lure of the Local: Senses of Place in a Multicentered Society* (1997).

Ann Reynolds is Associate Professor of Art History and Women and Gender Studies at the University of Texas at Austin. Her book *Robert Smithson: Learning from New Jersey and Elsewhere* was published by MIT Press in 2003. Her essays have appeared in the exhibition catalogues *Robert Smithson* (The Museum of Contemporary Art, Los Angeles), *Other Worlds* (Baltic/Reaktion Books), and *Tempus Fugit* (The Nelson-Atkins Museum of Art); in the anthologies *Varieties of Modernism* (Yale University Press/Open University), *Art in the Landscape* (Chinati Foundation), *The Visual Culture Reader* (Routledge), and *Visual Display: Culture Beyond Appearances* (New Press); and in the journals *Art & Text*, *Bookforum*, *Center*, and *October*. Currently, she is completing an essay on *Spiral Jetty* for the Dia Foundation, and is working on a book-length study on creativity and community titled *Playtime*.

Kirsten Swenson is a Ph.D. candidate in Art History and Criticism at the State University of New York at Stony Brook, where she teaches courses in twentieth-century European art and postwar American art. She has published articles on Lee Bontecou and Eva Hesse. Swenson is the Smithsonian American Art Museum's 2004–05 Douglass Foundation Predoctoral Fellow in American Art. She currently works as a Teaching Fellow at the Whitney Museum of American Art, New York.

Anna Vallye writes in the fields of twentieth-century art and architecture history. She has worked in the Curatorial and Special Projects departments of the Solomon R. Guggenheim Museum in New York, and is currently a Ph.D. candidate at Columbia University.

Mel Bochner studied painting and philosophy at the Carnegie Institute of Technology, Pittsburgh. After moving to New York in 1964, he worked as a studio assistant to Jack Tworkow, Robert Motherwell, and Ruth Vollmer. His first major essay, "Primary Structures," was published in *Arts Magazine* in 1966. He has since written regularly for *Arts*, *Art Voices*, *Art and Artists*, *Artforum*, and *Studio International*. Bochner has taught at the School of Visual Arts, New York, and Yale University, New Haven, Conn., where he is currently an adjunct professor in the School of Art.

Thomas Nozkowski is a painter and Professor of Fine Art at the Mason Gross School of the Arts of Rutgers University in New Jersey. He is a Guggenheim fellow and the recipient of an American Academy of Arts and Letters Award in Painting. He has had over sixty solo exhibitions, and his work is represented in the collections of the Corcoran Gallery of Art, the Metropolitan Museum of Art, The Museum of Modern Art, and the Phillips Collection, among others. A twenty-five-year survey of his drawings was presented by the New York Studio School in 2003.

Richard Tuttle is a painter and sculptor. He studied art at Trinity College, Hartford, Conn., and the Cooper Union, New York, in the early sixties. His first solo show was held at the Betty Parsons Gallery, New York, in 1985. He is the recipient of both a National Endowment for the Arts fellowship and the Skowhegan Medal for Sculpture. The San Francisco Museum of Modern Art organized a major traveling retrospective of his work in 2005.

Sol LeWitt is a conceptual artist and painter. After receiving a B.F.A. from Syracuse University in 1949, he moved to New York, where he worked as a draftsman for architect I.M. Pei. His influential text "Paragraphs on Conceptual Art" was published in 1967. In the late sixties and early seventies, LeWitt participated in the seminal group exhibitions "Primary Structures," at The Jewish Museum, New York (1966), and "When Attitude Becomes Form," at the Kunsthalle Bern (1969). The Museum of Modern Art, New York, organized the first major retrospective of his work in 1978.

INDEX

This book is published in conjunction with the exhibition "Thinking the Line: Ruth Vollmer and Gego," curated by Nadja Rottner and Peter Weibel and presented at: **Ursula Blickle Stiftung, Kraichtal** September 13–October 19, 2003, **ZKM | Center for Art and Media Karlsruhe** January 16–March 21, 2004, **Neue Galerie am Landesmuseum Joanneum, Graz** July 2–August 29, 2004, **Miami Art Central** September 21–November 14, 2004

Exhibition
Curators Nadja Rottner, Peter Weibel
Research assistance Almut Haboeck
Exhibition coordination Valentina Dobrosavljevic (Kraichtal); Carmen Beckenbach, Petra Meyer (Karlsruhe); Elisabeth Fiedler, Andrea Harrich (Graz); Patricia García-Vélez, Laurie Escobar (Miami)
Conservator Tilman Daiber (Kraichtal, Karlsruhe); Walter Rossacher, (Graz)
Technical direction Ursula Blickle Stiftung (Kraichtal); Martin Häberle and team (Karlsruhe); Walter Rossacher and team (Graz); Benjamin Levin and team (Miami)

Catalogue
Editors Nadja Rottner, Peter Weibel
Project direction Nadja Rottner
Editorial assistance Andrea Harrich, Almut Haboeck, Ulrike Havemann
Copyediting Barbara Ross
Proofreading Chesley Hicks
Book design John Isaacs
Printing and binding Excelsior Printing Company, North Adams, Massachusetts

© 2006 Hatje Cantz, Ostfilden-Ruit, and authors
© 2006 for the reproduced works by Ruth Vollmer: the artist

Published by
Hatje Cantz Verlag
Zeppelinstrasse 32
73760 Ostfildern
Germany
Tel. +49 711 4405-0
Fax +49 711 4405-220
www.hatjecantz.com

Hatje Cantz books are available internationally at selected bookstores and from the following distribution partners:
USA/North America—D.A.P., Distributed Art Publishers, New York, www.artbook.com
UK—Art Books International, London, www.art-bks.com
Australia—Tower Books, Frenchs Forest (Sydney), towerbks@zipworld.com.au
France—Interart, Paris, commercial@interart.fr
Belgium—Exhibitions International, Leuven, www.exhibitionsinternational.be
Switzerland—Scheidegger, Affoltern am Albis, scheidegger@ava.ch

For Asia, Japan, South America, and Africa, as well as for general questions, please contact Hatje Cantz directly at sales@hatjecantz.de, or visit our homepage, www.hatjecantz.com, for further information.

ISBN-10: 3-7757-1786-2
ISBN-13: 978-3-7757-1786-1

Printed in USA

BUNDESKANZLERAMT ▪ KUNST